THE
CARPET

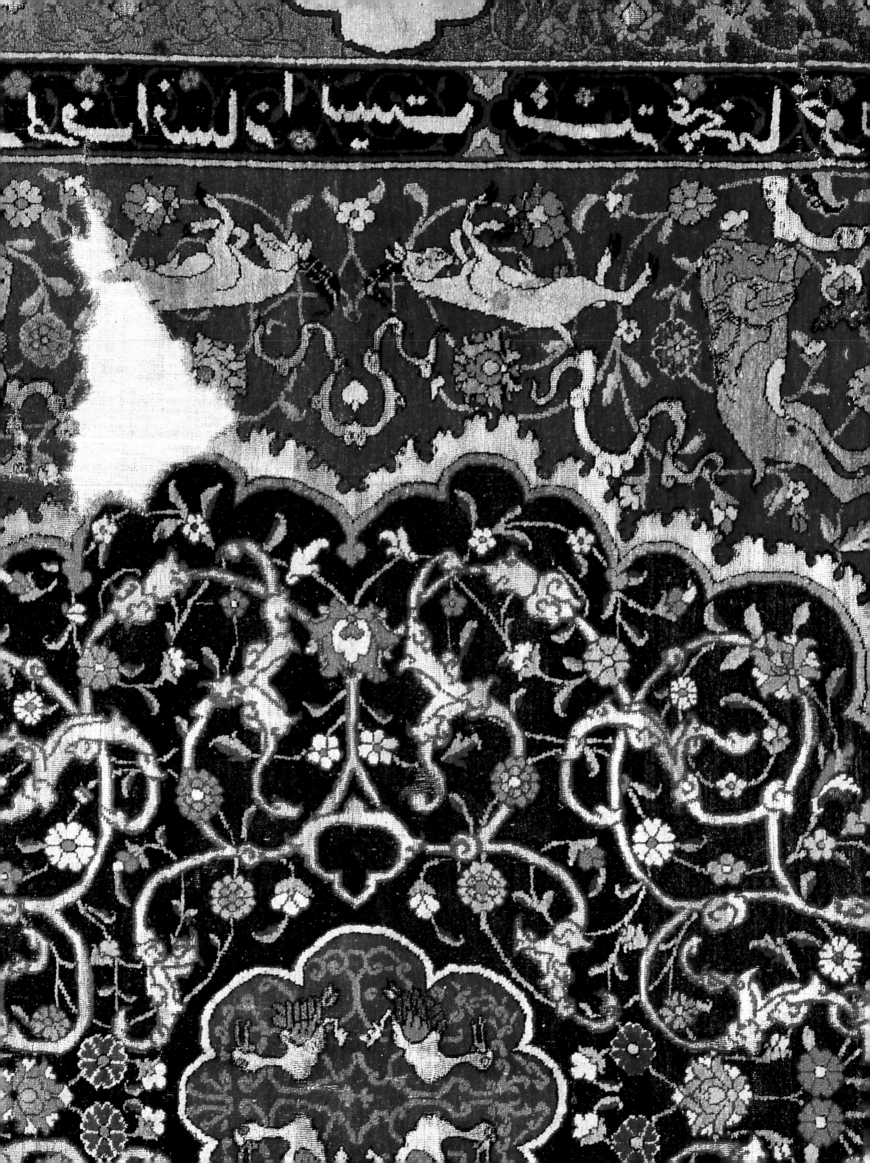

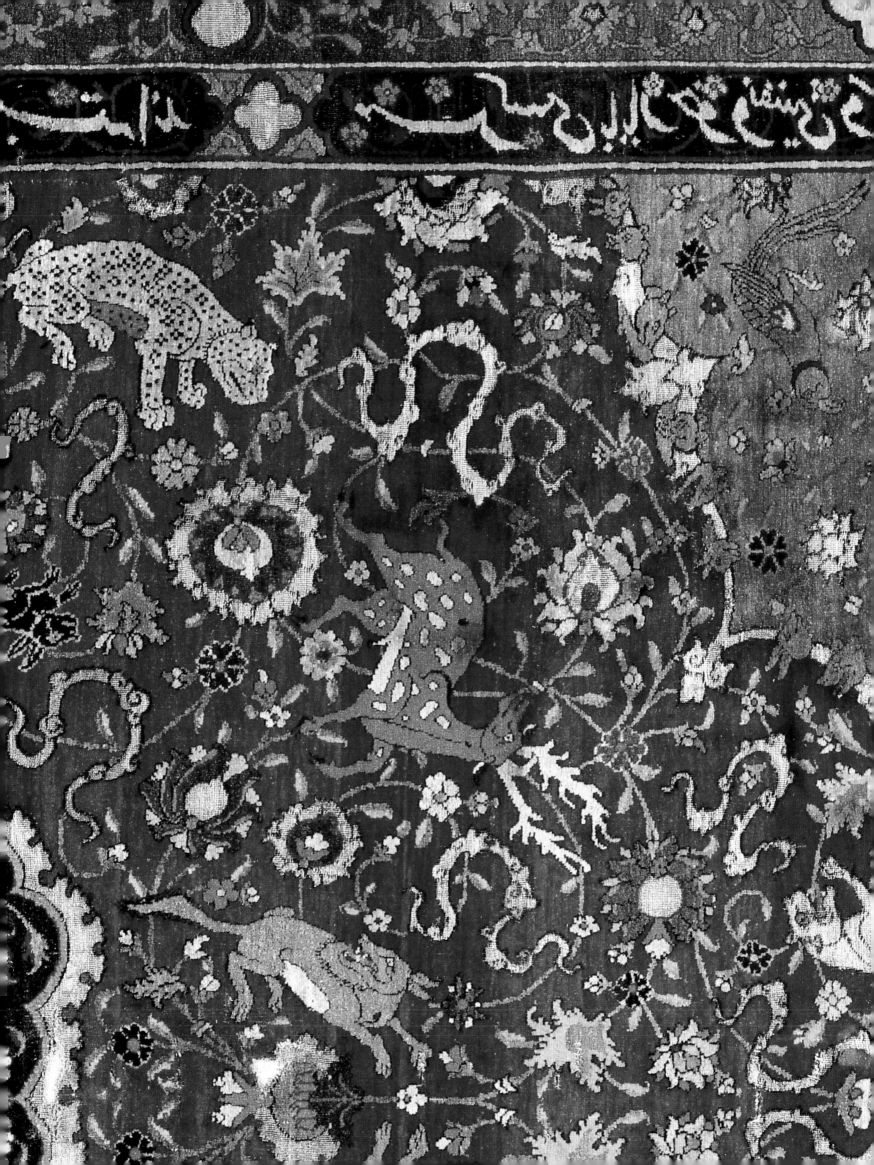

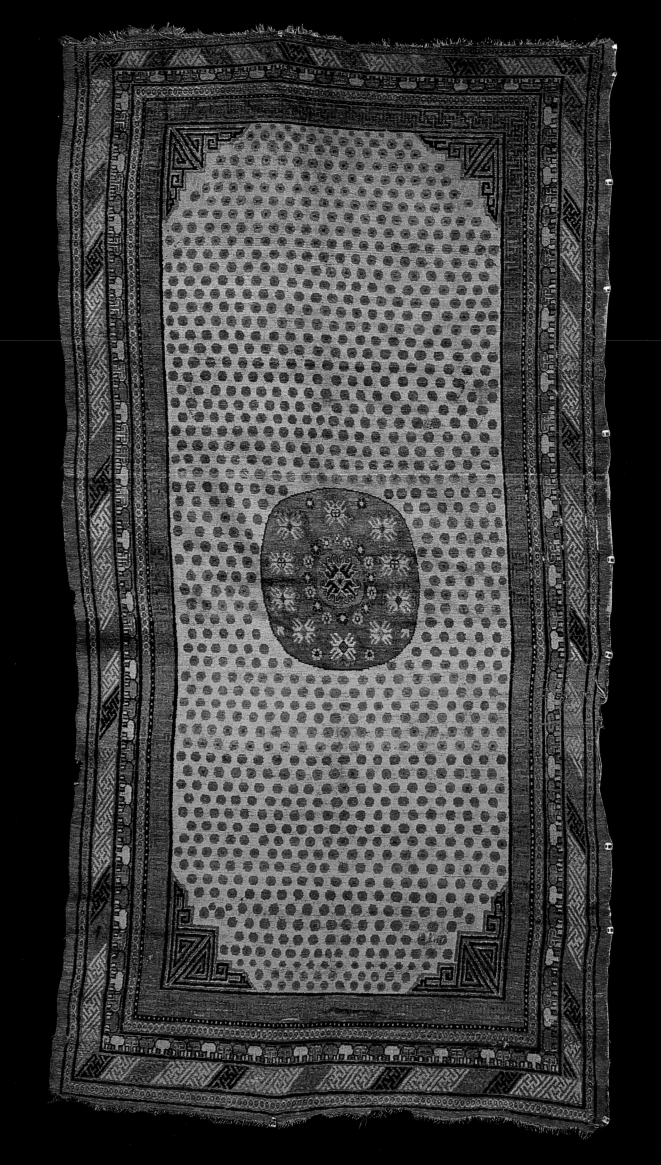

ENZA MILANESI

THE CARPET

ORIGINS, ART AND HISTORY

FIREFLY BOOKS

A FIREFLY BOOK

Published by Firefly Books Ltd. 1999
First published in Italian as *Il Tappeto: I Luoghi, L'Arte, La Storia* in 1997 by Arnoldo Mondadori Editore, S.p.A.

First Printing

Library of Congress Cataloguing in Publication Data is available.

Canadian Cataloguing in Publication Data

Milanesi, Enza
 The carpet : origins, art and history

Translation of: *Il tappeto: I luoghi, l'arte, la storia.*
Includes bibliographical references and index.
ISBN 1-55209-438-3

1. Carpets. 2. Carpets—History. I. Title.

NK2795.M5413 1999 746.7 C99-930405-4

Published in Canada in 1999 by
Firefly Books Ltd.
3680 Victoria Park Avenue
Willowdale, Ontario
M2H 3K1

Published in the United States in 1999 by
Firefly Books (U.S.) Inc.
P.O. Box 1338, Ellicott Station
Buffalo, New York
14205

English translation by Rosanna M. Giammanco Frongia, Ph.D.
English text edited by Charlotte DuChene

Printed in Spain
D.L. TO: 1412-1999

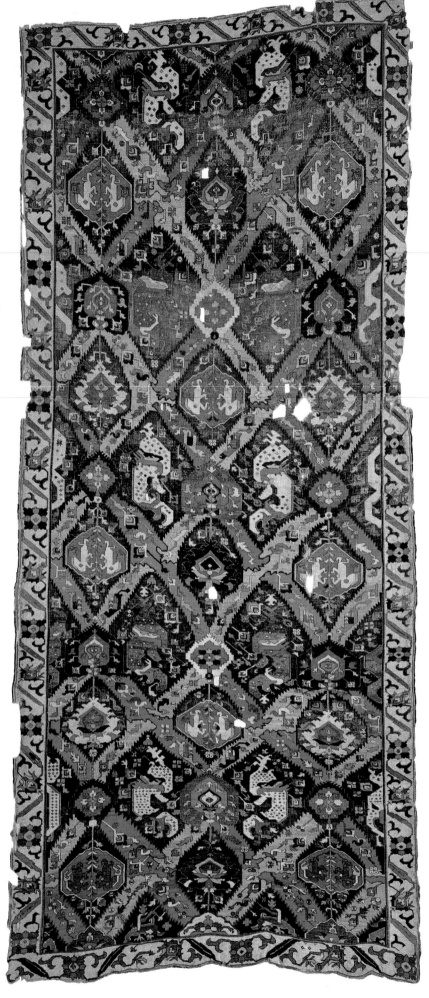

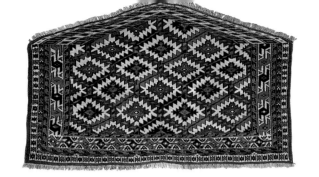

Contents

FOREWORD

From the perspective of Western culture, it is not always easy to understand the complexities of the antique Oriental carpet. Undoubtedly, part of its fascination lies in its dual nature as a simple, even humble artifact, intended to be used in a variety of ways, and as a complex artistic object with ancient designs unfamiliar to us, created by using the knot, an ancient weaving technique largely unknown to the West.

By providing not only the tools to understand the decorative and technical aspects of each carpet but also the ability to recognize each specimen, including its geographic area of production, this book is intended to enable the reader interested in art and antiques to see and appreciate the carpet as an artistic expression.

At the same time, this book is for anyone interested in owning a beautiful book on the subject of carpets simply for the pleasure of reading it and enjoying the lovely illustrations, since it is intentionally neither a manual nor a guide but a book that aims to inform as well as captivate.

The first part of the book is a general introduction to the subject, dealing in concise fashion with the origins of the carpet, its practical and artistic functions, its historical development, its manufacture and the materials employed. With the aid of diagrams and drawings, we study the carpet's decoration, the layout system, the ornamental motifs, their symbolic meaning and origin and how the decoration was interpreted (either geometrically or curvilinearly). Also a discussion of the four cultural spheres in which carpets were produced—the nomadic life, the village, the city and the large workshops—briefly covers the problems of dating carpets and the very concept of the antique carpet.

The second part of the book is divided into the main geographic areas

of production: Anatolia, Persia, the Caucasus, India, western Turkestan, eastern Turkestan, China and some historical European centers. In turn, each section consists of two parts: an historical stylistic analysis and a photographic catalog of a representative selection of carpets from the area, analyzed and interpreted.

By following an historical path and using photographic breakdowns, drawings, captions and comparisons, we examine the carpets that are most representative of a particular style in their distinctive features and in their decoration. They are compared with other similar carpets, along with other historical and artistic artifacts and documents, and placed in their historical, religious and social context.

The photographic catalog is intended as a guide to help identify the stylistic features of each of the large geographic areas of origin and, within each of them, the leading production centers that gave their names to the various styles.

The novelty of this book, compared with other works in the same genre, lies in the importance given to photographs and drawings and in the attempt to go beyond the historical and technical aspects by studying in more depth the cultural aspects of carpet making. In fact, it is thanks to a thorough historical-cultural exploration and the study of real carpets that we provide the reader with the best possible tools to recognize the style and provenance of carpets.

Hence, we entitled this work The Carpet: Origins, Art and History, *because rather than excluding any of the carpets' aspects, we tried to situate each specimen in a wide, all-inclusive context, retaining intact all characteristics of cultural significance, as with other notable works of art.*

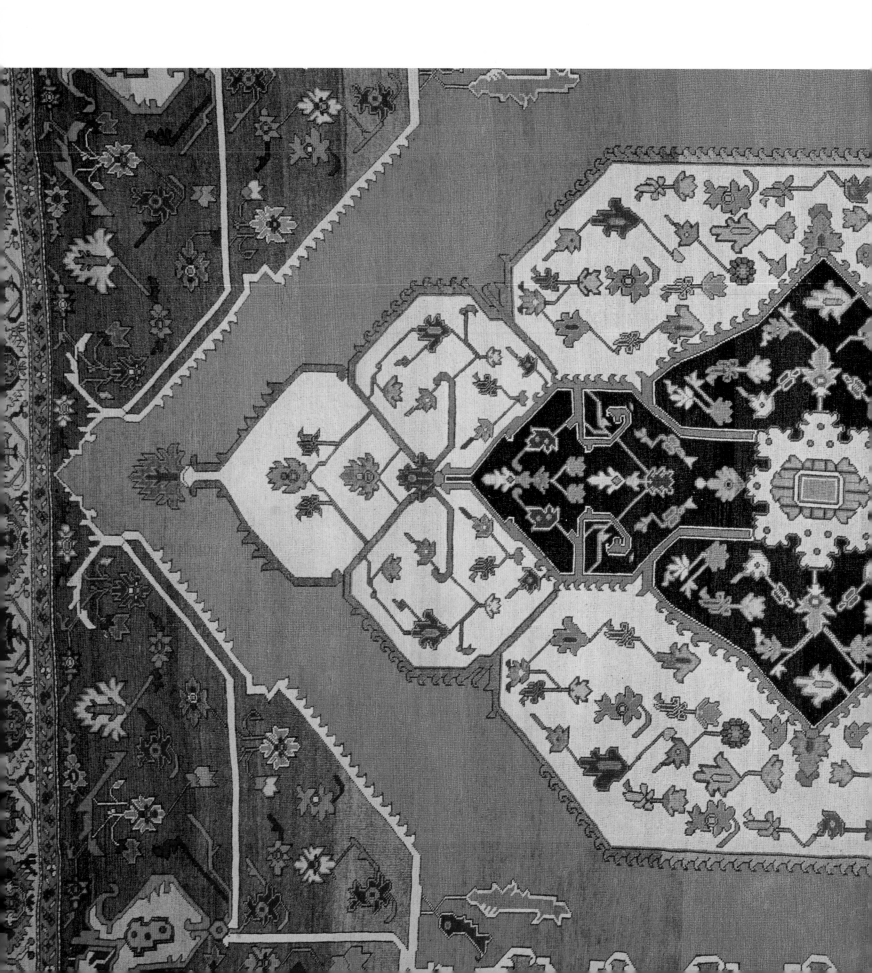

THE WORLD OF CARPETS

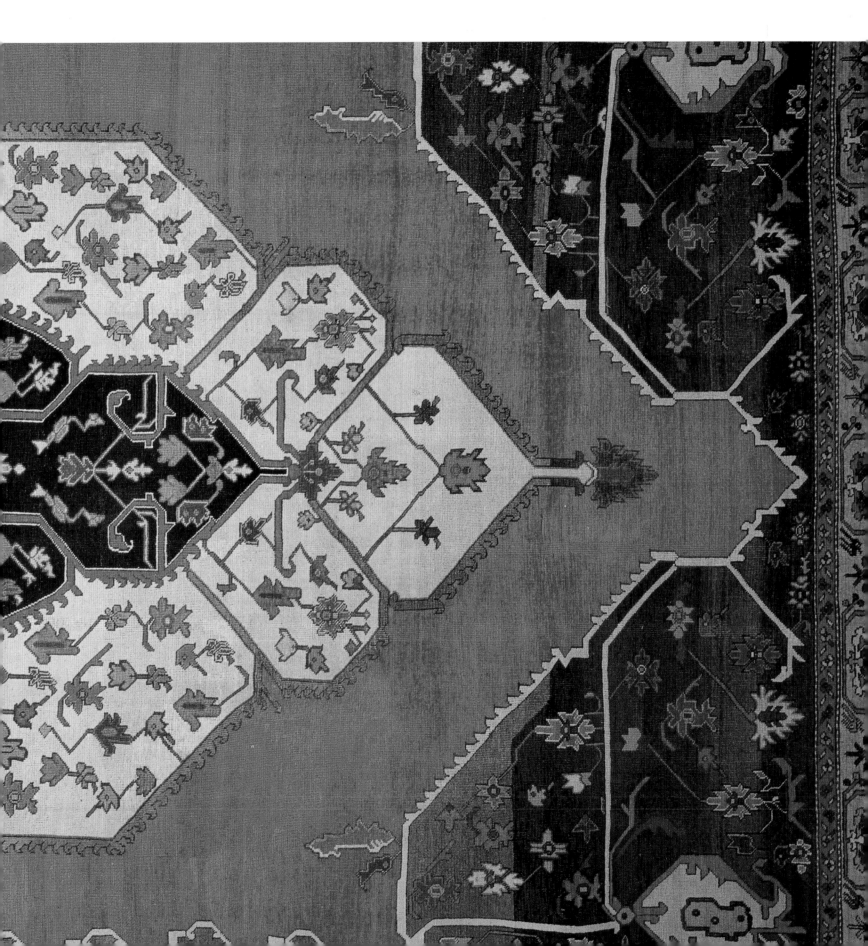

WHAT IS A CARPET?
ITS ORIGINS

The carpet, more than any other type of antique art object, is found in the real world as a concrete object with a practical use. The fact that theories continue to be debated about its origins carries the carpet into the academic realm as well.

From time immemorial, carpets have been manufactured in all social contexts in the Middle East—in nomadic life as well as in settled, aristocratic locales—for practical use in everyday life.

We know this not just from the traditional Oriental way of life but also from historical evidence, such as 15th-century Persian miniatures, in which princes and dignitaries are depicted outdoors comfortably seated on richly decorated carpets. For Westerners, who lack such a tradition, the carpet represents only an element of decoration.

Historically speaking, what does this artifact consist of? First of all, we must clarify that the term "carpet" usually means, in this context especially, the knotted carpet—a specific type of textile that is handmade on a loom using the knotting technique. This technique creates not a simple, flat surface but a "fleecy" textile, a true artificial "pile" that hides the supporting foundation or framework. The foundation is the grid formed by the crossing of horizontal strands, or lines (the weft), with vertical strands, or chains (the warp).

The technique of knotting involves creating horizontal rows of small knots usually looped around two warp threads, alternating with one or more lines of weft. After each knot, the yarn is cut to produce the "fleece," which is the pile of the carpet.

To create decorations, strands of different colors are used, following a procedure in which each knot is used like a tile in a mosaic.

The primary materials for carpets are wool, cotton and silk yarn. By their very nature, these textile fibers are subject to deterioration. This is especially true of wool, the most commonly used material, which crystallizes and turns to powder with the passing of time.

The highly perishable nature of the materials does not favor their preservation and helps explain the scarcity of specimens from ancient eras. It also has a fundamental effect on the criteria used in the chronological classification of carpets and on the actual definition of what constitutes an antique carpet.

Uncertain origins

Why was the knotted carpet born, and where did it originate? Lacking any solid evidence, we can provide no clear answers to these questions. Nonetheless, two theories have developed about the origin of the knotted carpet.

The first theory places the creation of knotted carpets in a remote age, maintaining that they were the work of rugged, nomadic populations seeking to protect themselves from the cold ground without sacrificing their precious animals for their skins. Thus, carpets were born on rudimentary horizontal looms, which could be easily taken apart and transported as utilitarian objects, to replace with an artificial "fleece" the natural sheep- and

goatskins these tribes used to keep their bodies warm and to avoid direct contact with the ground.

This theory, then, contends that the original intent of carpet making was practical, not artistic. The desire to decorate the interiors of tents with these specific textiles would come later, and their embellishment with a variety of colors and designs would follow, becoming a constant in the carpet's decorative motifs. With the passage

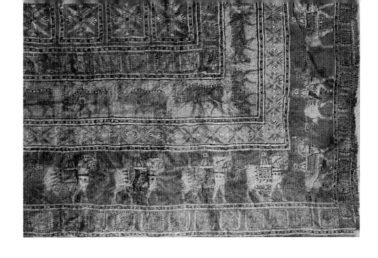

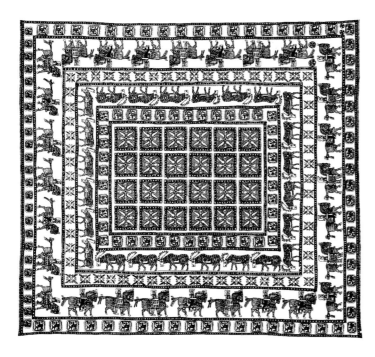

of time, the nomadic populations introduced these artifacts to the inhabitants of villages and cities, who took them as their own for the purpose of decoration.

According to supporters of the second theory, the knotted carpet, though still born in a primitive age, belongs to a later, more evolved era and was created by already-settled societies that used cumbersome fixed vertical looms. In addition, the new textile was created in response to a clear aesthetic need: the desire to decorate the interiors of permanent homes and dwellings. Only later would the nomadic tribes make this new artifact their own, creating rougher and more primitive versions by using horizontal looms created by adapting the more evolved vertical looms to their different way of life.

The Pazyryk discovery

The second theory seemed to receive concrete support in 1947 in the wake of an important archaeological discovery in Siberia by the S.I. Rudenko expedition. The grave of a Scythian chief was found in the Pazyryk Valley, deep

in the Altai Mountains. In this valley, the expedition also found a well-preserved knotted carpet that had been frozen in ice, along with a chariot, mummified bodies and household articles. The carpet was made of wool, with symmetrical knots on a densely decorated 189 x 200 cm (74 x 79") surface. The center of the field was divided into 24 small squares, decorated inside by a crosslike element, either a flower or a palmette.

Two of the carpet's borders aroused special interest: the inside border, composed of a row of elk, and the outside border, which depicted a procession of mounted horsemen, perhaps the funeral procession of the deceased Scythian chief. The predominant colors were white, red, yellow and light blue, testifying to an already strong taste for combining various colors.

The find, called the Pazyryk carpet, is preserved at the Hermitage Museum of St. Petersburg and was dated to the fifth century B.C. by Rudenko. It is the oldest known knotted textile. Its refined workmanship from a remote age would seem to confirm the theory of a primeval artistic need as the origin of the carpet. In any case, regardless of either theory, we can still believe that the knotted carpet was born of the need to seek protection from the cold by isolating the body from the ground, as well as the aesthetic desire to decorate the interior of dwellings.

Birthplace of the carpet

Due to the widespread use of the knotted carpet throughout the Middle East, the birthplace of the carpet remains shrouded in mystery. The most reliable theory holds that Central Asia—more specifically, Turkestan—was the cradle of this particular artifact. In fact, except for the Pazyryk carpet, the most ancient carpet fragments were found there, datable to the second or third century B.C. According to this theory, large groups of migrating peoples then spread the art of knotting from Turkestan to the west to Persia, Anatolia and the Caucasus and to the east to China and, much later, to the south to India.

CARPET MAKING: MATERIALS, DYES AND KNOTTING

Wool, cotton and silk are the primary materials for carpets. Because of its availability throughout the Orient, wool (from sheep, goats or less durable camel hair) is the most widely used fiber for carpet making. In antique carpets and especially those made by nomadic tribes, wool was used for both the pile and the foundation. Cotton, a strong fiber, is suitable for the underlying foundation. It was also used in the pile to create white areas. Since it is the crop of a cultivated plant, however, cotton is not found in the carpets produced by nomadic tribes. Because of its soft quality and shine, silk is the most precious of the materials, used mainly in the pile, alone or combined with wool, exclusively by specialized city workshops. Wool, cotton and silk are spun into yarn by twisting the fibers.

Dyes

Traditionally, yarn dyeing was performed by men. Until the 1860–1870 period, only natural dyes were used. Later, chemical dyes appeared (aniline dyes, at first, and, in the early 20th century, chrome dyes). They soon replaced the natural dyes in the large production centers, later in other cities and, finally, in the villages (without, however, affecting the nomadic tradition).

Natural dyes were made by master dyers using secretly guarded formulas and were composed of substances found in nature: saffron flowers and pomegranate skins for yellow; kermes, lac, cochineal (the dried bodies of female cochineal insects) and madder root for red; tea or tobacco for black and brown; and many others. Creating complementary tints, derived from the primary colors

The Vaghireh

Vaghireh, a Persian term, refers to patterns of traditional designs for each production that are used as an outline in knotting. Sized small so that they could be placed next to the loom, the *vaghireh* consisted of sections of field motifs, along with a series of modules for four or five borders, and often a cornerpiece. They thus served as an aid to the manufacture of the whole carpet by demonstrating the designs. Sometimes the *vaghireh* were painted, but more often, they were actual miniature carpets, which would better render the idea of the finished product. *Vaghireh* were traditionally used by women weavers in small town and village workshops, while in the specialized ateliers, where commercial needs dominated, the weavers used car-

toons on square-ruled paper on which miniaturists had drawn the diagrams of their designs. The nomadic populations, however, handed down their simpler, stylized designs by word of mouth.

Although the oldest surviving *vaghireh* date from the 17th century, they were undoubtedly utilized even earlier and were especially popular in Persia, Anatolia and the Caucasus. Their use was greatly expanded during the 1800s. In the West, they are collectors' items, just like the carpets themselves.

Below: Detail of a *vaghireh*. Persia, Hamadan area, 19th century. Verona, Tiziano Meglioranzi Collection.
Right: Bidjar *vaghireh*. Persia, 19th century. Private collection.

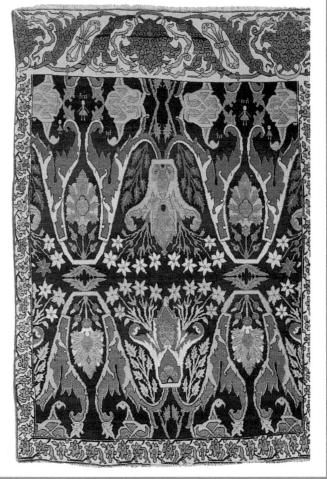

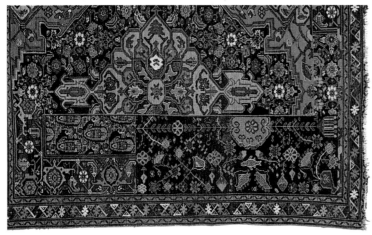

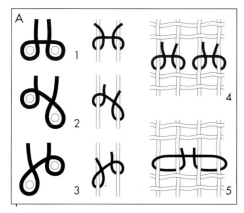

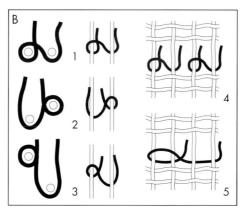

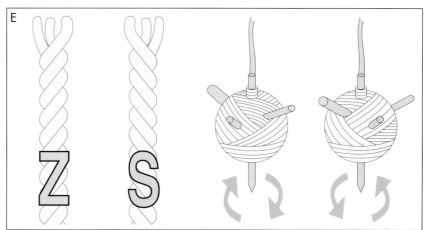

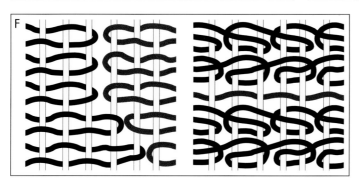

A. Symmetrical knot, also known improperly as the Ghiordes, or Turkish, knot: The yarn is looped around both warp threads, then the two ends are drawn out to protrude between the threads. This pair of free ends forms a tuft of the pile. (1–3) Knot shown in cross section and in perspective views following three possible inclinations; (4) two consecutive knots tied between two rows of weft; (5) the *jufti*, or "false," symmetrical knot.

B. Asymmetrical knot, also known improperly as the Senneh or Persian knot: The yarn is wound around one warp thread and then looped behind and around the other, leaving the two ends of the tuft separated by the one free thread; depending on which thread is wrapped, knots are said to be "open" to the left or to the right. (1–3) Knot shown in cross section and in perspective views following three possible inclinations; (4) two consecutive knots tied between two rows of weft; (5) the *jufti*, or "false," asymmetrical knot.

C. The single-warp, or Spanish, knot: The yarn is wrapped around a single warp thread, using alternate ones, bringing the two free ends of the knot to either side of the warp chain.

D. Vertical loom with adjustable bench and fixed beams (left) and vertical loom with rotating beams (right), which permits the weaver to remain stationary.

E. Diagrams showing the twist of fibers, which is useful in determining a carpet's origin. Fibers twisted clockwise result in a "Z" yarn, while fibers twisted counterclockwise result in an "S" yarn.

F. Diagrams of the flat-weave techniques of kilims (slit technique, left) and soumaks (looped weft technique, right).

Right, detail of the back of a carpet: A close examination is important in learning how to appreciate as well as appraise the refinement of the knotting, because the smaller the knots and the greater the density of the knotting, the greater the value of the carpet.

Kilims and Soumaks

Also part of the Oriental tradition are flat-woven carpets, similar to Western tapestries. These have neither knots nor pile, and as different colored threads are used for the weft, they serve a decorative and structural purpose. *Kilims* and *soumaks* employ different weaving techniques. The kilims follow the "slit" method: The weft is not continuous but is interrupted at each change of color so that, at the border between the two color areas, slits 2–5 cm (¾ –1¾") long

are formed. Soumaks follow the "looped-back" technique: The weft passes over three to four warp threads, then loops back behind one or two threads, creating an oblique stitch.

Below: Sileh soumak with a dragon design. Caucasus, mid-19th century. Verona, Tiziano Meglioranzi Collection. Right: Prayer kilim. Anatolia, 19th century. Verona, Tiziano Meglioranzi Collection.

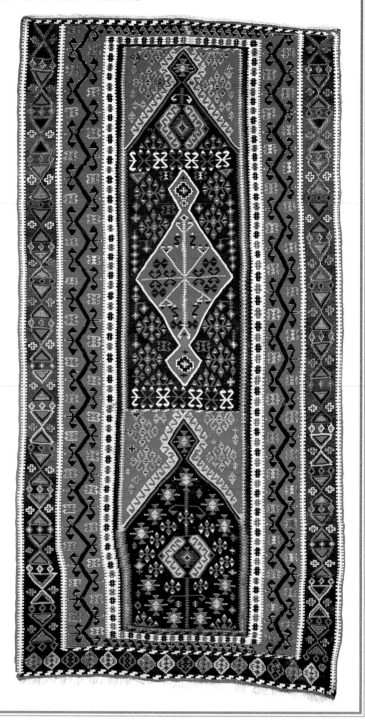

by further soaking the yarn in two or more different colors, was a lengthy procedure. For this reason, the new chemical dyes met with success, and the 1860–1870 time span became an important reference point in the chronological classification of carpets.

Knots

Two basic kinds of knot have been used throughout the Orient: the symmetrical knot, also known (improperly) as the Ghiordes, or Turkish (*turkibaft*), knot, because it was used mainly in Turkey; and the asymmetrical knot, also known (again improperly) as the Senneh, or Persian

(*farsibaft*), knot, because it was used in Persia. Both types are still practiced. For example, in the Persian city of Senneh (present-day Sanadaj), the so-called Turkish knot has always been used. Stylistically, the symmetrical knot, being larger and square, creates geometric designs, while the asymmetrical knot, smaller and of irregular shape, is more able to create curvilinear motifs.

A variant of these two systems is the *jufti* knot. It is also known as the "false" knot because, although derived from a Khorasan practice where it was used for relief effects, the *jufti* knot served in modern production to increase the weaving speed, resulting in less durable

The fringes consist of the ends of the warp threads, which are cut from the loom and then tied or knotted in various ways. They represent the final phase in the making of a carpet. From left to right: Knotted, twisted and braided fringes; the last diagram on the right shows a carpet without fringes.

Below, detail of a Kerman carpet with floral decoration. Persia, late 19th century. Private collection. The manufacture of a carpet in silk increases its value and refinement with its denser knotting.

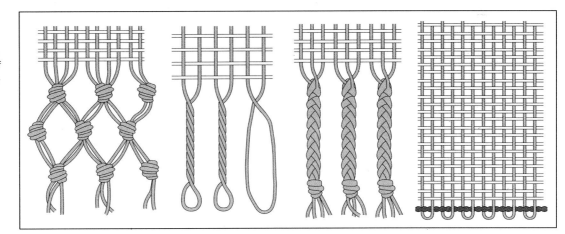

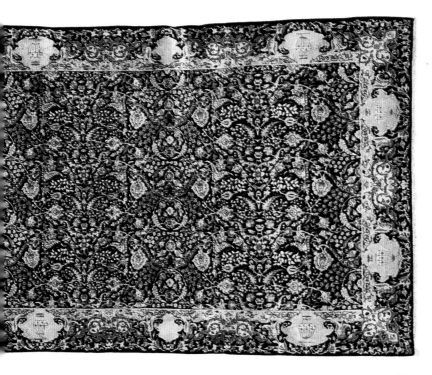

carpets. With reference to Western carpets, we should mention the single-warp knot, better known as the Spanish knot for its traditional use in Spain.

Customarily, knotting was done by women, except in the large city workshops and court ateliers. The technique involves alternating a horizontal row of knots with one or more rows of weft, working continuous rows of knots and weft strands across the width of the loom. Having stretched the warp threads on the loom, the weaver ties each row of knots, using a hooked knife. Each row of knots is usually followed by two rows of weft threads to secure the knots and reinforce the carpet's structure. Everything is tightened by beating down the weft and knots using a special wooden or metal comb.

To each knot corresponds a color, in accordance with the pattern being created, which may have been memorized, followed on partial models (such as cartoons and *vaghireh*) or dictated color by color. Once the carpet is fully knotted, the ends of the warp threads are cut from the loom to free the carpet and are braided in various ways to form the fringe.

The Abrash

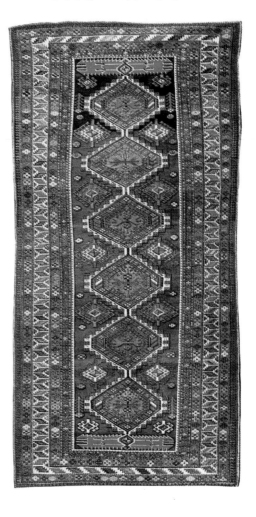

Shade variations that are sometimes present in the ground color of the carpet are called *abrash*. These irregularities are caused by different degrees of color absorption by the fibers or when skeins of the same color, but from different baths, are used. *Abrash* may be a natural product of aging, or they may be applied in the weaving process to give the carpet a more handmade look; they may also provide movement to the solid color of the ground when it is considered too uniform for the Oriental taste. Hence, the *abrash* should be considered not a defect but an unusual technical and aesthetic feature. Shirvan medallion carpet.

Caucasus, 19th century. Private collection.

THE ARCHITECTURE OF THE CARPET: ITS LAYOUT

Just as in a true architectural plan, the carpet's layout consists of diagrams on which the decoration is laid out, the drawings composed and the decorating motifs selected. These are all ancient systems, arranged and set by tradition and therefore considered classical; however, they have always been kept alive and are used for modern carpets as well.

The layouts can be directional, nondirectional or centralized.

Directional layouts

Directional layouts are arranged according to a single axis of symmetry and thus give a direction to the carpet, since they are meant to be looked at from one direction only. Certain carpets that depict animals and gardens (called "figural" carpets) and carpets that repeat a single, unchanging decorative motif across the entire field but with a direction, such as the *boteh*, have this structure. The most eloquent examples are prayer rugs. Prayer rugs serve the practical purpose of helping the faithful Muslim to orient his position, therefore his prayer, toward Mecca. For this reason, the field is dominated by the design of a niche, or mihrab, in a given direction, inside which the Muslim kneels, placing his head on the top of the arch and his hands on the corners.

Nondirectional layouts

Nondirectional carpets may be viewed from any direction, since the design is not directed toward any one point, no parts of it stand out and it is formed by continuous elements or by self-enclosed, equal motifs that are repeated continuously to fill the entire field. Most of the compositions known as full-field are of this type: They are very regular, and their decoration is formed by

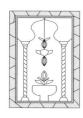
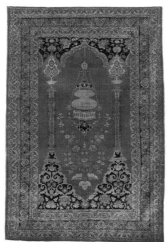
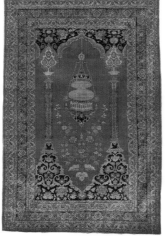

Heriz prayer rug. Persia, 19th century. Private collection. This is the most common directional layout and is distinguished by the design of its niche, or mihrab, on which the faithful kneel daily to say their prayers—the head is placed on the top of the arch, while the hands are placed on the corners.

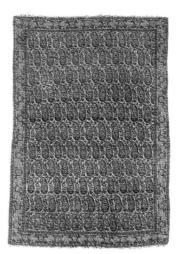

Senneh carpet with full-field decoration. Persia, early 20th century. Private collection. The decoration is full-field, evenly spread throughout the layout, and thus lacks a primary element. At first glance, the layout seems nondirectional; however, the small *boteh*, with their tips pointing upward, instill a sense of direction to the carpet.

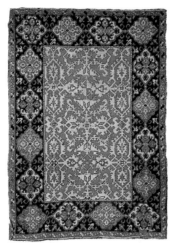

Ushak carpet with Lotto-type arabesques. Anatolia, early 17th century. New York, The Metropolitan Museum of Art. In this case, the full-field layout is nondirectional and can be looked at from any direction. The decoration is formed by a continuous element without beginning or end.

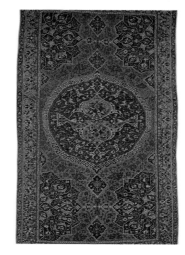

Ushak medallion carpet. Anatolia, 16th or 17th century. Vienna, Österreichisches Museum für angewandte Kunst. This nondirectional layout is centralized because of the medallion in the center, which dominates the rest of the decoration. Fractions of four other secondary medallions can be found in the corners (also known as spandrels). This is the best-known and most widespread layout.

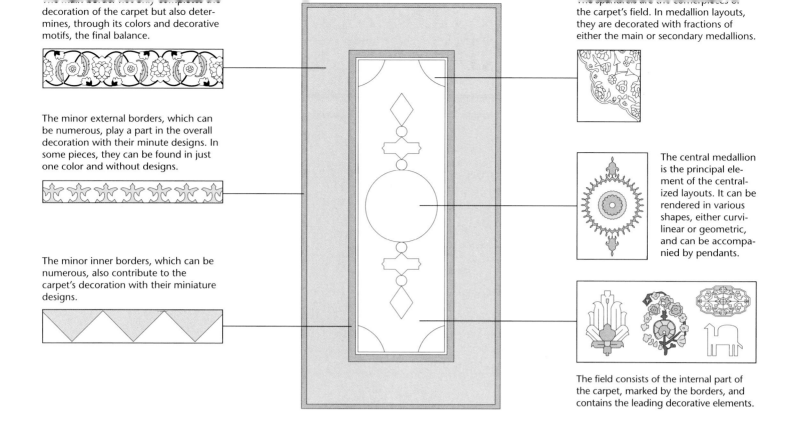

decoration of the carpet but also determines, through its colors and decorative motifs, the final balance.

The minor external borders, which can be numerous, play a part in the overall decoration with their minute designs. In some pieces, they can be found in just one color and without designs.

The minor inner borders, which can be numerous, also contribute to the carpet's decoration with their miniature designs.

the carpet's field. In medallion layouts, they are decorated with fractions of either the main or secondary medallions.

The central medallion is the principal element of the centralized layouts. It can be rendered in various shapes, either curvilinear or geometric, and can be accompanied by pendants.

The field consists of the internal part of the carpet, marked by the borders, and contains the leading decorative elements.

unchanging, repeating motifs arranged in perpendicular or diagonal rows or by continuous designs, which, in turn, form grids or endless scrolls. This type of layout is typical of the arabesque carpets, where the decoration is formed by a ribbon of changing shape that extends regularly across the entire field.

Centralized layouts

Centralized layouts may also be viewed from any direction, but their decoration is composed of a dominant, central element around which secondary motifs are arranged. The central element is usually a medallion—a large rosette shaped in the form of a circle, an ogive (a pointed, or Gothic, arch), a star or a sharply profiled poly-

gon. Medallion layouts are the most widespread and can be arranged in different ways. Usually, the field is dominated by a single, centrally placed, more or less large medallion surrounded by fractions (known as spandrels, or cornerpieces) of four secondary medallions set in the corners of the carpet.

In the so-called four-and-one arrangement, the four secondary medallions are whole and are placed near the four corners, rotating around the central medallion. Yet another variation is the multiple-medallion layout, consisting of two or more equal medallions placed along the length of the field. Sometimes the medallions vary in size, with the larger one in the center and the smaller ones at the sides, or vice versa.

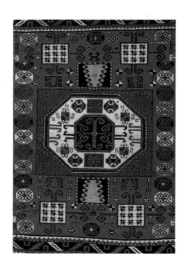

Detail of a Kazak medallion carpet. Caucasus, second half of 19th century. Milan, V. Hazan Collection. This medallion layout is also known as the "four-and-one"; it is a centralized layout in which the large central medallion is accompanied by four smaller medallions located near the corners.

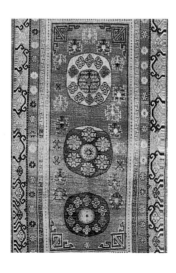

Detail of a three-medallion Khotan carpet. Eastern Turkestan, late 19th century. Private collection. This nondirectional layout shows three medallions placed one after the other lengthwise. This layout can have either medallions of equal dimensions or a larger central medallion, thus giving way to a centralized layout.

STYLES AND SPHERES OF PRODUCTION

The design of the carpet coincides with the way in which the layout and decorative motifs are interpreted and composed. The methods are many and vary according to geographic area and center of production. However, all designs are expressed following two primary languages—the geometric style and the floral style. The two styles differ in the type of line used: The first uses straight lines, while the second uses curved lines, which is why it is also known as the curvilinear style.

The geometric style

The geometric style is typically, though not always, created by using symmetrical knots, their regular shape producing straight lines. The style, therefore, consists of abstract or stylized figures (ultimately derived from the natural world) distributed equally across the carpet space. The final product has an immediate, spontaneous, often primitive character that reflects a rather simple organization of labor. In fact, carpets in this style were manufactured primarily by small artisans and nomadic tribes, the latter using primitive horizontal looms with designs handed down orally from generation to generation. So it is no coincidence that the first carpets, like the Pazyryk specimen, were made in the geometric style. This style was widely used in all areas, but especially in Anatolia, the Caucasus and Central Asia.

The floral (or curvilinear) style

More recent than the geometric style, the floral style was most probably born in the 15th century and was further

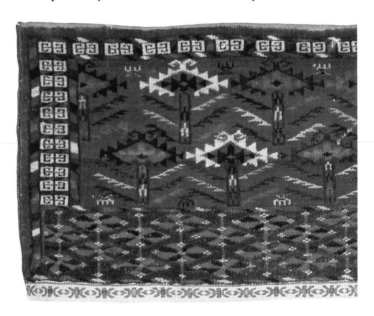

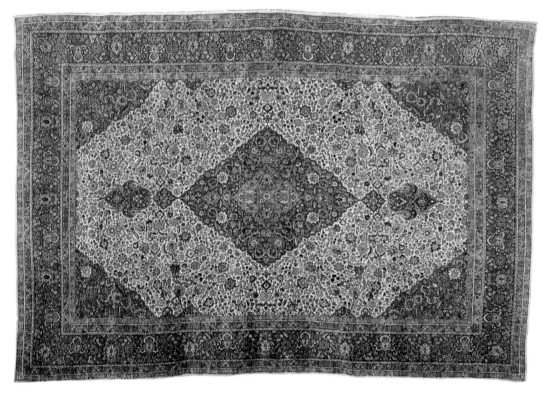

Above, detail of a Tekke *torba* (a type of bag) with geometric decoration. Western Turkestan, 19th century. Lübeck, Museum für Völkerkunde. Left, Kerman medallion carpet. Persia, 19th century. Private collection. A comparison of the two specimens highlights the stylistic differences of the production centers: nomadic (above) and urban (left). The characteristics of a carpet produced in a city workshop include a more refined look and a greater attention to detail, along with a harmonious variety of colors and designs, which can be either floral (or curvilinear), such as in this example, or geometric. The characteristic of the bag produced in the nomadic environment is simpler and instinctive, executed exclusively in a geometric style with modules, with a few colors brightened by white.

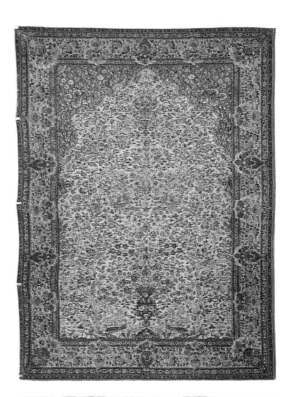

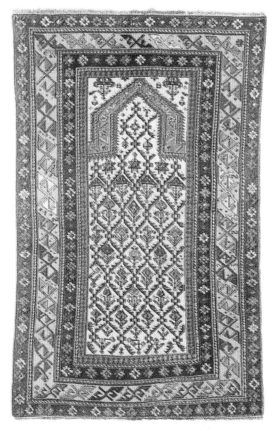

Left, Kashan prayer rug. Persia, 19th century. Private collection.

Right, Shirvan prayer rug. Caucasus, 19th century. Private collection.

Bottom left, Tabriz medallion carpet. Persia, 19th century. Private collection.

Bottom right, Shirvan medallion carpet. Caucasus, 19th century. Private collection.

Two different interpretations of the same layout can be seen in these two pairs of carpets (the first pair are prayer, the second medallion). Both the geometric style and the floral (or curvilinear) style are depicted.

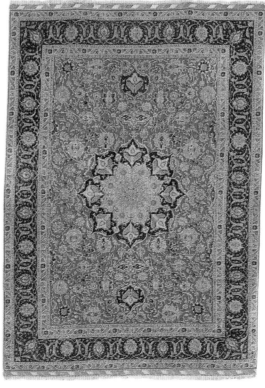

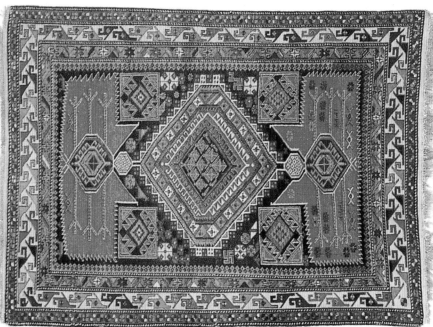

refined in Persia during the 16th century. It normally makes use of asymmetrical knots (but again, this is not a rule), which, being smaller, form even the finest curved lines; this facilitates the creation of complex designs of arabesques and naturalistic, or lifelike, floral elements, which often include human and animal figures.

Floral-style carpets are therefore complex and detailed. They are the result of the new development of an equally complex organization of labor, with a separation of the planning and execution stages of carpet making: The planning was assigned to the master designer (usually a miniaturist, called *ustad* in Persian), and the execution was left to the woman weaver or, more often, to the workshop team of men weavers, since the labor force also changed during this period.

The birth of this style brought about the introduction of models of the carpet's design: the squared cartoons and the *vaghireh*. Geographically speaking, the floral style finds its highest expression in the carpets from Persia.

Right, village medallion carpet. Midwestern Anatolia, 19th century. Paris, private collection. Compared with nomadic carpets, those produced in villages were open to outside influences, such as in this case, where the secondary medallions, in green and turquoise, reveal a certain creativity. Below, detail of a Kurdish village carpet with geometric decoration. Eastern Anatolia, early 20th century. Venice, Rascid Rahaim Collection. Both village and nomad carpets radiate simplicity in their use of head borders, or outside bands, along the short sides of the carpet worked with the kilim technique. Kurdish village carpets from eastern Anatolia use decorative motifs, such as hooked or stepped rhombuses, and dark colors.

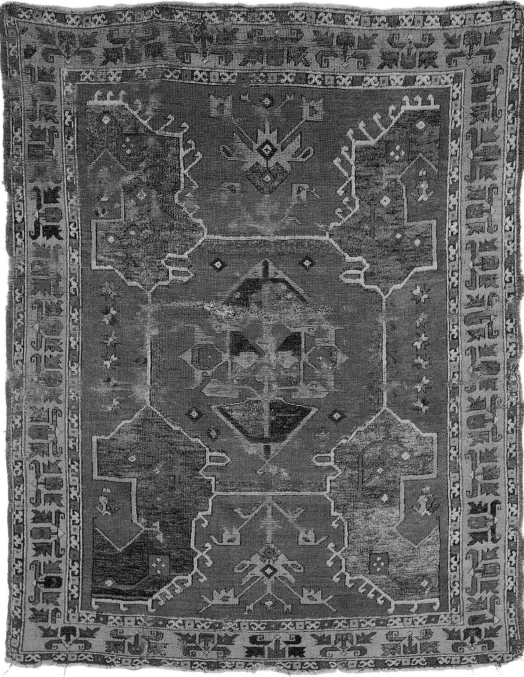

The spheres of production

Using either the geometric or the floral style, designs and decorative motifs were composed and interpreted in varying fashions, depending on time and place and even within single geographical areas. Hence, it is impossible to make broad, encompassing classifications without exceptions. In any case, bearing in mind that every carpet is the result of the relationship between technique, history, tradition and practical function and that its overall character is shaped by the context in which it was made, one can establish four broad stylistic groups corresponding to the four cultural spheres that took shape and evolved over the centuries: the nomadic tribe, the village, the city and the court.

The village, city and court spheres belong to the settled form of life and therefore share the vertical loom, which is more complex but more cumbersome than the horizontal loom used by the nomadic tribe, its structure requiring the support of walls and ceilings in permanent dwellings. It must be emphasized, however, that each sphere is valuable in and of itself and that, contrary to superficial theories, even carpets produced in less evolved spheres have, like other carpets, well-defined stylistic and cultural values.

The nomadic sphere

In this environment, carpet production is still an activity essential to the very life of the nomadic tribe and alien to commercial considerations. Using the knotting technique on small horizontal looms (which are better suited to the nomadic life, since they can be dismantled even with a work in progress), women make carpets, sacks, saddlebags, saddlecloths, pillows, door covers, and so on.

Left, Ushak medallion carpet. Anatolia, 16th or 17th century. Vienna, Österreichisches Museum für angewandte Kunst. In this large carpet, we can see the highly refined style of the great court ateliers. The designs of these carpets, intended for royalty and embassies, were created by master miniaturists and executed by weavers following precise blueprints. The floral, or curvilinear, style is meticulously carried out in a harmonious and balanced display of many colors. The overall resulting character is particularly sumptuous and refined.

Right, Kashan medallion carpet. Persia, second half of 19th century. Private collection. In city workshops, the weavers created carpets based on highly detailed, prearranged models. At first, these carpets were produced for domestic trade, then, gradually, for export to the West.

These are small and, for the most part, narrow, rectangular carpets—averaging 80–120 x 150–200 cm (31–47 x 59–79")—decorated with simple stylized or abstract geometric designs of figures from nature, laid out in patterns codified by the tradition of each tribe and handed down orally.

Normally, a small number of colors are used, and these can be either bright or quite dark, but they generally create strongly contrasting palettes. The nomadic tribal carpet thus seems spontaneous and primitive, *naif*, yet animated by an ancient, pure tradition, which is its attraction.

The small and large workshops
Small village workshops are still run by the women of a single family nucleus who make carpets for their own use and for small-scale commerce; they occasionally use the horizontal loom. As with the carpet production of nomadic tribes, these carpets are relatively small, but the stylized, abstract designs are more varied, open to imagination and outside influences, and thus not based simply on oral tradition. These carpets are more mature and complex.

Town and city workshops, on the other hand, use only vertical looms and produce medium and large carpets averaging 150–200 x 220–270 cm (59–79 x 87–106"). They make carpets for the market only, for both local sales and export abroad. The master designer creates the models, and the weaver (man or woman) executes the designs. The compositions, whether in the geometric or the floral style, are complex and use a wide variety of colors in harmonizing palettes. Carpets created in this way, with great care given to each stage, are elaborate and refined.

The large court ateliers were a special production sphere of the past. Extremely rare specimens, generally of enormous size—the Ardebil carpet, for example, measures 534 x 1152 cm (210 x 446")—were created for the nobility by the leading court artists. They created highly refined designs using a vast range of colors and an elaborate curvilinear style. These carpets, most of which are preserved in museums, with some signed by the artist designer, have an extremely refined and exclusive spirit, well suited to sumptuous court life.

DECORATION: SYMBOLS AND MEANINGS

In the Orient, the carpet always had and still retains a practical function, as well as a symbolic function whose meaning is now obscured. It signified a magical space whose borders stood for the terrestrial, human sphere, erected as a protective barrier around the field, which symbolized the sphere of the heavens and the divine. In the past, therefore, carpet decoration was perfectly suited to such a space and included elements that were purely ornamental and others that were heavily symbolic in nature. With cultural changes and the passing of time, the latter lost their deep original meaning and were transformed into simply decorative elements whose original shapes are sometimes unrecognizable.

To recognize all such symbolic elements that appear in the productions from different regions (apart from China, which constitutes a special case)—and are therefore the expression of shared ancient cultures and religions—we must trace them back to their original meaning, which requires that we study Islamic culture and, going back in time, even pre-Islamic religions, such as shamanism and Buddhism.

The primordial shamanistic concept of the forces of nature as the seat of good and evil and the belief of the later faiths, such as Islam, in a divinity that can be neither depicted nor defined form the theoretical ground of these decorations, to which must be added the contribution of symbolic Buddhist representations that penetrated from the Far East.

The tree, whose symbolic meaning is recognized throughout the Orient, is among the most common decorations in carpets, where it appears in stylized or naturalistic forms, multiplied to form the Persian garden layout or standing alone, on a large scale, as in the carpets typical of eastern Turkestan. It represents the "tree of life," symbol of fertility and continuity, and also the "axis of the world," a symbol connecting the underworld (the roots symbolize the world of magic), the earth (the human world) and the divine (the branches symbolize the heavens). For this reason, it is often depicted inside the mihrab in prayer rugs. Sometimes, it is flanked by a pair of birds, an allusion to union and regeneration. Often, the tree is replaced by flowers and plants growing from a vase, but its meaning remains unchanged.

Clouds are represented symbolically by the Chinese "cloud collar" motif, a circle with four or more elements shaped like multifoil arrows creating a clover. The motif suggests the "heavenly gate," a celestial entryway con-

Above, Marby medallion carpet with figures. Anatolia, first half of 15th century. Stockholm, Historiska Museum. Below left, diagram of the Marby carpet with the tree of life. Below right, the cloud-collar pattern and some motifs derived from it:

(1–2) two versions of the cloud collar; (3) the cloud band; (4) the trefoil motif.
Facing page, a Khotan medallion carpet border with the trefoil motif. Eastern Turkestan, 19th century. Private collection.

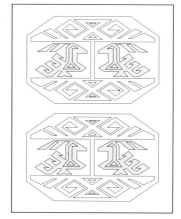

necting to the divine realm and also protecting it, just like clouds that surround and protect the sun. This motif, simplified first as a "cloud band," is obtained by transforming one point of the "collar" into a twisting ribbon, known as *chi*, which resembles the Greek letter omega. It has been used in the field of Anatolian and Persian carpets since the 16th century, though more often in the border of carpets. A second simplification of this motif is the "clover," or trefoil, a linear, stylized version of the "collar" turned into a row of elements reminiscent of lilies or clovers, intermeshing with an identical facing row of a different color. Typical of ancient carpets from the Caucasus, especially eastern Turkestan, this motif is used only in the borders. The use of the cloud-band and clover motifs in the borders is not accidental but justified, because as symbols of the "heavenly door," they must protect the divine space, represented by the field.

Another motif derived from clouds is the *chintamani*, also called the "thunder and lightning" motif, used across the whole field in some 16th-century carpets from Anatolia. It is formed by two small, wavy lines underneath three small disks set to form a triangle. Its origin is uncertain: Some claim that it is descended from Tamerlane's coat of arms; others, that it is derived from a Buddhist symbol; still others, that it imitates the spotted skin of animals, such as the leopard, which shamans used in their sacred rites.

The central medallion, protected by the borders and set in the center of the field, symbolizes the sun, the divinity, the state closest to the supernatural. This symbolic meaning is found both in the geometric four-and-one layouts, popular in the Caucasus and in Anatolia, and in the Persian curvilinear layouts, featuring a central multifoil medallion enriched by two pendants (the sun and the moon) and accompanied in the corners by sections of four secondary medallions. In both cases, the four secondary elements reinforce the symbolism, as they stand for the "solar gates" that lead to the divine center while protecting it.

The layout of the three grouped medallions is probably derived from Buddhist symbols and represents the Buddha seated between two disciples; this would explain why the central medallion is often larger and has a different decoration than the two side medallions. This layout, widely used in Anatolia and the Caucasus, is also

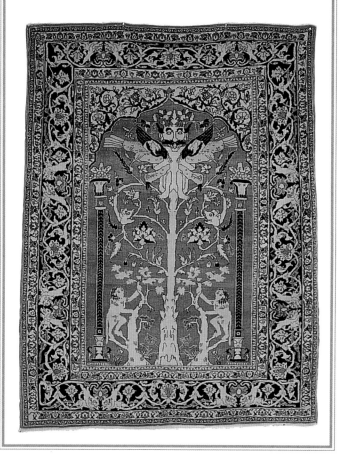

The Waq-Waq Tree

The *waq-waq* tree is a particular image of distant Indian origin in which philosophy, religion and myth come together. The branches or the fruits of this tree are metamorphosed into human and animal monster heads, which scream *"waq-waq"*— hence the name, which means "howling" in Persian. Like all trees, this type of decoration is always linked to the mystery of life and regeneration and especially to the vital energy issuing forth from trees and to their great powers of divination. In fact, when Alexander the Great was poised to conquer the Orient, a speaking head from a tree of this type predicted his future. The *waq-waq* tree is depicted in some Persian miniatures from the 13th and 14th centuries and made its appearance in Indian carpets in the 16th century, later spreading to Safavid Persia. It is also present in some rare 19th-century Persian carpets produced in Heriz.

Heriz prayer rug with *waq-waq* tree. Persia, c. 1820. Rome, Giacomo Cohen and Sons Collection.

present in carpets from eastern Turkestan, where it was interpreted by single round-shaped medallions.

The niche, or mihrab, is a unique feature of prayer rugs, the Islamic rug type par excellence. Although the Muslim faithful are not required to pray solely on carpets with this layout, the carpet, once chosen for prayer, must be used exclusively for that purpose. The mihrab serves the practical function of orienting the faithful toward Mecca and is based on the real niche carved out of the internal wall of every mosque, which it reproduces schematically. It is therefore a symbolic representation of the heavenly gate that leads to knowledge and to paradise, to be gained through daily prayer. At the same

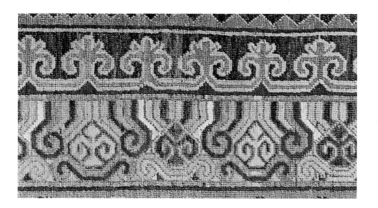

time, the mihrab is a haven, a place that welcomes the faithful and puts them in contact with the divine.

A sacred place, the mihrab often contains the "tree of life," also interpreted as a flowering vase, and the water basins used in ritual cleansing, which suggest the water of eternal life. Finally, from the top of the arch hangs a mosque lamp, symbol of divine light.

In the carpets produced by some Caucasian and Persian tribes, two hands are often depicted in the corners, one on each side, variously interpreted as the hands of Fatima, daughter of Mohammed—an allusion to the five Islamic rules—as a contraction of the name Allah written in Arabic or, more simply, as a suggestion for the correct position in which to place the hands while prostrated in prayer. Born in Anatolia in the 15th century, the prayer-rug layout later spread throughout the Islamic East, though Anatolia remained the most prolific production area.

In all cultures, Eastern as well as Western, the garden is symbolically linked to the idea of paradise. In fact, the word "paradise" is derived from the Persian *pairideieza*, meaning "garden, enclosure, park." In Islamic religion as well, paradise represents the final reward of the faithful, a garden all in bloom, where the four rivers of life flow.

The "garden" layout of carpets originated in 16th-century Persia and was inspired by the shah's gardens, which were set as rectangular or square areas divided by water-rich canals. This led to a composition of lawns full of water pools, flowerbeds, trees and (often) animals. The style was very popular in Persia, especially in Kerman and Kurdistan. Later, a naturalistic version spread to India. However, Anatolia, then under Ottoman rule, resisted the style due to the Sunni ban on images.

In the context of an anti-image, or iconoclastic, culture such as Islam, human and animal figures are totally devoid of symbolic meaning. In fact, the *Sunna*, the book of rules, forbids all representational images for fear they might lead to idolatry and because, by imitating God's creation, they constitute an offense. The Anatolian artists at the Ottoman court, being Sunni and thus orthodox, remained faithful to this rule, unlike the Persian artists at the Safavid court, who were Shiites and thus less rigid on this matter. According to their faith, in fact, figurative art was acceptable as long as it was directed to the spiritual or the contemplative. For this reason, human and animal figures began to appear in the carpets of 16th-century Persia. These figures, executed realistically, did not dominate the composition, since they

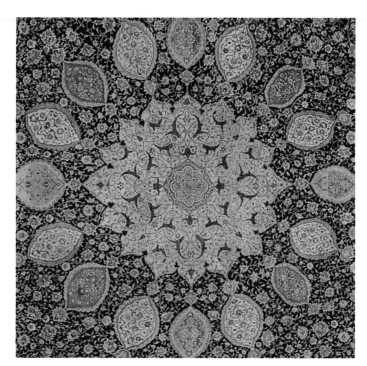

Above, detail of the Ardabil carpet, with an elaborate central medallion. Persia, 16th century. London, Victoria and Albert Museum.
A–B–C. Diagram of central medallion, distinguished by a polylobate circle, either round or ogival. This represents the divine sun and is often accompanied by two pendants representing the sun and the moon.
D. Diagram of the three superimposed medallions. These probably represent Buddha and his two disciples.
Right, drawing of the mosque sacred lamp.

Arabesque: The Islimi Motif

The *islimi* motif is an unusual arabesque that consists of a stem coiled around itself as in a spiral, usually ending in two forked leaves, which, in turn, become elaborate arabesques. Whether extremely thin and linear or dense and easily noticeable, the *islimi* motif is usually complemented by flowers and leaves; in carpet decoration, it is typically presented in the field, multiplied in complex arabesques; less often, it is found repeated in smaller sizes in the principal border.

Also known as *aslimi* or *eslimi*, the name's precise meaning remains uncertain. According to some Western experts, the name comes from the word "Islam," since it is a motif typical of Islamic arts in general. Others claim it refers to a shah named Selim or to a miniaturist named Aslim. Still others claim it means "serpentine," since its shape is reminiscent of a coiled snake, or "branch" or "bud," because it is used as a plant element.

A typical Persian motif, the *islimi* first appeared in the 16th century, if not earlier, and in the following century, it became more curvilinear and complex. It was rediscovered in the 19th century, when it was often applied to carpets produced in Kerman and Meshed, with sometimes quite elaborate interpretations.

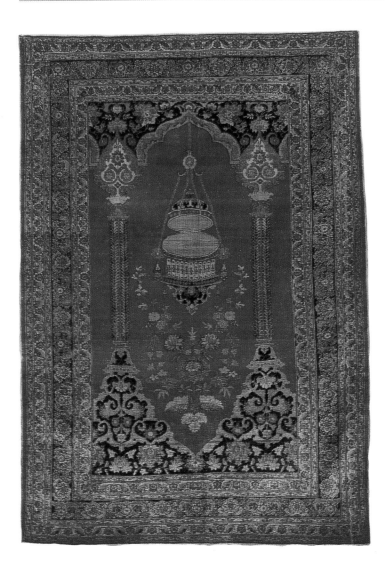

Above, Heriz prayer rug. Persia, 19th century. Private collection. The mihrab, or niche, orients the faithful toward Mecca and symbolizes the celestial portal. Here, in curvilinear style, the sacred lamp hangs from the center of the arch and the flowering plant, or tree of life, within the niche.

Right, Shirvan prayer rug. Caucasus, 19th century. Private collection. In this version of the niche, which is done in geometric style, two stylized red hands on either side of the arch can be seen. While interpreted in various ways, they also suggest the position to be held while in prayer.

were used to better render the idea of paradise or to illustrate moral concepts by way of epic or mythical episodes, much like the miniatures of the same period. The hunting and animal scenes must be interpreted in this context.

Hunting was highly regarded in the Orient, as it exemplified prowess, strength and mastery over nature. Reserved for the shah and his court, hunting also had a

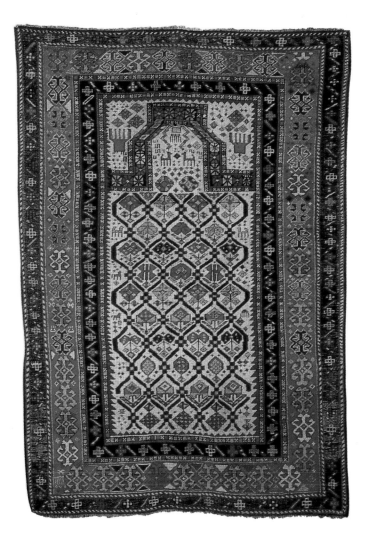

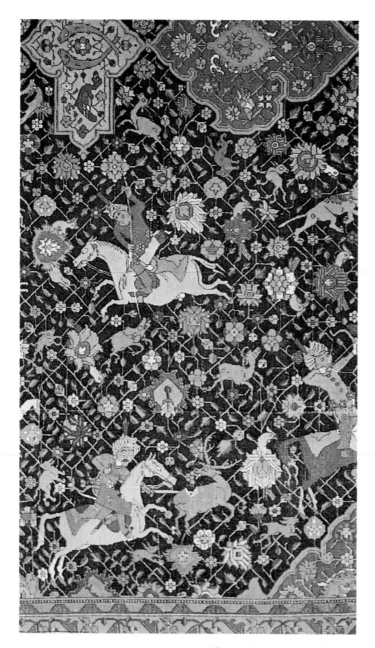

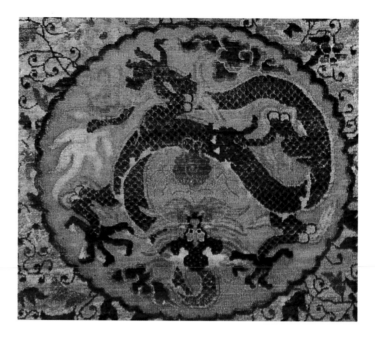

Left, detail of a medallion carpet with hunting scenes. Northwestern Persia (Tabriz?), dated either 1522–23 or 1542–43. Milan, Museo Poldi Pezzoli. Mounted hunters chase prey and fight beasts without dominating the scene—in fact, they blend into the arabesqued field. Above, detail of a medallion carpet. China, 19th century. New York, The Metropolitan Museum of Art. The center of the medallion is dominated by the dragon, mythical animal of ancient Chinese origin. Below left, garden carpet. Northwestern Persia (Kurdistan), 18th century. Milan, G. Mandel Collection. The garden is connected to the concept of paradise, and the layout, inspired by actual royal gardens, is divided into orderly flowerbeds by streams and fountains.
Below right, detail of a naturalistic carpet. Persia, 16th century. New

York, The Metropolitan Museum of Art. Arranged on an arabesqued field decorated with palmettes are various animals, such as birds, lions and tigers, engaged in battle.

Facing page. Top right, Kashan animal carpet. Persia, 19th century. Private collection. "Noble" animals, such as gazelles and storks, are shown in a curvilinear style. In village or nomad carpets, however, domestic animals are shown in geometric style, such as in the diagrams opposite: (1) dog; (2) cock; (3) camel.
Bottom, Lotto carpet, also called Ushak arabesque carpet. Late 16th or early 17th century. Florence, Museo Bardini. The arabesque, a typically Oriental element, permits decoration without representation, thus satisfying the *horror vacui* of Islamic art.

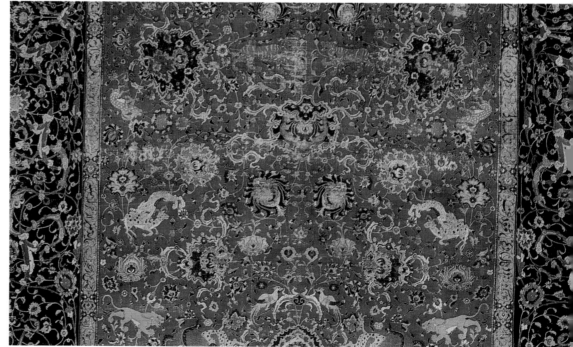

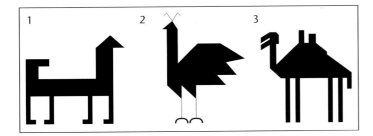

meaning connected to the theme of paradise and thus to spiritual life. Hunting-theme carpets, in which horsemen and prey pursue each other across arabesques and floral motifs, were created at the Safavid court in Persia, especially in Isfahan, while artists in India developed more realistic versions.

The animals represented in carpets can be real or mythical. Real domestic animals appear in nomadic carpets, though in a stylized form, while real "noble" animals, such as horses and deer, are rendered lifelike in the so-called animal carpets of Safavid Persia. Both real and fantastic animals are depicted in animal battle scenes, which originated in China and spread to Central Asia between

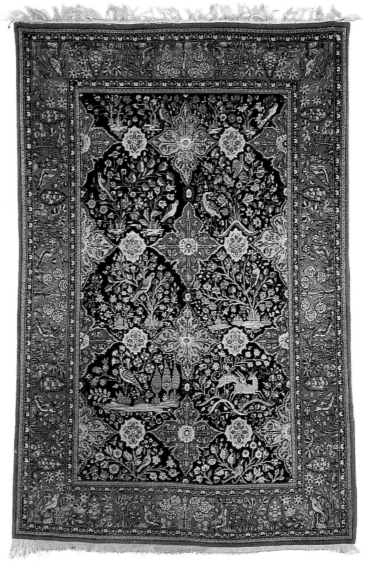

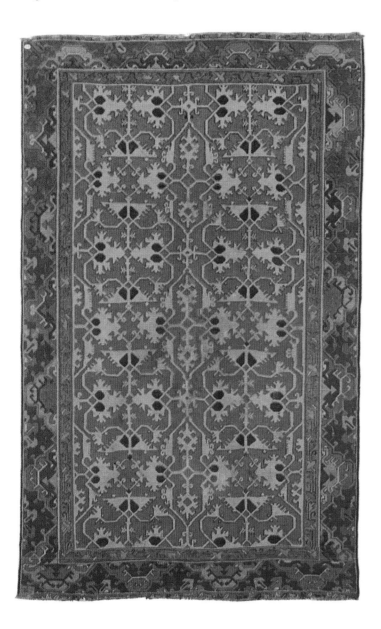

the 14th and 15th centuries. These battles exemplify the struggle between good and evil, on earth as well as between cosmic forces, and thus symbolize the balance of creation. Also of Chinese origin are two mythical animals: the dragon, symbol of omnipotence; and the phoenix, symbol of immortality. Paired together, they represent the marital union, while in combat, they represent the balance and harmony of the contrasting forces of creation. This theme became popular in the 14th and 15th centuries, inspiring, among others, the ancient Caucasian dragon carpets.

An element common to all Islamic arts, the arabesque perfectly expresses the iconoclastic Muslim spirit, since it adorns without using figures from the natural world and is thus conducive to contemplation without falling into idolatry. A ribbon extending without beginning or end, the arabesque expresses the search for the divine, at the same time revealing the dimension of the divine even while continuing to veil it. The arabesque can be used in the carpet guided by a geometric layout, large and punctuated by corners (typical of the ancient carpets produced in Ushak), or in a curvilinear layout, where it is a thin, intricate ribbon, a central element of the curvilinear style perfected in Persia during the 16th century.

DECORATIVE MOTIFS

In the varied and rich decoration of Oriental carpets, we can identify a first ornamental group, which can appear either in the field or in the borders. Its function is to fill the open spaces and to complement the leading elements. It is composed of small geometric figures of distant naturalistic origin, such as eight-pointed stars, swastikas, "S"-shaped designs, hooked diamonds, and so on.

A second group of ornamental elements is composed of leaves and flowers, the former usually in lanceolate, or lance-shaped, form, with more or less serrated outlines, and the latter distinguished by two types: the rosette and the palmette. The rosette has an oval or roundish shape, is symmetrical and is usually adorned with petals. The palmette, extremely popular in Persia since the 16th century, is an oriented flower whose shape resembles a fan, a bud, an artichoke, a vine leaf, and so on, according to the many interpretations. The palmette may be used as a complementary element (as in the *herati* design) or as the leading element (as in the in-and-out palmette motif).

A third group of decorative elements contains various distinctive motifs. While some of these are interpreted in various ways, depending on the place of production, they can be identified nonetheless; others, on the contrary, are specific and unique to a single geographic area. Used as single elements or as repeating elements, these can be separated into field motifs and border motifs.

Field motifs

Field motifs make up the entire decoration of the field, arranged facing each other in parallel rows or in various other ways. They can also appear together with other ornamental elements, such as medallions or rosettes.

The well-known *boteh*, incorrectly referred to in the West as the "Kashmir," is shaped more or less like a teardrop. It has been variously interpreted as a symbol for the flame of Zoroaster, as the tear of Buddha, a feather, a pinecone, and so on, but perhaps its ancient origin is to be sought in the world of flowers, since its name in Persian means "bouquet of flowers." Interpreted in geometric or curvilinear form, it is usually arranged in parallel rows that cover the entire field, or it can appear by itself, accompanying other elements. It first emerged in 18th-century carpets and successfully spread in the 1800s to Anatolia, the Caucasus and especially Persia.

Like the *boteh*, the *herati* design is used throughout the Orient. Developed in Persia during the 18th century, it is named for its probable place of origin, the town of Herat (formerly in Persia, now in Afghanistan). The *herati* is a complex composition of floral elements: four flowers or

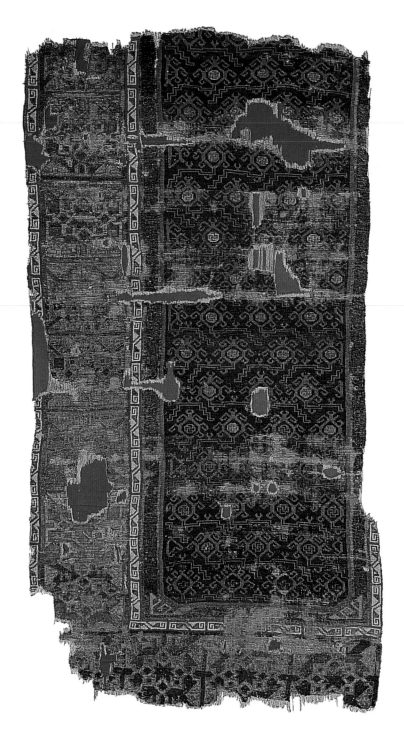

Fragmented Seljuk carpet. Central Anatolia (Konya?), 13th century. Istanbul, Türk ve Islam Eserleri Muzesi. This carpet, found in the Alaeddin Mosque in Konya, belongs to the oldest extant group of carpets after that of Pazyryk. The field decoration consists of small, repetitive geometric motifs, such as swastikas, hooked octagons, and so on. The main border's decoration consists of eight-pointed stars, while the minor borders are filled with "S"-shaped motifs. Although they appear to be abstract in nature, they are, in fact, derived from the flower world.

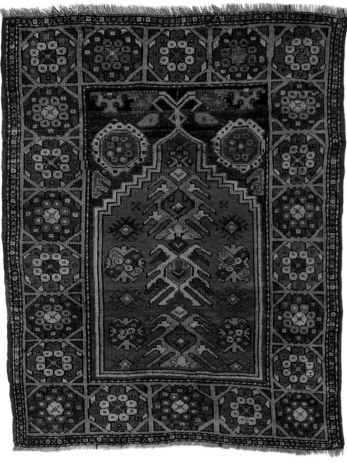

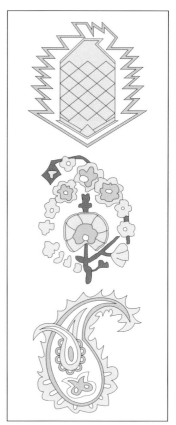

Above, diagram of the rosette, a floral motif often used to cover a field.
Left, a Mudjur prayer rug. Anatolia, 19th century. Bergamo, La Torre Collection. Noteworthy are the border's geometric rosettes.
Below left, detail of a three-medallion Hila carpet. Caucasus, 19th century. Private collection. The field is decorated with tear-shaped *boteh* in a geometric style. This motif is sketched at right in the geometric, floral and "mother-and-son" floral versions.
Below, diagram of various versions of the cloud-band motif; the motif can be found in the field as well as in the borders.

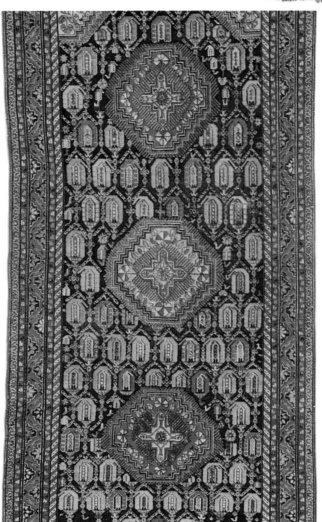

palmettes located at the points of a rhomboidal, or dia-mond-shaped, figure, with a flower inside the rhomboid and four falciform, or sickle-shaped, leaves—resembling small fish and therefore known as *mahi*, from the Persian word for "fish"—around the four corner flowers. Because of its great popularity, the *herati* design has been inter-preted in many ways—in both geometric and curvilinear styles that are more or less naturalistic—so much so that it is sometimes unrecognizable. This design may appear as the single element throughout the field of the carpet or in association with medallion layouts.

The *gul* is a small, geometric medallion, variously shaped as an octagon, a hexagon or a rhomboid with different profiles (serrated, multifoil, straight, hooked), divided into four parts of different colors, inside which are other small geometric elements. This ancient motif has been variously interpreted as representing a rose, an elephant's foot or a camel's foot. It could be derived from ancient tribal totemic emblems, although the name, from a Persian word meaning "flower," suggests a plant origin. The *gul* motif is characteristic of the carpets from western Turkes-tan, where it was used full-field, repeated in parallel rows alternating with smaller polygonal or cross-shaped motifs. The *gul* changes form and profile according to the tribe it represents. In the West, the *gul* is sometimes erroneously

called the "Bukhara pattern," after the city where rugs from Turkestan were warehoused but not made.

The cloud band, of ancient Chinese origin, is a symbolic motif consisting of a narrow, winding band, known as *chi*. It can be smooth or knotted, depending on the different versions. As a field motif, it combines with other decorative elements, such as palmettes, and sometimes stands out when it is large. It first appeared in carpets in 16th-century Persia—especially in carpets from Herat—and in India and is still a characteristic motif of the carpets produced in these regions.

The "in-and-out" palmette is a decorative motif of floral carpets in which one or two pairs of palmettes form the ornamental motif, their tops oriented alternately toward the center and the borders of the carpet. Usually arranged across the entire field, this motif appears with other ornamental elements. Evolving in 16th-century Persia, this motif also became popular in later centuries, though in less elaborate versions.

An ancient symbolic motif, the *chintamani* consists of three small disks arranged to form a triangle, placed above two wavelike lines. It is used in the field in offset rows multiplying to infinity, which usually gives a directional reading to the full-field layout. In the 16th century, it was used in the Ushak carpet in Anatolia and is dark on a light (white or ivory) background.

The *afshan*, or *avshan*, motif is distinguished by its arrangement of parallel rows of rosettes alternating with rows of palmettes, with long stems of forked leaves branching out from the points of the palmettes. Arranged across the full field, this motif, derived from 16th-century Persian designs, was developed in northern Persia and the Caucasus during the 18th century. It was popular in the Caucasus in the 1800s, especially in Kuba and Baku, where larger, more geometric versions were made.

The *kharshang*, or *harshang*, is a complex motif, consist-

The Shah Abbas Palmette

An ancient floral motif inspired by the fan-shaped leaves of the palm or the lily, the palmette first appeared in carpets at the turn of the 16th century. By the end of the century, it had become the prima donna of the floral carpet style. In fact, during the reign of Shah Abbas I the Great (1587–1629), the court's finest miniaturists and artists, in addition to creating new carpet designs, were involved in elaborate adaptations of motifs that were already known and consolidated into the general artistic tradition.

Among these was the palmette, which they elaborated into richer and more lifelike forms, creating palmettes still slightly closed, as though budding, and therefore of elongated form; and "flaming" palmettes, which were those already flowering, with open, sunburst corollas fringed by many petals. These new floral designs, created in honor of the sovereign, were called "Shah Abbas palmettes," and in the decoration of carpets, they were joined together by curvilinear vines and enriched by sickle-shaped leaves. The basic design of this novel composition was named "Shah Abbas design," and even in later centuries, it enjoyed remarkable success in all Persian carpet productions, becoming one of the more typical compositions in the region.

Right, detail of a Senneh carpet with full-field *herati* decoration. Persia, 19th century. Private collection. Shown below, diagram of the *herati* motif. At the points of the central diamond-shaped element containing a flower are four flowers or palmettes, and surrounding them are long, curling leaves, similar to sickles or to small fish. This design originated in the 18th century.

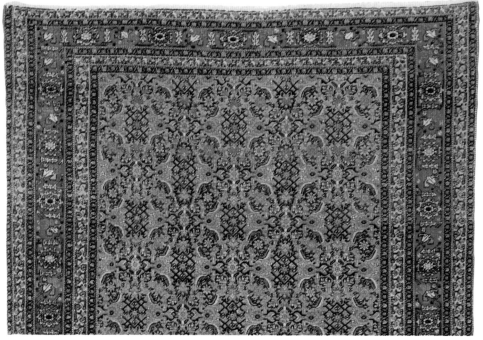

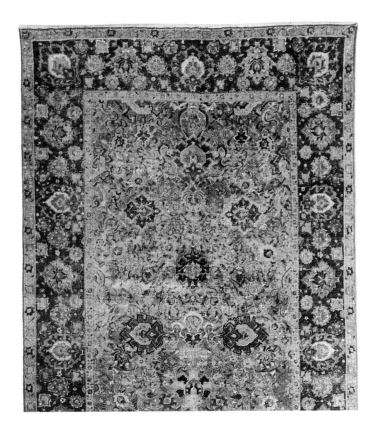

ing of three leading elements: an unusual, slightly zoomorphic "flaming halo" palmette (hence the name *harshang*, from the Persian for "crab"); a diamond-shaped flower accompanied by four straight stems, each ending in a forked leaf; and a second flower, roundish and with a notched profile. Arranged in parallel rows across the full field, this design was developed in northern Persia and the Caucasus during the 18th century and might be derived from 16th-century prototypes. This design was gradually simplified, so by the 1800s, only two of the three original elements remained. Its geometric version became typical of the carpets from Caucasian areas.

The *mina khani* motif is composed of four round, daisy-like flowers arranged in the shape of a diamond and attached to one another by a shoot; this diamond lattice encloses another, smaller flower. Repeated over the entire field, this composition creates a sort of floral grid. Also based on a 16th-century Persian prototype, the provenance of this motif is unknown, though debated to be either Kurdistan or Khorasan. In the 19th century, it became the characteristic decorative element of carpets produced in the Persian city of Veramin. The etymology of the name is also uncertain, since *mina* is a woman's name in Persian that could have given its name to the flower in the com-

Top, detail from a carpet with floral decoration. Persia (Herat?), 17th century. Florence, Museo Bardini. The field decoration is dominated by the in-and-out palmette motif, consisting of pairs of large palmettes, their tops alternately directed toward the interior and exterior of the carpet. Even the border of this carpet features a palmette motif, which appears in different forms, closed or open, such as in the drawing above.

Right, Tekke carpet with full-field tribal *gul* decoration. Western Turkestan, 19th century. Private collection. An ancient motif typical of western Turkestan, the *gul* has many forms, all of which are related to the tribe of origin. These variations are visible in the diagram above right.

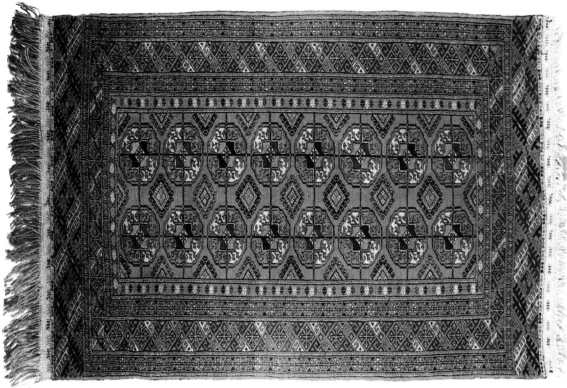

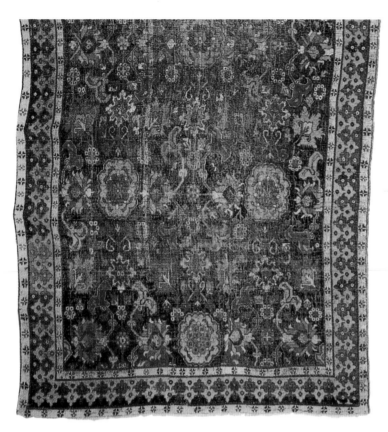

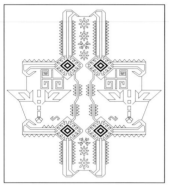

Above, detail of a Kuba carpet with floral decoration. Caucasus, 17th century. Private collection. In the field, *afshan* motifs are visible, with their long stems ending in a forked leaf. Left, a diagram of a geometric *afshan* motif.

boteh motifs typically appear together with other motifs. It is widely used in Persia.

The *herati* border motif is less elaborate than the *herati* field motif and consists of alternating rows of rosettes and palmettes, divided by the typical sickle-shaped leaves. Widely used in Persia, this motif was rendered, in the 19th century, in a new version, known as the "turtle" because of the palmette's vague resemblance to that animal.

The *cloud band* motif is similar to the field motif of the same name and is often the leading element in borders, given its symbolic meaning of a cloud band protecting the field. It was used as early as the 16th century in Anatolia, especially in the Ushak carpets, with *chintamani* designs and in the "bird-pattern" carpets.

Derived from the "cloud collar," the *trefoil* motif consists of two facing and interlocking rows of elements resembling a lily or a clover in two colors, usually red and yellow or red and blue. Used in ancient carpets from Anatolia and the Caucasus, this motif is particularly characteristic of eastern Turkestan carpets.

The *medachyl*, or *madakhell*, motif, probably a 19th-century simplification of the trefoil motif, consists of two facing and interlocking rows of two-colored elements, usually diamond-shaped arrowheads or small triangles. This motif is typically employed in secondary borders and is found especially in the carpets of the Caucasus.

The *running dog* motif, also derived from the "cloud collar," is composed of two rows of two-colored elements that vary greatly in design, depending on interpretation, from geometric waves to more or less curved hooks. Typically decorating secondary borders, it was widely used in Caucasian productions, especially in carpets from the northeast, where it also decorated the principal borders.

The *Kufic*-script, or *kufesque*, motif is among the most ancient of decorative motifs. It was discovered on fragments of Anatolian carpets datable to the 13th century. Based on the Kufic style of the Arabic alphabet used by the Seljuk Turks, this motif is shaped like a capital "I" flanked by two lower and wider geometric elements, sometimes complemented by a rosette. White is the color that characterizes this motif, which is often found in the carpets of Anatolia (such as Holbein carpets) and the Caucasus.

The *cartouche* motif is based on the decorations embossed on the leather covers of the Koran, in which sacred verses were inscribed, framed within elongated polygons with straight and curved sides. Transferred to Persian and Mameluke carpets in the 16th century and with the inscriptions removed, the cartouches were interpreted more or less geometrically and appear in many productions, such as the Anatolian carpets known as "Transylvanian" produced in the 1700s and 1800s.

The *çubukli* motif, named for long, narrow pipes typical of Anatolia, is a set of long, narrow, continuous frames (usually seven) in two alternating colors, decorated by small flowers or diamonds. Characteristic of Anatolia, where it first appeared in the late 1700s, this motif is found especially on carpets from Ghiordes.

position; and furthermore, since *khaneh* means "house," *mina khani* could indicate the garden of a house.

The *zil-i-sultan*, or *zellol sultan*, is a motif composed of a flowering vase flanked by two small birds. Created in Persia during the 19th century at the time of Prince Zellol during the Qajar dynasty (1786–1925), this motif has been interpreted in varying degrees of naturalism and spread through western Persia, especially to the Malayer region.

Border motifs

The borders of carpets (their outer areas) play an important role in the overall balance of the carpet and in the identification of the carpet's dating and provenance. The number of borders vary and can be divided into principal and secondary borders. The decorative motifs in borders are plentiful and varied, from simple "S" shapes to tendrils, rosettes, flowers and more complex designs.

The *boteh* border motif is identical to the *boteh* field motif and usually appears as a single decorative element in secondary borders, serially repeated. In main borders,

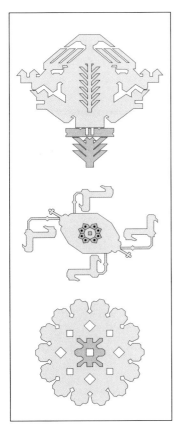

Left, a diagram of the three elements composing the elaborate *harshang* motif. From top: a zoomorphic palmette resembling a crab (*harshang*), hence the name; a rhomboidal flower with forked leaves; a roundish flower similar to a notched wheel.
Below left, diagram of a full-field *chintamani* decoration. The *chintamani* motif is composed of two small wavy lines beneath three small disks arranged to form a triangle. Its name is applied to a particular type of 16th-century Anatolian carpet with a light background.
Below, a diagram of the Persian *zil-i-sultan* motif, which is composed of a central vase with flowers flanked by two small birds.
Right, diagrams of decorative border motifs. From top to bottom: *herati* in a "turtle" version; cartouches; Kufic motif; running dog; cloud band.

The *dentate*, or *serrated*, *leaf* motif is a simple design composed of two notched geometric leaves arranged diagonally to form a "V," inside which is an element that resembles a wine goblet but is actually a stylized tulip. This motif is distributed on a light-colored background and decorates the principal borders of Caucasian carpets.

The *kotchanak* motif, possibly descended from ancient tribal heraldic emblems, consists of a rectangle or square embellished on two opposite sides by two pairs of hooks similar to rams' horns. This motif distinguishes the carpets of western Turkestan but also appears frequently in Caucasian carpets. It sometimes appears in the field as well, though as isolated, widely spaced elements.

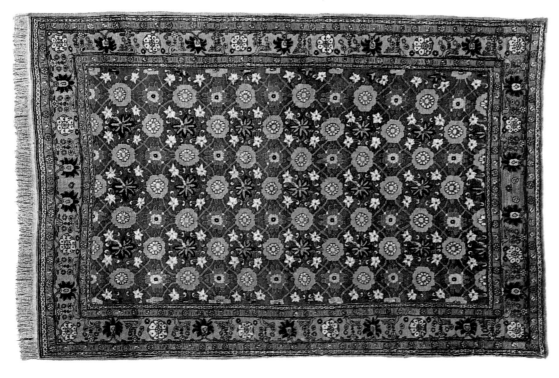

Veramin carpet with floral decoration. Persia, 20th century. Private collection. This carpet, of modern workmanship, repeats the traditional design of this area, the *mina khani* motif, in a full-field arrangement. The *mina khani* consists of four flowers, similar to daisies, attached to one another by their stems to form a floral grid, as shown in the diagram below.

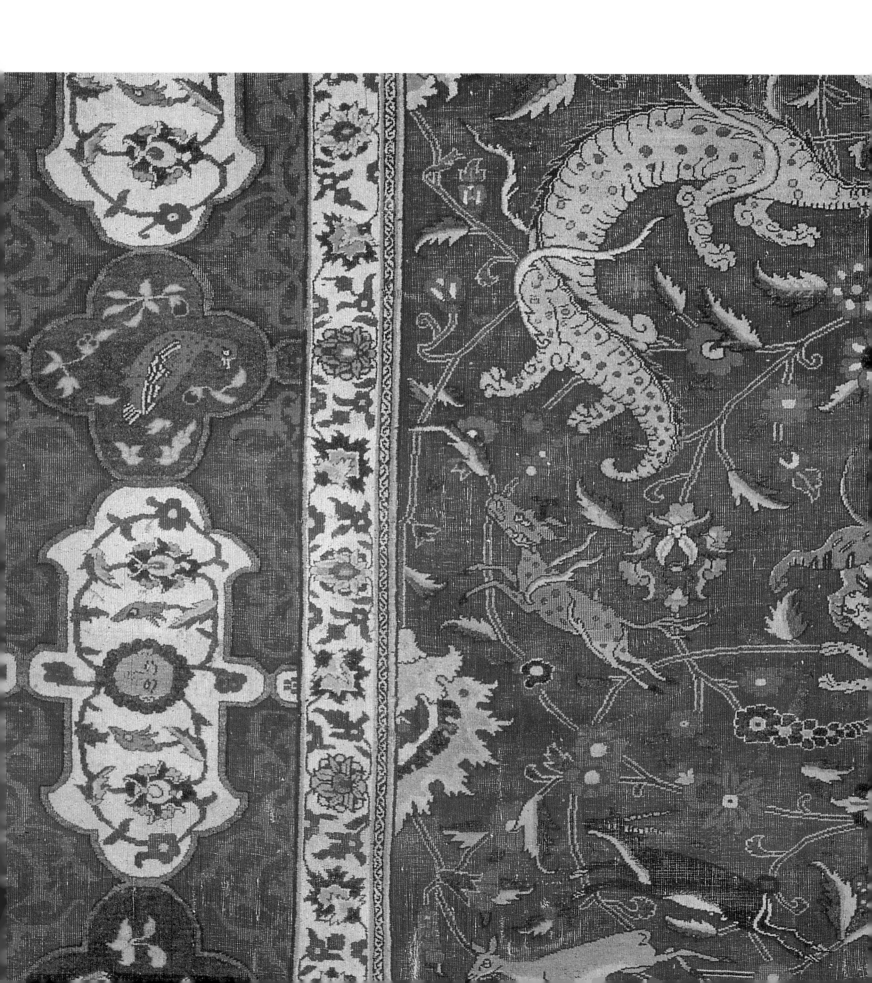

THE ART OF THE CARPET

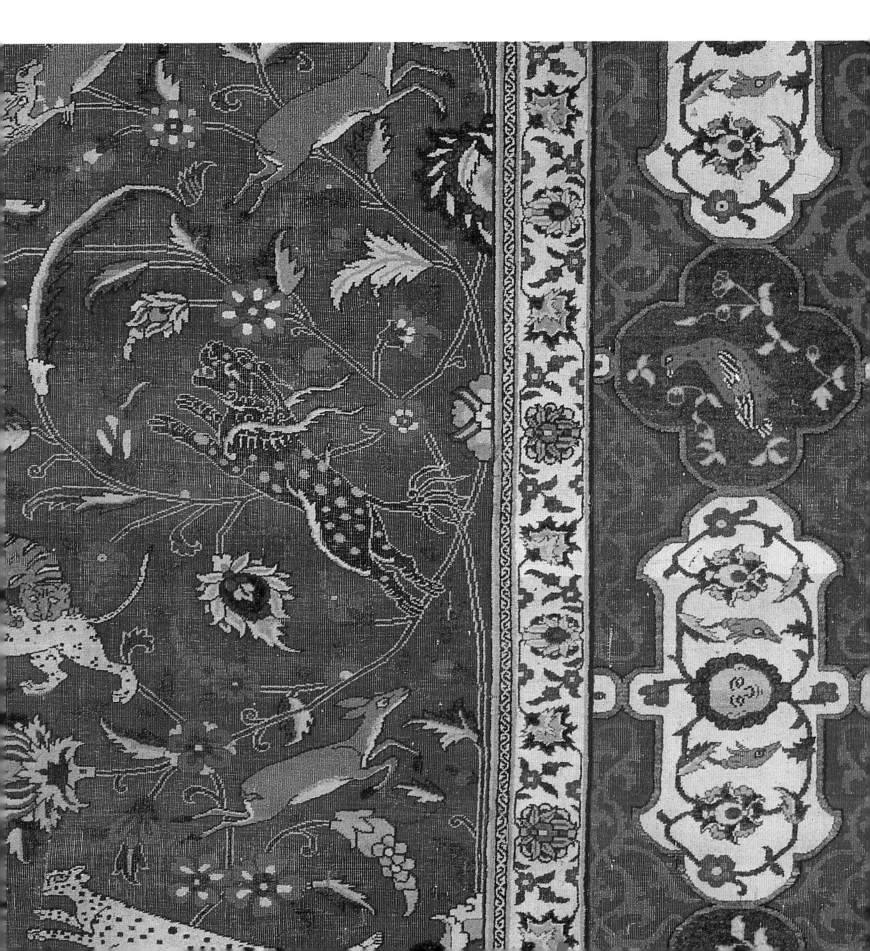

THE CARPET
AND THE ORIENT

The West has been producing excellent carpets since the Middle Ages, first in Spain and, later, especially during the 17th century, in France, such as the Savonnerie and Aubusson productions. When we think of carpets, however, we think of the Orient, which has always been considered the true homeland of the carpet. This is understandable, for it was here that the carpet was born and developed, where it was at once a central article of everyday life and one of the highest forms of art. In the West, we use these fascinating artifacts in our homes only as an element of furnishing, as bright decoration, while in the East, carpets have always represented the focus of the house, and even the home itself—the place where one eats, sleeps, seeks refuge. Finally, to the Muslim faithful, the carpet is also the sanctuary that isolates and protects from impure soil and where one bows down in prayer five times a day; for under the impact of Islamic culture, the carpet took on a new, deep significance while undergoing an artistic evolution and anchoring itself even more to daily life.

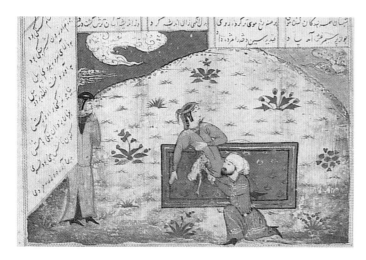

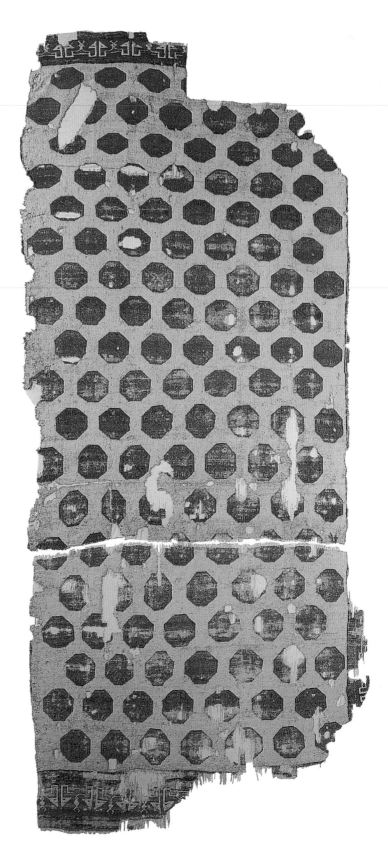

Above, miniature from the *Shah Nameh* (*Book of Kings*) by Firdusi depicting *The Mubad removing Rustam's fetus from his mother Rabadeh*. Persia, second half of 15th century. Florence, Biblioteca Nazionale Centrale. In the Orient, the carpet is often depicted in miniatures, in religious scenes as well as in epic or everyday scenes. Whether or not it originated as a luxury item, the carpet was always considered a living object to be used in daily life, in palaces and homes as well as outdoors.

Right, Seljuk carpet fragment. Central Anatolia (Konya?), 13th century. Istanbul, Türk ve Islam Eserleri Muzesi. The oldest carpets, extremely rare and, for the most part, fragmentary and incomplete, are to be found only in museums or great collections. Furthermore, the fact that carpets were subjected to daily use and of a highly perishable nature has influenced their dating and classification criteria.

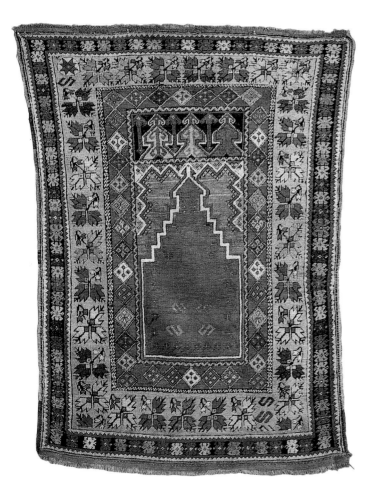

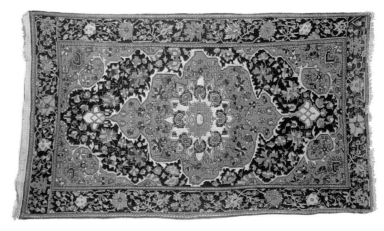

pieces manufactured before the introduction of chemical dyes (first aniline, which had little resistance to light and damaged the fibers, and later chrome), which occurred between the 1860s and 1870s. *Semi-antique*, or *old*, carpets were manufactured from the 1860–1870 period to the early part of the 20th century, when the still predominant traditional features were partially modified in response to new commercial needs. All other carpets, those produced since the 1920–1930 period, were *modern* carpets, which wholly conform to market demands, especially from the West, to the clear detriment of the quality and tradition of each provenance.

These traditional criteria, although still accepted by many as valid, are now considered obsolete, since their chronological rigidity does not permit a better classification of new genres not highly regarded in the past, such as carpets made by nomadic tribes or in villages. If the traditional classification were applied, these carpets, usually manufactured of fibers dyed with plant substances, would be considered "antique" even if produced after

Above, Mudjur prayer rug. Anatolia, 19th century. Venice, Rascid Rahaim Collection. In the Orient, carpets are also objects closely linked to religion. While on a prayer rug, the faithful is protected from the impure ground as if he were inside a holy place.

Right, Sarouk medallion carpet. Persia, early 20th century. Persia, Carpet Museum. Carpets dating from the mid-19th century onward are the most abundant in the world of collectible antiques, such as this one displaying typical designs and colors.

To understand the carpet's true cultural value and its artistic import, we must look at each specimen within its original context—as an object that is closely linked to everyday life.

The carpet as a "living" object

Called *ghali* by the Persians, meaning "what is stepped on," the carpet is a living object, made to be used as both a sacred and a living space and therefore destined to wear and tear and ultimate destruction. The perishable nature of its fibers also contributes to the rather short life of the carpet compared with other artistic genres. This explains the true rarity of the more ancient specimens, thus justifying the application of wider and less rigid criteria of chronological classification to carpets than those usually applied to other art objects.

Chronological classification

Until a short time ago, all carpets were divided into three categories:

Antique carpets were generally defined as traditional

the 1920–1930 period, since a carpet made by nomadic tribes after 1930 is not as constrained by Western commercial needs as a carpet from the same period produced in a city workshop.

In conclusion, the more recent classification criteria prefer to dispense with rigid dates, which may lead to contradictions and exceptions, and simply consider "antique" all carpets made before the 1920–1930 period, sometimes extending the antique period to 1950.

This classification system is quite elementary, and the definition of "antique carpet" spans a wide chronological spectrum. We should point out, however, that in general, the more ancient specimens, made before 1800, are so rare that they are encountered only in museums or large collections and that what is left of the 16th- and 17th-century production is, for the most part, found only in fragments.

Hence, the carpets on the market today are primarily from the 19th and early 20th centuries, because these are the carpets most likely to have been preserved, given their recent manufacture.

THE GEOGRAPHY OF CARPETS

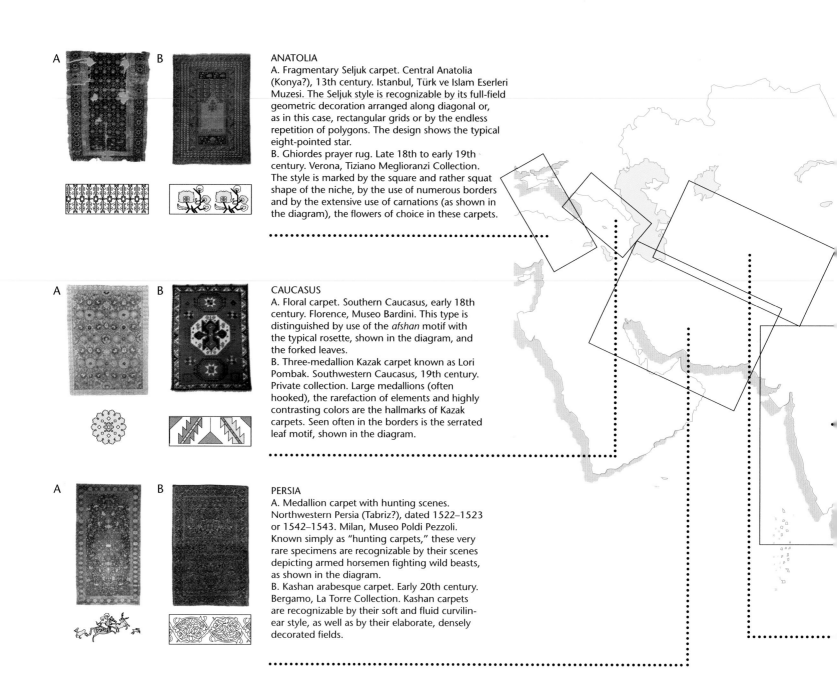

ANATOLIA

A. Fragmentary Seljuk carpet. Central Anatolia (Konya?), 13th century. Istanbul, Türk ve Islam Eserleri Muzesi. The Seljuk style is recognizable by its full-field geometric decoration arranged along diagonal or, as in this case, rectangular grids or by the endless repetition of polygons. The design shows the typical eight-pointed star.

B. Ghiordes prayer rug. Late 18th to early 19th century. Verona, Tiziano Meglioranzi Collection. The style is marked by the square and rather squat shape of the niche, by the use of numerous borders and by the extensive use of carnations (as shown in the diagram), the flowers of choice in these carpets.

CAUCASUS

A. Floral carpet. Southern Caucasus, early 18th century. Florence, Museo Bardini. This type is distinguished by use of the *afshan* motif with the typical rosette, shown in the diagram, and the forked leaves.

B. Three-medallion Kazak carpet known as Lori Pombak. Southwestern Caucasus, 19th century. Private collection. Large medallions (often hooked), the rarefaction of elements and highly contrasting colors are the hallmarks of Kazak carpets. Seen often in the borders is the serrated leaf motif, shown in the diagram.

PERSIA

A. Medallion carpet with hunting scenes. Northwestern Persia (Tabriz?), dated 1522–1523 or 1542–1543. Milan, Museo Poldi Pezzoli. Known simply as "hunting carpets," these very rare specimens are recognizable by their scenes depicting armed horsemen fighting wild beasts, as shown in the diagram.

B. Kashan arabesque carpet. Early 20th century. Bergamo, La Torre Collection. Kashan carpets are recognizable by their soft and fluid curvilinear style, as well as by their elaborate, densely decorated fields.

Dates on Carpets

Dates, expressed in Islamic numbers or translated into the Gregorian calendar in Western characters, are sometimes present in the border or the field of carpets. Such dates are not always reliable, often added by the weavers to increase a carpet's value. It is useful to know how to convert a Muslim year to a year in the Gregorian calendar: Divide the Islamic date by 33.7 (since the Muslim calendar is lunar and adds one year to every 33.7 Gregorian, or solar, years); subtract the sum from the date itself; then add 622, the year of Muhammad's flight to Medina (A.D. 622), which marks the beginning of the Islamic era.

Without any useful information, such as dates, inscriptions or even signatures (which

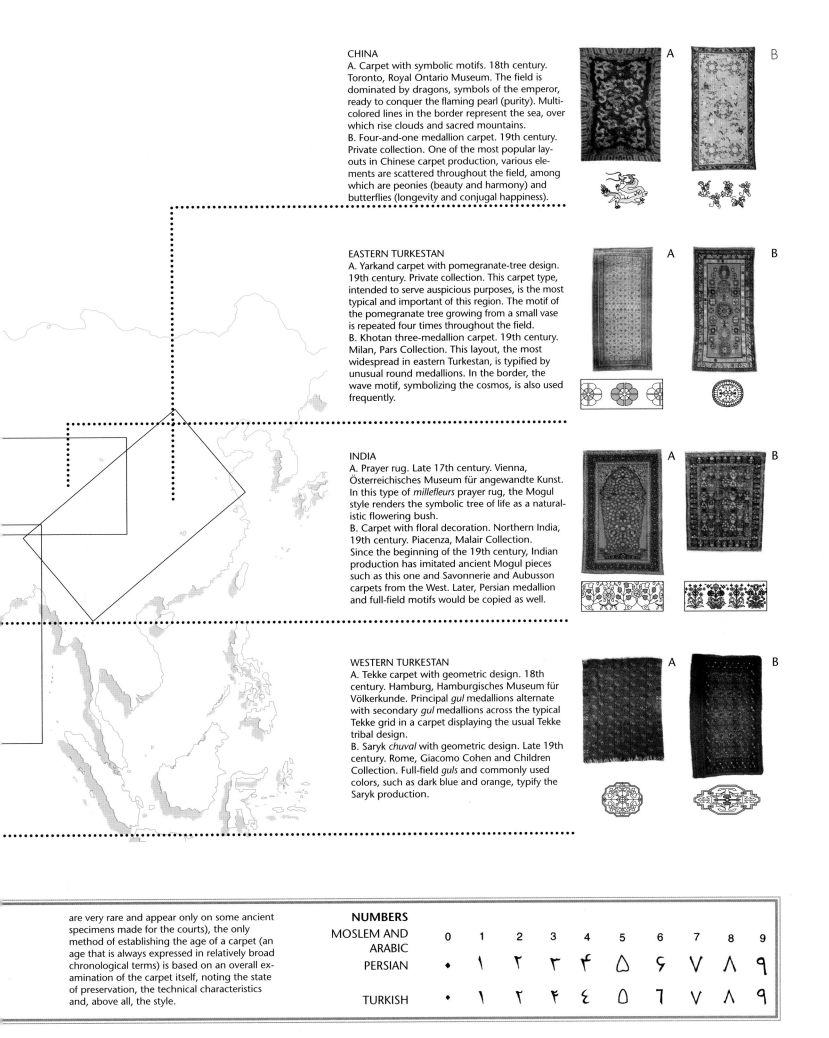

CHINA

A. Carpet with symbolic motifs. 18th century. Toronto, Royal Ontario Museum. The field is dominated by dragons, symbols of the emperor, ready to conquer the flaming pearl (purity). Multicolored lines in the border represent the sea, over which rise clouds and sacred mountains.

B. Four-and-one medallion carpet. 19th century. Private collection. One of the most popular layouts in Chinese carpet production, various elements are scattered throughout the field, among which are peonies (beauty and harmony) and butterflies (longevity and conjugal happiness).

EASTERN TURKESTAN

A. Yarkand carpet with pomegranate-tree design. 19th century. Private collection. This carpet type, intended to serve auspicious purposes, is the most typical and important of this region. The motif of the pomegranate tree growing from a small vase is repeated four times throughout the field.

B. Khotan three-medallion carpet. 19th century. Milan, Pars Collection. This layout, the most widespread in eastern Turkestan, is typified by unusual round medallions. In the border, the wave motif, symbolizing the cosmos, is also used frequently.

INDIA

A. Prayer rug. Late 17th century. Vienna, Österreichisches Museum für angewandte Kunst. In this type of *millefleurs* prayer rug, the Mogul style renders the symbolic tree of life as a naturalistic flowering bush.

B. Carpet with floral decoration. Northern India, 19th century. Piacenza, Malair Collection. Since the beginning of the 19th century, Indian production has imitated ancient Mogul pieces such as this one and Savonnerie and Aubusson carpets from the West. Later, Persian medallion and full-field motifs would be copied as well.

WESTERN TURKESTAN

A. Tekke carpet with geometric design. 18th century. Hamburg, Hamburgisches Museum für Völkerkunde. Principal *gul* medallions alternate with secondary *gul* medallions across the typical Tekke grid in a carpet displaying the usual Tekke tribal design.

B. Saryk *chuval* with geometric design. Late 19th century. Rome, Giacomo Cohen and Children Collection. Full-field *guls* and commonly used colors, such as dark blue and orange, typify the Saryk production.

are very rare and appear only on some ancient specimens made for the courts), the only method of establishing the age of a carpet (an age that is always expressed in relatively broad chronological terms) is based on an overall examination of the carpet itself, noting the state of preservation, the technical characteristics and, above all, the style.

NUMBERS	0	1	2	3	4	5	6	7	8	9
MOSLEM AND ARABIC PERSIAN	٠	١	٢	٣	۴	۵	۶	٧	٨	٩
TURKISH	٠	١	٢	۳	٤	۵	٦	٧	٨	٩

ANATOLIA

The art of the knotted carpet was brought to Anatolia (which corresponds roughly to present-day Turkey) around the 11th century by the rulers of the Seljuk dynasty, who came from Turkestan and ruled over Asia Minor until 1299. They imposed on the region their Islamic faith and their culture, which included the ancient tradition of carpet making based on geometric designs and lively colors. In fact, we should point out that Central Asia, from which the Seljuks originated, is considered the cradle of carpet making. Thus the production of knotted carpets grew in this period of relative peace and were also successfully exported to Europe. Renowned critic Marco Polo wrote about Anatolia in his Travels, at the end of the 13th century "... here the choicest carpets in the world are made, and those with the loveliest colors."

Starting from this specific background, the carpet came to play a very important role in Anatolia as both a deeply religious object and an element of cultural fusion among the peoples of different origins (Mediterranean, Asian and Moslem) who lived in that region, such as Armenians, Greeks, Byzantines and, of course, Turks. Even with the passing of centuries and fashions, Anatolian carpets always stood out for their strong fidelity to the original Seljuk compositions based on geometric or stylized designs and strongly contrasting colors.

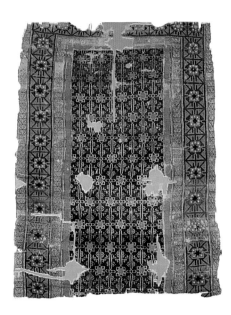

Seljuk carpet fragment
Central Anatolia (Konya?), 13th century
Istanbul, Türk ve Islam Eserleri Muzesi

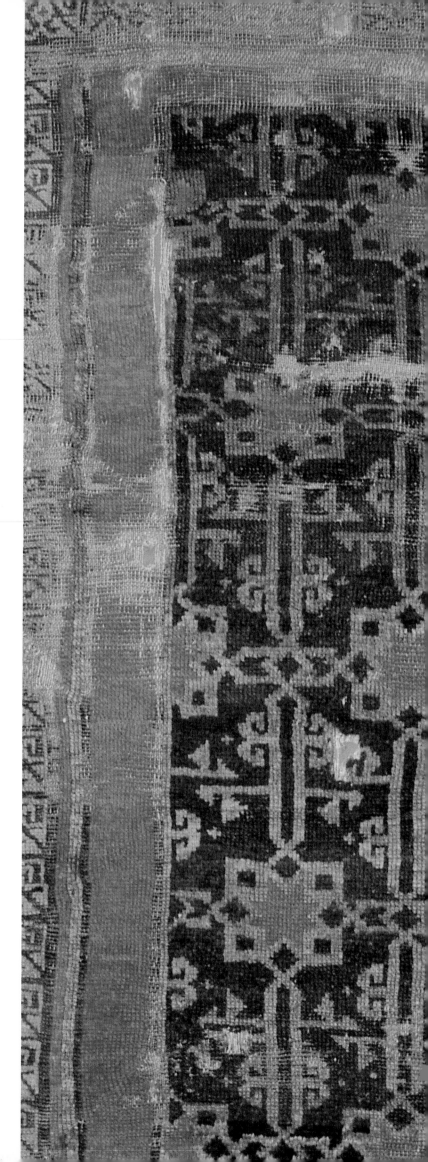

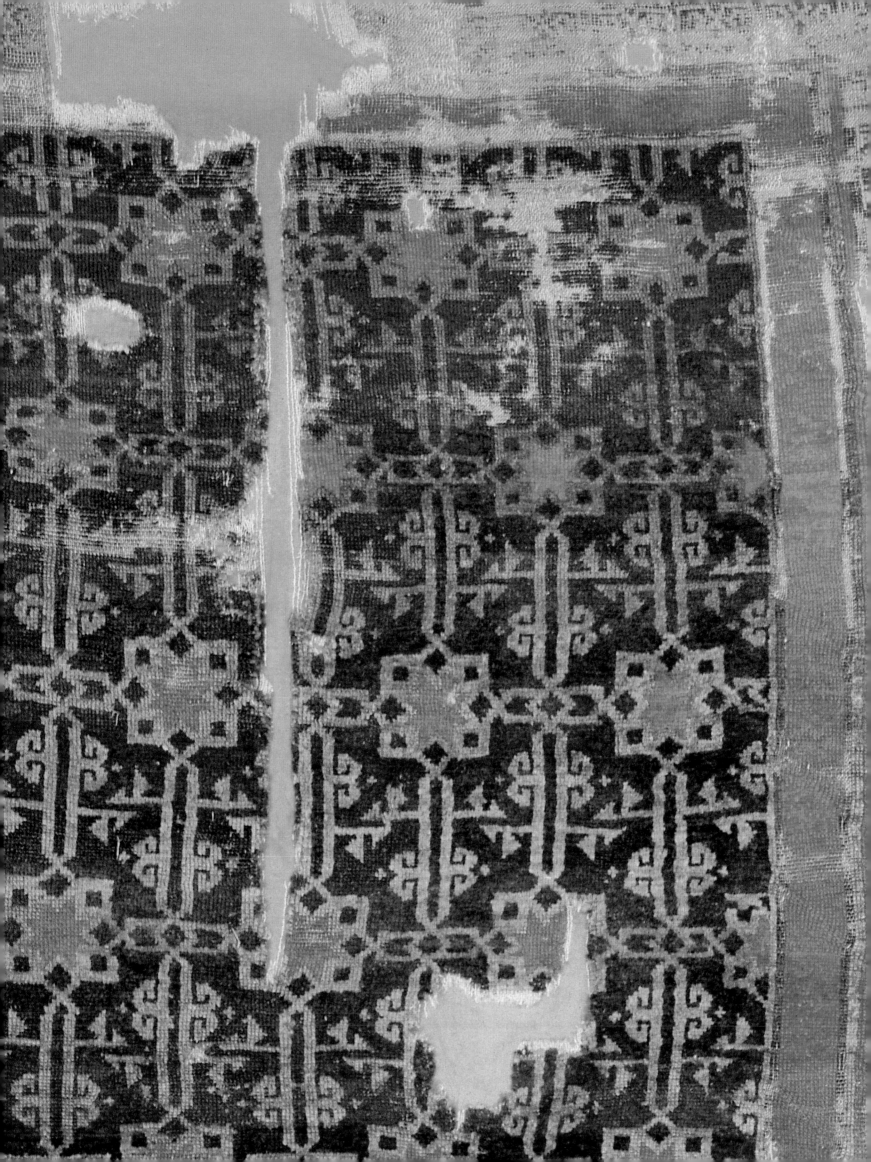

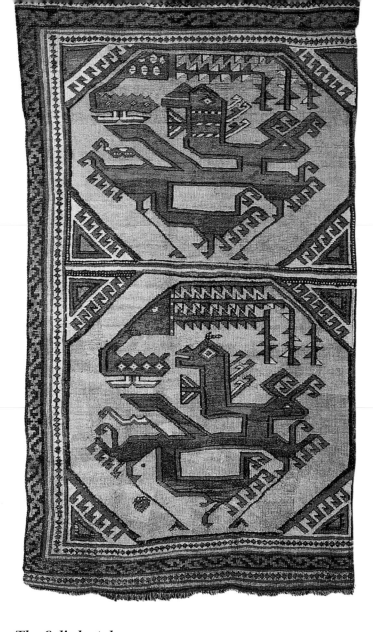

Left, fragmentary medallion carpet, known as the Berlin carpet. First half of 15th century. Berlin, Islamisches Museum. Inside each octagonal medallion is a Chinese motif, representing the battle between the dragon (bottom) and the phoenix (top). This carpet, along with the Marby carpet, which depicts two birds surrounding the tree of life, is a type of Anatolian figural carpet that disappeared after 1453. Above, *Annunciazione*, by Gentile da Fabriano (c. 1370–1427), tempera on wood. Rome, Vatican Pinacoteca. Paintings such as these, in which figural carpets of the Ming and Marby type are depicted, were used to date these two examples to the first half of the 15th century.

The Seljuk style

Today, documentation of the Seljuk style is provided by a group of almost complete specimens and of fragments uncovered in Konya and Beyeshehir, datable to the 13th century and linked to production in Konya. Made of wool using the symmetrical knot, these fragments have full-field decorations composed of varying geometric grids, stylized floral arabesques and the endless repetition of small octagons or other more or less open elements. These typical, elementary decorative motifs have a naturalistic origin and are derived from ancient Central Asian traditions. These carpet fragments have wide borders often decorated with Kufic script. The grounds are colored in many shades of red, as well as in ivory, blue and light blue.

Two remarkable figural carpets

Historically, the second most important group of carpets, after the Seljuk carpets we just examined, are two remarkable figural carpets of uncertain origin: the Berlin carpet and the so-called Marby carpet. Both carpets feature two large superimposed octagonal medallions on a yellow ground, decorated with stylized animal figures: The Ming carpet depicts a battle between a dragon and a phoenix; the Marby rug, two birds flanking the tree of life. Both motifs are foreign to Islamic tradition, since the first is of Chinese origin and the second is pre-Islamic. However, the Central Asian origin of the Turkish peoples sufficiently justifies their authenticity.

Both specimens have been dated to around the first half of the 15th century based on their documentation in Western paintings; in fact, similar carpets were depicted in European paintings and frescoes of the 14th through the 16th centuries. One such painting is the *Annunciazione* by Gentile da Fabriano (c. 1370–1427), a painting on wood preserved at the Vatican Pinacoteca. The Ming and Marby carpets have been the subject of much study and debate. In addition to the Seljuk, Ottoman and Caucasian production centers, they have also been linked to Byzantine textiles of the same period, which present similar figural motifs. The Byzantine connection is supposedly verified by the fact that after the

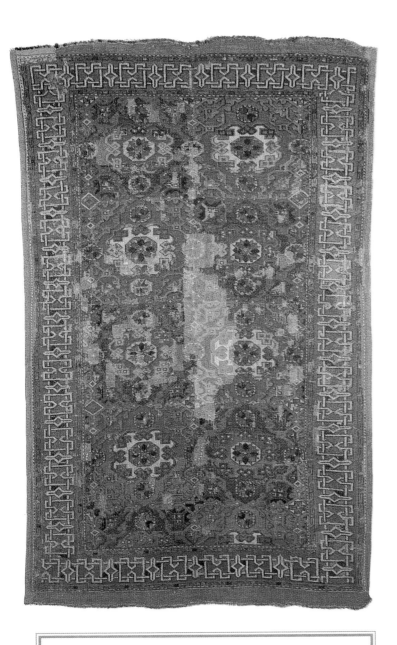

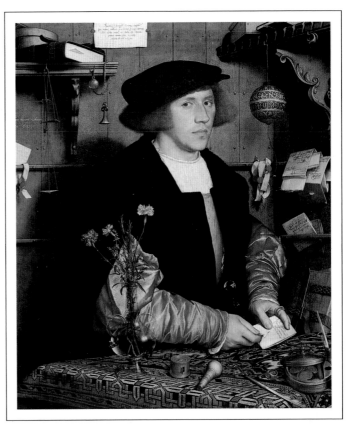

Left, Ushak carpet of the small-pattern Holbein type. 16th century. Florence, Museo Bardini. The field octagons are framed by an arabesque with heart-shaped interweavings; the border has a Kufic motif.
Above, *Portrait of the Merchant George Gisze*, Hans Holbein the Younger (1497–1543). Berlin Gemäldegallerie. The carpet is a small-pattern Holbein (the Kufic border is shown in detail on the left).

Major Areas and Types

KONYA AND BEYESHEHIR
Fragments of Seljuk carpets (13th century). Full-field layout with small geometric figures and wide borders, often with Kufic script.

BERGAMA
Large-pattern Holbein type (15th to 17th centuries). Decorated with large, regular polygons; borders with Kufic script or trefoils.

Transylvanian, or Siebenbürgen, carpets (early 17th to mid-18th centuries). Double-niche layout.

USHAK
Small-pattern Holbein type (15th to 17th centuries). Rows of small octagons embellished with heart-shaped interlacery; borders with Kufic script.

Lotto-type, or arabesqued, carpet (end of 15th to early 18th centuries). Full-field arabesques, yellow on red ground; borders with Kufic script, cartouches, cloud bands.

Medallion Ushak (latter half of 15th to early 19th centuries). Central ogival medallion with spandrels of four polylobate medallions in the corners; blue medallions on red ground, or vice versa.

Star-patterned Ushak (first half of 16th to 18th centuries). Rows of star-shaped or eight-pointed medallions.

Ushak prayer rug (starting from mid-15th century). Mihrab with keyhole-shaped recess.

Double-niche Ushak (starting from mid-16th century). Hexagonal medallion formed by two mirroring niches.

CAIRO
Mameluke carpets (15th to early 16th centuries). Dense geometric elements with kaleidoscopic effect.

Floral style or court carpets (16th to 17th centuries). Full-field layouts, prayer and medallion carpets.

Ottoman conquest of Byzantium in 1453, this type of design disappeared together with all other animal representations. These two styles, therefore, lost all following and today are simply precious historical evidence.

Carpets and Western painting
Production of the Seljuk models, on the other hand, greatly increased under the new Ottoman dynasty. During their long rule (1299–1922), the Ottomans, who were also Muslims, greatly promoted the art of carpet making. The 15th and 16th centuries stand out as the most splendid period of this production. Unfortunately, only a few specimens have survived. Western painting of that period, however, offers us indirect testimony of these carpets. Thanks to the lively trade that developed, especially with Italian cities, carpets were imported from Anatolia into Europe as precious luxury items, worthy of being depicted by painters as a symbol of sacredness in their religious paintings or as a sign of authority or social weight in portraits.

Hence, Italian and northern European artists often inserted in their religious or secular scenes examples of carpets that were common in the West, having been

Detail of *The French Ambassadors Jean de Dinteville and Georges de Selve* by Hans Holbein the Younger, dated 1533. London, National Gallery. A large-pattern Holbein appears in the painting, with the border decorated with a trefoil motif and the field showing two superimposed large squares outlined in white, each containing a yellow octagonal element, in turn filled with decorations. Both large- and small-pattern Holbein carpets, believed to originate from Bergama, reveal their ancient Seljuk origins in their decorative motifs and geometric style.

In the first type, small octagons, often enclosing a star, are generally arranged in a uniform series of superimposed rows, framed by a typical geometric arabesque, which, in turn, is shaped into unusual triangular interweavings that resemble hearts. Large-pattern Holbeins have a less elaborate layout, being based simply on the superimposition of two, three or at the most four large squares, each containing a decorated octagon. Both types of carpet, usually small in size and rendered in strong colors, with red and blue predominating, typically have borders decorated in Kufic script. Sometimes, large-pattern Holbeins have trefoil borders.

Heirs to the Seljuk tradition not only in their decorative motifs but above all in their strong sense of geometry, Holbein carpets were extremely popular in later productions. However, beginning in the 17th century, the compositions began to lose their original vigor, becoming more confused and chaotic. The earliest small-pattern Holbeins are thought to have come from Ushak and the large-pattern carpets from Pergamon (present-day Bergama in western Turkey).

Lotto or arabesqued Ushak carpets

Another type of carpet is known as the Lotto carpet, named for the Venetian painter Lorenzo Lotto (1480–c. 1526). Known in Europe since at least 1516, this type of carpet has a very unusual, easily recognizable composition: a yellow grid of geometric arabesques that form rows of cross-shaped elements alternating with rows of octagonal or rhomboidal elements, all set inside a generally bright red field. The oldest specimens (end of the 15th to the 16th century) have borders decorated in Kufic script, while the borders of carpets from the 17th century onward are decorated with cartouches or cloud-band motifs.

Lotto carpets were exported to the West in large quantities and were in production until the early 1700s. Also called "arabesqued Ushaks," after their city of origin, these carpets are expressions of an art that had reached maturity and could create new and more complex compositions while remaining faithful to the geometric spirit and decorative models of the Seljuk tradition.

Cairo production

As discussed later in this book, Ushak was the leading Anatolian center for the production of carpets for the court, though not the only one. After the 1517 conquest of Egypt by the Ottomans, the Cairo ateliers, which had been active under the defeated Mameluke dynasty (1252–1517) and had created a unique model for them (the so-called Mameluke carpet), were also used for production.

The Mameluke carpet is easy to recognize, because its field is richly filled with various geometric figures (rhombuses, octagons, squares, circles, etc.) of varying sizes, arranged to create a typical kaleidoscopic effect. In the most common layout, the figures rotate around a central medallion, which, in turn, consists of many superim-

imported exclusively from nearby Anatolia. The ornamental motifs of these carpets, although reworked, were handed down over time until the 1800s and even later. For this reason, the classification of Anatolian carpet styles has come to include certain styles that were named after the painters who made them famous by reproducing them in their works, although they may not necessarily have been the first to introduce them.

Holbein carpets

Holbein carpets, named for the German painter Hans Holbein the Younger (1497/98–1543), are evidence of the survival, in reworked form, of traditional Seljuk designs. Known in Europe at least since the mid-15th century, they are characterized by unusual geometric medallions and are divided into two main types: small-pattern Holbeins and large-pattern Holbeins.

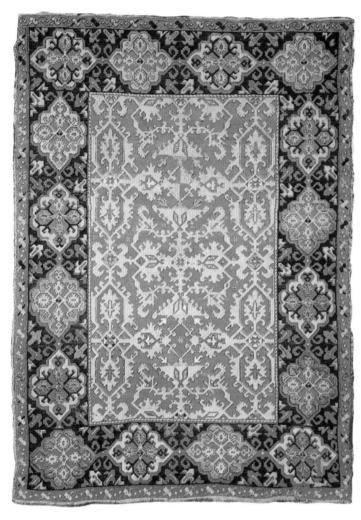

leaves in the *saz* style, also called the "reed-leaf style," which was then popular with Ottoman court artists. It is named for a typical decorative motif—the curved, lance-shaped leaf. These carpets have full-field layouts of the prayer or medallion type and feature small, round central medallions surrounded by an overwhelming background decoration—an unusual inversion of tendency compared with the Ushak and Persian carpets of the same period, where the central element dominates the whole composition. These carpets were manufactured from the beginning of the 16th century to the end of the 17th century.

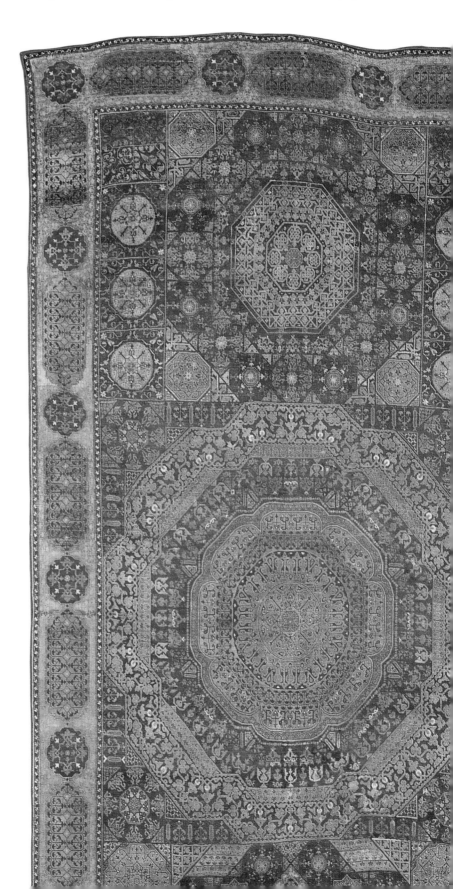

Above, Lotto or Ushak carpet with arabesques. Early 17th century. New York, The Metropolitan Museum of Art. This carpet presents an unusual yellow geometric arabesque on a red background.

Right, detail of a Mameluke medallion carpet. Cairo, early 16th century. New York, The Metropolitan Museum of Art. Egyptian production preceding the Ottoman invasion of 1517 is notable for the "kaleidoscope" effect created by a variety of small geometric figures knit closely together.

posed geometric figures. The colors are lively but few, often only red, blue and green; the borders are usually decorated with the cartouche motif. Production of these carpets, which are also identifiable on a technical basis because they use the asymmetrical knot, began in the 15th century and lasted until the Ottoman conquest. Because of these unique features, the Mameluke carpets are an exception that cannot be included in the production of Anatolia. Indeed, they represent an unusual fusion of the geometric style shared with Anatolia and the asymmetrical technique used in Persia.

After the Ottoman conquest, the Cairo ateliers began to produce a new style of carpet, resulting from the refined taste of the new rulers as well as Persian and Chinese decorative influences. Such production consists of a group of floral-style carpets, also known as the Turkish court style, identified by naturalistic elements in curvilinear designs.

Using a limited number of colors and made with the asymmetrical knot like the earlier Mameluke production, this style adopted ornaments of naturalistic flowers and

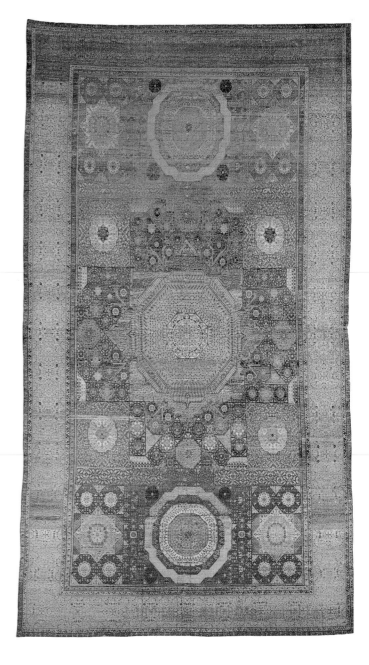

Mameluke medallion carpet
Cairo, 16th century
Florence, Museo Bardini

Mameluke medallion carpet
Cairo, 16th century
Vienna, Österreichisches Museum für angewandte Kunst

Even before the Ottomans conquered Egypt in 1517 under the Mameluke dynasty (of Turkish origin), the impressive workshops of Cairo were already in operation, manufacturing carpets using the asymmetrical knot, which were later called "Mameluke" for the name of the rulers. These carpets had a very particular geometric style based on the close arrangement of geometric figures of different shapes. The basic polygons in the above carpet are the octagon and the square; they are repeated concentrically inside the medallion and arranged, in smaller sizes, one next to the other in the field. This produces a singular kaleidoscopic effect typical of this carpet style, even though the number of colors used is limited.

This is the only surviving example of a Mameluke carpet with a silk pile. Together with an exceptionally varied palette, this creates an unusual effect of changing brightness, heightened by the kaleidoscopic effect—a result of the very dense, mosaic-style design—that is typical of these carpets. The three superimposed octagonal medallions are arranged on a field that is completely filled with small, brightly colored geometric elements, such as octagons, squares and rectangles, placed one next to the other and repeated inside each other. Also unusual is the wide principal border decorated with arabesques, which gives an eclectic touch to the whole.

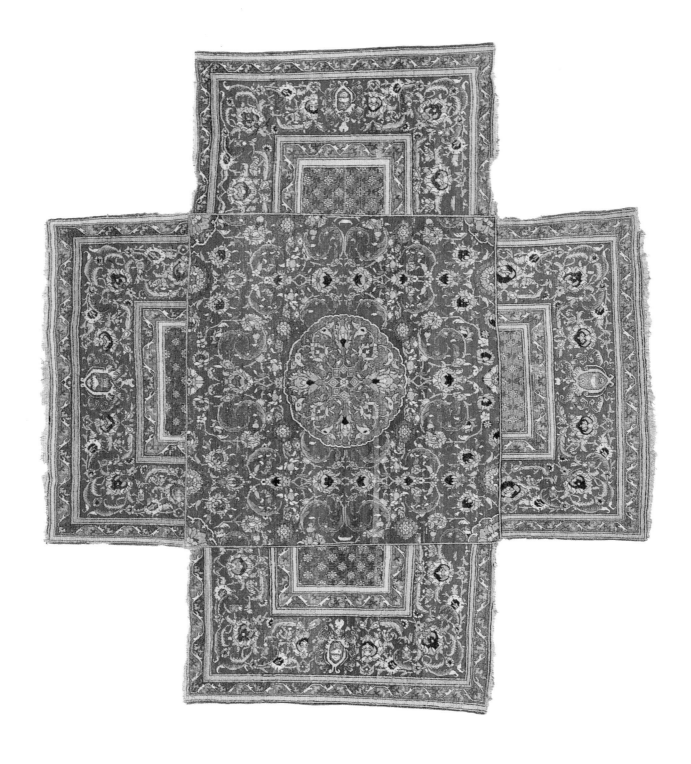

Cruciform medallion carpet
Cairo, mid-16th century
San Gimignano (Siena), Museo Civico

The small size of the medallion, the curvilinear decorations with pal-mettes, the sickle-shaped leaves of the *saz* reed and the asymmetrical knotting indicate that this Ottoman court carpet was made in Cairo after 1517.

The carpet's crosslike shape, designed to cover the top of a table with four borders draping over the sides, and the presence of four coats of arms (unidentified) indicate that it was made for the home of a noble European family. According to legend, Cardinal Orsini presented it as a gift to Cesare Borgia in 1502, who in turn gave the carpet to Niccolò Machiavelli, who brought it to San Gimignano. Stylistically, however, the carpet is datable to the mid-16th century, not before.

The spandrels present the halves of four minor medallions in typical polylobate form. The way they are cut alongside the border hints at a pattern that repeats itself endlessly.

In this example, the main border displays on three sides the typical 16th-century palmettes; the bottom border has a design composed of "endless knots," typical of 15th-century kufesque borders.

The red (or blue) central ogival medallion with serrated edges is typical. Decorated with floral motifs and complemented by tear-shaped pendants, it dominates the composition.

A delicate, continuous plant shoot decorates the two minor borders; while the inside border usually has a yellow ground, the outside border is generally dark.

The dark blue (or red) field displays a yellow plant shoot growing palmettes, lotus flowers and jagged oak leaves, a motif often found in other Ottoman court arts.

Fractions of two additional principal medallions are visible at both the top and the bottom, suggesting an endless pattern.

Ushak medallion carpet
16th century
Lugano, Thyssen-Bornemisza Foundation

In the Ottoman court production, the Ushak medallion type stands as the example of highest refinement and stateliness. Stylistically, it features a centralized layout, with the ground colors contrasting with the medallion colors, and an intricate curvilinear design applied to naturalistic floral motifs.

Ushak and court production

During the 16th and 17th centuries, the region of Ushak (not just the town) was the principal center producing carpets for the Sultan and the Ottoman nobility. In these refined court ateliers, the artist designers created for master weavers new, large decorations that were complex and refined; compared with the earlier carpets made in the local geometric style, these carpets were closer to the floral style and the curvilinear designs then being developed in Persia.

In the Anatolian production, medallion Ushaks are the carpets most similar to the Persian carpets of the same period. The center contains a singular ogival medallion decorated with arabesques and palmettes, on a field densely filled with slender, lifelike plant shoots and with lotus flowers, palmettes and typical "oak leaves." Near the corners of the field are the halves of another four, secondary, round multifoil medallions that suggest end-less repetition. There are two color schemes: One has a blue medallion in a red field enriched with yellow shoots; the second, more elaborate scheme has a red medallion in a blue field and yellow shoots. Flowers and palmettes, along with Kufic motifs, decorate the borders of the more ancient specimens, while carpets dating from the 17th century on have wider borders with more rarefied designs.

The curvilinear design, the floral elements and especially the central structure—all foreign to the Anatolian language, which, since the earliest Seljuk production, was identified by the repetition of one or more elementary modules—led to the theory that this production was directly influenced by Persian models from the Safavid court. According to serious studies conducted in the 1980s, however, the medallion layouts seem to have been developed independently during the same period in Anatolia and Persia, perhaps because of shared models

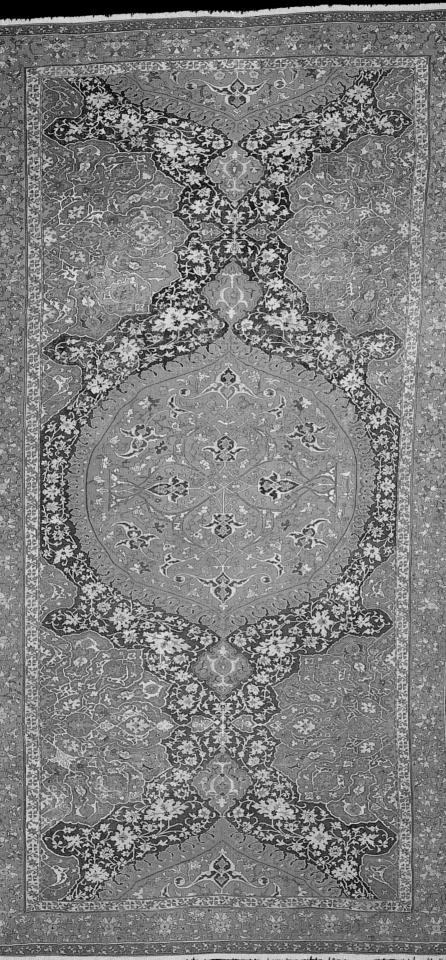

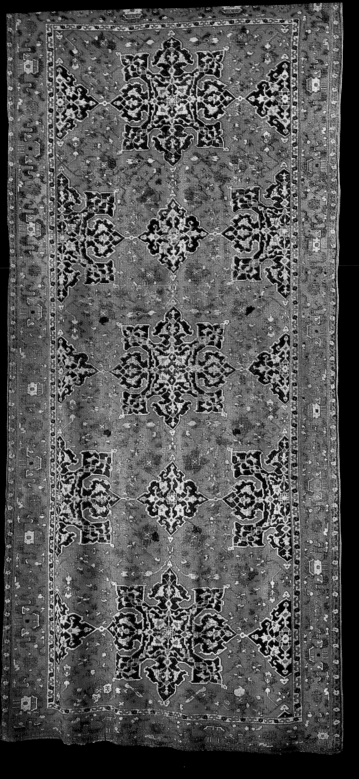

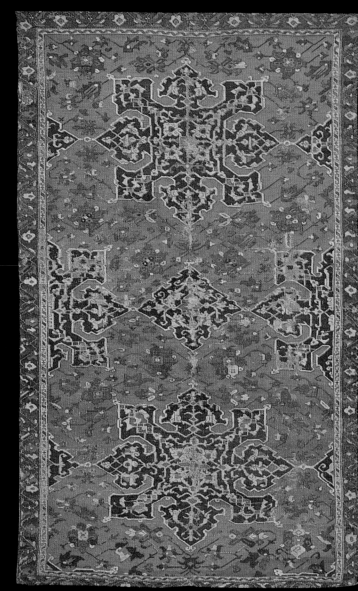

Left, Ushak carpet with stars. 17th century. Florence, Museo Nazionale del Bargello. While quite similar to the previous type, these carpets are remarkable for the alternation of large star-shaped medallions with smaller, cruciform medallions, arranged over a red ground. Both the larger and smaller medallions are dark in color, finely arabesqued in yellow and outlined in white.

Above, Ushak carpet with star medallions. 16th century. Paris, Musée des Arts Décoratifs. This carpet is smaller than the previous one and has only two star-shaped medallions; however, the medallion fractions along the border suggest an infinite pattern. Also noteworthy is the different decoration of the main border: Here, it is done in a stylized plant shoot, and in the previous carpet, a cloud-band motif is used.

brought from Central Asia in the early part of the 15th century in the wake of Timurid's invasions.

Whatever the origin, this model met with great success and influenced later production; it was probably created in the latter part of the 15th century under the rule of Mohammed II the Conqueror (1451–81). Under this reign, the so-called oak-leaf style was developed and, not coincidentally, also applied to other arts, such as miniatures and ceramics. During the 16th and 17th centuries, it was slowly replaced by the *saz*, or "reed-leaf," style, as seen in, for example, the Cairo floral carpets. Clearly reserved,

at least at the beginning, for the Ottoman nobility and not for export, medallion carpets enjoyed their greatest splendor around the middle of the 16th century and continued to be made, in increasingly mediocre versions, until the early 1800s.

Two other carpet types with similar decoration and colors, although smaller and more elongated, were made during the same period: the medallion Ushak and the star-patterned Ushak. The star-patterned Ushak presents regularly spaced, offset rows of eight-pointed, large star-like medallions with a dark background alternating with

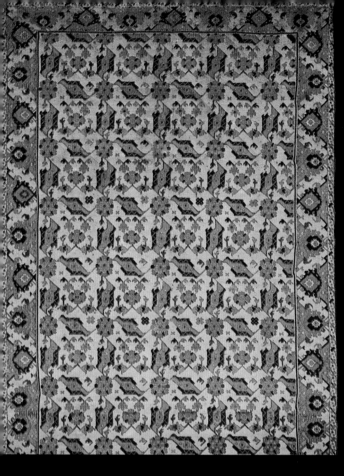

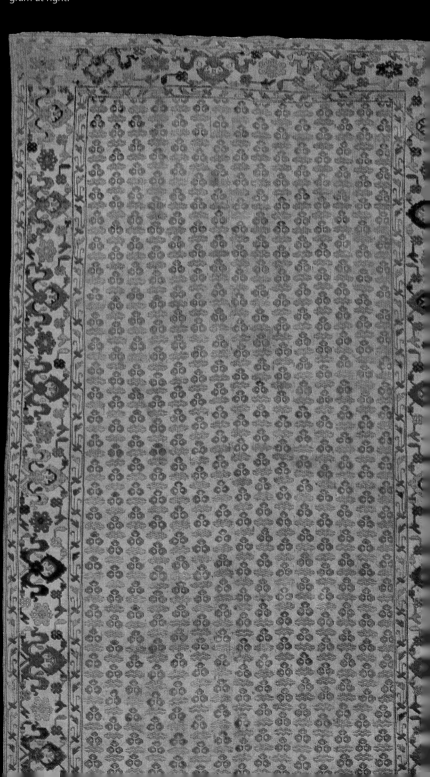

maller, crosslike medallions, all set against a red ground nriched with floral elements. Along the field's central xis, the medallion Ushak presents a repetition of leadng medallions that are round or, more often, ogival in hape and with scalloped edges, flanked on each side by wo rows of secondary polylobate, or multifoil, medalions that are cut in half or in wedges at the carpet's borders. In both models, the breaking of the medallions long the borders suggests endless repetition, thus making the design more in keeping with the strictly traditional Anatolian language.

Within the vast array of this extremely lively and colrful production are two carpet types that are distinuished by a light background, white or ivory, on which mall, full-field designs are neatly set, usually framed by loud-band borders. These are the "bird-pattern" Ushaks nd the *chintamani* Ushaks. The first type has repeating ows of rosettes, each surrounded by four typical elonated geometric leaves, very similar to stylized birds with olded wings and long beaks, thus mistakenly giving the ame of "bird" to this carpet type. This design was quite opular, especially in the 17th century.

The second type is characterized by repeating, alterating rows of the *chintamani* motif, probably of Budhist origin, formed by two small wavelike segments nderneath three disks (a ball and line pattern). Ancient xamples are rare today, though there are many imitaons that date from the early 20th century.

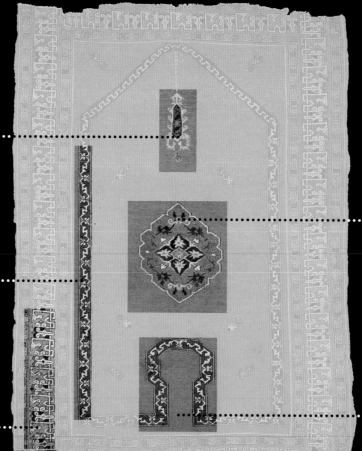

From the center of the mihrab's arch hangs the sacred mosque lamp, symbol of divine light. It can be depicted in various ways, more or less realistically.

As in all prayer rugs, the mihrab in these early examples is simple, squarish and outlined by a thin, geometric border on a red background. The arch is pointed.

The decoration of the main border, with a variously geometric Kufic motif with typical white interlacery, distinguishes these early carpets.

The mihrab's center is dominated by a small, hexagonal medallion, variously interpreted, which also represents divine light.

The octagonal recess at the bottom of the mihrab, similar to a keyhole, symbolizes both the water basin for ritual ablutions and the holy mountain, where the human meets the divine. A small medallion may sometimes be placed here as well.

Fragment of Ushak prayer rug (Bellini type)
Late 15th or early 16th century
Berlin, Museum für Islamisches Kunst

This early simple prayer rug, created in the region of Ushak, served as prototype for other types of carpets and was rendered in various ways throughout Anatolian production centers, successfully spreading abroad as well. These carpets are identifiable by their faithfully traditional geometric language and a simple, squarish niche that features an unusual keyhole-shaped recess in the lower part.

Birth and development of the prayer rug

The first prayer rugs, made around the mid-15th century in the region of Ushak, as documented by Western paintings, were destined to have an incredible development, thus giving birth to the most representative type of Anatolian carpet, which came to be produced in towns as well as in villages and large city workshops. Beginning in the 16th century, the production of these rugs increased, again in the Ushak region, and so in addition to the large-scale medallion specimens, smaller rugs, known as Bellini rugs, were produced, after the surname of the famous Venetian painters Gentile Bellini (1429–1507) and Giovanni Bellini (c. 1432–1516).

These rugs remained faithful to the traditional Seljuk geometric language and decorative motifs. They are decorated by a niche, or mihrab, placed in a red field—the mihrab with a pointed arch and simply outlined by a dec-

orative border and, in the lower part, by an unusual octagonal recess resembling a keyhole. This last motif, symbolizing either the basin used for ablutions or the sacred mountain, is the typical distinguishing element of these early Ushak rugs. The mihrab is decorated inside with a mosque lamp hanging from the top of the arch and by a small, usually hexagonal medallion in the center, possibly also signifying divine light. Usually, the main border is decorated in Kufic script in many variations.

The prayer-rug layout is also present in the so-called Tintoretto rugs—named for another celebrated Venetian artist (1518–1594)—which are more properly known as double-niche Ushaks because of the hexagonal shape of the main medallion, obtained by joining two mirroring niches. The use of a central rosette and four cornerpieces is typical of the nondirectional architecture of medallion carpets, but the mosque lamp hanging from the top of

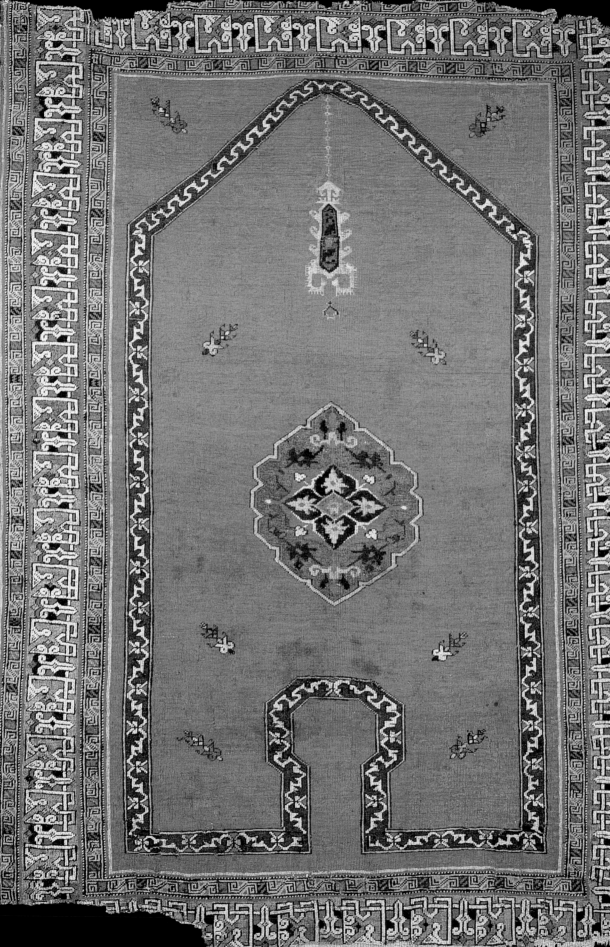

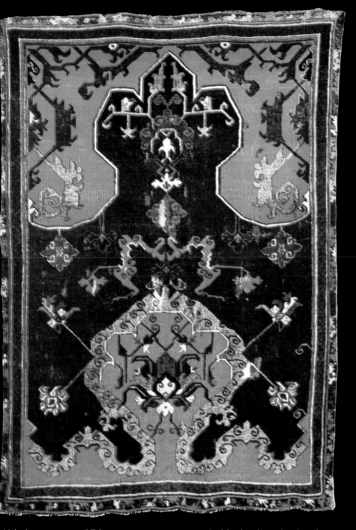

Ushak prayer rug. 17th century. Berlin, Islamisches Museum. Despite the elaborate design of the mihrab compared with those of the original carpets, this Ushak prayer rug is recognizable thanks to its singular "keyhole" octagonal recess in the lower part of the mihrab, enclosing a floral medallion.

Mihrab Shapes

The prayer rug is truly representative of Anatolian carpet making, the meeting place of geometric-based aesthetics and of a deeply felt religious need.

This type, whose hallmark is the symbolically represented mihrab—the architectural niche that is located inside all mosques—was successfully adapted in every Ottoman production center, from the large Cairo works to city and village shops. It was also exported abroad, where it was interpreted in different ways, yet remains a typical Anatolian model, produced continuously from the 15th century onward.

As each production center wished to differentiate its carpets, it modified the classical pattern, creating designs that then became traditional and typical of each center.

Thus, the mihrab comes in many shapes and sizes: It is slender in Melas, squat and squarish in Ghiordes; or it can be arranged on slender columns, on shelves or on variously shaped arches (acute, arrowhead, stepped, upturned "V" shape, and so on). In addition to the traditional sacred lamp and water basins, the field can also contain complex or stylized floral elements.

the rosette often gives these rugs an orientation typical of prayer rugs. Usually small in size and decorated with a cloud-band principal border, this 16th-century layout became widely popular, especially beginning in the 17th century.

The Ushak double-niche carpets manufactured in city workshops were meant for domestic use but were also intended for the Western market that developed in Anatolia in the 17th century. In fact, beginning in the mid-16th century, along with the outstanding court specimens made in large-scale specialized ateliers on commission from the Ottoman nobility, another kind of carpet began to appear. This production was more ordinary, though in no way minor; it was made both for domestic use and for export. These carpets were made in town and village workshops at different levels of evolution throughout Anatolia.

Of small and medium size, these town and village carpets exhibit a larger knot and fidelity to the traditional geometric style, which also translated into the stylized forms of the elaborate designs created in the great court ateliers. In addition to the double-niche carpets described above, the leading representatives of this production are the Transylvanian carpets and prayer rugs, so named for the region of Transylvania, then an Ottoman province, where they were found in abundance. These carpets, however, were probably manufactured elsewhere in western Anatolia, possibly in the town of Melas or the town of Bergama, and then exported to Transylvania.

These small carpets rarely have a single-niche layout. For the most part, they have an unusual double-niche design. It has therefore been customary to use the name "Transylvanian" to refer to a particular type of double-niche carpet. This type is derived from the Tintoretto-type Ushak carpets but, unlike them, displays a greater sense of geometry, which confers an unusual severity to the whole design, making them especially attractive. The field is dominated in the center by a large hexagonal

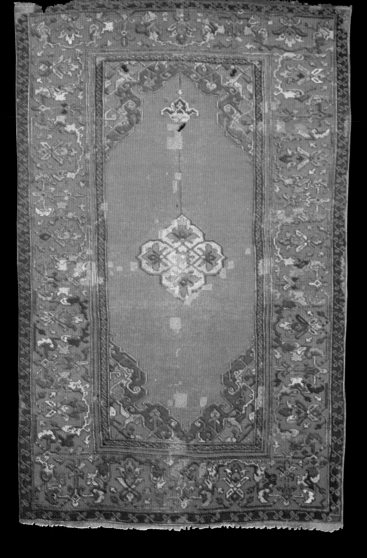

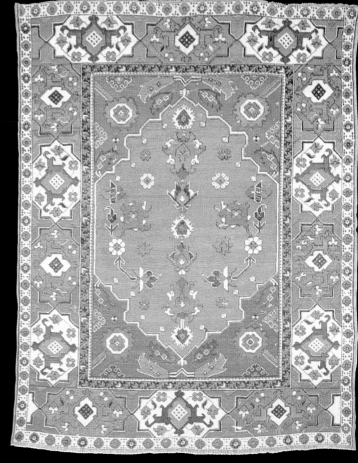

medallion containing stylized floral decorations, which also decorate the four cornerpieces. The colors are primarily red, yellow, blue, light blue and ivory; the main border is typically decorated with an unusual interpretation of the cartouche motif, which contains a crablike element, actually a floral motif. Transylvanian carpets were made between the first half of the 17th century and the beginning of the 18th, and their design was widely imitated in later centuries.

Prayer rugs had already appeared in the Ushak region, but it was in the city workshops and in villages beginning in the 17th century that their production greatly increased, with forms and styles that varied according to periods of production, external influences and, especially, areas of production, with each locality working out its own particular design. Soon this model became the most significant and most widely followed in Anatolia, depicting a merging of that region's religious spirit and geometric tradition.

Thus, the niche on these carpets can be represented very simply, in imitation of the first classic examples from Ushak, or in a complex design, such as in coupled-column carpets, where, using a more architectural language, they are rendered as portals divided by slim double columns that, in turn, usually bear three arches ending in cusps. Carpets can have one or multiple niches, as in the *saph* (which means "row" in Turkish) carpets. In the latter, also called multiple or family prayer rugs, the niche is repeated several times in orderly fashion, forming a continuous series of niches side by side.

The large production of prayer rugs over the centuries was thus identified according to their different styles, such as the shape of the arch, the niche, internal decoration or border design, and was classified according to the centers, cities or villages of provenance. For example, the oldest specimens have been classified as coming from Ghiordes, Kula and Ladik.

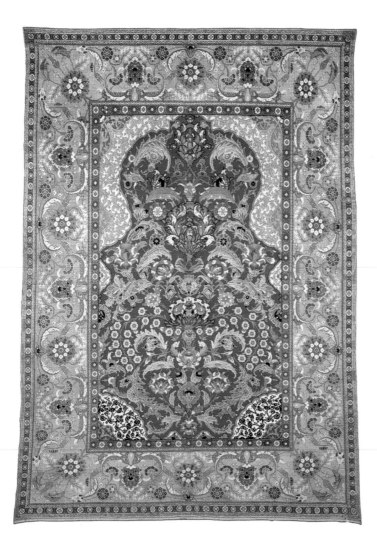

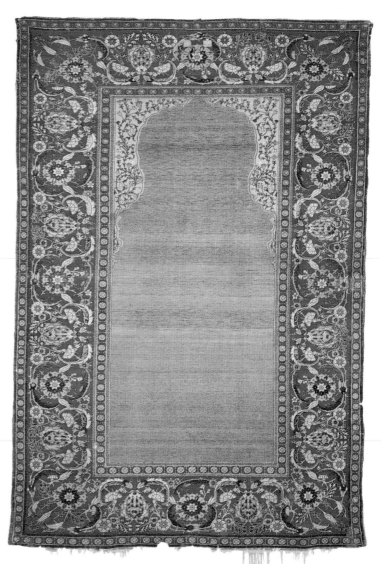

Prayer rug
Istanbul? Bursa?, end of 16th century
Vienna, Österreichisches Museum für angewandte Kunst

Typical of the Ottoman court style, also known as *saz*, are the mihrab with a wavy arch, floral decorations, such as palmettes and rosettes, the typical curving and lance-shaped *saz* reed leaf (also an element of other Ottoman decorative arts) and a limited but refined color palette, such as light blue, white and dark red. Floral prayer rugs of this type were made in the Cairo and Anatolian royal works with so many similar characteristics, their precise identification is impossible. Carpets with weft and warp in silk, such as the specimen above, are nevertheless said to come from Istanbul or Bursa, a production center near Istanbul.

Prayer rug
Istanbul?, 1610
Berlin, Museum für Islamisches Kunst

Production of prayer rugs in the Ottoman court style began in the mid-16th century. The more precious ones were made at the Istanbul and Bursa works beginning at the end of the 16th century and throughout the 17th century, using silk for the foundation and cotton for the white and light blue sections of the pile. Some rare specimens, such as this 1610 rug attributed to Istanbul, have the mihrab in a solid color. The decoration consists of the complex, wavy arch, the two arabesqued cornerpieces and the main border, which features a winding vine embellished with palmettes, rosettes and *saz* leaves on a dark bordeaux ground.

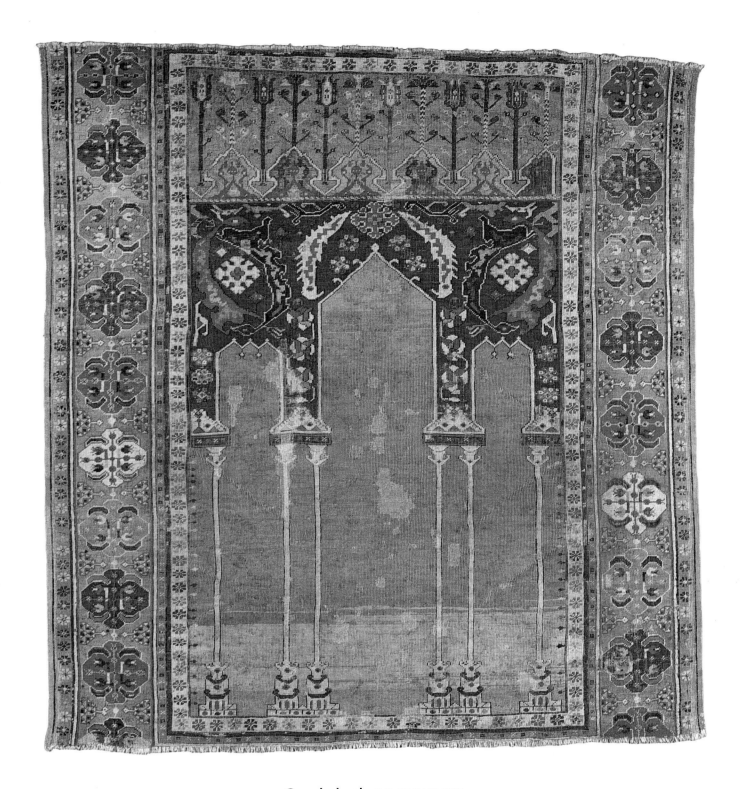

Coupled-column prayer rug
Ladik, late 17th century
Florence, Museo Bardini

This carpet represents the mihrab as a portal divided by pairs of slender columns that support three Islamic-cusped arches: one major central arch flanked by two minor tricuspid arches. This type spread throughout Anatolia in the first half of the 17th century with such great commer-

cial success that the oldest examples were found in Transylvania. Its origins, however, are still debated. The presence of tulips, seen above the mihrab, indicates this carpet probably originated in the city of Ladik.

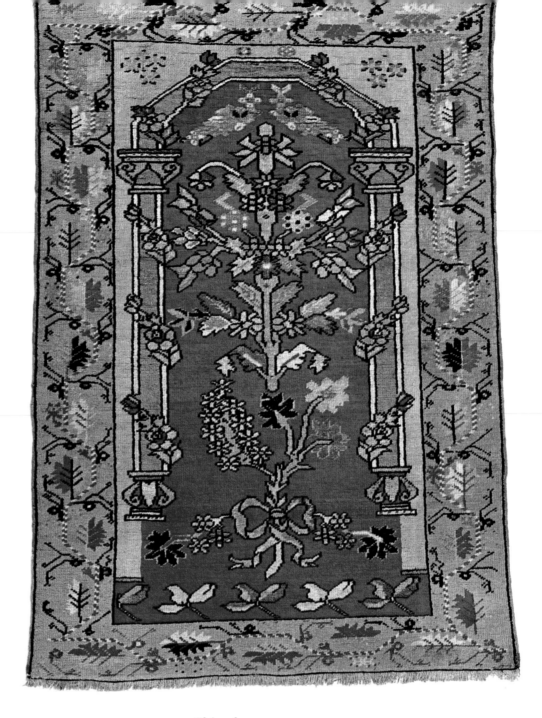

Ghiordes prayer rug
Late 18th century
Milan, Pars Collection

The West's influence is easily seen in this example. The mihrab, with its squared arch supported by thick columns with classical capitals, is neither Islamic nor traditional; the tree of life underneath the arch, rendered as a realistic floral bouquet—each flower unique and tied by a bow—shows the influence of French taste, which had reached Anatolia by the late 18th century. This Frenchified style (also known as "Turkish baroque"), which introduced foreign decorative motifs and modified traditional motifs, is well represented here. The tendril border motif is typical of 18th- and 19th-century Ghiordes carpets.

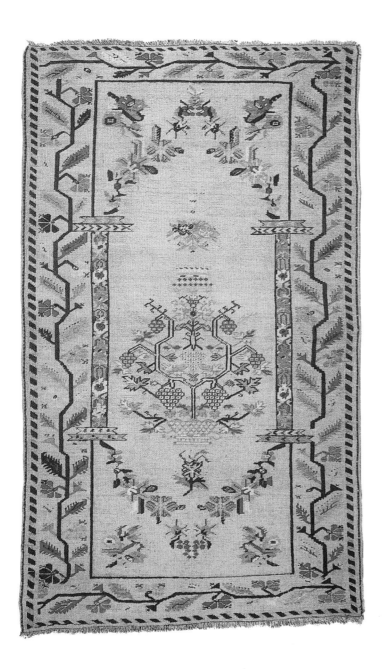

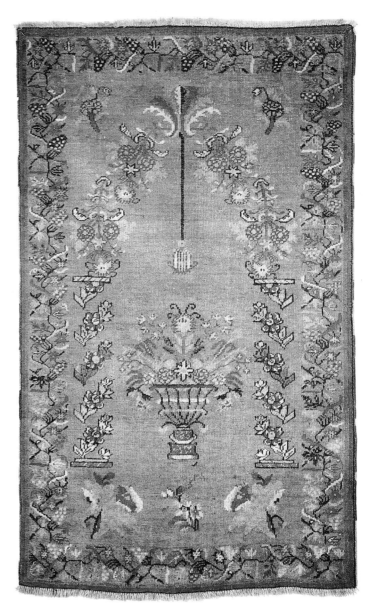

Ghiordes double-niche carpet
Late 18th century
Milan, G. Mandel Collection

By the end of the 18th century, it was the rich Ghiordes production that interpreted the Turkish baroque style. It introduced French decorative elements and translated traditional motifs and layouts in the French floral style. This bi-directional carpet shows a transition phase, with the design split between geometric tradition and foreign novelty. The slender columns and the floral arch pattern are all that remain of traditional mihrab. The colors are few and tend to the pastel; the background is solid and often beige.

Ghiordes prayer rug
Late 19th century
Rome, Giacomo Cohen and Children Collection

The Mejid style, named for Sultan Abdul Mejid I (1839–1861), who imposed it on every artistic pursuit, saw the widespread entrenchment of French style in Anatolia. The above carpet stands as a perfect example of this hybrid style for the following reasons: the transformation of the mihrab from architectural element to a quasi-unrecognizable shape outlined in floral bouquets; the use of foreign motifs, such as the elaborate central vase; the use of realistic flowers and leaves; and the choice of Savonnerie- and Aubusson-style pastels, with heavy use of beige, in this case, for the background.

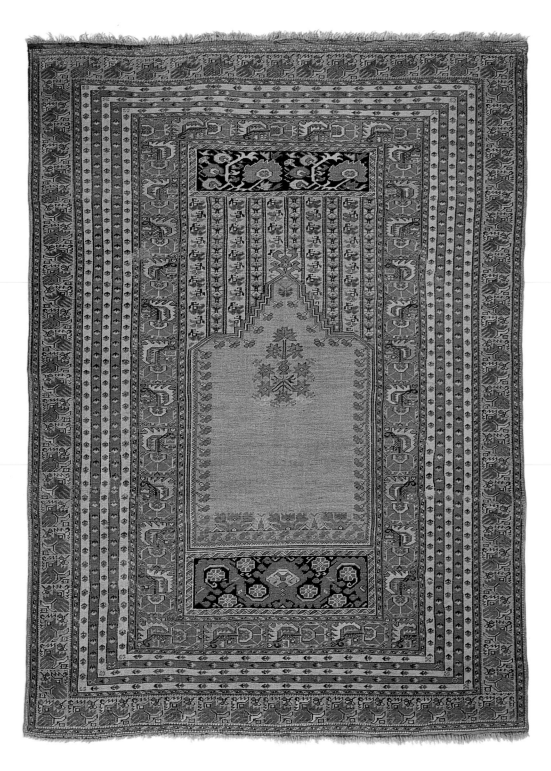

Ghiordes prayer rug
Late 18th to early 19th century
Verona, Tiziano Meglioranzi Collection

This carpet displays the typical Ghiordes prayer-rug design, marked by the important and numerous borders; the squat and squarish shape of the niche, recognizable in the inverted "V" arch resting on narrow shoulders and the row of carnations along its interior; and the transformation of the sacred lamp into a bouquet of flowers. Also typical are the two panels placed above and below the niche, filled with a cloud-band and a carnation motif, a flower used often in this type. The middle border, decorated with two-toned *çubukli* motifs and flanked by minor borders with stylized floral designs, are also typical.

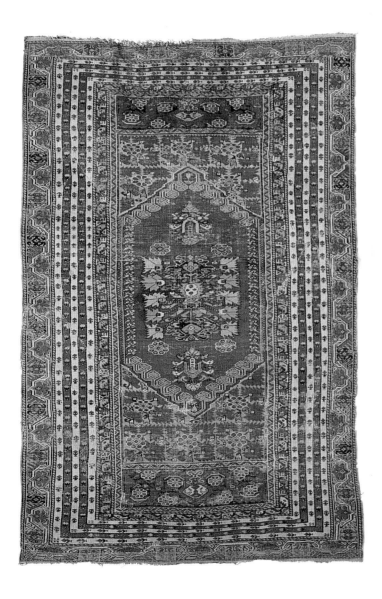

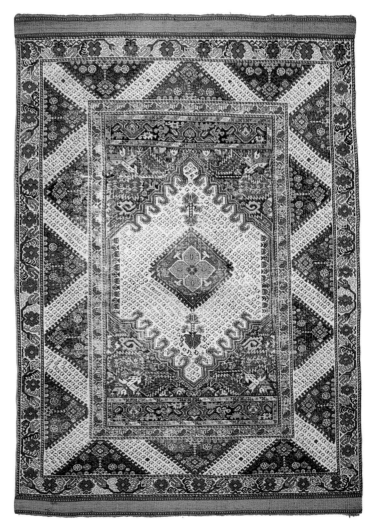

Ghiordes double-niche carpet
First half of 19th century
Cleveland, The Cleveland Museum of Art

This carpet is also recognizable as originating from Ghiordes because of the many borders (including one with the *çubukli* design) that dominate the central medallion—in reality a lozenge-shaped double niche enclosing a stylized floral decoration with serrated-petal carnations. Carnations also appear in the field, alternating with rosettes. Note the two rectangular panels placed above and below along the short sides of the carpet and embellished with the cloud-band motif.

Kiz-Ghiordes carpet
Early 19th century
Berlin, Museum für Islamisches Kunst

The word *kiz* in Turkish means "girl" and usually indicates nuptial carpets, part of a bride's trousseau; this makes the carpet a village production, intended for domestic use. Datable to the beginning of the 19th century and distinguished by a double-niche layout, these carpets vary in their decorations depending on their provenance. This carpet is distinguished by the white background of the central hexagon, decorated with the black *sinekli,* or "flies," motif, symbol of fertility. *Sinekli* also appear in the white zigzag stripes that decorate the high main border.

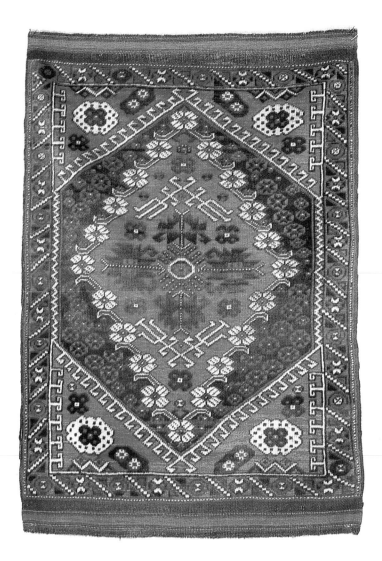

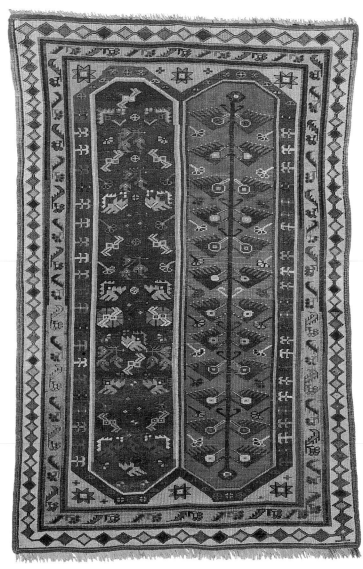

Kiz-Bergama carpet
Late 19th century
Rome, Giacomo Cohen and Children Collection

The double-niche layout and use of white make this a *kiz* nuptial carpet as well. The Kiz-Bergama are distinguished by the large white apple-tree blossoms in the corners and along the inner hexagon's perimeter, as well as by the white key-shaped designs that run along the cornerpieces. Both are symbols of fertility. Other distinguishing features are the restrictive color palette (only white, black and dark red), the stylized floral decoration in the center and the central decoration composed of octagons with eight-pointed stars.

Makrì carpet with side-by-side niches
19th century
Bergamo, La Torre Collection

The typical Makrì layout, influenced by ancient multiple-niche (known as *saph*) prayer rugs, sees the unique pairing of two or three long and narrow geometric niches of differing colors. Typical is the geometric tree of life in the left niche with comb-shaped leaves; polygons or flowers are sometimes used. The white border with multicolored diamonds is another Makrì feature. The colors found in these carpets are always vivid and powerful.

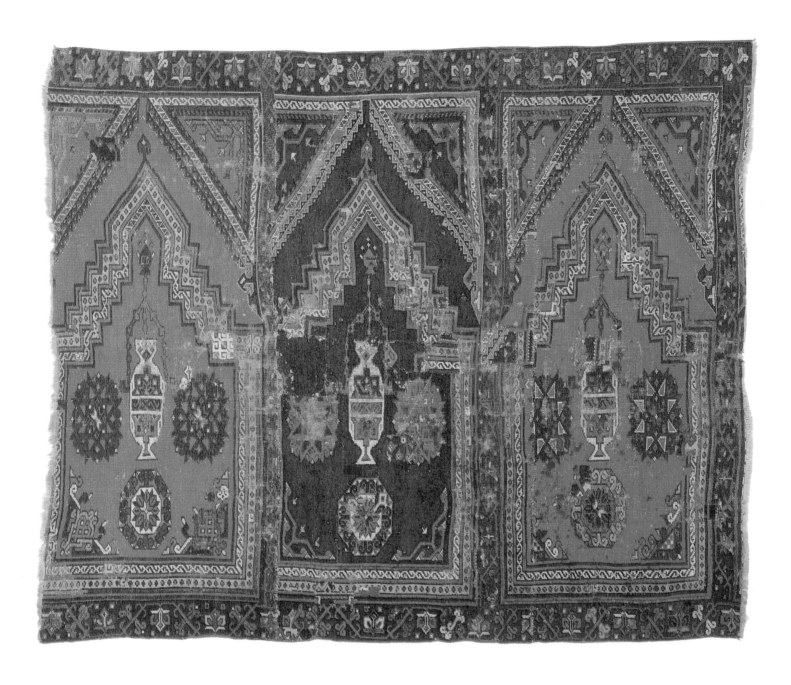

Fragment of multiple-niche, or *saph*, prayer rug
Northeastern Anatolia, first half of 15th century
Washington, The Textile Museum

In *saph* carpets, there is no longer a single niche but multiple niches of the same size and shape placed alongside one another, often varying rhythmically in the ground's color and decoration, as in this example. *Saph* (derived from the Turkish for "row" or "in rows") carpets, also known as family prayer rugs, became popular in the 17th and 18th centuries and were originally intended for collective prayers. Their popularity declined in the 19th century. Ghiordes and Ushak were major producers of this carpet.

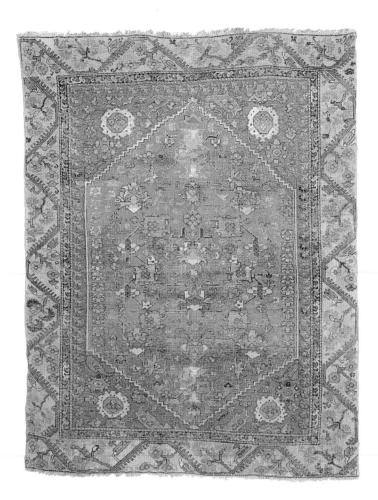

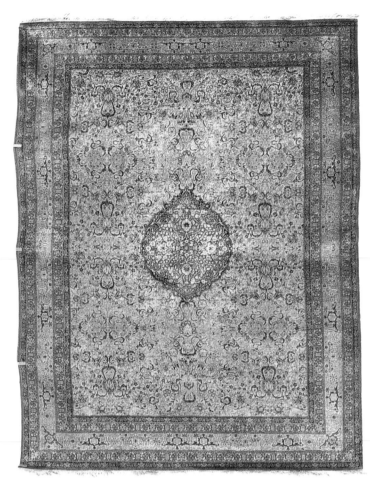

Demirdji double-niche carpet
18th century
Florence, private collection

Usually of squarish shape, carpets from this area are known for their border motif, a zigzagging red vine on a yellow or blue background from which grow groups of three stylized flowers alternating with groups of three carnations. The older models typically display a double-niche layout, as in this carpet, while later productions went to a hexagonal medallion and later to superimposed medallions. Also typical is the red central medallion on a blue background. The sacred lamps have been transformed here into vases set at the upper and lower points of the medallion.

Hereké medallion carpet
19th century
Private collection

This relatively recent production (mid-19th century) differs in technique and style from other Anatolian carpets. The use of silk and the asymmetrical knot set it apart technically, while the carefully chosen colors and the refined floral decorations, copied from French, Indian and especially Persian traditions, set it apart stylistically. From the cloud bands to the palmettes and the floral motifs done in a pure curvilinear style, this carpet is clearly emulating Persian models. Even the border, with its turtle motif, is typical of Persian Heriz carpets.

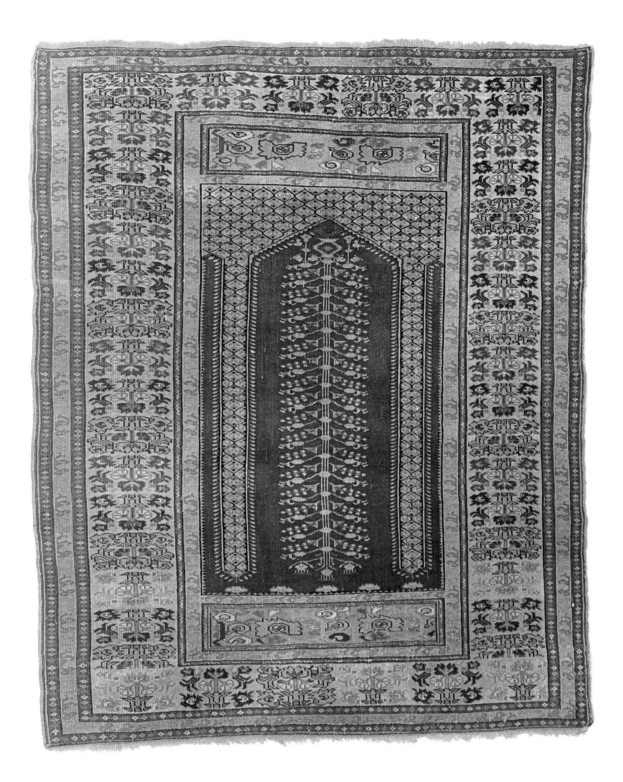

Kula prayer rug
Late 18th century
Milan, Pars Collection

The design of this carpet is typical of a Kula prayer rug: The architectural columns have become large ribbons decorated with stylized floral elements surrounding a slender blue (or red) niche. The mosque lamp, which can be identified by the chains from which it hangs, has been changed into an elaborately decorated tree of life. The yellow-ground external border has been decorated with the "alligator" motif, an arabesque of linked multicolored stylized palmettes.

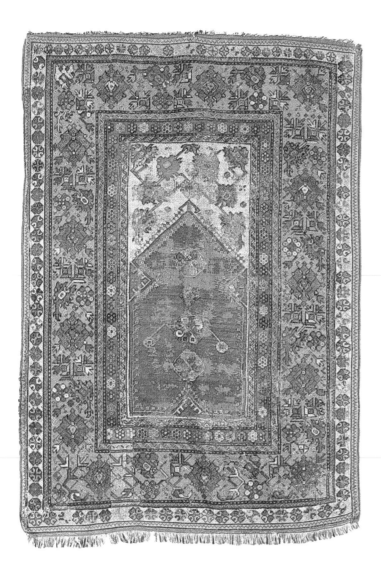

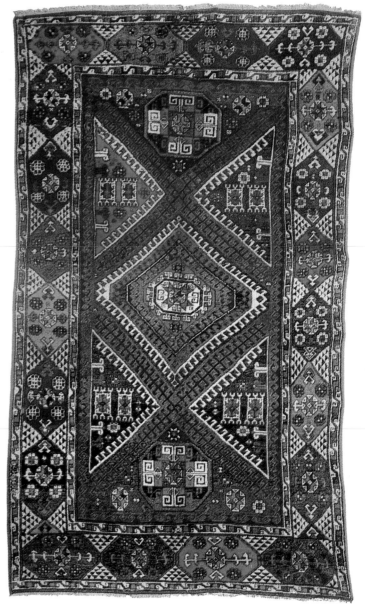

Melas prayer rug
Late 19th or early 20th century
Cleveland The Cleveland Museum of Art

Melas carpets can be recognized by their arrowheadlike niche. The niche is usually a rusty red (as in this example) and contains geometric versions of the mosque lamp and the tree of life. On top of the niche is an unusual area, with a light-colored background, decorated with a Chinese motif of stylized leaves and palmettes. The main border has a yellow ground filled with rosettes or large geometric flowers. The use of warm colors is characteristic, from brick-red to golden yellow.

Konya three-medallion carpet
19th century
Private collection

Konya carpets, originating from central Anatolia, remained faithful to their purely geometric design of Seljuk origin well into the 19th century. The decoration consists of geometric shapes and elementary polygons, some with a hooked outline, often superimposed, as in this example. The eight-pointed star is often used, in both the borders and the field. Colors are vivid and contrasting and include heavy use of white to brighten backgrounds and highlight outlines.

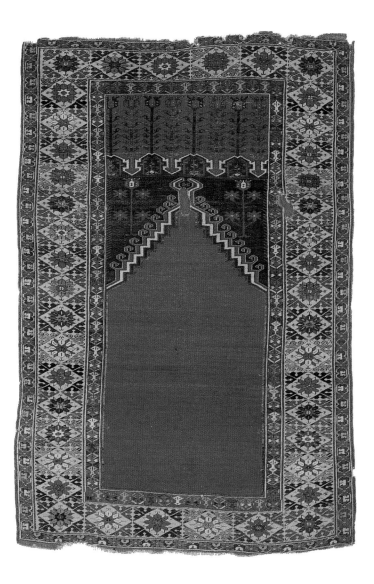

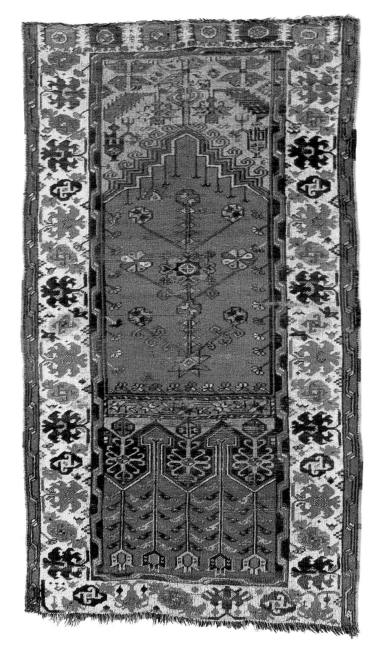

Ladik prayer rug
18th century
Istanbul, Türk ve Islam Eserleri Muzesi

Typical decorative elements of this production are the stylized tulips standing on straight stems alternating with cusps; they decorate the panel above the niche in alternating colors, as shown here. The niche, with a stepped arch bordered by hooks suspended above a uniform red field, is typical. Another popular version of the niche is made of three cusps. Also typical are the stylized floral elements flanking the niche and the main border with a yellow ground filled with a rosette motif (as it is here) or sometimes done in stylized flowers and bright colors.

Ladik prayer rug
Late 19th century
Cleveland, The Cleveland Museum of Art

This carpet is easily recognizable by the stylized tulips in the panel. The panel shown here is larger than in the previous carpet and is located beneath the niche. This is because it comes from a later production. The niche, however, retains its traditional design and encloses a stylized tree of life. The floral decorations flanking the arch are done in a particular motif, with two long, serrated leaves. The border displays an interesting stylized decoration of rosettes and palmettes.

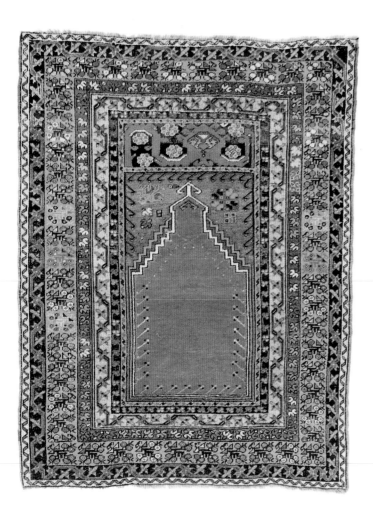

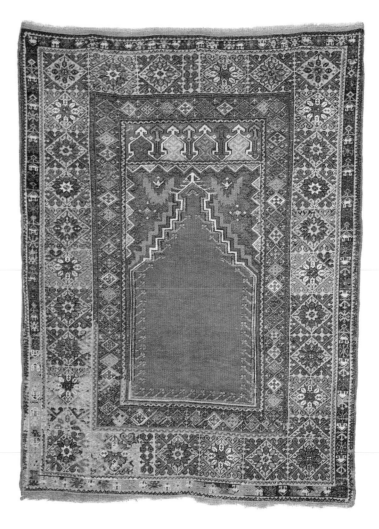

Kirshehir prayer rug
19th century
Bergamo, La Torre Collection

Carpets from this area share many common traits with the Mudjur, such as the solid-red niche with a stepped arch, outlined in white and other colors, topped by an arrowhead and surrounded along its inside perimeter by tiny flowers. Distinguishing features of the Kirshehir carpets include bouquets of stylized carnations in alternating colors filling the characteristic yellow ground of the main border. Also common is the upper panel decorated with arrowhead rosettes (as seen in the diagram), cloud bands or carnations.

Mudjur prayer rug
Mid-19th century
Milan, Galleria Hermitage Collection

Although similar to the Kirshehir production in the stepped-arch mihrab ending in an arrowhead with a similar motif above, Mudjur prayer rugs are marked by stronger colors, with the solid ground of the mihrab contrasting with the lively borders. The main border, in yellow, contains a typical rectangular motif consisting of a lozenge and a geometric rosette done in strong colors that produce a mosaic effect. Also common are the inside border decorated with diamonds and the upper panel with the typical arrowhead motif.

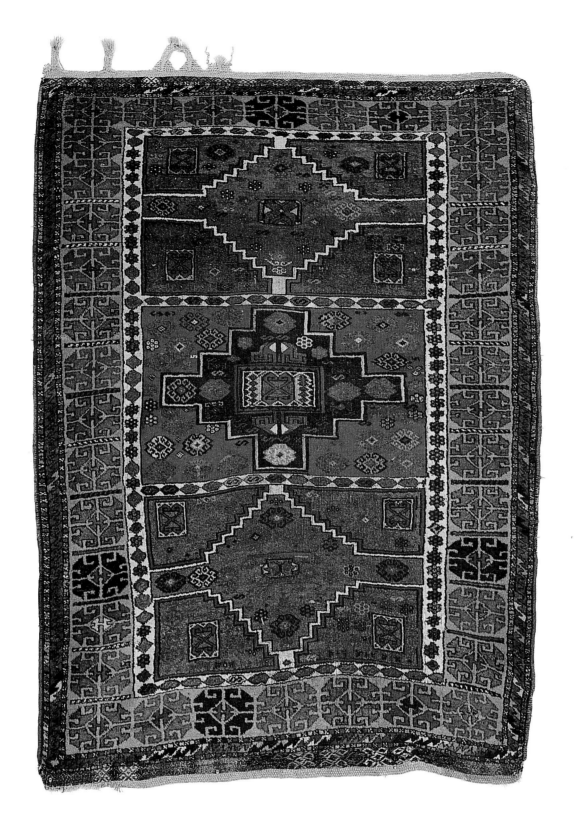

Medallion carpet
Eastern Anatolia (Yörük?), 19th century
Venice, Rascid Rahaim Collection

The simple and spontaneous nature of this carpet reveals its nomad origins typical of eastern Anatolia, where there is a complex stylistic history due to the many nomadic and seminomadic populations that live there. It is only by convention that the more naïve carpets with a coarser workmanship are attributed to the Yörük tribe. In any case, the area's production favors layouts with three to five central polygonal medallions, superimposed either singly (as in this example) or in pairs, and muted, even subdued, colors, which is unusual for Anatolia.

PERSIA

Like Anatolia, Persia (present-day Iran) was a cultural melting pot for various civilizations from the Mediterranean, the Middle East, central Asia and even eastern Asia, except that in Persia, carpet making was more a refined art and a social tradition than an expression of religious belief.

Although no specimens from before the 16th century have survived, we do know from literary sources that in very early times, several local tribes and those of Seljuk origin were already making carpets in different regions of Persia. First the Ilkhanid dynasty (1256–1353) of Mongol origin and later the Timurid dynasty (c. 1360–1405) from Central Asia brought a high refinement to the arts of miniatures and bookbinding and introduced Chinese symbols as stylistic elements. Thus they influenced local carpet making, as documented by precious miniatures from the 14th and 15th centuries that depict geometric carpets very similar to the Anatolian carpets of the Seljuk period. Such specimens have borders decorated with Kufic script and fields decorated with stars, octagons or interlacery stretching across the whole field; sometimes, the fields are sectioned into squares or octagons, such as in the small-pattern Holbeins. The first signs of a new style were already making their appearance at the end of the 15th century, but it was following the rise of the Safavid dynasty (1502–1722) that the Persian carpet truly achieved its independence.

Full-field cartouche carpet
Northwestern Persia (Tabriz?), mid-16th century
Vienna, Österreichisches Museum für angewandte Kunst

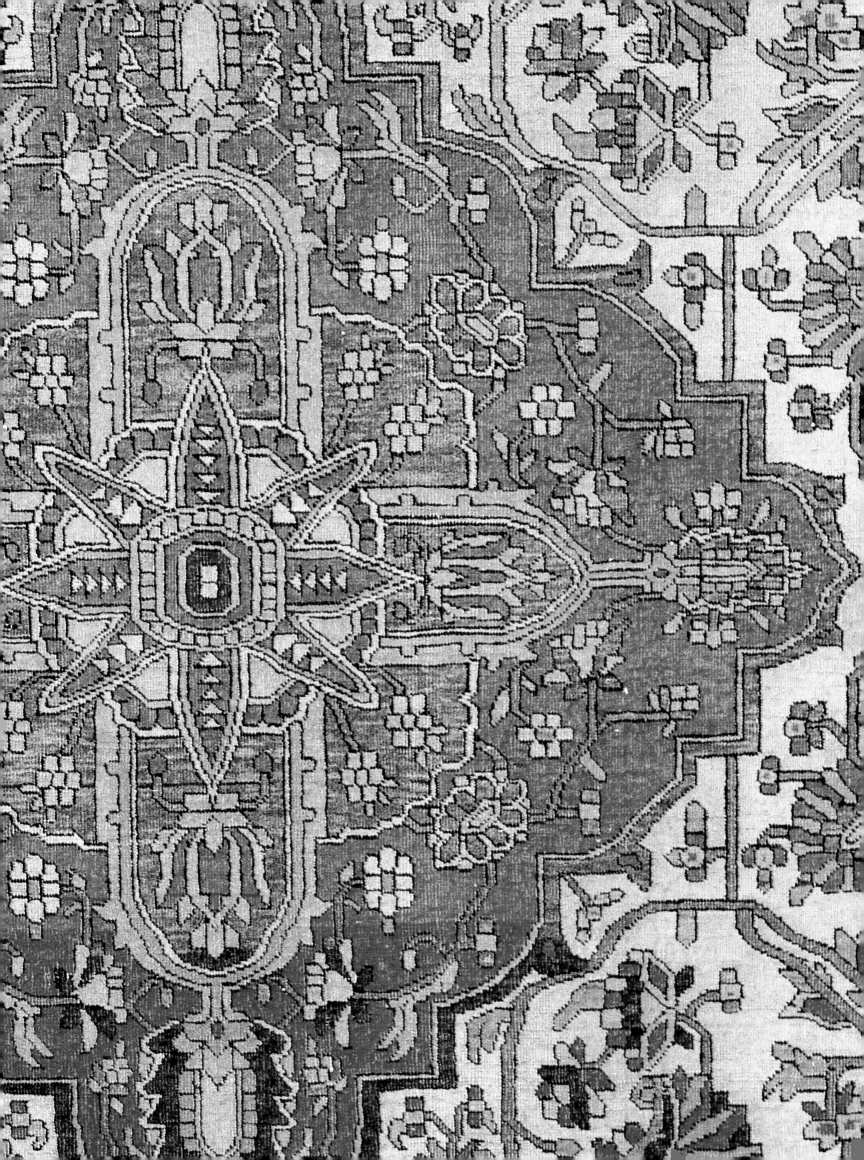

The Safavid dynasty and the curvilinear style

Under the splendid, long-ruling Safavid dynasty, the carpet became one of the most important expressions of art and society, achieving maximum development during the reign of Shah Abbas I the Great (1587–1629). The art of carpet making—which became the particular focus of attention—now took its inspiration not from the old ornamental motifs but from the subtle arabesques and floral motifs that decorated the borders of miniatures and embossed-leather book covers. It was thus forced to completely modernize its traditional rigid geometric structure to adapt to the new curvilinear fashion.

Thus the new decorative style was defined by webs of slender stems and flowering branches, whose endless, symmetrical interlacery stretched over the entire field, which gradually filled up with all kinds of flowers and with palmettes, animals and small human figures. The new calligraphic sensitivity gave birth to a decorative style based on a dense network of lines and patterns rather than the juxtaposition of colored surfaces. In addition, borders became more important, filled with a wide variety of decorative patterns that were always chosen to highlight and frame the highly complex arabesques of the field. This curvilinear, or floral, style also allowed for

Major Areas and Types

TABRIZ, HERAT, KASHAN, KERMAN, ISFAHAN
Medallion carpets (early 16th century). Large sizes; dense arabesque decorations with a central medallion in various shapes (star, polylobate, roundish, etc.); border with cartouches or floral elements.

Animal carpets (early 16th century). Arabesque decorations, without medallion; floral elements and real and mythical animal figures stand out in the ground.

Hunting carpets (early 16th century). Arabesque decoration, hunting scenes with hunters, horses and prey.

Garden carpets (early 17th century). The field is divided geometrically into four or more regular segments representing a garden filled with plants, streams, ponds, fountains, flowers, fish and birds.

Tree and shrub carpets (16th century). Relief version of the previous type. Sometimes the trees are distributed around central medallions.

KERMAN, JOSHAGHAN
Vase carpets (17th century). Decoration composed of flowering vines that climb from small vases and create a sort of regular grid over the entire field.

HERAT, ISFAHAN
Floral carpets (beginning from the late 16th century). Arabesqued field decorated with palmettes, rosettes and *herati*.

KASHAN, ISFAHAN
"Polish," or Shah Abbas, carpets (late 16th to 17th centuries). Full-field floral decoration (or with central medallion) without any sense of calligraphy; made with silk and gold and silver metallic threads.

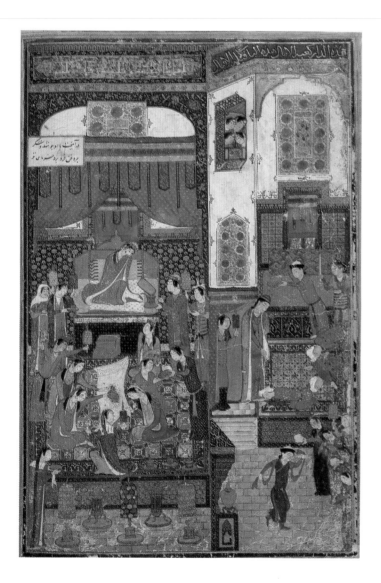

more lifelike designs that could satisfy the Persian predilection for figures from the natural world, to which the influence of China contributed.

A major technical revolution

This new decorative style brought about a major technical revolution based upon three important changes. First was the use of silk for both the foundation and the pile of the more precious carpets, which allowed for finer knotting and thus a far more detailed and minute type of decoration. Second was the establishment of court ateliers in major cities, such as Tabriz, Isfahan, Kashan, Kerman and Herat (as the Ottomans in Anatolia and the Mamelukes in Egypt had done), where highly skilled weavers labored to create large knotted carpets for the Safavid aristocracy. Third was the division of labor in the carpet-making process into the creative phase and the weaving phase. Court miniaturists were commissioned to create designs that, once transferred onto cartoons, were then used as models by the workers of the imperial ateliers.

This splitting of the role into creative artist and actual weaver had never before been applied to carpet making,

Left, Humay story miniature. Persia, 14th century. London, British Museum. The carpets seen in this miniature have dense, full-field geometric decorations, in accordance with the style of the pre-Safavid era, much like the Anatolian Seljuk carpets. They were decorated with stars, octagons and interlacery or sectioned into squares and octagons.

Facing page, bottom left, miniature of Isfandiar asking Gushtasp to help him reclaim the throne, taken from *Book of Kings* by Firdusi. Persia, between 1323 and 1335. Settignano, Villa I Tatti, Berenson Collection. Note, at the foot of the throne, the carpet with a high border decorated with a red and gold Kufic motif.

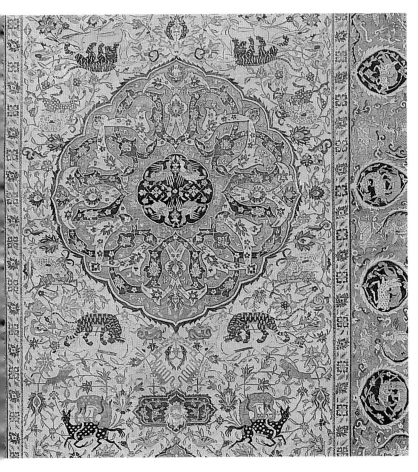

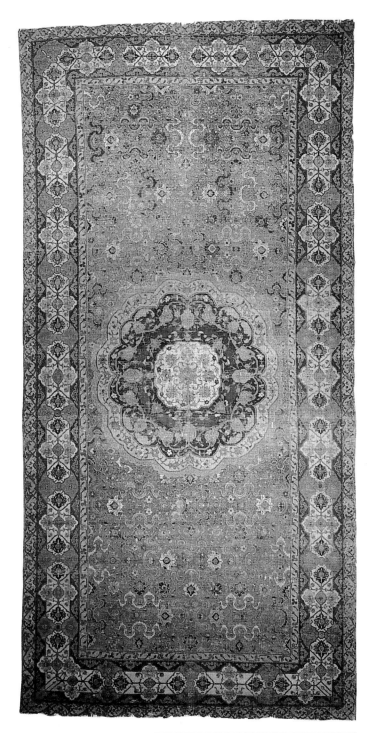

Above, detail of "Sanguzsko" medallion carpet. Southern Persia (Kerman?), late 16th century. Lugano, Thyssen-Bornemisza Foundation. Noteworthy are the animals, both large and small, found in the field as well as the border, often depicted fighting amongst themselves. This carpet belongs to a group of 15 carpets—one of which belonged to Prince Sanguzsko (hence the name)—that share a figural medallion and light colors. The border motif, with its lobate animal medallions, hints at Kerman origin.

Right, medallion carpet. Northwestern Persia (Tabriz?), early 16th century. Florence, Museo Bardini. The field, decorated with palmettes and cloud bands, and the main border, decorated with alternating cartouches and small medallions, are both noteworthy. The cloud bands are of Chinese origin, as is the wavy border of the medallion and the use of turquoise; both were inspired by mirrors of the T'angh era. Bottom right, top to bottom, diagrams of three typical Persian borders: cartouche, *herati* and palmette.

Living Creatures and the Human Figure

In orthodox Anatolia ruled by the Sunni Ottomans, the ban dictated by Muhammad's followers on depicting any type of living creature (except in miniatures) was obeyed literally. The situation was different in Persia under the rule of the Timurid and Safavid dynasties, who were Shiites. There, animals and human figures had already begun to appear in court carpets in the 16th century, borrowing beloved themes from local miniaturist art, which, since the Ilkhanid rule in the 13th century, had evolved into a highly developed and fashionable art. War or love scenes taken from popular Persian epic poems, such as *Shah Nameh* (*Book of Kings*) by the poet Firdusi, or hunting scenes teeming with hunters, horses, prey and mythical animals were drawn on the cartoon models of the large court carpets by the same miniaturist masters who illustrated the books.

Layouts were based on a central polylobate medallion or followed directional diagrams. In any case, the small figures were never in the foreground but,

rather, were lost in the arabesqued ground together with other decorative elements, such as naturalistic flowers, palmettes and cloud bands. Only toward the end of the 19th century, due to Western demand, did the human figure become the carpet's protagonist. It was then placed inside true pictorial scenes that took their inspiration not only from miniatures but also from books, photographs, portraits, even everyday life. Hence, appearing on the carpets from the Kerman and Kashan production of the turn of the century are mythical and heroic scenes, strange hunting scenes or sketches from quotidian life, sometimes even bust portraits of public personalities or wealthy clients, accompanied in the borders by inscriptions or poetic verses.

Miniature from a manuscript of anthology excerpts for Prince Baysunghur. Eastern Persia (Khorasan? Herat?), dated 1427. In this garden love scene, Prince Baysunghur of the Timurid dynasty himself appears.

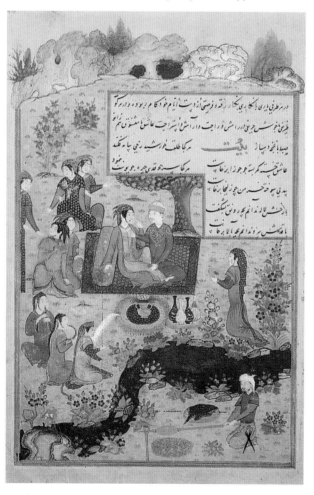

which until then had always used patterns that were passed on through oral history from generation to generation or created spontaneously on the loom. This became the greatest difference between town and court carpets and those produced in villages or by nomadic tribes.

Always in search of new decorative effects and protected by Safavid patronage, the great Persian artists created elaborate designs using an extensive range of colors, often utilizing their carpets as pages on which to write poetry or religious verses. Sometimes, these masters even signed and dated their works, thus further establishing them as true works of art.

The carpet acquires new meaning

This important process, which took place in Persia during the 16th century, radically changed the very meaning of the carpet. It went from being an item traditionally linked to daily life and worship to being a social emblem for an opulent class, an object of luxury, often incorporating gold and silver thread and created to embellish the palaces and open-air pavilions of the Persian court or to be presented as magnificent gifts with which to astonish the rulers of the great European nations. The close link between the nobility of the time and the art of the carpet is also confirmed by history. When, around the mid-17th

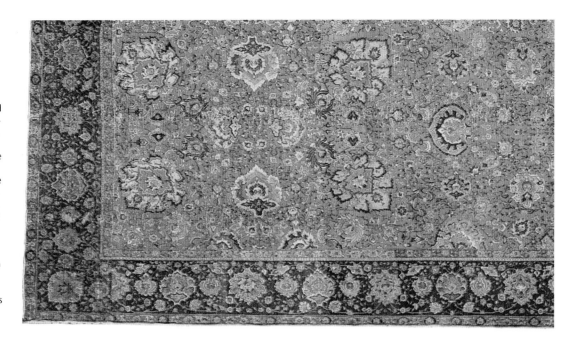

Facing page, medallion carpet. Northwestern Persia (Tabriz?), late 16th to early 17th century. Vienna, Österreichisches Museum für angewandte Kunst. In the Safavid style, the carpet could become a page on which religious texts could be written, as in this rare example. The field here is divided into various compartments, each containing inscriptions. Right, detail of floral decoration carpet. Northeastern Persia (Herat?), late 16th to early 17th century. Milan, Museo Poldi Pezzoli. The Safavid style saw the emergence of the interweaving of flowering stems and branches, which would become the foundation of the Persian decorative style, eventually filling entire fields and borders. Bottom, medallion carpet. Northwestern Persia (Tabriz?), 16th to 17th century. Berlin, Museum für Islamisches Kunst. The curvilinear style permitted the inclusion of floral elements and animals, as here, where we see deer, gazelles and peacocks.

century, Safavid patronage began to dwindle, carpet making also began to show its first signs of decline and went into a crisis after 1722, at the time of the Afghan invasion and the waning of the dynasty for which it had been the most impressive symbol.

Earliest carpet types

Any treatment of the earliest Persian carpets must speak in terms of rarity, in part because of the intentionally precious nature of those specimens. In fact, it is no coincidence that all the surviving examples from the Safavid era are now preserved in great collections. These carpets cannot be classified according to production center, because not only were identical models often circulated among several workshops, but there were also similarities in weaving techniques and similarities in features, such as their large size or the use of silk and precious-metal threads.

The leading ateliers of the Safavid period were at Tabriz, Kashan, Kerman, Herat and Isfahan, but the differences among the carpets from these places are superficial. For example, the carpets from Tabriz are known for their severe color palette and somewhat stiff design. Those from Kashan are marked by a more fanciful, open style and are usually made of silk, with elegant, sumptuous results.

It is difficult to differentiate Herat's carpets from those of Isfahan, because both used the same floral motifs, although the former may have a livelier composition and the latter a certain almost baroque fullness. Classification must, therefore, be based on the different types of decoration, subdividing the existing carpets into medallion, floral, animal and hunting, tree and shrub, garden, vase, Portuguese and Polish carpets. While these types were later imitated in other places and ages, they never again achieved the technical mastery and inventive richness of that distant golden age.

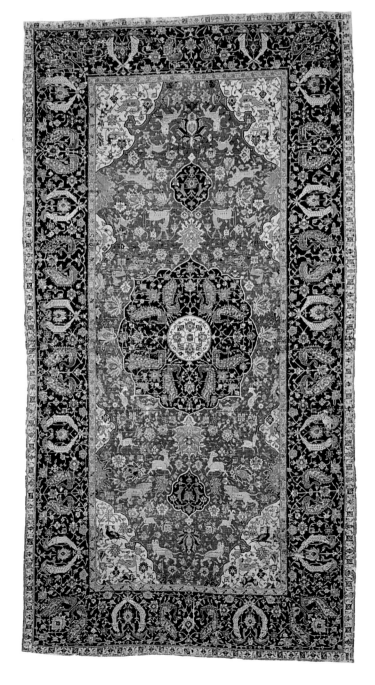

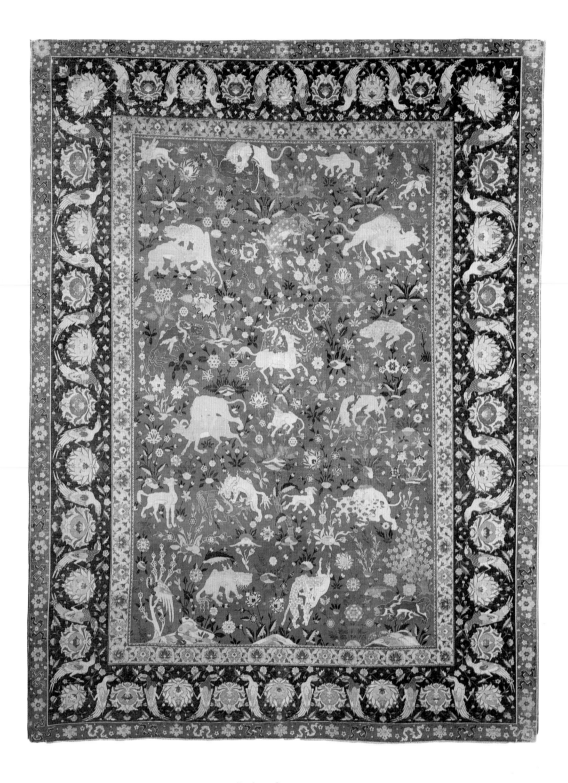

Animal carpet
Central Persia (Kashan?), second half of 16th century
New York, The Metropolitan Museum of Art

On its bright red background, this silken example displays naturalistic animals—both real and imaginary—engaged in combat, as well as smaller bushes and flowering branches. Note the main border in which palmettes are placed alongside pairs of birds pecking at flowering branches. In the outer minor border, small flowers alternate with cloud bands. This medallionless nondirectional layout, which often also lacked a symmetrical axis, was used especially in Tabriz, Herat, Kashan and Isfahan.

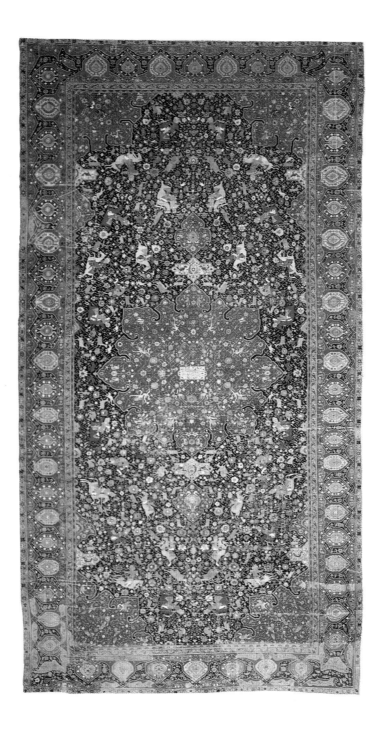

Medallion carpet with hunting scenes
Northwestern Persia (Tabriz?), 1522–23 or 1542–43
Milan, Museo Poldi Pezzoli

Hunting-scene carpets are interesting examples of medallion layouts in which the field is filled not only with arabesques and other floral elements but mostly with scenes of armed horsemen chasing and fighting wild beasts with spears and bows. They were inspired by miniatures, contemporary literature and the luxurious life at court, with symbolic references to Eden. In this large-scale example (365 x 570 cm, or 144 x 224"), a cartouche in the center of the medallion displays the artist's name and the Arabic date, interpreted as either 1522–23 or 1542–43.

The two medallion pendants, arranged vertically, are transformed into two mosque lamps, rendered somewhat realistically; these two elements and the absence of human or animal figures suggest that this carpet might have been made for use in a mosque.

This cartouche contains poetic verses and the date 946—which corresponds to A.D. 1539–1540—and a name, Maqsud of Kashan, probably the carpet's designer. In any case, the city of provenance is not certain, but may have been either Kashan or Tabriz.

The central medallion is a magnif cent large rose window divided into 16 sections and surrounded k 16 almond-shaped pendants. The light ground color of the medallic contrasts sharply with the dark field densely filled with flowers and palmettes.

The main border is decorated with a cartouche motif alternating with small round medallions. It is a typical decoration of this type, borrowed from decorations in illuminated books.

The four cornerpieces are decorated with fractions of medallions identical to the central one. This creates the illusion of endless repetition and gives a sense of indeterminacy.

The minor border has a delicate cloud-band motif on a light background. This motif from China is often found also in the field of this type of carpet.

"Ardabil" medallion carpet
Kashan? Tabriz?, dated 1539–1540
London, Victoria and Albert Museum

Although the medallion layout was also used in Anatolia, it is the most popular and significant of Persian styles, favored in all periods, starting with the Safavid reign, and in all productions. In fact, the curvilinear style found its best expression in these carpets, from the various contours of the central medallion to the field densely packed with arabesques, lifelike floral elements, small human and animal figures, palmettes and other ornamental motifs.

Medallion carpets of the Safavid age

These large elongated carpets, with an average length of 400–500 cm (156–195")—the largest being the Ardabil carpet, which measures 534 x 1152 cm (210 x 446")—are distinguished by dense fields of arabesques and flowers, often including animal and human figures and even celestial creatures. The field is dominated by a central medallion, which may be of various shapes—a star, a circle, ogival or multifoiled—but which always stands out in the field because of its size and its color, which con-

trasts with the background. Usually, the medallion is completed by two pendants placed along the length of the carpet to give it a symmetrical axis and is complemented by the fractions of four other medallions of similar or different shape arranged in the corners to impart a certain indefinite quality to the whole.

Sometimes, instead of an arabesqued, flowering background, the medallion is set in a field of cartouches that are decorated in different colors and are of more or less elongated, multifoil shape, similar to shields, of the same

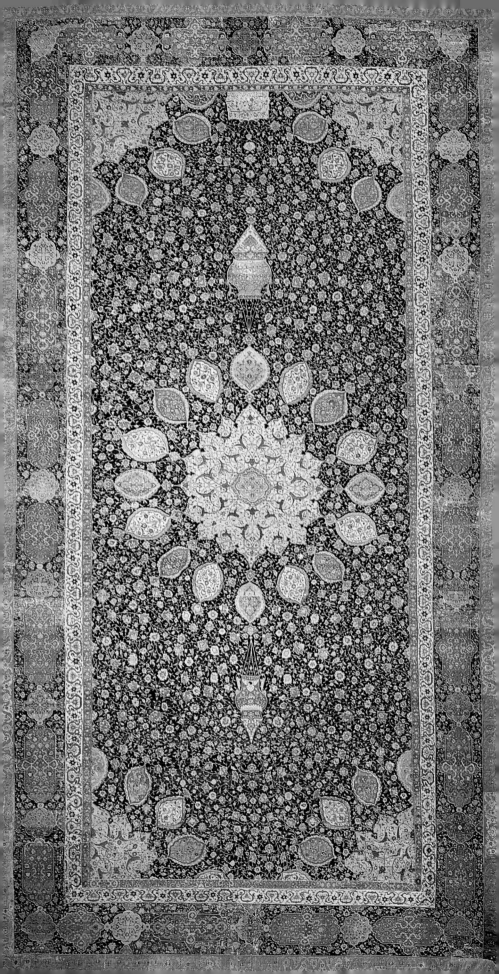

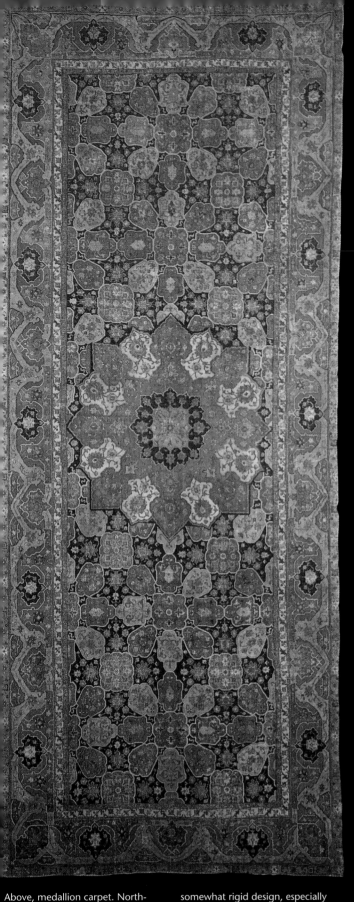

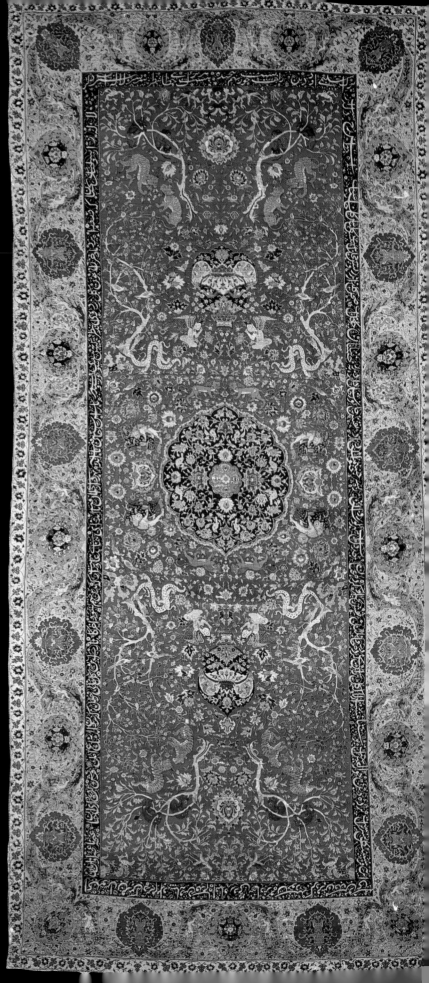

Above, medallion carpet. North-
western Persia (Tabriz?), mid-16th
century. Vienna, Österreichisches
Museum für angewandte Kunst. In
this example, the star medallion is
arranged not on an arabesqued field
but on a ground filled with multicol-
ored, shield-sha...

somewhat rigid design, especially
evident in the arabesque of the
main border, indicates that the influ-
ence of the previous geometric style
was still strong.

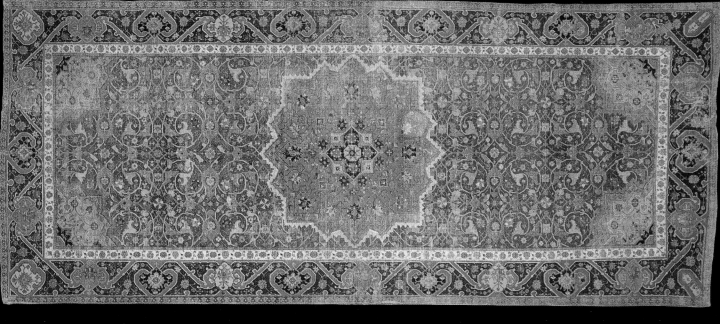

Facing page, right, medallion carpet. Tabriz? Kashan?, mid-16th century. Milan, Museo Poldi Pezzoli. In both the medallion and its pendants, we can distinguish plant elements, animals and *houri*, the winged heavenly creatures. The innermost border, with the dark ground, contains an inscription praising the carpet and the shah, possibly Tahmasp I (1524–1576). The refined workmanship is confirmed by the silk and silver threads used. The originality of the composition favors attributing the provenance to Kashan rather than to Tabriz.

Above, medallion carpet. Northwestern Persia (Tabriz?), early 16th century. Lisbon, Fundação Calouste Gulbenkian. The straight-line profile of the central medallion and the rigid arabesque in the field, which also contains the *islimi* motif with the typical spiral ending in a forked leaf, indicate a transition phase from the previous geometric style to a truly curvilinear one, typical of the major Safavid production.

size or of varying sizes, which produce a special mosaic effect.

The principal borders, fairly broad in size, typically feature floral elements or cartouches that often contain poetic or religious verses on a background which is arabesqued like the carpet's field. The color of the border's background generally contrasts with the color of the field to better highlight the overall composition.

Also developed independently in Anatolia during the same period, this type of decoration was influenced in Persia by the decorative trims around miniatures and especially by the patterns on the embossed, gilt-leather covers of books, which featured a round or oval central element with four similar medallions or fractions placed at the corners of the book cover, all richly decorated with slender arabesques and floral elements in pure calligraphic style.

Compared with the Anatolian style, Persian carpets stood out for their stronger sense of balance and of centrality and completeness, as well as a more marked and refined sense of line. The main centers of production of this style, first introduced in the early 16th century, a period that coincided with the rise of the Safavid dynasty, were Tabriz, Kashan, Kerman and Herat. However, due

to its success and popularity and to the high mobility of the master designers, it is impossible today to determine with certainty the provenance of these carpets.

We can, however, try to identify a path of historical style, although each of the grandiose surviving specimens of the Safavid age is unique as to history and characteristics.

The style of the first specimens from the early 16th century is recognizable, because the design is somewhat schematic. This quality was inherited from the earlier geometric taste, as we can see from the carpets depicted in miniatures, which still favored polygonal medallions with sharp profiles and geometric-looking arabesques that were not totally curvilinear. Also, the field grounds were not yet densely strewn with arabesques of stems and flowers and appeared quite sparse and rarefied; finally, the main borders were decorated with large-scale motifs that transformed the arabesque into a broad, continuous and winding band.

The end result was elaborate and refined, yet not without a certain overall rigidity incurred by the moment of transition from a marked geometric style, of which we no longer have surviving examples, to a totally different curvilinear style that began to dominate after the mid-16th century.

In fact, beginning in the second half of the 16th century, all geometric rigidity began to disappear, the multifoil medallions became more complex, and the field's backgrounds became dense networks of extremely slender arabesques, minute flowers and small animal, human and heavenly figures drawn in a naturalistic manner. All of this translated onto the carpet the new floral taste and the new calligraphic sensitivity, which had by then reached maturity.

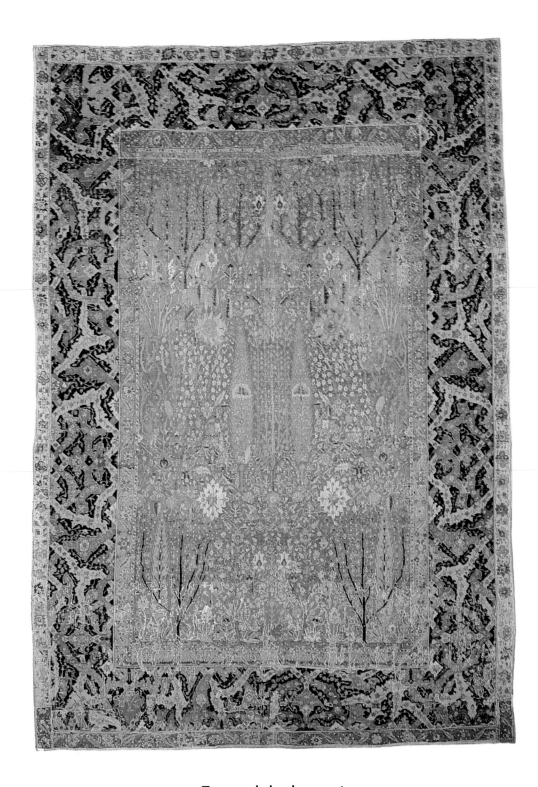

Tree-and-shrub carpet
Northeastern Persia (Herat?), early 16th century
Philadelphia, Philadelphia Museum of Art

Taking its inspiration from the parks surrounding the palaces of the shahs and thereby symbolizing paradise, this carpet type portrays lifelike trees, preferably cypresses, alternating with flowering bushes. In general, the layouts are oriented, as in this case, or centered around a central medallion; in the 17th century, a layout of horizontal, symmetrical rows was preferred. Noteworthy is the principal border, which is decorated with an interlacery of three distinct arabesques, each of separate color and highlighted by the dark ground.

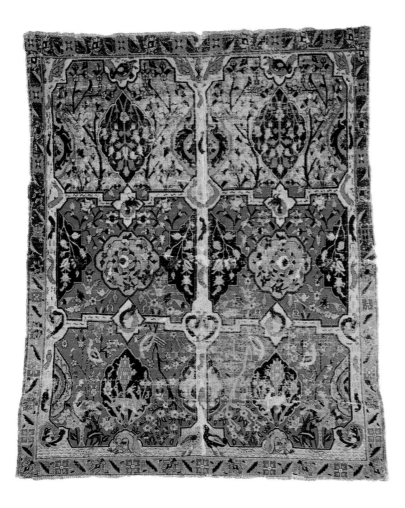

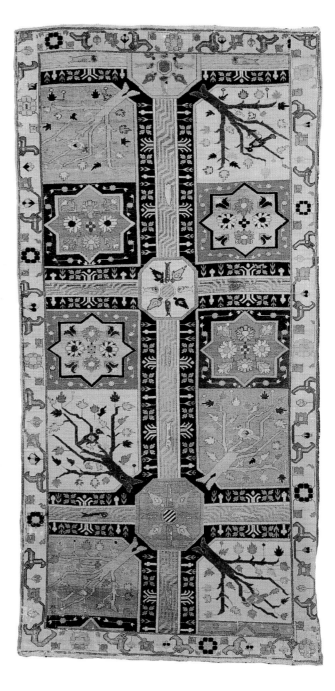

Carpet with garden design
Southern Persia (Kerman?), late 17th to early 18th century
Vienna, Österreichisches Museum für angewandte Kunst

Sharing inspiration and symbolic intent with the previous example, this type of carpet features a maplike rendering of streams and water canals that neatly subdivide the field into four, six or more sections; in turn, each section is filled with plants, flowers, pools and fountains and repeats the pattern of square or rectangular flowerbeds and tree-lined avenues and canals of real Persian gardens. Sometimes, as in this case, animals are depicted: In fact, the streams and the pools host fish and aquatic birds, while fawns and birds romp in the flowerbeds, rendered as medallions.

Carpet with garden design
Southern Persia (Kerman?), late 17th to 18th century
Paris, Musée des Arts Décoratifs

The above specimen is a more schematic and geometric version of the previous carpet. Small fish are swimming in the wavy streams, while straight avenues alongside the banks accommodate flowers, plants and tall trees, with birds sitting on their branches. The rectangular sections formed by the crossing streams contain pools and star-shaped garden beds teeming with flowers. Kerman has been identified as the provenance of this rather rare type, while Kurdistan has been identified as the origin of an even more geometric version, dating to the 17th and 18th centuries.

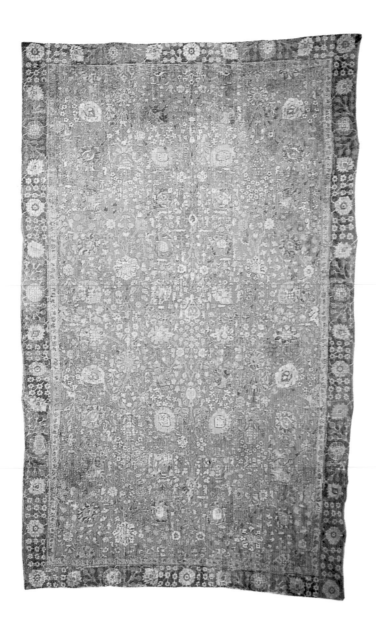

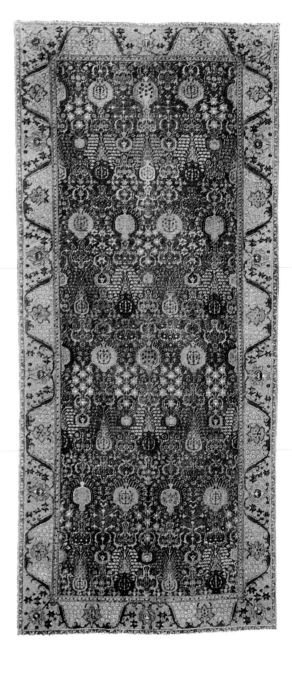

Carpet with vase design
Central Persia (Joshaghan?), 17th century
Private collection

This particular type, attributed to Joshaghan and Kerman, is distinguished by a curvilinear and more or less regular flower grid formed by the intersection of two long pairs of stems, often rising from vases. The grid, spread over the whole field, organizes the rich distribution of flowers, palmettes and other floral elements, more or less realistically depicted. There are variations of this basic pattern, such as this example in which the very small vases placed along the middle vertical axis organize the composition, with the grid in the background somewhat hidden by the exuberant blossoming.

Carpet with vase design
Central Persia (Joshaghan?), 17th century
Vienna, Österreichisches Museum für angewandte Kunst

Here, the vases that give their name to this type are more in evidence, but from them rise flower bouquets instead of stems, so instead of a grid, we have a set of small, repeating modules wedged one into the other. Only a few colors are used, neither strong nor contrasting; the only bright touches are the yellow vases and the white flower corollas, which stand out against the dark ground. The main border, with a yellow ground, features palmettes linked by tendrils and small, unusually shaped white flowers. Carpets with a vase design must not be confused with carpets executed with the vase technique, which are recognizable by their special workmanship, not the design.

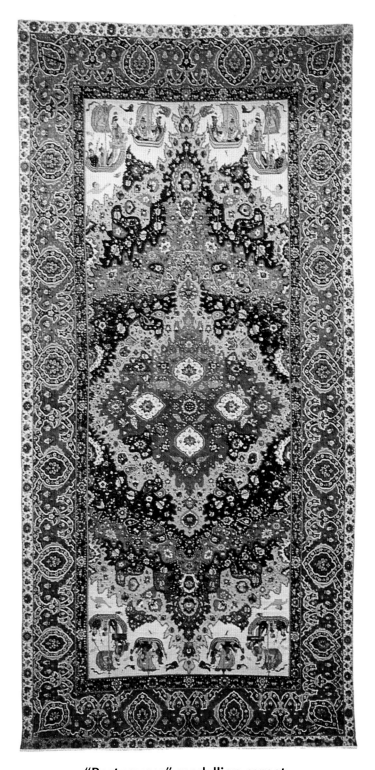

"Portuguese" medallion carpet
Southern Persia, 17th century
Vienna, Österreichisches Museum für angewandte Kunst

The name given to this type is conventional, for while they are indeed medallion carpets, they feature unique spandrels filled with sea scenes, waves, fish and swimmers, including large sailing ships and sailors in European outfits. Because of their unusual scenes, these carpets were thought to come from the Indian city of Goa, an ancient Portuguese colony, hence the appellation. However, it is more likely that these carpets—while commissioned from Goa—were produced in southern Persian workshops that had contacts with Goa's European settlers. This entire production dates from the 17th century.

In this specimen, the cloud band is especially wavy and elaborate, with several knots; it is a recurring secondary motif in this carpet type.

The wide, dark border stands out against the strong red of the ground; it is also embellished by palmettes of various designs and orientations, linked one to the other by a flowering shoot. Note, in the field, the unusual pairs of small facing birds, here arranged at the base of each palmette.

The palmette is the protagonist of this carpet type. Here, it is rendered in several colors and forms—with open or closed fronds and in the in-and-out design so that the palmettes are oriented toward the carpet's center and also away from it.

Lost amid the intricate flowering shoots are small, lifelike, brightly plumed birds, unusual for this type of carpet, which is dominated by plant elements.

Carpet with floral decoration
Northeastern Persia (Herat?), 16th century
Lugano, Thyssen-Bornemisza Foundation

The floral type, produced from the end of the 16th century to the late 18th century, was one of the more successful creations of the Safavid production and was imitated in the Orient (especially in India), as well as in the West (especially in Great Britain). Rediscovered in the 19th century, it is still one of the most imitated ancient types.

Floral carpets of the Safavid age

The many examples of this style, among the best known and appreciated of Persian carpets, feature full-field decorations in which palmettes (often arranged in the in-and-out design), lance-shaped leaves and often cloud bands dominate because of their size and colors, which contrast with the deep red background filled with tiny floral elements linked together by slender arabesques and plant tendrils. Sometimes, birds and other small animals also appear in the background.

Because these are full-field decorations based on layouts without orientation, this composition, unlike other types of the same period—the medallion type, especially—is not necessarily symmetrical with the carpet's axis and sometimes extends only along the length of the carpet.

The borders are usually very dark in color and of indeterminate hue, somewhere between blue, green and black, and are generally decorated with border *herati*—large flowers or palmettes, often flanked on each side by large, lance-shaped leaves.

The palmette is the prima donna of this style of decoration and among the favorite subjects of the artists

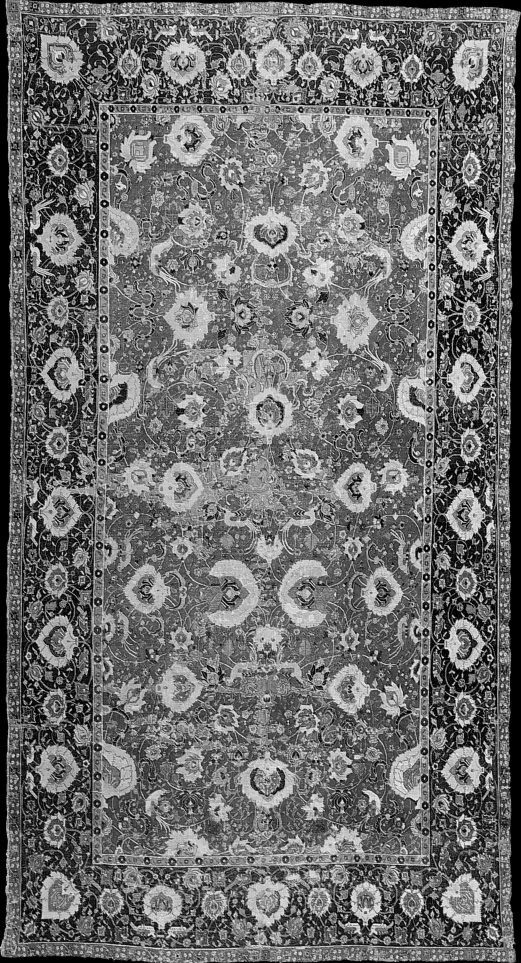

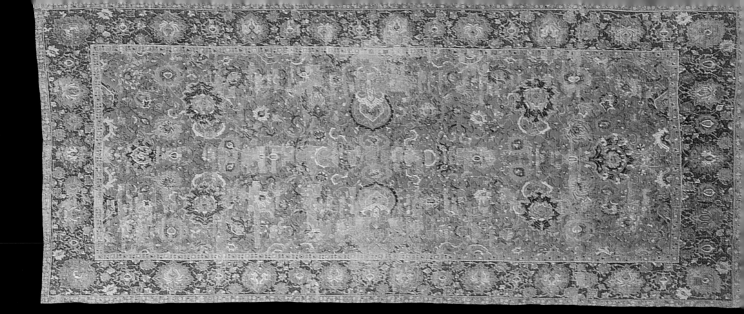

Left, detail of carpet with floral decoration. Northeastern Persia (Herat?), late 17th century. Milan, Museo Poldi Pezzoli. This example is decorated with palmettes and cloud bands; although filled with a continuous floral arabesque, the field is less crowded than the borders. Below: Next to the borders, fractions of palmettes suggest endless repetition.

Above, carpet with floral decoration. Northeastern Persia (Herat?), late 16th to early 17th century. Florence Museo Bardini. The field contains the usual palmettes rendered somewhat large and in various forms and colors. Each element is connected by the continuous arabesque. Note the white cloud band in the field.

working at the court of Shah Abbas I the Great between the end of the 16th century and the beginning of the 17th. They interpreted the palmette in both closed and open forms and dedicated it to the ruler as a classic motif, reworked and made fashionable.

Floral carpets, which were born at the end of the 16th century, enjoyed great success and became so widespread that their provenance cannot be established with certainty. Thus, at one time, floral carpets were all attributed to Isfahan, while the tendency today is to attribute them to Herat. In both cases, however, these are named

Below, carpet with floral decoration. Northeastern Persia (Herat?), end of 16th century. Vienna, Österreichisches Museum für angewandte Kunst. Both the foundation and the pile of this large carpet (350 x 742 cm, or 138 x 292") are made of silk yarn, with extremely refined knotting. The field is decorated with palmettes of various shapes and sizes, buds, leaves and cloud bands, all linked by an arabesque rendered as a plant shoot. In the floral decoration are scattered realistic animals, including mythical dragons and *jiling* (half-dragon and half-deer), gazelles, deer, leopards and birds, some engaged in battle, some isolated. The main border has an ele-

gant interplay of elaborate cloud bands on a floral ground. The minor border, bearing inscriptions, has flowers alternating with cartouches on a yellow ground.

Right, detail of carpet with floral decoration. Northeastern Persia (Herat?), 17th century. Lisbon, Fundação Calouste Gulbenkian. In addition to palmettes and other floral elements, this carpet displays the original pattern from which the *herati* design developed. It is formed by a generally roundish flower, surrounded, almost embraced, by two long, sickle-shaped leaves oriented away from each other.

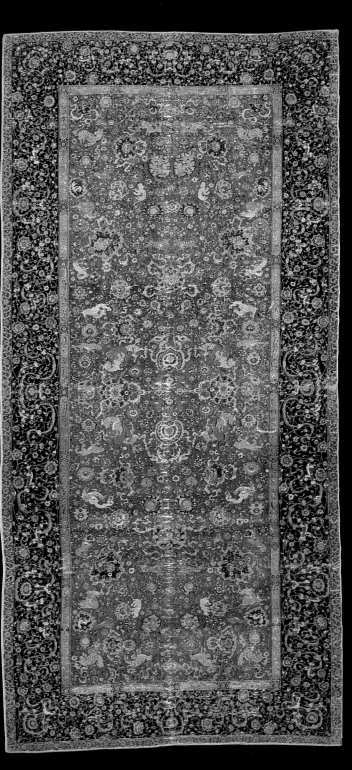

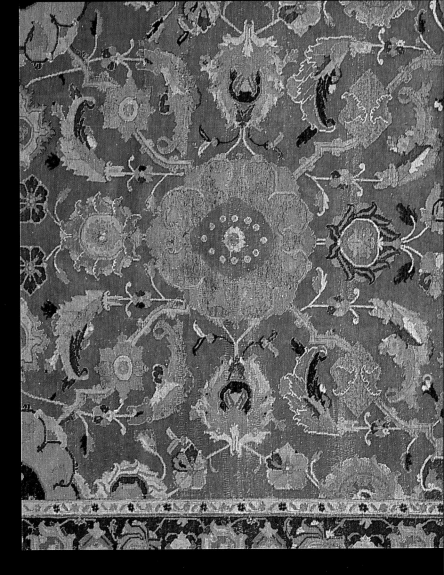

of purely commercial convenience, and other centers of production cannot be excluded.

Herat has been recognized as the birthplace of one of the most common decorative elements of these carpets, the *herati*, which initially consisted of a palmette (or a rosette) accompanied only by two large, scythe-shaped or curling leaves with serrated edges. This ancient pattern was reworked into the motif known as the field *herati* (or, more simply, *herati*, like the original prototype), many variants of which were widely used in carpets made throughout Persia in the 1800s and 1900s.

The provenance of floral carpets is further complicated by the so-called Indo-Isfahan or Indo-Persian carpets, evidence that this design had spread to India, making it very difficult to tell a Persian floral carpet from an Indian carpet of the same design. Broadly speaking, Persian carpets have a greater sense of calligraphy, highlighted by the dark outlining of the figures, and a more pronounced predilection for strong colors; Indian carpets have either pale outlines or no outline at all, the typical lac-dye red dominates in the background, and generally, the overall composition is less powerful.

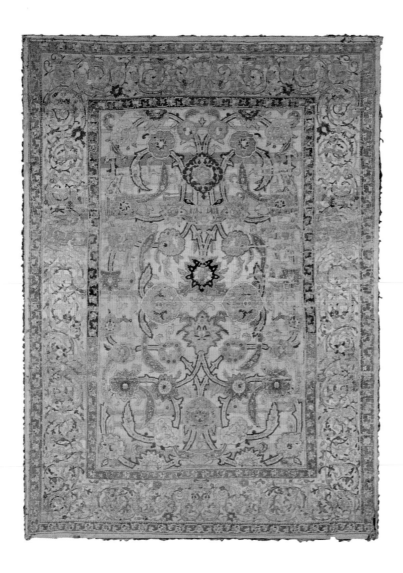

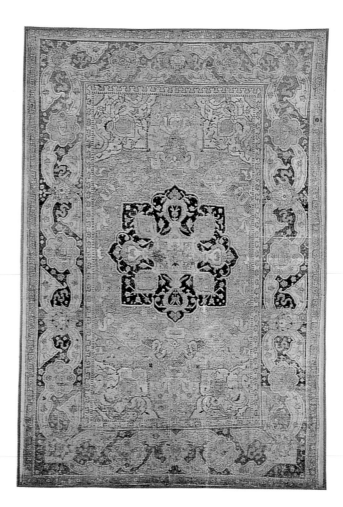

"Polish" carpet with floral decoration
Kashan? Isfahan?, before 1603
Venice, Museo del Tesoro della Basilica di San Marco

This appellation is given to several carpets found in European collections, featuring the same stylistic elements of carpets from the reign of Shah Abbas I, which were shown at the 1878 Paris International Exposition by Prince Czartoryski of Poland. These carpets are, for the most part, decorated in the floral style and have coarse knotting, although made with precious materials, such as silk and especially silver threads, as they were intended for the courts of Europe. The above specimen was possibly presented as a gift to the Republic of Venice by Shah Abbas I in 1603, in an effort to find an ally against the Turks.

"Polish" medallion carpet
Kashan? Isfahan?, early 17th century
Venice, Museo del Tesoro della Basilica di San Marco

During a 1622 diplomatic mission, several years after the gift of the carpet on the left, this carpet also was presented as a gift to the Republic of Venice—an ally against the Turks. "Polish" carpets are modest in size, but their layouts vary. The above example is 140 x 210 cm (55 x 83"), with a lovely polylobate, square, central blue medallion. Some of these carpets are decorated with coats of arms of the Polish nobility, which is why their provenance was incorrectly attributed to Poland; however, they were definitely made in either Kashan or Isfahan in Persia.

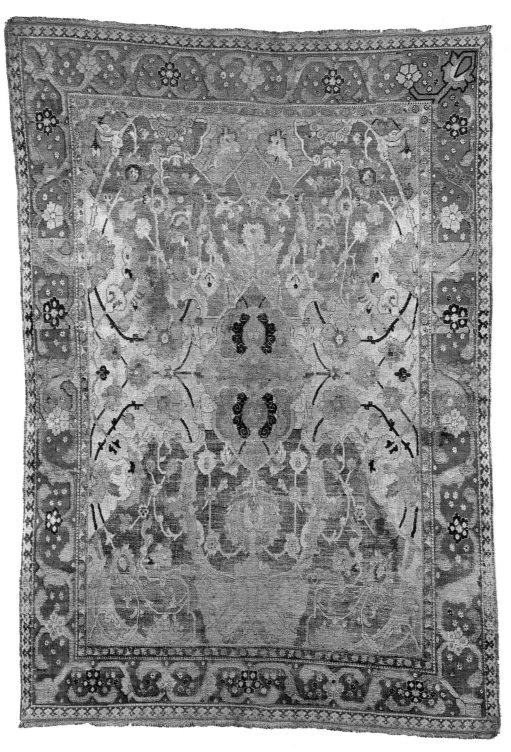

"Polish" carpet with floral decoration
Kashan? Isfahan?, 17th century
Vienna, Österreichisches Museum für angewandte Kunst

Compared with other classic Safavid carpets, the "Polish" production, in addition to modest size and coarse knotting, has simple designs that lack careful detail or calligraphic effect, as well as light colors without the use of refined contrast. All of this supports the theory that it was not destined for the Persian court—which was knowledgeable about the glorious local style—but rather for the courts of Europe. For this reason, these carpets were made precious with silk and with gold and silver brocade. The above carpet is enlivened by the contrasting green field and red border. Note the outer border embellished with a reworked trefoil motif.

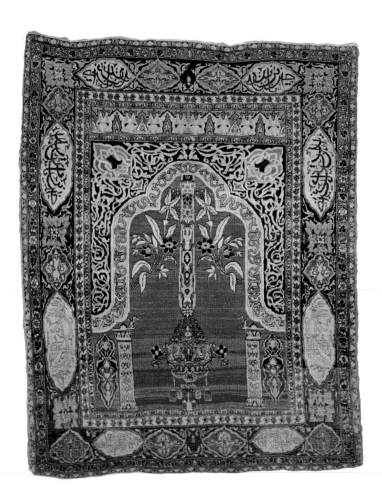

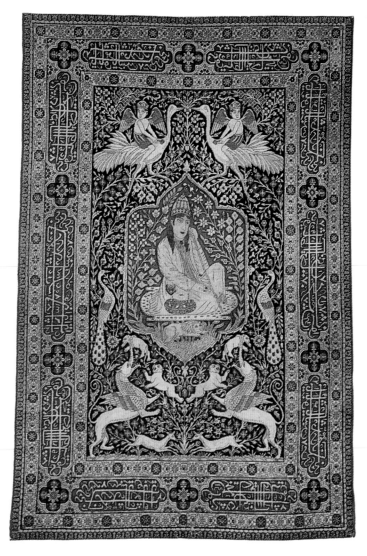

Tabriz prayer rug
Mid-19th century
Verona, Tiziano Meglioranzi Collection

Around the mid-19th century, after the 18th-century crisis created by the Afghan invasion of 1722, a rebirth of the Persian carpet occurred, with the establishment of new city works and a rediscovery of ancient Safavid decorations. New types also appeared, such as the prayer rug, marked by a very elaborate curvilinear mihrab that contained lifelike flowers and sometimes animals, as well as the sacred lamp. However, this was a foreign, imported genre, produced primarily to meet the demands of the Western market, and thus lacks special significance.

Kerman figural carpet
Late 19th century
Private collection

Toward the end of the 19th century, figural carpets appeared, influenced by the local miniaturist art and also by Western taste and culture. In addition to mythical scenes from Persian literature and epic poetry, with winged genies and fabled animals—such as in the above example—and heroic representations from the nation's history, scenes from hunting or everyday life were also depicted, along with portraits of leading public figures or well-known clients. The borders were typically decorated with cartouches filled with inscriptions or verses related to the central scene; sometimes the inscriptions were also inside the field.

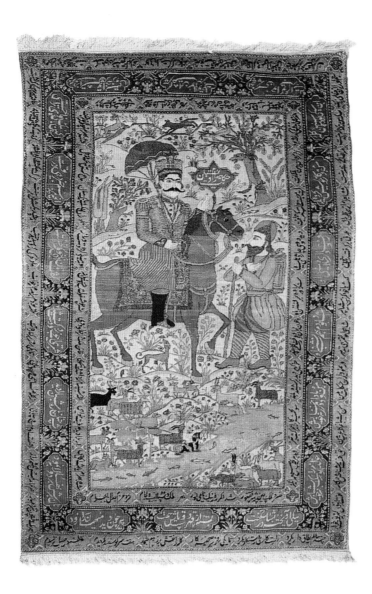

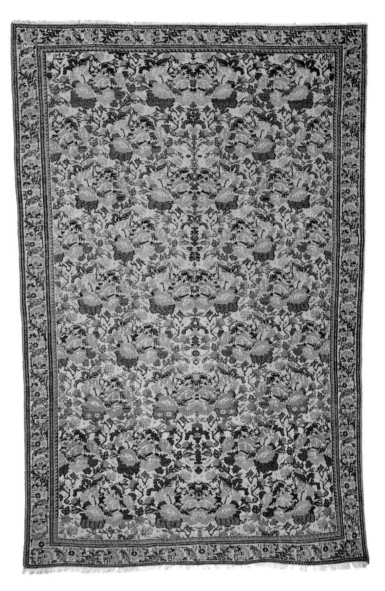

Kashan figural carpet
Late 19th century
Private collection

This example, which portrays a Persian epic scene, denotes the influence of local miniaturist art, while the intent of realism and the importance given to the figures—shown larger, dominating the composition—signal the influence of Western prints and photographs. For the first time, at the end of the 19th century, the human figure is the carpet's protagonist; no longer confused on arabesqued backgrounds, it is placed inside true painted scenes. Note that the inscriptions are written in the cartouches of the main border and inside the two minor bands.

Malayer carpet with floral decoration
Dated 1878
Villastanza, Morlacchi Collection

Toward the end of the 19th century, a Western-flavored style developed in Persia. Inspired by 17th-century French floral decorations, the carpets were filled with large, naturalistic compositions of roses, peonies and other flowers, arranged in bouquets or in lush patterns, either in a central composition or full-field, as in this carpet. Pastel tints, pale green, beige (for the grounds, especially) and pink in all its hues were the favorite colors in this unusual palette. The leading production centers were Senneh and the region of Malayer.

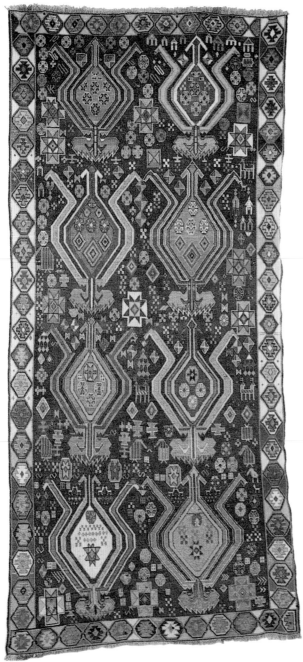

Shahsavan carpet with geometric decoration
First half of 19th century
Milan, private collection

Nomadic Persian carpets from the 19th and early 20th centuries differ in their compositions from carpets produced by tribes from other regions, which are denser and more elaborate; they also stand apart in the frequent use of motifs borrowed from the city or from abroad. This rare example, executed with the symmetrical knot by the Shahsavan tribe situated in Azerbaijan, in northwestern Persia, uses Caucasian decorative motifs, such as the octagons containing stepped-profile *guls* inside the borders and the large, variously rendered palmettes in the field. Note the small, stylized human and animal figures, a typical tribal touch, scattered in the field.

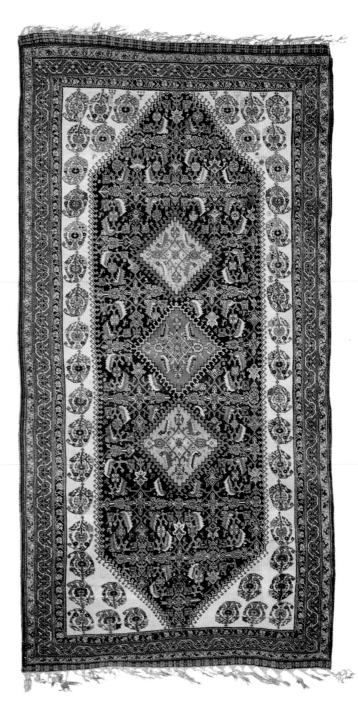

Qashqa'i carpet with superimposed medallions
Second half of 19th century
Rome, Luciano Coen Collection

Among the 19th-century tribal productions influenced by urban designs is that of the Qashqa'i (or Kashkai), a tribe from the southern area of Fars, where the Khamseh group also lived. Evident in the above example are motifs foreign to the tribal tradition, such as the *herati* and *boteh*. Here, the latter is interpreted as a wreath of flowers arranged teardrop-style around a larger, central flower. The diamond-shaped medallions and the exterior bands along the shorter sides, decorated with rectangles containing a white and blue diamond, are also typical of Fars, thus also of Khamseh production.

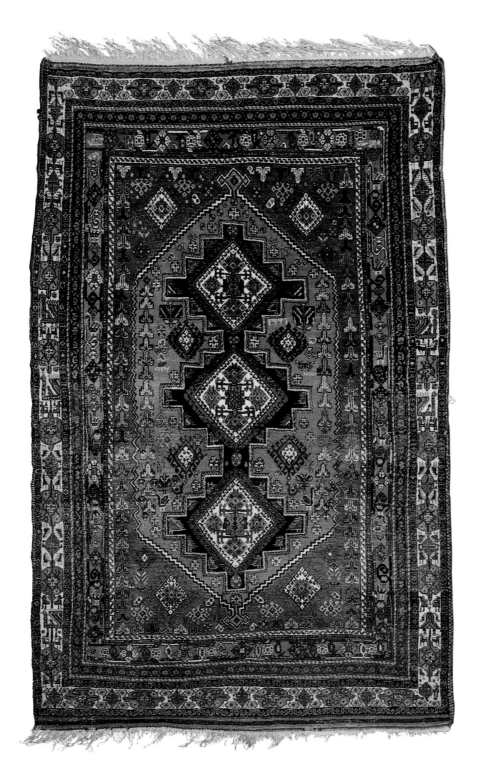

Afshari carpet with superimposed medallions
Dated c. 1900
Rome, Luciano Coen Collection

City decorative motifs, especially the *boteh*, rendered geometrically, influenced nomadic and seminomadic production from the region south of Kerman, in southern Persia—called Afshari for the name of the major local tribe. These carpets, with widely varied decorations, are more faithful to local tribal tradition. Typically, the layout consists of superimposed diamond-shaped medallions with hooked profile; in the field and borders, stylized animals, often birds, such as the *morghi* hen; and finally, white-ground borders, with rosettes alternating with cruciform figures, and exterior multicolored bands along the carpet's shorter sides.

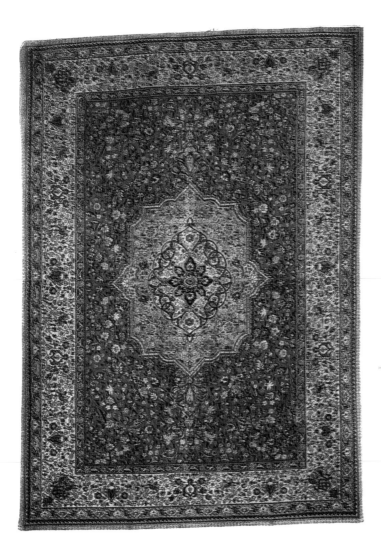

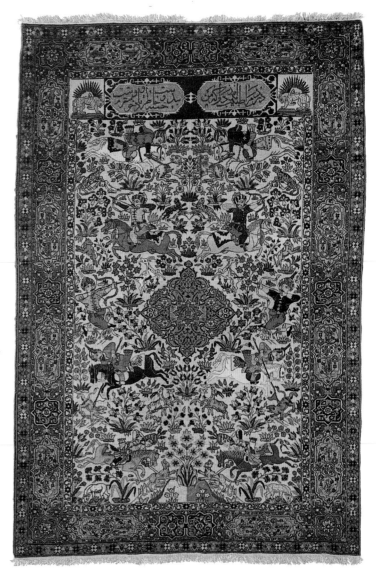

Tabriz medallion carpet
Late 19th century
Private collection

Tabriz, an ancient production center in northwestern Persia and once capital of the Safavid empire, led the 19th-century Persian carpet revival, which began to compete with Anatolia for the Western market. Tabriz carpets are distinguished by the use of the symmetrical knot, a somewhat coarse wool and a pile traditionally cut medium-low. Considerable attention is given to detail, and the layouts, such as the central-medallion layout in the above example, are descended from classic Safavid production. The borders are decorated with *herati*, cartouches or cloud bands. Blue, ivory, terra cotta and pastel tints are the favorite colors.

Tabriz medallion carpet with hunting scenes
19th century
Bergamo, La Torre Collection

It is clear from the above example how classic Safavid decorations inspired the 19th-century Persian masters, who reproduced them on smaller carpets, albeit with more modest workmanship. Around the central medallion, among the flowering bushes, is a hunting scene, where horsemen armed with bows and spears and kneeling archers are engaged in marking or striking their prey. In deference to 19th-century taste, the figures are larger and dominate the composition, unlike 16th-century prototypes in which animals, prey and horsemen were lost among the flowers and intricate arabesques. In deference to the classic patterns, the principal border is usually decorated with cartouches.

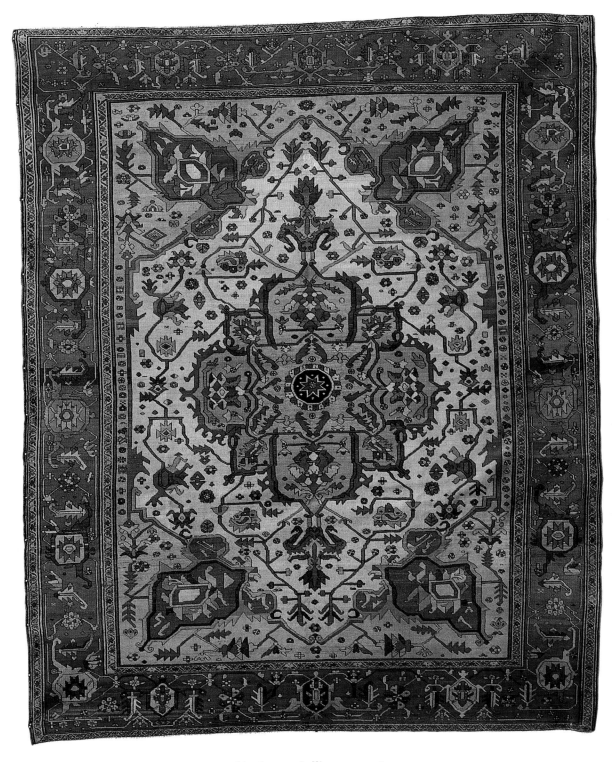

Heriz medallion carpet
19th century
Venice, Rascid Rahaim Collection

This production is marked by the use of the symmetrical knot and the squarish shape. The style here consists of the classical Persian floral motifs rendered in clearly stylized form and high-lighted by one or more borders of different hues; also, large extensions of color are used. The more popular layout has a central star-shaped medallion with four or eight lobes, embellished with geometric corner motifs. The borders are filled with *herati*, often rendered in the turtle variation, as in the above example.

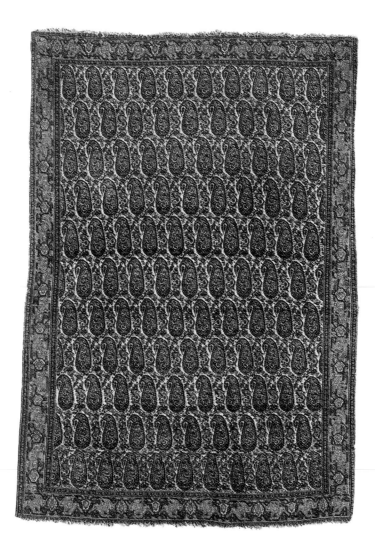

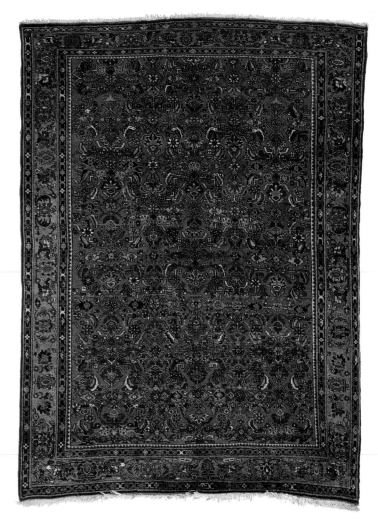

Senneh carpet with full-field *boteh* decoration
Late 19th to early 20th century
Cleveland, The Cleveland Museum of Art

The city of Senneh (today's Sanandaj), in western Persia, gave its name to the asymmetrical knot, although the knot used here has always been symmetrical. Thanks to the high knotting density and the low-cropped pile, Senneh production stands out for its minutely detailed designs—especially *herati* and *boteh*—distributed full-field (as in this specimen) in endlessly repeated, orderly rows. The borders are usually embellished with the *herati* design, which sometimes becomes a turtle pattern. The ground's predominant colors are blue, black and ivory.

Bidjar carpet with floral decoration
19th century
Milan, private collection

This production from western Persia was executed with the symmetrical knot and features a wide variety of designs, from the central medallion to *mina khani* and *kharshang*. Typical of this group, however, is the inflexible and rectilinear rendition of classic Safavid designs, particularly the vase layout represented here, enriched by arabesques and flowering tendrils, endlessly repeated, with geometric palmettes and flowers linked by a thin, abstractly drawn grid. A contrasting color palette is customary, with brilliant red, yellow and green decorations that stand out against the dark grounds.

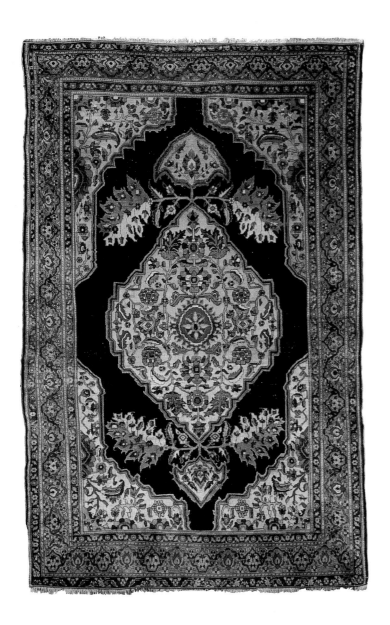

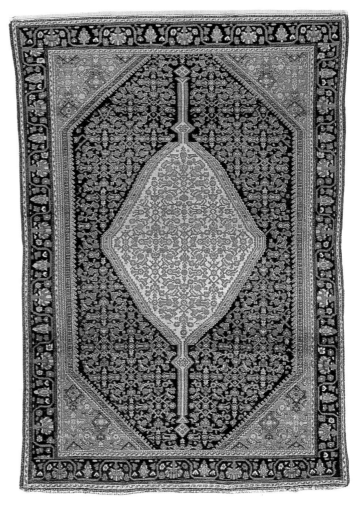

Malayer medallion carpet
19th century
Private collection

The floral design of this specimen, similar to the Sarouk and Fara-han style, points to a provenance from the southeastern area of Malayer. Malayer is a complex production area, since carpets from the north feature layouts with squarish medallions or small designs scattered full-field, while those from the south feature prefer-ably roundish, central medallions embellished with complex floral decorations. In both cases, however, the language is stylized. Generally, strong colors such as red and blue are used.

Malayer medallion carpet
19th century
Private collection

The above carpet exemplifies the second style originating from the Malayer region—the large, diamond-shaped geometric medallion with long, rigid pendants, as well as a decoration centered around the *herati* motif, red on blue, interpreted geo-metrically. These elements are typical of northern Malayer and resemble the Hamadan production, whose ancient specimens are now especially rare. The two Malayer styles differ in structure as well: The southeast uses both knotting techniques, while the north (as in the above example) uses only the symmetrical knot, with just one passed weft row for each row of knots, instead of the usual two.

Farahan medallion carpet
Early 19th century
Milan, Pars Collection

Production from the region of Farahan may be classified into two style groups. The first features a full-field distribution of floral decorations. The second has a well-balanced medallion layout with a central dominating medallion filled with floral decorations, often encircled by a typical serrated sun-burst; the rest of the field is sparsely filled with floral elements and fractions of the medallion arranged above and below. This particular layout, typically with a beige or red ground, enjoyed popularity in Victorian England.

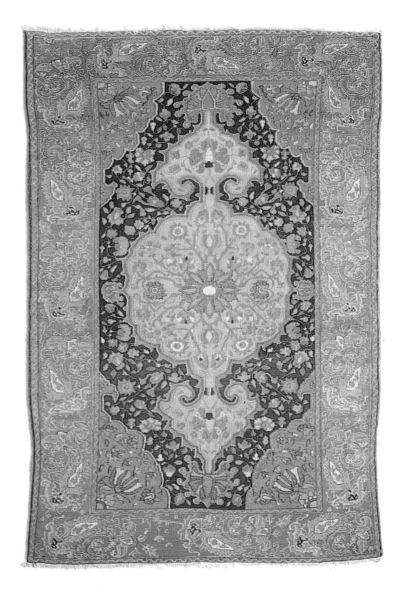

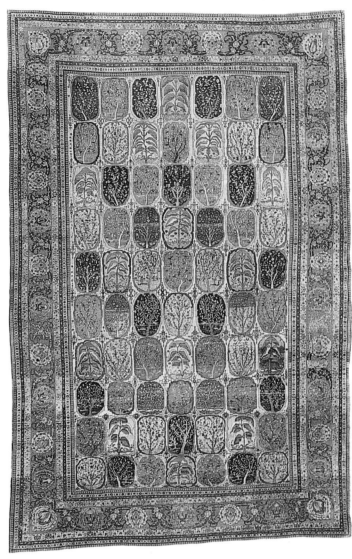

Sarouk medallion carpet
Late 19th century
Turin, Behrouz Collection

The prevailing layout in Sarouk carpets is the central medallion, which may be a very large hexagon or a smaller, roundish or diamond-shaped figure, with pendants and cornerpieces. Colors are exceedingly important in Sarouk production: Natural dyeing substances continued to be used for some time, even after chemical dyes had been introduced. A typical shade is an intense salmon-rose, such as in the above example, highly appreciated in the United States from the end of the 19th century onward. This particular shade was called *dughi*, because it was obtained by adding *dugh* (yogurt) to the dyes.

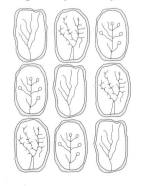

Sarouk carpet with trees
Late 19th century
Piacenza, Malair Collection

The Sarouk style is easily recognizable, because it adopts a linear version of the traditional Persian floral decorations, creating a peculiarly rigid effect. Toward the end of the 19th century, this original style slowly became more curved and naturalistic. An eclectic production, Sarouk carpets include medallion layouts as well as prayer rugs, full-field decorations and original stylized tree motifs, as in the above example, where each small tree is enclosed in a frame and arranged on a ground of a different color. The ground color is typically beige, red or blue, while the decorations are yellow, light blue and brown.

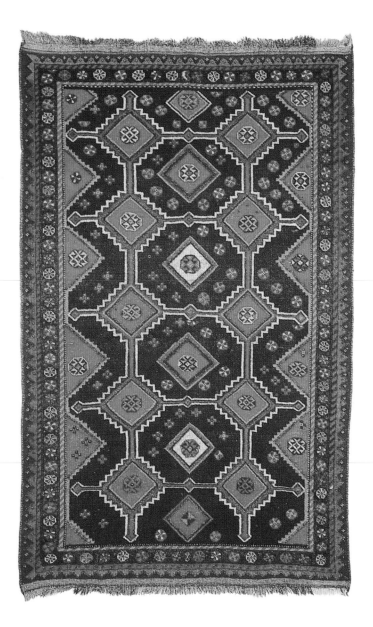

Serabend carpet with full-field *boteh*
19th century
Private collection

This production is recognizable by its unusual decoration consisting of a full-field layout of regular rows of tiny *boteh*, all pointing in the same direction, as in this example, or in both directions in alternating rows. The *boteh* profile may be continuous and straight or interrupted and made up of tiny flowers. It was probably the predilection for this motif that gave birth to the name *boteh miri*, meaning "the chosen, the best." The field color is always red, with white, blue, black and yellow *boteh*.

Lori carpet with geometric decoration
Early 20th century
Private collection

The production of this nomadic and seminomadic population from southwestern Persia is problematic, since both symmetrical and asymmetrical knotting was used in a variety of designs. In any case, it includes grid carpets, such as the above specimen, often with stylized plant elements or minute geometric figures arranged in regular rows across the whole field. In general, the color palette is either light or bright; the colors became darker starting at the turn of this century, and red and blue became the leading colors.

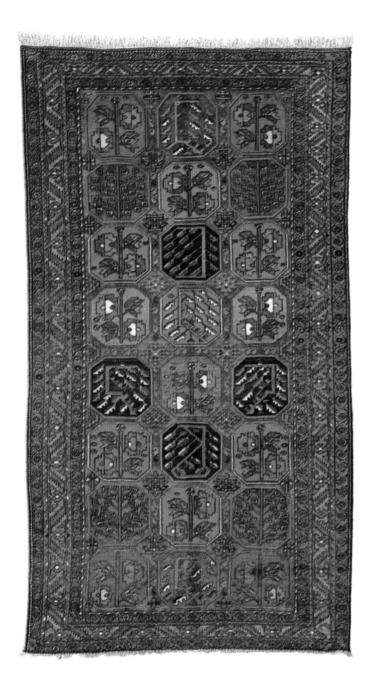

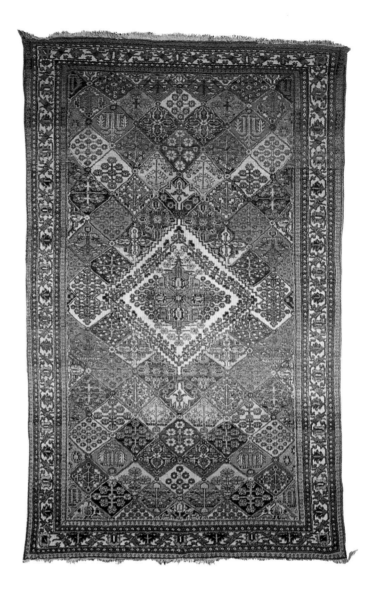

Baktiari carpet with floral decoration
Late 19th century
Private collection

Carpets originating from the region of Chahar Mahal, in south-western Persia, were improperly given the appellation of the no-madic and seminomadic Baktiari groups who were a local cultural force during the 19th century. Actually, carpets from this area should be classified as village production—with more curvi-linear nomadic designs—with clearly tribal traits. Most common to these carpets is the so-called Baktiari motif, such as shown here, consisting of a field sectioned into squares, octagons or rhombuses and containing stylized plant elements.

Baktiari medallion carpet
Late 19th century
Rome, Giacomo Cohen and Children Collection

Here, we see a successful merging of the Chahar Mahal tradition and the influence of other Persian regions. The central-medallion layout, a foreign influence, takes shape as a large geometric flower enclosed within a diamond-shaped floral frame, which, in turn, is surrounded by a lozenge, the traditional Baktiari motif. The lozenges are arrayed close to each other, and each contains a styl-ized plant element—a flower, a shrub or a small flowering tree.

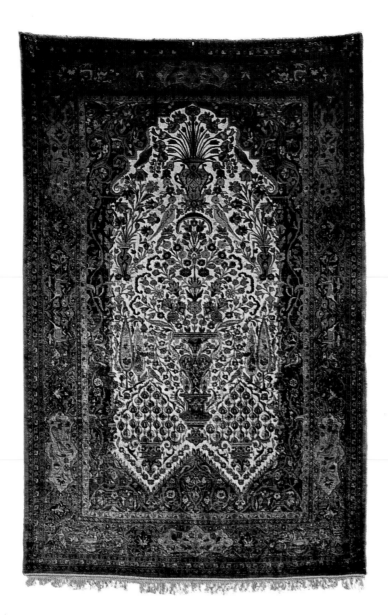

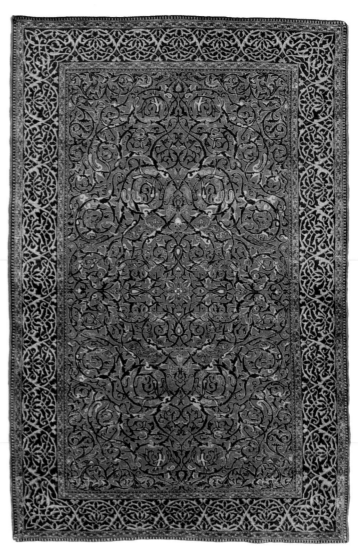

Kashan prayer rug
Late 19th century
Venice, Rascid Rahaim Collection

Kashan arabesque carpet
Early 20th century
Bergamo, La Torre Collection

Kashan, in central Persia, was an ancient Safavid production center and remains today a renowned provenance for highly prized carpets that are densely knotted with the asymmetrical knot and are distinguished by the use of at least one light blue weft. Kashan carpets emulate ancient compositions and classical Persian decorations and favor the central-medallion layout, usually complemented by pendants and cornerpieces. The medallion is typically arranged on a ground filled with arabesques, palmettes, leaves, and so on. These carpets are usually medium-size to large and include small prayer rugs with light grounds, such as the above example, made of silk and enlivened with trees of life, flowering vases and animals.

The soft, fluid curvilinear style typical of Kashan carpets marks the above example, inspired by full-field classical decorations. The traditional *islimi* arabesque extends in thin and winding lines across the scarlet-red field and is enriched with the classic forked leaves, other serrated leaves, buds and small palmettes. The center contains a small flower with four petals. The increasingly complex arabesque is repeated all along the principal border. The color palette is traditional, with the red or ivory of the field contrasting with the dark border and pastel decorations.

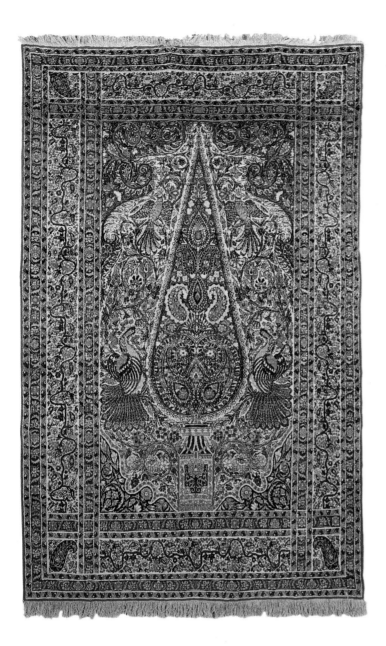

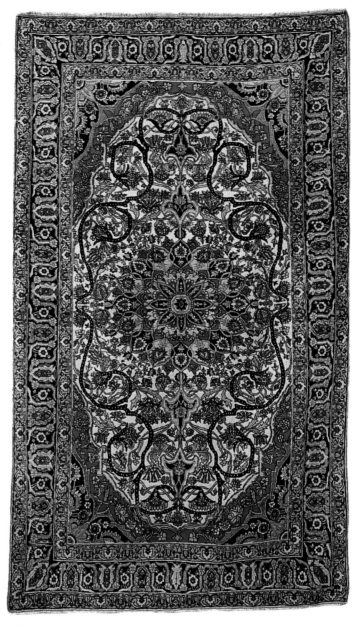

Kerman Ravar prayer rug
19th century
Milan, private collection

The appellation Kerman Ravar is a purely commercial convention used in Europe to refer to the more refined carpets of higher quality and value produced in Kerman and the surrounding area; Ravar is a village located northeast of Kerman that has an ancient carpet-making tradition, whose style, however, is not clearly distinguishable from that of the neighboring, more famous Kerman. Sometimes the appellation is corrupted into "Lavar" or "Laver." The elaborate curvilinear style typical of Kerman carpets is well represented here, crowded with many decorative elements, such as the tree of life, rendered as a cypress embellished with *boteh*, and two pairs of birds. Note the numerous borders, another typical Kerman trait.

Kerman medallion carpet
19th century
Venice, Rascid Rahaim Collection

Kerman, a famous ancient Safavid production center located in southern Persia where possibly the vase design and technique were born, still produces some of the most sought-after carpets. Technically, these carpets are marked by three passed weft rows for each row of knots, the middle weft row being traditionally pink and, in more recent specimens, light blue. Stylistically, Kerman carpets are elaborately curvilinear and, unlike Kashan carpets, are executed in a variety of Safavid and other layouts. The medallion layouts feature polylobate rose windows or stars arranged on arabesqued fields scattered with floral elements, such as in the above example.

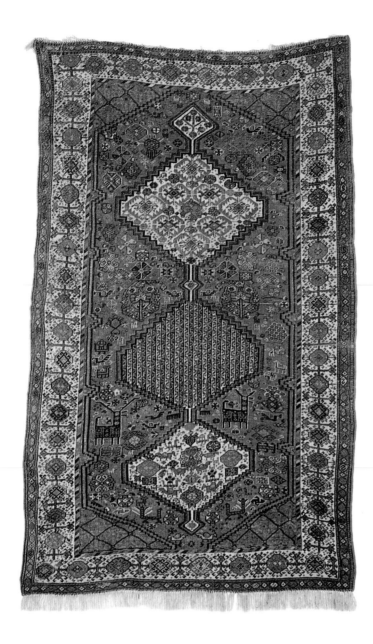

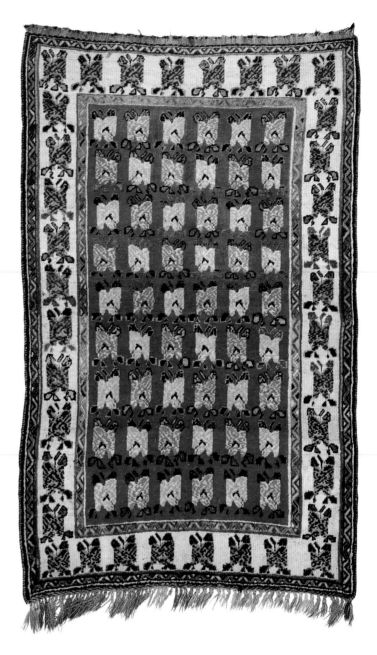

Khamseh superimposed-medallion carpet
Late 19th century
Villastanza, Morlacchi Collection

Carpets from the southern region of Fars are sometimes improperly called Shiraz, from the name of the city that acted as a collection center; in reality, they were made by two nomadic tribes, the Qashqa'i and the Khamseh. Their productions are similar, therefore distinguishable only by certain structural features and by the color palette (which is lighter in the Khamseh production). Diamond-shaped medallions with pendants of the same shape are typical, as is the *moharramat* motif, with two-colored vertical stripes inside the central medallion, and a preference for stylized animals. Among the latter, the most popular figure is the pecking hen, called the *morghi* motif, shown here in the lower medallion as two pairs of superimposed facing hens; both the Khamseh and the Afshari claim to have originated this motif.

Qashqa'i carpet with roses
C. 1930
Verona, Tiziano Meglioranzi Collection

With the turn of the century, Persian nomadic production also came under the influence of city decoration and thus of Western taste, reproducing French-style naturalistic floral decorations and translating them into the stylized language of the nomadic tradition. The Qashqa'i people adopted the rose primarily for carpets for everyday use, such as the *gabbeh* shown above, an obscure form typical of the Fars region, possibly used as a pallet or blanket, since it has a particularly high and soft pile. These carpets are executed with several passed weft rows for each row of knots, with stylized, brightly colored roses arranged in rows across the field on red or white grounds.

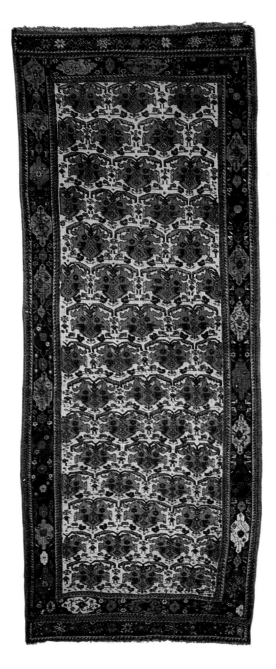

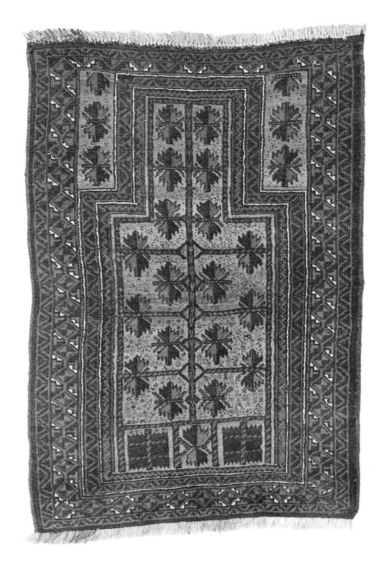

Afshari carpet with floral design
First half of 19th century
Venice, Rascid Rahaim Collection

Baluch prayer rug
Late 19th century
Private collection

Nomadic and seminomadic production from the region south of Kerman is usually called Afshari, for the name of the leading local tribe. These carpets were made with both symmetrical and asymmetrical knots, in a variety of decorations taken from local tribal tradition, as well as from neighboring city styles (the *boteh*, especially), but always interpreted geometrically. The above example uses a local, stylized floral motif repeated in offset parallel rows. Typical colors are white or blue for the field to contrast with the mostly red, yellow, light blue and brown decorations.

Nomadic and seminomadic tribes living near the Afghanistan border give their name to this production; it is sometimes erroneously called Baluchistan, which is the name of a neighboring region shared by Persia, Afghanistan and Pakistan that has a different style. These carpets are marked by softness and a dark, limited palette. They have full-field layouts influenced by motifs from neighboring areas. Typical of the production are prayer rugs, such as the one above, marked by rigidly geometric mihrabs with squared arches, containing trees of life in two colors, on a camel-colored ground, with branches perpendicular to the trunk and stylized leaves or flowers. The main borders are usually decorated geometrically.

THE CAUCASUS

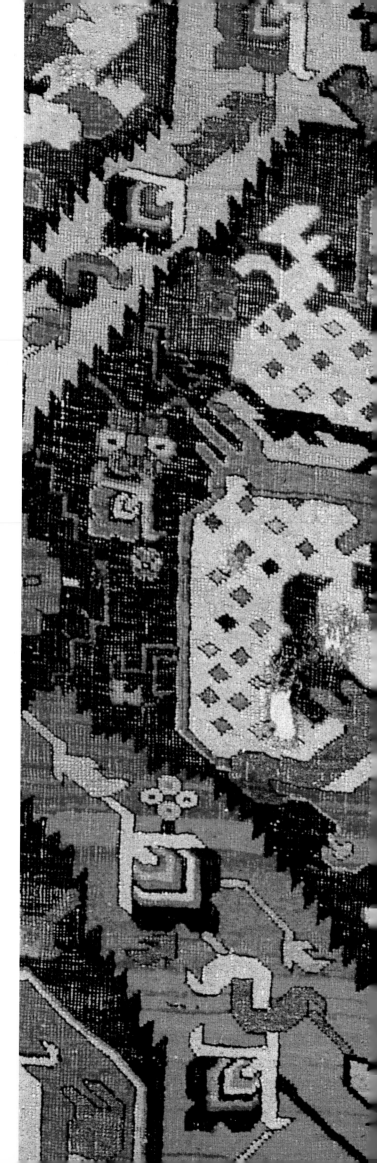

A natural passage area between Anatolia, Central Asia and Persia, the Caucasus region was subjected to raids from time immemorial and was inhabited by various ethnic groups of different cultures as a result. For example, in the 11th century, it was invaded by the Seljuk Turks, followed by Mongols; in the 16th century, it came under Persia's sphere of influence, while in the 19th century, it was occupied by Russia.

In all likelihood, the ancient Caucasian populations learned the art of knotting in the 11th century from the Seljuk invaders, whose taste was accepted locally and who set up carpet-production centers that used very bright colors and especially geometric-style motifs. However, no surviving specimens of such original creations exist; nor does any documentary evidence, since the oldest surviving examples date from the 16th to 17th centuries and thus belong to a later artistic period influenced by the spreading Persian floral style. Despite this influence, the language of the Caucasian carpets remained faithful to the original geometric style learned from the Seljuk rulers, as well as to their knotting technique, which remained symmetrical, confirming the existence of major local production centers that predated the influence of Persian culture.

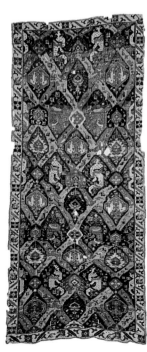

Dragon carpet
Southern Caucasus (Karabagh?), 17th century
Berlin, Museum für Islamisches Kunst

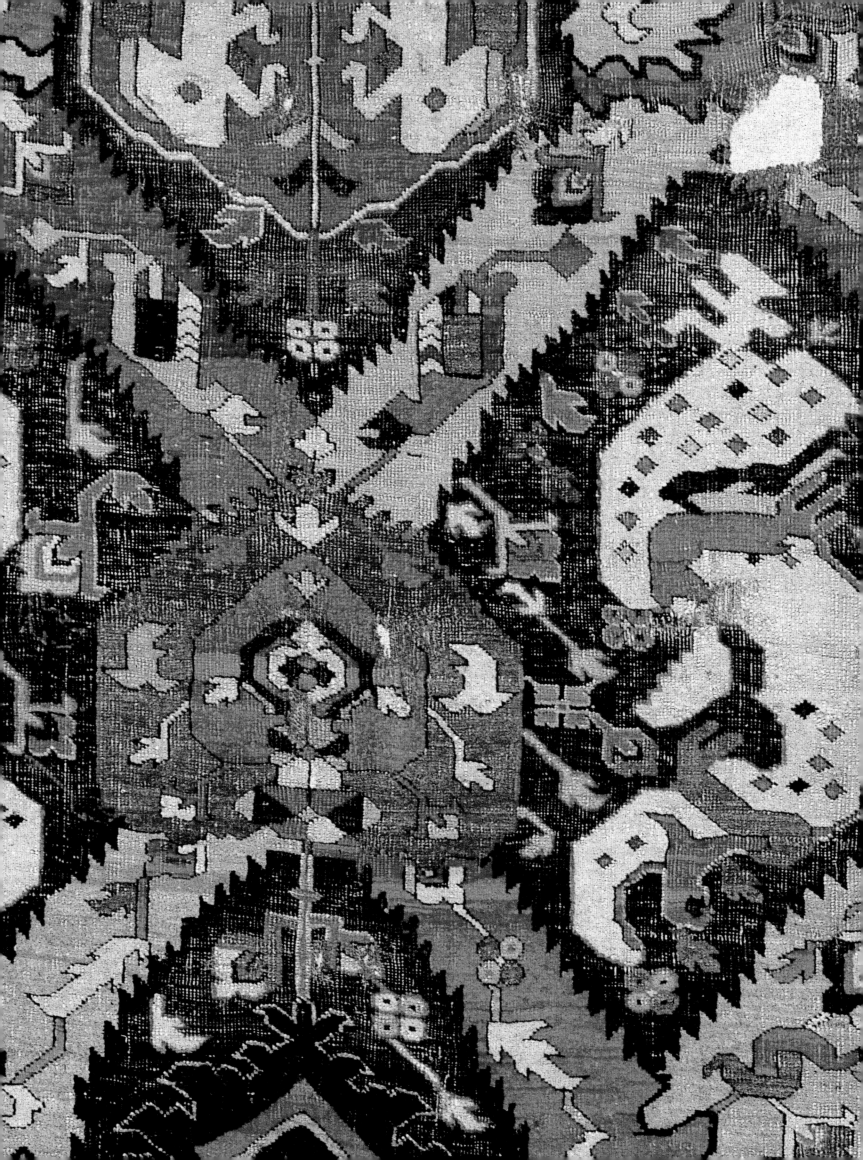

The period of Persian influence: two types of carpet

The period of Persian influence lasted from the 16th century to the beginning of the 19th century and led to the creation of two complex carpet types manufactured in large sizes in specialized workshops for a wealthy clientele: the dragon carpet and the floral carpet.

The dragon type is unique and is present in the so-called dragon carpets, which repeat this legendary animal across the field. Dragon carpets are large and elongated—average size, 200 x 450–500 cm (79 x 177–197")—and are based on a grid layout, with the grid being formed by long, narrow, stylized leaves in two colors, set diagonally to mark off large, open, diamond-shaped spaces. Inside these spaces are "S"-shaped dragons with a light-colored, often spotted mantle so heavily stylized as to be almost unrecognizable. Palmettes and other flowers, all strictly geometric, are sometimes placed at the intersections of the leaves and occasionally also inside other diamond-shaped spaces free of dragons.

In the early specimens, the dragons are small and oriented in only one direction; later, in the 18th century, they become larger and are oriented in both directions. In addition to dragons, some early carpets contain—in other diamond-shaped spaces or in the center of floral elements—animals such as the phoenix, the *chi'lin* (formed by a half-dragon and a half-deer) and other mythical animals that are often difficult to recognize. However, by the 18th century, they practically disappear, giving way to dragons, which have forever been the protagonists of this carpet type.

This carpet type usually has three borders: a narrow main border flanked by two narrower minor ones, all variously decorated either with geometric motifs or with those derived from the Persian naturalistic style, such as tendrils formed of leaves and palmettes, rosettes, small medallions, elements shaped like a horizontal "S" and serrated leaves. The background colors are usually red, black or blue, with the dragons and the other decorative motifs in ivory, yellow and green.

The provenance of these rugs, as well as their dating, remains somewhat debatable. At the beginning of the 20th century, some scholars attributed them to Armenia (which is why these carpets are also known as Armenian carpets), others to the area of Kuba; today, they are more generically attributed to the region of Karabagh, located

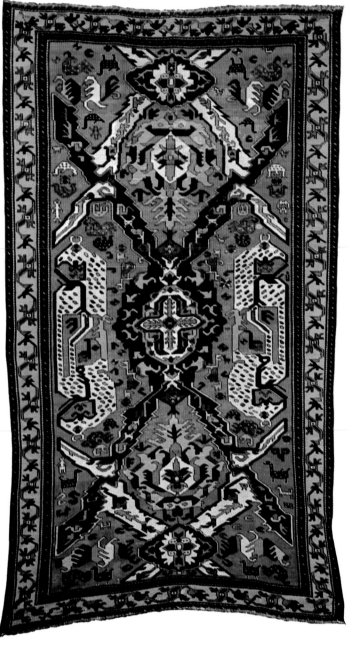

Above, dragon carpet. Southern Caucasus (Karabagh?), late 18th century. Berlin, Museum für Islamisches Kunst. In the evolution of the dragon-type style, the floral grid has expanded and the dragons have become larger and are no longer oriented.
Below left, diagrams of typical Caucasian borders, with serrated leaves (top) and geometric motif (bottom).

Facing page, left, dragon carpet. Southern Caucasus (Karabagh?), 17th century. Washington, The Textile Museum. In this carpet with a denser design, the lozenges contain not just dragons but *jiling* and phoenixes as well.
Facing page, right, detail of dragon carpet. Southern Caucasus (Karabagh?), late 17th century. Private collection.

Major Areas and Types

SOUTHERN CAUCASUS (KARABAGH?)
Dragon carpets (16th or 17th century to early 19th century). Grid structure filled with stylized dragons alternating with floral elements. Lively, contrasting palette.

SOUTHERN CAUCASUS
Flower carpets (16th or 17th century to early 19th century). Grid structure with exclusively floral elements that gradually become increasingly stylized. Very bright palette.

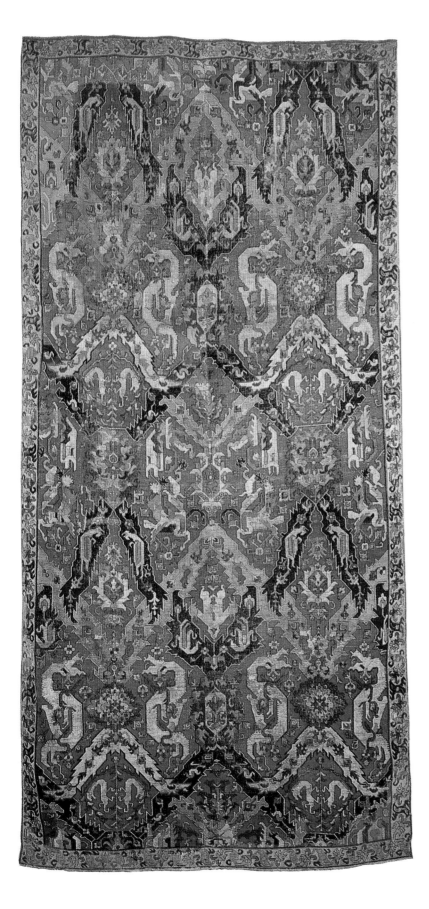

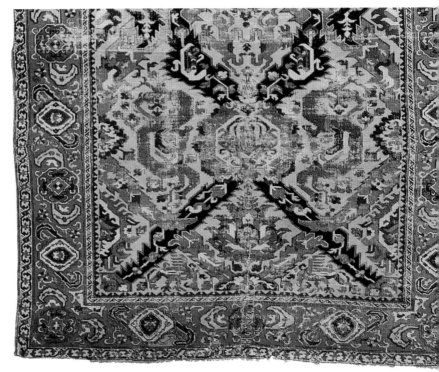

Meaning of the Dragon

A legendary animal, the dragon is often portrayed as a guardian of treasures or princesses. In the West, the dragon has had an essentially negative connotation, being linked with the idea of evil and the devil, like the snake, to which it bears a close relation. Not so in the Orient, where the dragon possesses both a positive and a negative meaning, which is expressed, not coincidentally, by its dual nature as both a land and a water creature and hence underground and heavenly at the same time. In this sense, it represents the creative power, the *élan vitale*, and therefore immortality. For this reason, it became the symbol of the powerful and, in China, of the emperor.

The cult of the dragon has its strongest roots in China and the Caucasus; but while this cult is native to China, its introduction to the Caucasus region is a subject of debate. Some scholars believe the cult of the dragon was brought by the Seljuk people; others, that it arrived with the Mongols. In any case, we do know that this is an ancient tradition and that in Armenia, the dragon is revered as the guardian of springs and waterways, as well as the creator of lightning. Therefore, its presence in carpets is intended to bring luck and to exorcise evil.

In China, the dragon is usually depicted in recognizable form, with realistic elements, such as wings, tail, legs and flaming tongue. It is not as easily recognized in the Caucasus, given its very stylized form following the local geometric style; the dragon, then, is portrayed as a light-colored "S" (which is sometimes spotted to simulate the animal's scales) or in two colors, and only with great effort can one identify the curving tail, the fringed wings, the hind legs and the horned or crested head.

in the southern part of the Caucasus and known for its rich production and the diffusion of its carpets. This theory is widely supported despite the fact that most of the dragon carpets were discovered in the mosques of eastern Anatolia. Some believe they may have been donated.

Chronologically, dragon rugs are datable from the 16th to 17th centuries, although some scholars consider them the inspiration for the Persian animal carpets and should therefore be dated to the early part of the 16th century. In any case, their production continued until the 1800s.

This first compositional element shows traces of Persian influence in the budding palmette: The motif is easily recognizable, though it is rendered geometrically and in larger form. It is repeated on the lower side of the carpet in the opposite orientation.

The outside of this medallion is composed of four large, serrated leaves, almost wide bands. This is reminiscent of the floral grid that decorated dragon carpets, arranged in pairs as if to form two curved parentheses around the central motif, which consists of an oblique, geometric flower.

This medallion, consisting of a central geometric flower surrounded by a typical white corolla akin to a flaming sun, gives the name of "Sunburst" to this second floral type. The motif was reworked in the 19th century in the so-called Chelaberd, or eagle Kazak, carpets.

Small elements, such as stylized flowers and leaves, are scattered to fill the red field of the carpet.

Typical of the floral carpet type is the narrow main border with a light ground, embellished with plant tendrils or small geometric figures, as in this carpet, which has a characteristic "S"-shaped motif.

Floral "Sunburst" carpet
Southern Caucasus, 18th century
Washington, The Textile Museum

Influenced by Persia and appearing at the same time as the dragon carpets, the floral carpets were made in large, elongated sizes and differ in their coarser knotting and their colors, which are not usually strong. These carpets feature a wide variety of floral designs in geometric style, all based on three models. The floral type, rather than the dragon type, continued to be manufactured in the later Caucasian production.

Floral carpets

This second type of ancient Caucasian carpet, which was influenced by Persian production, is held by many experts to be an offspring of the dragon type, while in reality, it is contemporaneous with it and therefore stylistically independent.

The origin of this carpet type is still uncertain. Once attributed to the northeastern city of Kuba, it is, today, more generally attributed to the southern Caucasus.

The composition of these carpets is always based on the infinite repetition of motifs arranged along three or more vertical axes. They have narrow principal borders, usually flanked by a narrow band on each side, with decorations consisting typically of geometric vines with two-colored trefoils, rosettes, geometric motifs of plant origin or small medallions.

These carpets appear in a wide variety of designs and motifs, though all of them are taken from three basic stylistic models. The first and oldest has the same type of grid structure as the dragon carpet but fills it not with those mythical animals but with stylized palmettes and small, variously rendered, cross-shaped medallions set within large diamond spaces marked off by the large, dense geometric grid. This type of composition sometimes includes very curvilinear cloud bands, the latter introduced locally from China through Persia. This floral grid model enjoyed modest commercial success outside of the Caucasus, as shown by the fact that some specimens of this type were found in Anatolia, in the cities of Nide and Bursa.

The second model, probably datable to the 18th century, is essentially a stylized, enlarged version of the grid layout that makes up the first model. The grid disappears in this model, however, and the expanded medallions

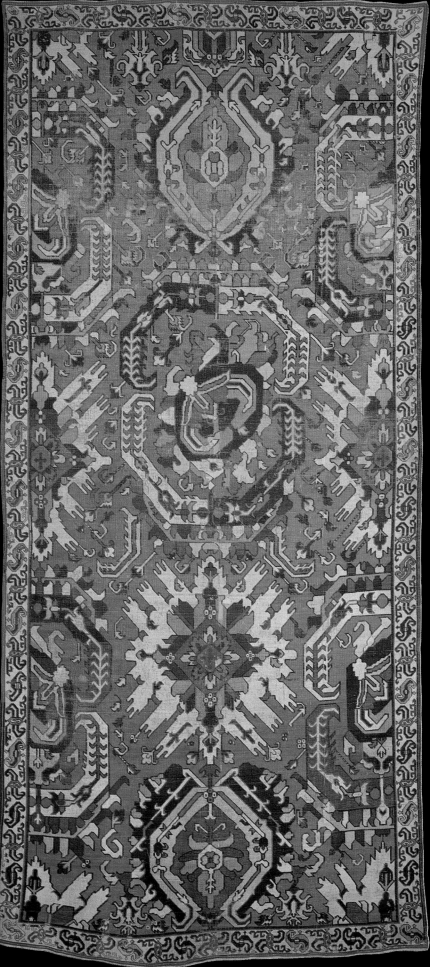

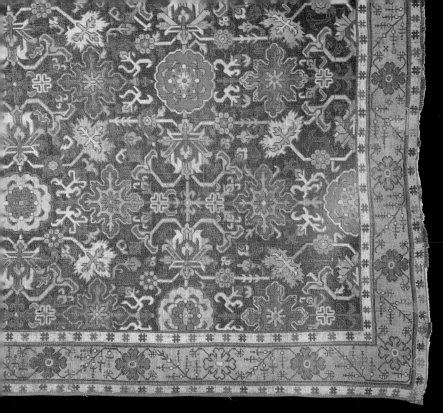

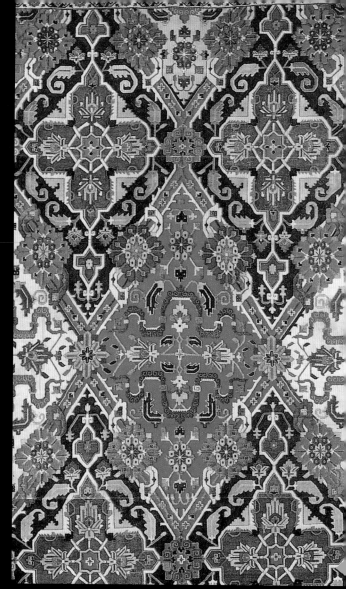

Above, detail of floral carpet. Southern Caucasus, 18th century. Washington, The Textile Museum. This third floral model features the *afshan* motif, which consists of four forked leaves that sprout from two palmettes arranged around a small central flower and alternate with large, roundish rosettes embellished by palmettes. The somewhat dark colors are typical of this production. Note the typical flowering tendrils with rosettes that decorate the main border, as well as the two narrow minor bands embellished with a tiny geometric pattern.

Below, detail of floral carpet. Southern Caucasus, early 18th century. Florence, Museo Bardini. This brightly colored specimen is also decorated with the *afshan* motif that became so popular in 19th-century Caucasian production. Worthy of note is the main border embellished with a typical two-colored trefoil motif.

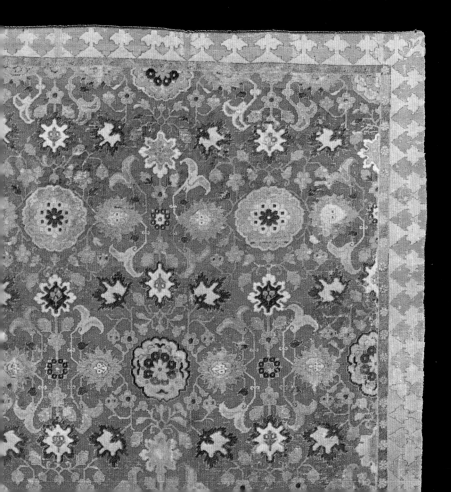

Above, detail of floral carpet. Southern Caucasus, 17th century. New York, The Metropolitan Museum of Art. This specimen, called Nide, exhibits the first floral model, consisting of a thick grid and an unusu stylized and sharp-edged cloud band.

appear isolated and unrelated to the rest of the compos
tion, already pointing to the typically rarefied languag
of 19th-century Caucasian carpets. In the particular var
ant called "sunburst," some floral medallions are trans
formed into "flaming suns" (also known as sunburs
carpets) on a pale background, alternating with large
highly stylized flowers, all arranged vertically along th
carpet's central axis, almost in imitation of the superim
posed-medallion layout. This variant was picked u
again in the 19th-century Chelaberd carpets, also know
as "eagle Kazaks," produced in the southern Caucasu
specifically in the region of Karabagh.

The third model also presents a full-field distribution
of geometric elements of floral origin; but these ar
much more minute, and instead of being sparsely dis
tributed in the field, they appear in great quantities and
are linked to one another by stems and arabesques.

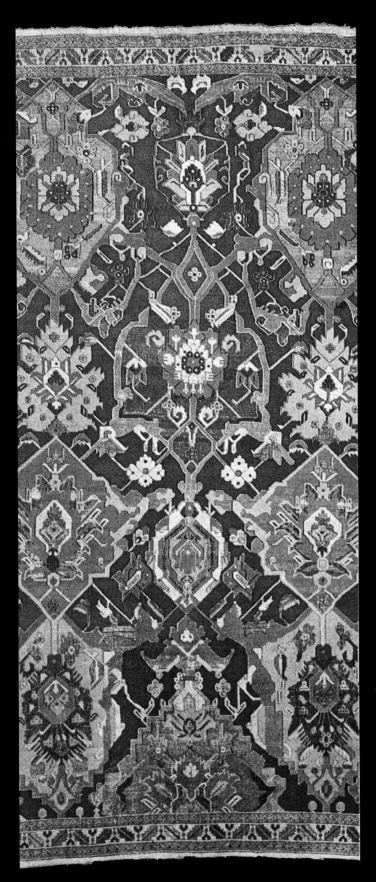

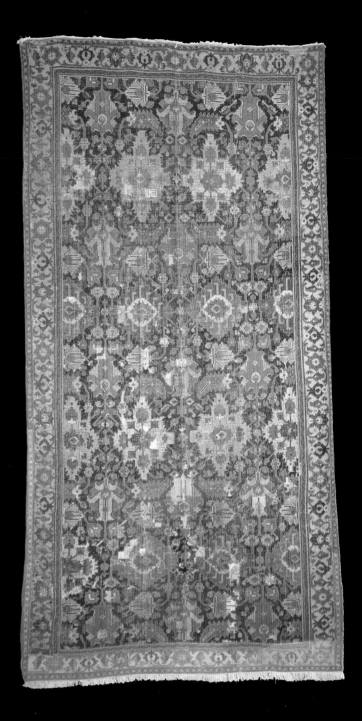

Above, detail of floral carpet. Southern Caucasus, 17th century. Vienna, Österreichisches Museum für angewandte Kunst.

Right, floral carpet. Southern Caucasus, 18th century. Washington, The Textile Museum. This specimen exhibits a variant of the third floral motif, with minute elements crowded next to one another. The in-and-out palmette is a recognizable Persian influence. Note the sunburst shape of the palmette resting on a light background. The main border is decorated with a flowering shoot on a typical light ground.

Among the various designs in this group are infinite repetitions of palmettes—clearly derived from Persia's Herat or Isfahan designs—and, along three vertical axes, infinitely repeated designs of *afshan* motifs (with the typical forked-leaf element) or *kharshang* (with the typical crablike palmette). The field ground of these carpets is generally dark blue or red, rarely green. Overall, the floral type, with the small and medium-size decorations and especially with the large sunburst or roundish medallions, was a strong influence on the 19th-century production of the Caucasus.

This layout, with three superimposed medallions, the enlargement of the elements and their sparse arrangement, denotes 19th-century Caucasian production. The octagonal medallion with a hooked profile on a white ground, enclosing a traditional cruciform figure (derived from an ancient Central Asian symbol of the sun), typically denotes the Lori Pombak carpets, so called after the name of a village and of a mountain range.

The main border is decorated with the recurring Caucasian motif of serrated leaves alternating with tulips, here given movement by a lively interplay of colors. The white ground, in particular, recurs frequently in this carpet type.

The secondary medallions present a hooked profile, possibly an ancient symbol meant to ward off the evil eye, and enclose an eight-pointed star, which was probably an auspicious symbol.

Worthy of note are the plain secondary borders embellished with small geometric figures. The small inside border has no clear outline, as is usually the case; instead, it becomes part of the field's decoration.

"Lori Pombak" Kazak carpet with three medallions
Southwestern Caucasus, 19th century
Private collection

The 19th century saw the prodigious rebirth of the true Caucasian carpet and of local village production, free of outside influence. The new geometric style merged the ancient tribal spirit and the Central Asian tradition with motifs from the courtly period through a process of enlarging or reducing the size of the original elements. The new soul of the Caucasian carpet would be found in its immediacy, traditional feeling, solemnity and elegance.

Changed historical conditions

The early 19th century was a period of considerable importance for the Caucasian carpet, since its development was aided by unusual historical circumstances. The Russian occupation, which began early in the century, brought with it the demise of the ancient Caucasian nobility and saw the end of the production of the large carpets made for them. As a result, the influence of the Persian floral style declined, the large, specialized ateliers closed, and there was a rebirth of production in villages.

Rebirth of village production

Village production, which obviously had never completely ceased, though no ancient specimens survive today, now found itself favorably positioned to best express the true creative spirit of the Caucasian peoples, unfettered by any particular aesthetic intent. The vigorous and lively new style merged the atavistic tribal spirit and the ancient Central Asian tradition with the decorative motifs drawn from the great carpets of the court period using a new interpretation. This involved a process of extrapolation, then isolation and enlargement, or vice

versa, of creating relatively denser designs with smaller elements, using a very rigid and geometric language, thanks also to the use of the symmetrical knot. This was not, then, a period of regression, of moving away from advanced forms back to more primitive ones, but an important moment in which the rediscovery of original roots led to expressive, creative growth. Technical workmanship also did not deteriorate but maintained its high level of refinement.

The new 19th-century style

We can therefore say that the true Caucasian carpet was born in the 19th century and sets itself apart from the carpets of other production areas with its simplicity and immediacy and, above all, with its overall impression of being both archaic and stately.

Caucasian carpets from the 19th century stand out for the simplicity of their composition and decoration, based on the relationships among primary and secondary elements and elements used to fill the spaces. The basic layouts consist of large medallions superimposed or arranged according to the well-known four-and-one scheme. Also frequent are full-field layouts, which include the repeti-

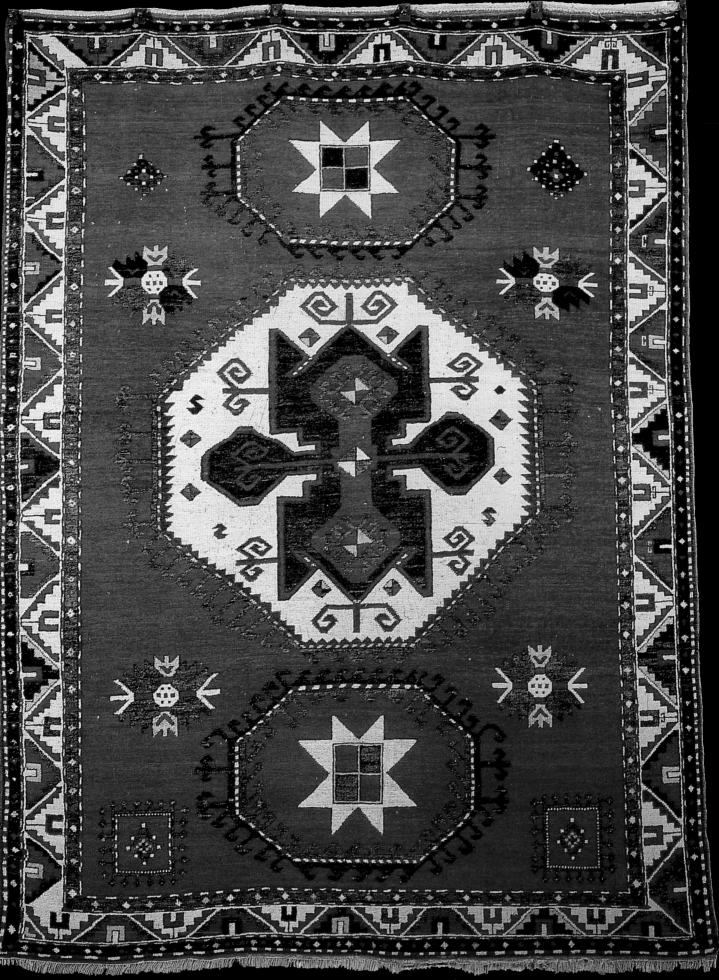

tion ad infinitum of small geometric motifs, such as *afshan, kharshang, boteh, herati* and *mina khani*, or of tiny stylized floral elements arranged in geometric grids.

This production also includes prayer rugs, with barely outlined mihrabs, often suggested only by a geometric arch, and usually filled with small and medium-size decorative elements that fill the entire field. All the resulting figures are geometric: The primary and secondary medallions are octagons, hexagons, diamonds or cross shapes, all with variously shaped profiles—stepped, fringed, smooth, hooked, and so on. Very stylized animal and floral motifs and, rarely, human figures, fill the spaces. Sometimes, eight-pointed stars, horizontal "S" motifs and small polygons are used.

Appearance notwithstanding, even the figures that seem to be completely abstract, such as the polygonal medallions, are not. Originally, in the ancient local tribal and Central Asian tradition, these figures were all taken from the natural world, and each one had a specific sym-

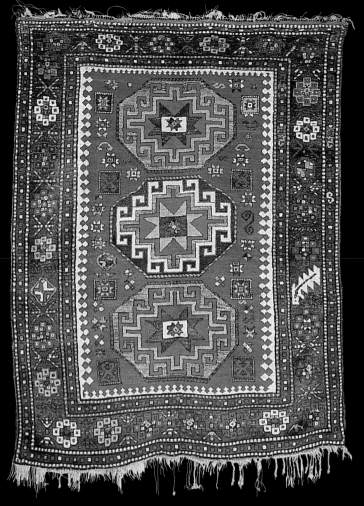

bolic meaning. Nowadays, many of these meanings have been lost or have become difficult to read, which is why these carpets are today admired for their seemingly primitive and abstract character.

Usually, these carpets have three borders: a principal border and two minor ones, always decorated with strictly geometric motifs. The designs of the principal border are varied and include especially the typical serrated leaves alternating with tulips; the characteristic wavy design of the running dog; vines with stylized floral elements; Kufic motifs; various polygons and eight-pointed stars; horizontal "S" motifs; *kotchanak* of Central Asian origin; and so on.

Highly contrasting brilliant and lively colors are used. Most common are cool or neutral tints, such as blue, various shades of green, ivory, white and black, arranged in striking contrast with an abundance of red and with yellow and orange.

Left, detail of Kuba floral carpet. Northeastern Caucasus, 19th century. Rome, Luciano Coen Collection. This carpet illustrates the Caucasian style's tendency toward more densely populated fields and smaller figures; the grid of the ancient courtly carpets has multiplied and narrowed and now contains minute geometric figures of floral origin.

Above, Kazak carpet with superimposed medallions. Southwestern Caucasus, 19th century. Venice, Rascid Rahaim Collection. The new Caucasian style was based on the elements made larger and arranged more sparsely; three large octagonal medallions enclosing a stepped-profile polygon are the primary elements and are complemented by small, geometric figures that fill the field.

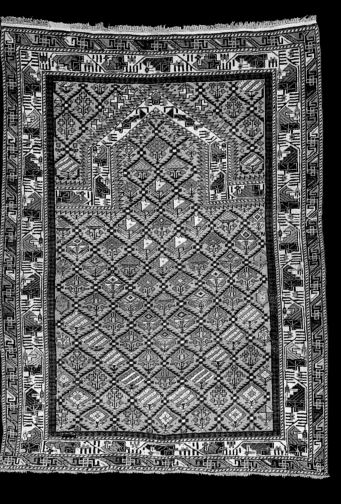

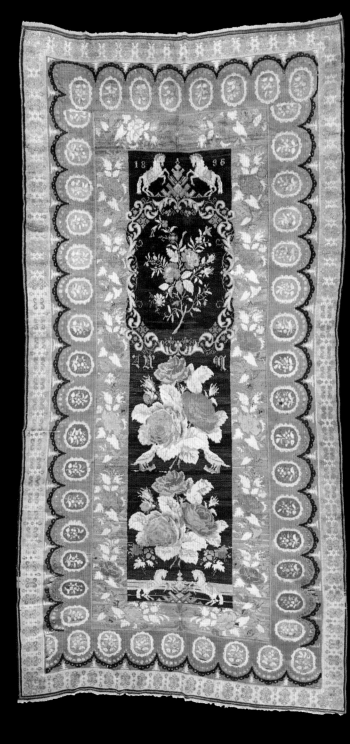

Above, Shirvan prayer rug. Mideast-ern Caucasus, 19th century. Private collection. The new 19th-century Caucasian style also reinterpreted the prayer rug, creating a special version of it in which the mihrab is recogniz-able only by the mere profile of the geometric arch, arranged over a uni-form floral grid that extends across the whole field of the carpet.

Right, Karabagh carpet with floral decoration. Southern Caucasus,

dated 1896. Bergamo, La Torre Collection. Beginning with the end of the 19th century, carpets of this type, also called "rose Karabaghs," were conditioned by the new market demands from Europe and therefore imitated the naturalistic decoration of the French baroque style. Note in this carpet the Western calendar date appearing at the top, as well as the numbers in Gothic script found in the car-pet's center.

Large quantities of the new style were produced throughout the Caucasus from the 1800s to the begin-ning of the 1900s. Most of the surviving examples are datable to the second half of the 19th century. Subdivid-ed into groups according to stylistic and structural simi-larities, they are usually classified according to the geographic area of provenance, although this is debat-able in many cases, and it is therefore preferable to group them under larger areas of provenance rather than specific localities.

The Western influence

In the first half of the 19th century, due to the heavy demand from the new Russian ruling class, the city workshops developed a Frenchified style, with geometric flower and rose decorations placed full-field or arranged in large bouquets. At first, this production was a happy blend of the local geometric tradition and the more real-

istic outside influence. Later, toward the end of the cen-tury, also because of new market demands from Europe, the realistic style came to dominate, with baroque com-positions of large, fleshy flowers and various animals such as horses and birds, drawn realistically.

These particular carpets, clearly of a hybrid nature, were manufactured especially in the Karabagh area and in the eastern Caucasus. Beginning at the end of the 19th century, also in response to the new market demands, all the geometric-style Caucasian carpets came to exhibit a generally denser composition, with more rigid designs and a larger number of borders.

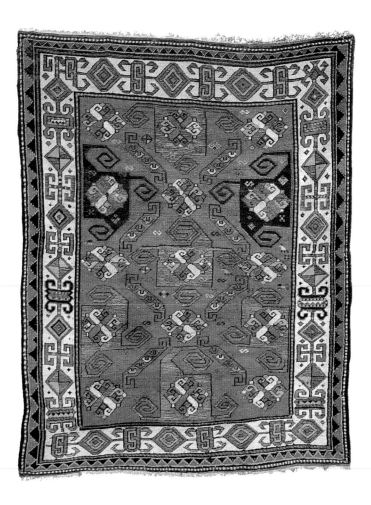

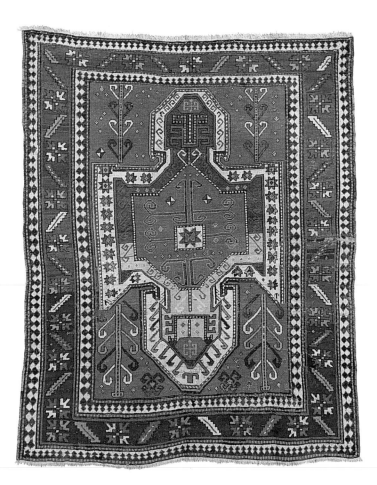

Kazak carpet with swastikas
Southwestern Caucasus, early 19th century
Milan, Michele Campana Collection

Although it denotes the most esteemed among Caucasian types, the name Kazak refers to an unspecified production area in the southwestern Caucasus, rather than a specific provenance; therefore, it groups together different productions with the same style and structure. Kazak carpets are distinguished by the sparse compositional arrangement, always consisting of large, imposing elements and strong, vivid colors. They are called "swastika carpets" because of the hooked polygons enclosing a flower, possibly a transformation of animal designs from the dragon carpets; the wide, green bands are reminiscent of the grids from those carpets. The main border has a white background.

"Sevan" Kazak carpet
Southwestern Caucasus, 19th century
Private collection

This carpet is a good illustration of the typical enlargement and sparseness of elements of the Kazak production. Carpets featuring this peculiar central polygon are named Sevan for a lake in the southwestern Caucasus; however, they were manufactured in several sites. The large, shield-shaped central medallion is derived from an ancient totemic design and also exists in two other variants. The small, multicolored trees with hooked branches arranged in the field's corners are typical of this production, as is the blue main border, with flowers and serrated leaves. The two minor borders feature the *medachyl* motif.

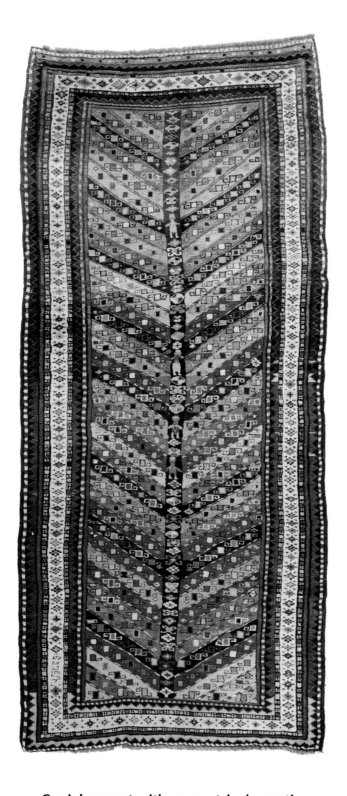

Ganjeh carpet with geometric decoration
Midwestern Caucasus, 19th century
Bergamo, La Torre Collection

The reference to the area of Ganjeh is a commercial convention for a particular production from the midwestern Caucasus that is marked by a coarser workmanship, a long, narrow shape and an unusually light color palette. Typical of this production are the multicolored diagonal stripes filled with small geometric figures of plant origin; here, instead of being parallel, the stripes converge upon the central axis, suggesting the tree of life. The central axis is pleasantly decorated with minute geometric figures and stylized human figures.

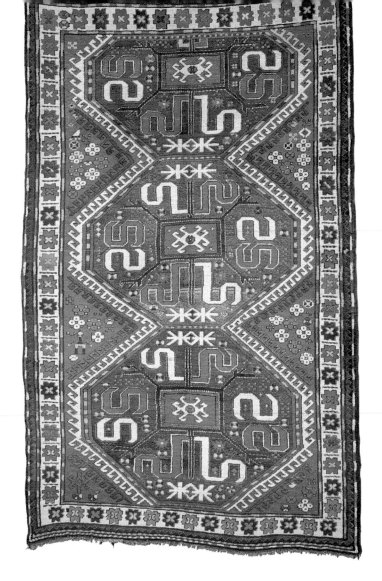

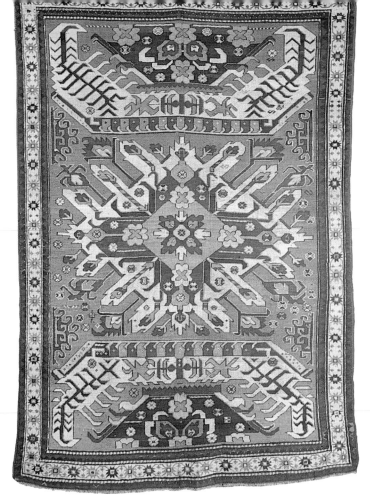

"Chondzoresk" Karabagh carpet
Southern Caucasus, second half of 19th century
Verona, Tiziano Meglioranzi Collection

The region of Karabagh in the southern Caucasus is the traditional production site where the ancient dragon carpets possibly originated. Nineteenth-century production may be classified into three style groups. The first style was produced in villages or by seminomadic tribes and is embellished with designs resembling those of Kazak. Chondzoresk carpets (so called for their presumed production site) belong to this type and are distinguished by three octagonal medallions with hooked profile enclosing snakelike elements that either are linked to the cloud-collar design or are a stylization of the dragon motif. Also present in the field is a stylized human figure.

"Chelaberd" Karabagh carpet
Southern Caucasus, second half of 19th century
Venice, Rascid Rahaim Collection

This carpet belongs to a group that is stylistically close to Kazak carpets and is distinguished by one or more unusual cruciform medallions, usually red and blue, with a white sunburst. The medallion design is based on ancient floral patterns composed of superimposed "flaming" medallions, called "Sunburst." These carpets have various appellations: Eagle or Adler ("eagle" in German) Kazaks, because the medallion recalls the two-headed eagle on aristocratic coats of arms; Sunburst Kazaks, again because of the flaming-sun shape; and Chelaberd, from the village to which production has been ascribed, although these carpets were produced in more than one village in the region of Karabagh.

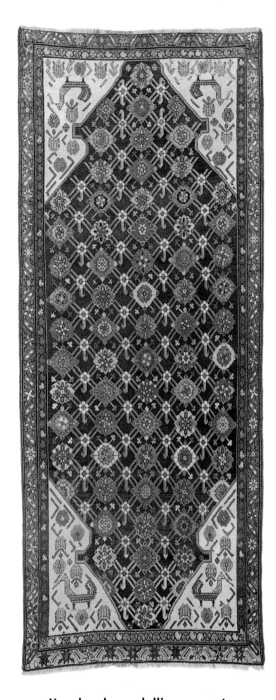

Karabagh medallion carpet
Southern Caucasus, second half of 19th century
Villastanza, Morlacchi Collection

This carpet belongs to the second Karabagh style group and refers to carpets produced in city shops that reworked Persian decorative motifs geometrically, distributing them full-field in regular fashion or setting them inside large, polygonal central medallions with a dark blue ground. Favorite among the Persian motifs are primarily the *boteh*, the *herati* and the *mina khani*, distributed in regular arrays. Here, the central medallion is embellished by a geometric version of the *mina khani* motif, recognizable by the floral grid and the tiny white flowers. In each of the four spandrels is a stylized bird.

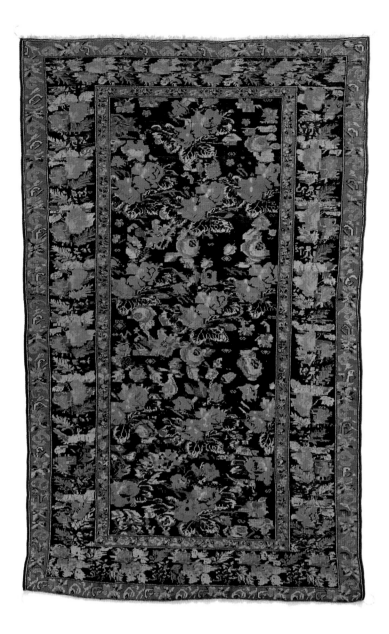

Karabagh carpet with floral or rose decoration
Southern Caucasus, late 19th century
Verona, Tiziano Meglioranzi Collection

The third style group attributed to the region of Karabagh was also produced in city shops and bears traces of the French decorative style, following the baroque taste of the new Russian nobility. Also called "rose Karabaghs," these carpets have geometric flowers arrayed full-field or in wreaths or, again, in bouquets, sometimes interspersed with stylized birds and variously shaped polygons. The borders are usually decorated with floral or geometric elements. Red and pink are the favorite colors for the flowers, which contrast strongly with the dark blue or black of the ground. Toward the end of the 19th century, production quality fell, with more lifelike representations of flowers and animals rendered with less contrasting and vivid colors, thus losing the traditional spirit.

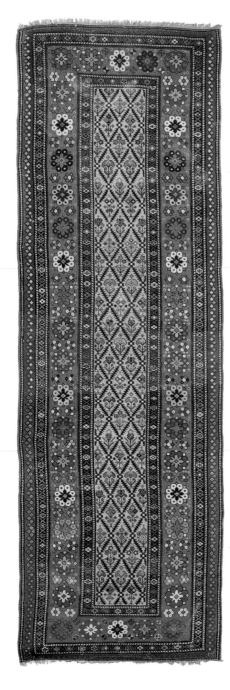

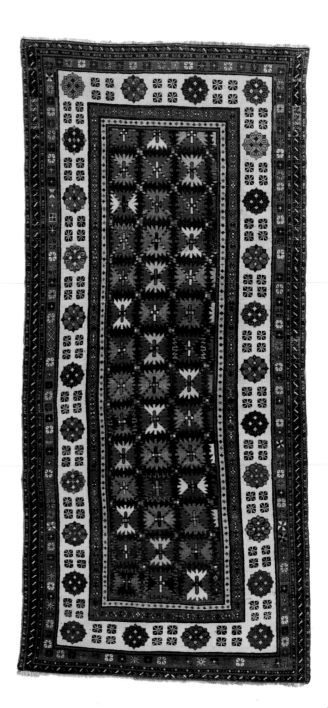

Talish carpet with floral grid
Southeastern Caucasus, 19th century
Private collection

Specimens from the region of Talish, in the southeastern Caucasus, are easily recognizable, first of all because of their long, narrow shape (on average, 100 x 250 cm, or 39 x 98"). Among the local designs, the more singular type has an empty field, usually dark blue or, rarely, red, or a field containing at the most one or two small figures; a yellow or white arrowhead motif usually gives movement to the inside perimeter. Other types present a full-field distribution of small, mostly flower- or plantlike ornaments, set in orderly rows inside a grid, as in the above example.

Talish carpet with floral decoration
Southeastern Caucasus, 19th century
Bergamo, La Torre Collection

The dark blue ground of this carpet is filled with multicolored geometric flowers with squared, notched corollas; each corolla is joined by its corners to other flowers to form a grid, as in the carpet at left. In the above example, note the main border's decoration, which is typical of this production in color and design: On a white background are placed roundish, multicolored rosettes separated by four small squared flowers neatly arranged. The numerous secondary narrow borders are decorated with small geometric elements and are also typical of this production.

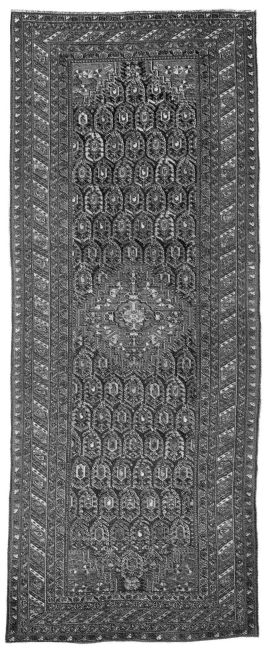

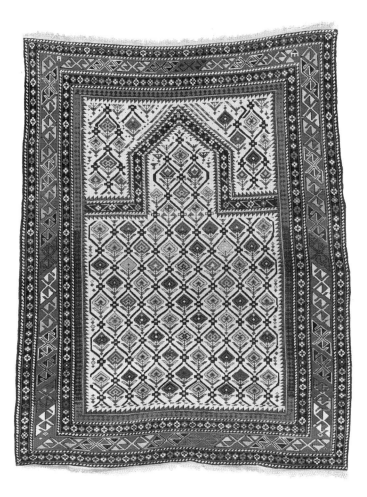

"Hila" Baku carpet
Mideastern Caucasus, 19th century
Private collection

Carpets from the region of Baku, in the mideastern Caucasus, contain primarily *afshan* or *kharshang* designs and are not vividly colored. Hila carpets, typical of this area, are named after a town in the northwestern part of Baku, although there is no certainty that this is their provenance. They are recognizable by their decoration, which recalls the medallion layout with sharp profiles of the Persian carpets: On a dark blue field scattered with multicolored *boteh* infinitely repeated, or inside grids, are set one to three small, eight-sided medallions with stepped profiles and four corner motifs, in turn enriched with flowers or stylized animals.

Daghestan prayer rug
Northeastern Caucasus, 19th century
Bergamo, La Torre Collection

The carpets from Daghestan in the northeastern Caucasus stand out particularly for their knotting, which is not very refined, and their high pile. Carpets with a white or blue ground and serrated-grid layouts containing geometric figures are usually attributed to this provenance. The prayer layout is often superimposed on this pattern, as in the above example, where the mihrab is recognizable only by the arch's geometric profile. Noteworthy are the numerous borders—the main border being decorated with a hooked motif—typical of this region. All prayer rugs with light-colored grounds are often said to come from Daghestan, although this does not take into account the Shirvan production.

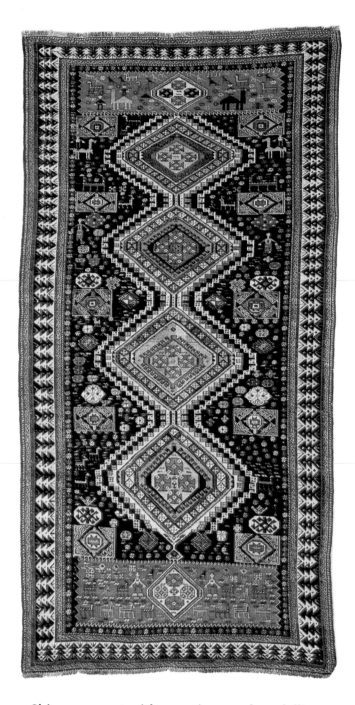

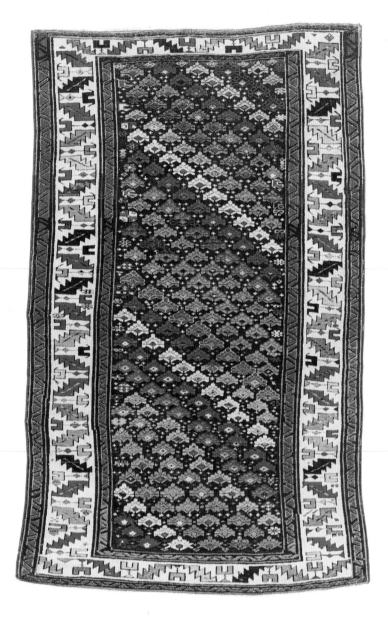

Shirvan carpet with superimposed medallions
Mideastern Caucasus, 19th century
Private collection

The numerous carpets from the region of Shirvan, in the mideastern Caucasus, come in a variety of decorations and may be classified into three types of layout. The first type is a superimposed-medallion layout with medallions of different geometric shapes. The type represented here has an unusual design: Large hexagonal medallions with stepped profiles are linked to each other and enclosed on each of the short sides by two red panels with serrated edges; the panels, in turn, are filled with stylized human and animal figures, which also embellish the dark ground of the field. Note the borders, especially one filled with superimposed arrowheads.

Shirvan carpet with floral decoration
Mideastern Caucasus, 19th century
Bergamo, La Torre Collection

Carpets with an eastern Caucasian provenance are marked by smaller and more densely arranged decorative elements that often yield a mosaic effect. This is clearly seen in the second Shirvan type, where tiny geometric floral elements or Persian motifs, such as the *boteh* and the *mina khani*, or other imaginary figures are distributed full-field in rows or inside grids. The above carpet features a decoration of tiny geometric flowers distributed full-field in rows of different colors. Note the principal border decorated with a classic notched-leaf motif.

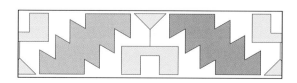

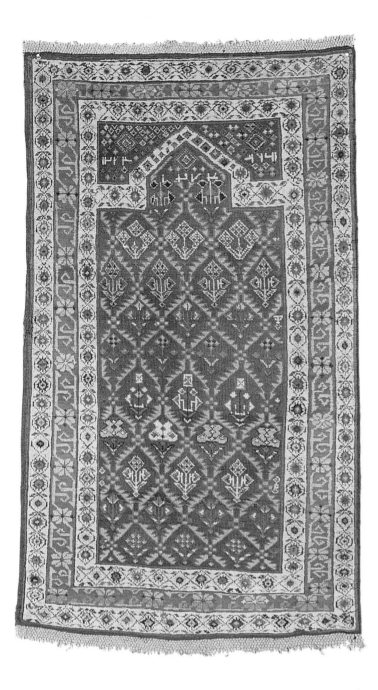

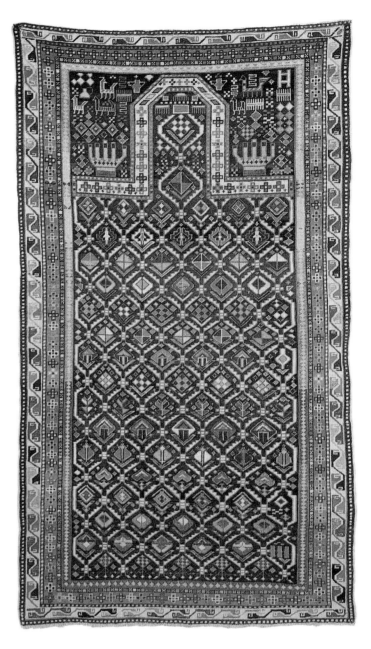

Shirvan prayer rug
Mideastern Caucasus, dated 1855
Venice, Rascid Rahaim Collection

The third Shirvan type comprises a good number of prayer rugs with a dark (blue or brown) or light (ivory or white) ground, embellished with small flowerlike elements arranged in an endless array inside hexagonal grids; the mihrab arch is superimposed on this design and can be square, five-sided or pointed. In this carpet, the mihrab arch is actually the inside border, which has a white ground and is filled with a flowering vine that even extends into the field. Above the arch, inside and on each side, are inscriptions, including the date.

Shirvan prayer rug
Mideastern Caucasus, second half of 19th century
Rome, Luciano Coen Collection

This Shirvan type contains several recurrent elements. For example, stylized figures of birds or vases are featured alongside the tiny geometric decorations on each side of the arch; farther down on each side are stylized yellow hands, which mark the position of the faithful on the carpet and were probably also intended to ward off evil. Totemic elements are characteristic inside the arch; this particular carpet contains comblike motifs that appear frequently but whose meaning is obscure.

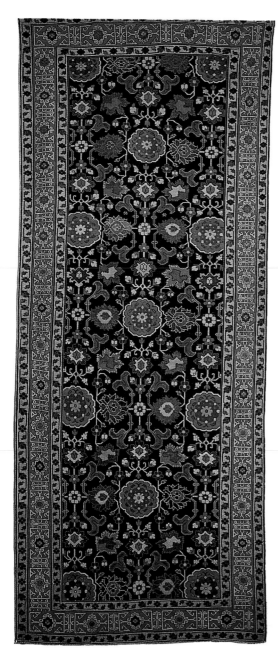

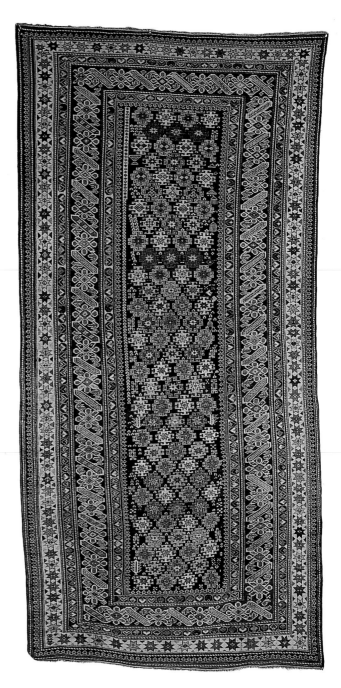

Kuba carpet with floral decoration
Northeastern Caucasus, 19th century
Venice, Rascid Rahaim Collection

The *afshan* and *kharshang* designs, reproduced here full-field, are typical of carpets from the region of Kuba; therefore, the provenance of all Caucasian carpets that contain them is usually attributed to Kuba, although such designs were also common in the region of Baku. Thus, only by examining the colors (which are stronger and richer in Kuba carpets) and the carpet's structure can we determine their true provenance. This particular specimen takes its inspiration from the floral models of the courtly period: In it, we recognize the *afshan* design with the white central rosette and the four long-stemmed, forked leaves, as well as the large, roundish rosettes and the sunburst palmettes. The main border is embellished with a Kufic motif.

"Chi-chi" Kuba carpet
Northeastern Caucasus, 19th century
Venice, Rascid Rahaim Collection

Carpet types that take their name from villages and towns close to Kuba are classified as part of the Kuba production, although their provenance may be questionable; therefore, the names of these carpets indicate only styles and designs with any certainty. Chi-chi carpets like this one, named for a village south of Kuba, are recognizable by the ground and the principal border. The field is usually dark blue and is covered with small, hooked, multicolored octagonal medallions set densely in rows. The principal border is decorated with an unusual motif trimmed in white on a blue or black ground and is composed of octagonal, cross-shaped rosettes alternating with oblique barrettes.

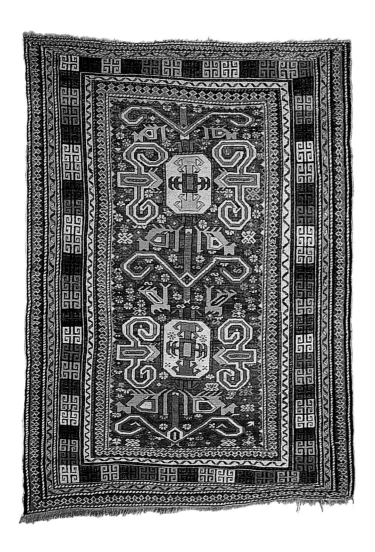

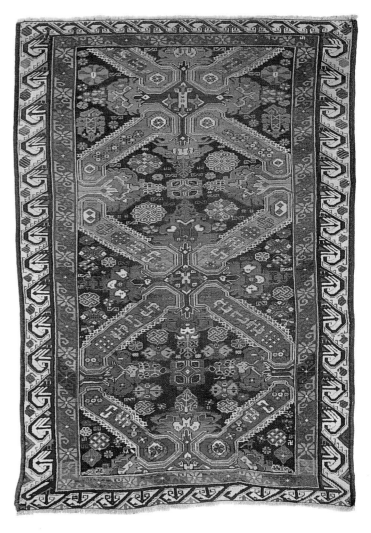

"Perepedil" (or "Perpedil") Kuba carpet
Northeastern Caucasus, 19th century
Venice, Rascid Rahaim Collection

Perepedil carpets take their name from a village north of Kuba. They are recognizable by an unusual field motif resembling rams' horns, in reality derived from ancient tribal emblems or from an early design of animals facing each other. This design has a white background and is set on the blue ground of superimposed medallions—the latter being primarily octagonal and light-colored—together with rosettes, geometric floral elements and facing pairs of stylized birds set above and below each medallion. Note the unusual main border embellished with a three-colored geometric pattern.

"Seichur" (or "Zeichur") Kuba carpet
Northeastern Caucasus, 19th century
Private collection

Seichur carpets, so named after the town north of Kuba, are recognizable by the white and blue running-dog design of the main border and by the use of a particular shade midway between rose and brick-red, which is often paired with red. It is also, and especially, recognizable by a field motif in the shape of St. Andrew's crosses, formed by four thick diagonal bars that depart from cruciform medallions set along the carpet's main axis. The crosses create a diamond-shaped grid, descended from ancient dragon layouts, which, in turn, encloses small geometric figures.

INDIA

In India, before the consolidation of the Mogul dynasty (1526–1858) founded by the legendary Babur (1526–1530), the knotted carpet was unknown as an artistic genre and a utilitarian object, probably because the region's warm climate does not require protection from the cold ground. Hence the Indian carpet exists not as a result of a spontaneous, centuries-old tradition but because of an imperial act of will. Emperor Humayun (1530–1555), who had taken refuge in Persia in 1544 in the wake of an Afghan revolt, had first been exposed to the refined craftsmanship of the Persian court ateliers and was so impressed that when he left, he asked for master designers to bring back to India. In any case, his successor, the emperor Akbar (1556–1605), an admirer of Safavid culture who was interested in carpets, ordered that specialized workshops be set up in Agra and Fathepur Sikri, the two capitals of his empire, as well as in Lahore, in modern-day Pakistan.

Therefore, from the very beginning, the knotted carpet in India was strictly a luxury object intended to decorate the palaces of the Mogul court and thus was inevitably destined to decline along with the court's waning, which began toward the end of the 18th century. These carpets have, then, a very rich character, though without the ideal and abstract elegance of the Persian production. Instead, they are concrete and exuberant, reflecting a sensibility based on naturalistic representations and brilliant colors.

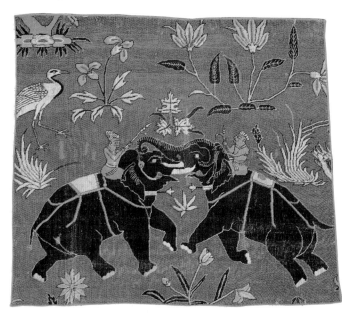

Figural Indian carpet fragment
17th century
Washington, The Textile Museum

The early Indian carpet

The Indian carpet came into being to serve the same purposes as the "classic" Persian carpet and thus adopted basic Persian features. A prime example is the technique, which uses the asymmetrical system, but with denser knotting more suited to rendering details realistically. In fact, the average density of the finest Indian carpets is about 15,000 knots per dm² (1,000 knots per square inch), sometimes reaching 30,000–40,000 knots per dm² (2,000–2,700 per square inch). Also, the Indian carpet was usually medium or large in size, reaching as much as 500 x 600 cm (197 x 234"). Finally, it used precious materials, such as priceless soft and shiny Kashmir wool, gold and silver threads and especially silk, which was often used, usually trimmed low, both in the foundation and in the pile.

Stylistically, the Indian carpet borrowed from the Persian carpet the curvilinear style with very refined flower or figure designs created by the court miniaturists. The first extant Indian examples are datable to the end of the 16th and beginning of the 17th centuries and consist of fragments representing grotesque figures, with heads of real and mythical animals, very close to the Persian rep-

resentations of the *waq-waq* tree, a legend that was also known in India.

Indo-Isfahan or Indo-Persian carpets

The most important examples of direct influence from Persian art are found in the 17th century in the so-called Indo-Isfahan or Indo-Persian carpets, datable, for the most part, to the first half of that century and distinguished by typical Safavid designs based on in-and-out palmettes, *herati* and sometimes cloud bands, arranged neatly on a full field. Initially attributed to Persia, and specifically to Herat, these carpets were later differentiated into two groups based on their color combinations and their degree of calligraphic sensitivity. Those with the most intense colors, with lac-red grounds and designs with pale outlines or no outlines at all, were said to show Indian sensitivity, while the others were said to reveal Persian taste.

As these are minor differences, we have preferred not to use this distinction and to treat these carpets as proof of the close relationship between the Safavid and Mogul courts, attributing to them a common Indo-Persian style, without any further differentiation.

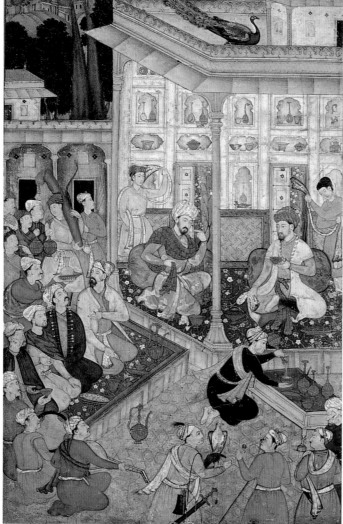

Left, the Emperor Babur receives Bedi-Uzzalman Mirza. Watercolor on paper from *Babur Nameh*, c. 1593. Paris, Musée Guimet. This miniature depicts floral carpets with a blue ground; there are no surviving specimens of such carpets.

Below, fragment of carpet with animals. Late 16th or early 17th century. Paris, Louvre. The grotesque character of this fragment, with heads of real and fantastic animals, recalls the Persian *waq-waq* tree.

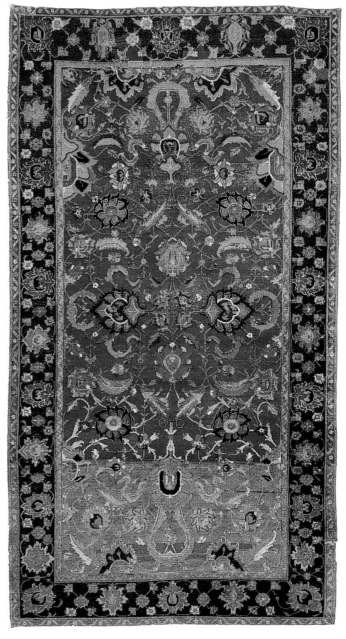

Lac Red

The unusual intense red with typical bluish reflexes (known as "lac red") that is used in the field of Indian carpets as a distinctive ground color is not a product of the madder root—a more commonly used plant-dyeing substance in the Orient —but is derived from the *Laccifer lacca*, a small type of fluid-containing insect. The female insect secretes a purple, resinous substance with which it creates a cylindrical shell; when the shell is ground, it yields a red powder that confers the characteristic red color to Indian yarns. In other parts of the Orient, another type of insect, the *Coccus ilicis*, or *Kermes*, was used; the dried, reddish bodies of these insects also yielded a coloring powder. At the beginning of the 19th century, yet another type of insect, the *Coccus cacti*, introduced from America, came into use. A parasite of the cactus plant and containing a high carmine-red content, it became popular in all the carpet-producing regions. Starting in the second half of the 19th century, chemical dyes, which were less expensive and yielded a colder, more uniform coloring, also came to be used in India.

The Mogul style

During the 17th century, as local miniaturists and artisans slowly replaced the Persian masters and workers in the large workshops, the carpets began to reflect a specifically Indian character, thus becoming less dependent on Persia and better adapted to interpreting the taste and needs of the dynasty in power, like the other artistic forms of the region.

Mogul carpets are recognizable, above all, for their floral and figure elements rendered with highly realistic detail made possible by the use of very dense and minute knotting. These decorative elements are typically arranged in directional layouts and distributed in completely asymmetrical fashion, unlike the symmetrical rigidity of the Persian compositions and the central-medallion layout. The area of the carpet is not densely filled with designs and much less with arabesques, thus achieving a nice balance between full and empty spaces, not with *horror vacui* but, rather, with the clear intent of showcasing the carpet's ground and its particular color.

Finally, Mogul carpets are recognizable for their unique color palette, a result of the masterful skill of Indian dyers, who could achieve, especially by repeated dyeings, unusual shades and colors so intense that they seem enameled. Lac red, with its unusual bluish reflections, is typical of Indian carpets; used in the ground, it highlights even more the designs colored in light yellow, mustard yellow, light red, pink, light blue, midnight blue, light green, emerald green, orange, black and brown. Another feature of Mogul carpets is the way one color segues into another, for this is done without outlines, even when two related tints, such as red and pink, or blue and light blue, are used side by side. These devices bring out depth and give an almost three-dimensional quality to the figures, thus highlighting the realistic intent of Mogul art.

Indo-Isfahan or Indo-Persian carpet with floral decoration. India?, 17th century. Lugano, Thyssen-Bornemisza Foundation. This type of floral carpet, with palmettes, *herati* and arabesques, was produced in India as well as in Persia. The lac red of the ground and the absence of black contour lines around the designs would tend to assign the provenance of this carpet to India.

Below, typical Indian borders with masks and naturalistic flowers.

These carpets have borders with a dark, very intense green-blue ground, which contrasts with the lac red of the field, giving it more depth. Finally, Mogul carpets are distinguished into floral and figural types.

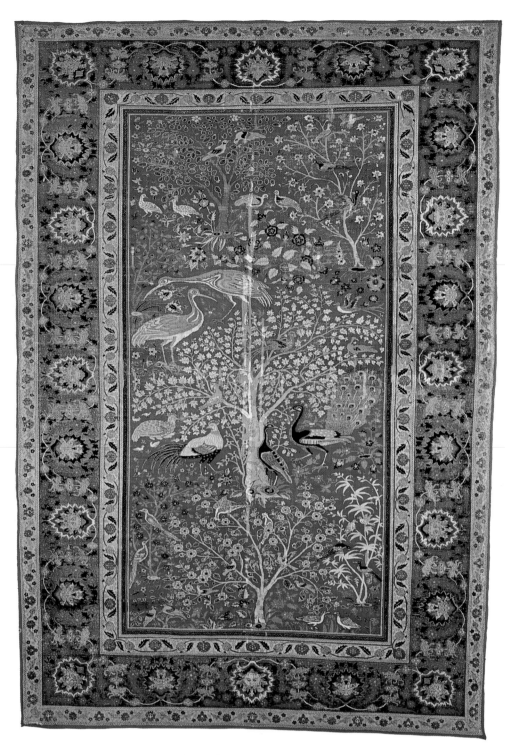

Figural carpet with animals
Early 17th century
Vienna, Österreichisches Museum für angewandte Kunst

This magnificent specimen, also known as the "peacock carpet," was probably designed by the painter Mansur, who worked at the court of Emperor Jahangir. The figural Mogul style is well represented here: first, in the realistic intent, since these are not mythical animals but real peacocks, partridges, herons, pheasants, and so on; second, in the lack of any symmetrical Persian-style rigor; and finally, in the typical lac-red color of the ground, which contrasts with the dark tint of the main border. Note the strange masque motif, which always decorates the borders in carpets of this type.

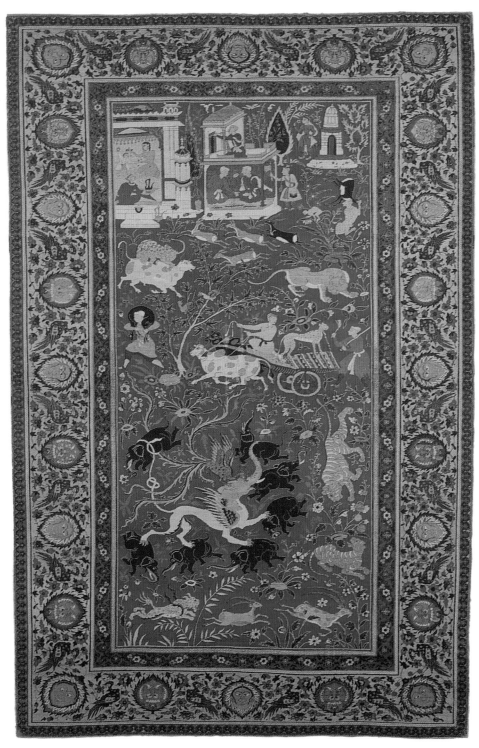

Figural carpet
Early 17th century
Boston, Museum of Fine Arts

The representation of figures in this carpet was influenced by local miniaturist art. This is especially true of the vignettes in the upper part of the carpet, where the figures are placed inside clearly drawn architectural units—note, in the upper left corner, a mother with child. The rest of the figures are lively and kinetic, foreign to Persian aesthetics but proper for the Mogul version of this style. All symmetry is absent, and there is a painterly attention to detail, made possible by the extremely fine knotting. Note the presence of local animals, such as the elephant and the tiger.

The typical Mogul prayer rugs have mihrabs with variously shaped arches that enclose large flowering plants, embellished above and below with other, smaller plants and flowers. Influenced by European herbals, all flower images take their inspiration from the real world of flora. Interesting is the characteristic lac red of the ground against which the white corollas of the larger flowers stand out.

Small carnations, open and budding, are drawn in the principal borders and in the spandrels.

The narrow side borders might point to an earlier presence of two additional mihrabs and, therefore, of a primitive multiple-niche, or *saph,* layout.

Small flowering plants resembling carnations, campanulas and snapdragons are realistically drawn on the ground.

The naturalistic character of this plant, which resembles a lily, is underscored by the unusually lifelike rendering of the leaves, which show all their veins and are even folded in various ways to achieve a three-dimensional effect.

The snail-like composition of the small stones in the lower part of the carpet and the clouds above are derived from Chinese art, which clearly penetrated into India through Persia.

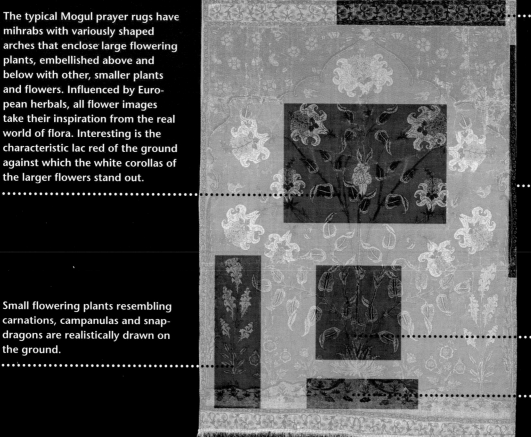

Prayer rug
Early 17th century
Lugano, Thyssen-Bornemisza Foundation

Flowers, and especially flowering plants, are the true protagonists of all the art forms of the Mogul style and therefore are also *de rigueur* in carpet decoration. In this specimen, as in the carpets with animal figures, the subjects are not abstract but truly lifelike, inspired by the natural world. They are arranged either in prayer-rug layouts or full-field, inside grids or scattered in groups of plants.

Flowers and the Mogul emperors

Like Persia, which always gave special consideration to flowers and gardens in all the arts, from poetry to carpets, Mogul India also stands out for its passion for the world of flowers. As early as the beginning of the 16th century, the famous Babur, founder of the dynasty, had many gardens set up on his lands, taking as inspiration the garden of Eden of which the Koran speaks. His nephew Akbar, the third Mogul emperor, supported the development of floral motifs in the decorative arts but, being still under the Persian influence, only at the idealized level of very stylized palmettes, buds and leaves.

It was only during the reign of Jahangir (1605–1628), Akbar's son, that the floral motifs took on new meaning and form. During a spring convalescence in Kashmir, a land rich in plants of many species, Jahangir, who was enamored of botany, asked the famous miniaturist

Mansur to join him and to execute several drawings of flowers in the fashion of herbals and prints that had been brought to India by European ambassadors and missionaries. Upon the emperor's return, these flower and plant drawings became the fashionable decorative genre at court. In this way, thanks to the early emperors' aesthetic inclinations and especially to Jahangir's passion for botany, a genuine Mogul floral decoration was born, inspired by nature and achieved with a realistic technique, depicting such a wide variety of species as to compete with Western herbals.

During the reign of Shah Jahan (1628–1658), son of Emperor Jahangir, the Mogul floral style reached full expressive maturity, evident in the perfect realism and the careful attention to detail. In particular, the flowering plant became the preferred motif in every artistic genre, from architecture and miniatures to carpets. It was dur-

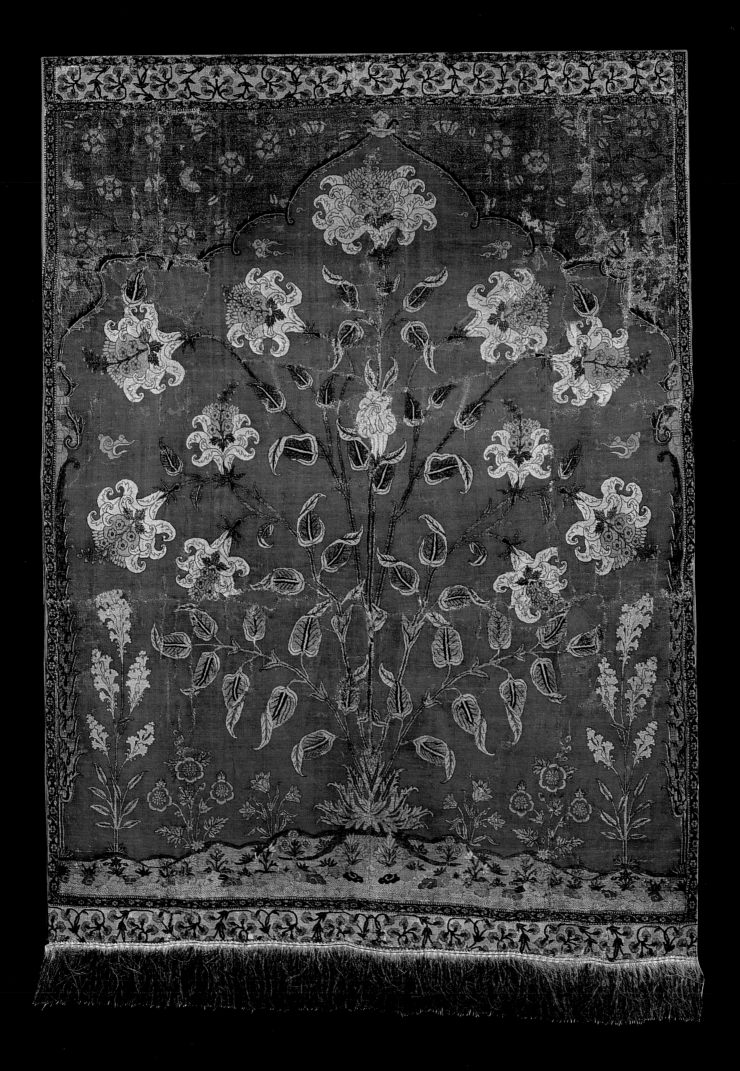

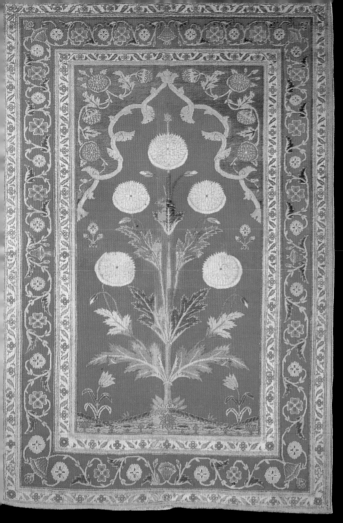

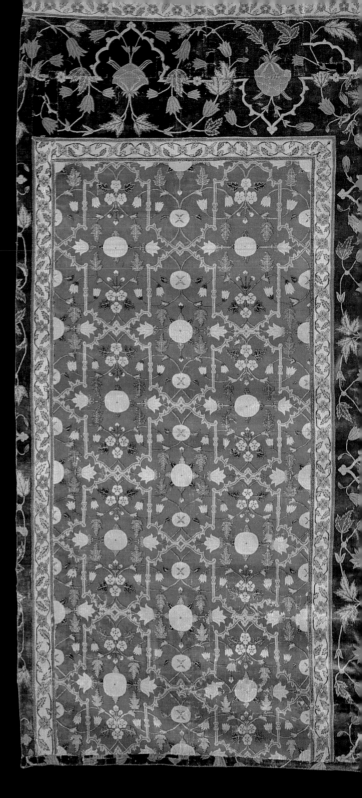

bove, prayer rug. 17th century. ew York, The Metropolitan Muse- m of Art. The flowering plant, ypical of the Mogul style, can easily ecome the protagonist of prayer- ug layouts. Here, the tree of life be- omes a naturalistic chrysanthemum lant, whose white flowers stand out n the typical lac-red background. he borders also are decorated with oral motifs: The principal border ontains a slender vine with rosettes lternating with four-petal flowers.

Right, carpet fragment with floral grid. 17th century. Lisbon, Fundação Calouste Gulbenkian. In Mogul carpets, flowers are some- times scattered full-field inside vari- ously shaped grids in nondirectional layouts. In this example, the geo- metric mixed-line grid contains large, roundish flowers, along with smaller flowers, buds and serrated leaves. Note the wide border em- bellished with a leafy vine, tiny flowers and large palmettes.

ng his reign that probably the largest number of high- value (for style and technique) carpets was produced. Unfortunately, only a few fragments remain, often de- picting the typical Mogul flowering plant together with Persian decorative elements, such as palmettes or *herati*.

Flowers and carpets
A distinctive decorative element of Mogul style and aste, flowers are arranged in various ways in the field. The prayer rugs, a type foreign to Indian religious life, eature a mihrab with the highly elaborate arch common o Mogul architecture and, inside it, a single flowering plant, rich in leaves and flowers, shown in a large, realis- ic transformation of the symbolic tree of life. The plant ses from the soil and is not flanked by sacred lamps

or water basins, as is the case with Anatolian or Persian carpets, but by other, smaller flowering plants of other species always growing from the soil.

The field color is generally lac red, and the borders and corners are also filled with small floral motifs. Often, in- stead of being completed at each side by small columns or pillars, the mihrab is flanked by sections of leafy- branched cypresses in decorated vases or growing from the soil.

Another group of carpets, in which many naturalisti-

ally depicted flowering plants of different species are distributed full-field in horizontal rows alternating on a lac-red ground, are more typically Indian, so much so that they are considered to represent the Mogul style. Also included in this group are certain rare and uniquely shaped examples with one curved or oblique side, probably meant to be placed around the base of thrones or fountains in the Mogul royal palaces, like the Amber Palace near Jaipur (c. 1630).

The 18th century

Toward the end of the 17th century and during the 18th century, flowers became denser, smaller and more stylized. In fact, in the so-called *millefleurs* ("thousand flowers") prayer rugs, the interior of the mihrab is decorated with myriad tiny flowers of various species, always growing from a single plant. The niche, on the other hand, is always flanked by two cypress trees. Close to the *millefleurs* style is a full-field style in which the small,

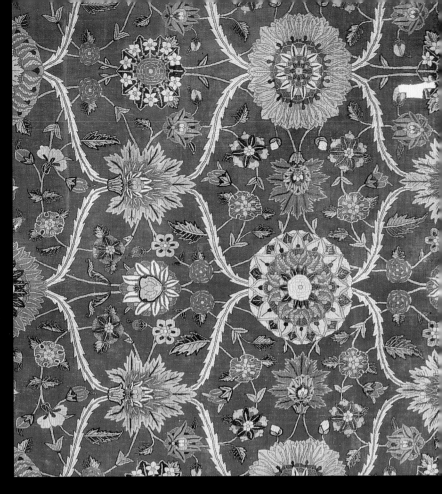

Below, Shah Jahan grants a hearing. Watercolor on paper. Mid-17th century. London, Office Library. Of interest in this miniature is the large floral-grid carpet with roundish flowers in a geometric grid (similar to the carpet illustrated on the opposite page) and the architectural decorations in which flowering plants dominate in typical Mogul style.

Right, detail of carpet with floral grid. Mid-17th century. New York, The Metropolitan Museum of Art. Sometimes the grid has an ogival shape, with its lines formed by serrated leaves, and the floral elements recall the palmettes and rosettes of Persian carpets. These elements, included in this unusual grid, are reminiscent of the Persian carpets decorated with vases.

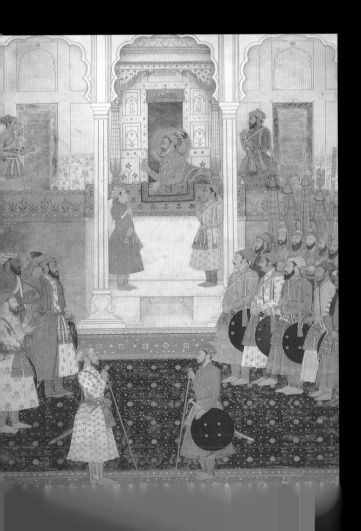

dense flowers are linked to each other by their stems, thus recalling the Persian floral arrangements.

The 19th century

Already in crisis at the end of the 1700s, the Indian carpet suffered in the 1800s from having to meet market demands, which led to technically perfect reproductions of classic Mogul models or to the adoption of European themes or, again, to the imitation of classic Persian motifs. In addition, in the same period, the local workshops came to be owned or managed by English or European companies.

Nevertheless, Indian carpets maintained their high quality at least until the 1860–1870 period, when the introduction of chemical dyes caused even the renowned Indian colors to start losing their intensity. All the surviving specimens from this time were made in city workshops, but given their general stylistic uniformity, it is impossible to accurately determine their provenance. Conventionally known as Agra carpets, after the name of that city, these carpets can be broadly distinguished by the quality of their wool: If it is soft and shiny, the carpet was probably made in a northern region, such as Lahore or Srinagar, Rajasthan or Uttar Pradesh; if the wool is coarse and opaque, it probably comes from southern regions, such as Masulipatam.

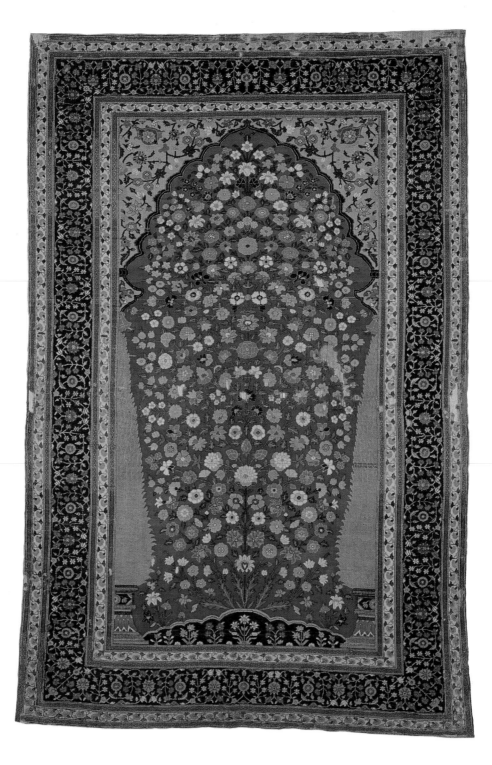

Prayer rug
Late 17th century
Vienna, Österreichisches Museum für angewandte Kunst

In *millefleurs* prayer rugs such as this one, the single large-flowering plant of the Shah Jahan period is replaced by a single densely flow-ered shrub that fills all of the mihrab's space, the myriad tiny flowers all of different form and hue. On each side of the mihrab is a partial cypress rising from a decorated vase, a constant element of *millefleurs* prayer rugs. Of interest are the two upper spandrels filled with a flowering arabesque on a yellow ground, as well as the minor borders embellished with a frieze of small yellow carnations on a white ground. The *millefleurs* pattern enjoyed wide popularity in the 18th and 19th centuries.

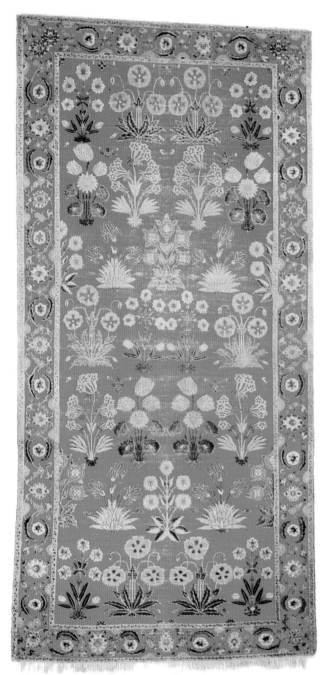

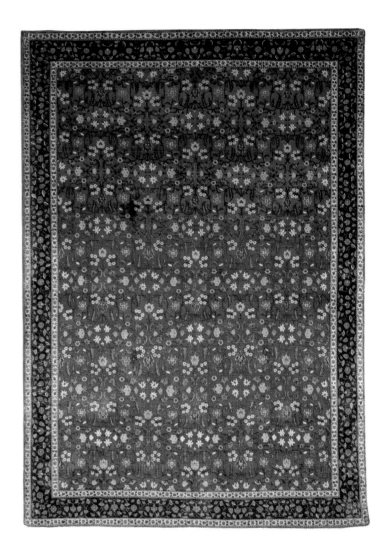

Carpet with floral decoration
First half of 17th century
New York, The Metropolitan Museum of Art

Carpet with floral decoration
Early 18th century
Oxford, Ashmolean Museum

Following the most typical Mogul style, as in this carpet, the flowering plants are distributed full-field in an oriented layout in horizontal alternating rows. They are the only element decorating the field, and although placed next to one another, they do not hide the lac-red ground. In the absence of *horror vacui*, there is no need for arabesques or other filling ornaments. Among the flowers portrayed from the natural world, we recognize carnations, chrysanthemums, irises, campanulas and roses. The principal border is embellished with a *herati* design of Persian origin, complete with palmettes, rosettes and the usual lanceolate leaves.

In this extremely elegant carpet, the full-field flower decoration shows traces of Persian influence, especially in the *herati* pattern, in the sickle-shaped, serrated leaves and in the palmettes. The vivid color contrast of pink and lac red and the variety of lifelike flowers, with their careful and detailed rendering, are all typical Mogul traits. The smallness of the flowers and buds and their dense distribution share the spirit of the *millefleurs* prayer rugs of the same period. This pattern was picked up again with much success in the 19th century.

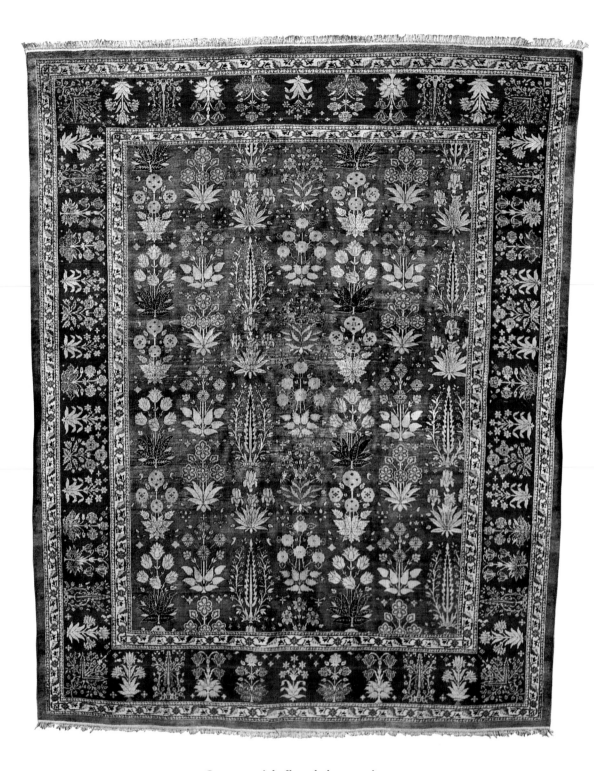

Carpet with floral decoration
Northern India, 19th century
Piacenza, Malair Collection

This large carpet (350 x 450 cm, or 138 x 177") clearly takes its inspiration from one of the more classic Mogul layouts, consisting of horizontal rows of flowering plants extending full-field; the same pattern recurs in the principal border, although with different motifs. As in 17th-century carpets, the flowers are rendered accurately and are copied from the natural world: At the very least, we recognize irises, chrysanthemums and cyclamens. The color palette, however, is no longer as brilliant and as varied as in the classic carpets; gone are the lac-red ground and the multicolored corollas of the flowers, a result of replacing the traditional natural dyes with chemical ones.

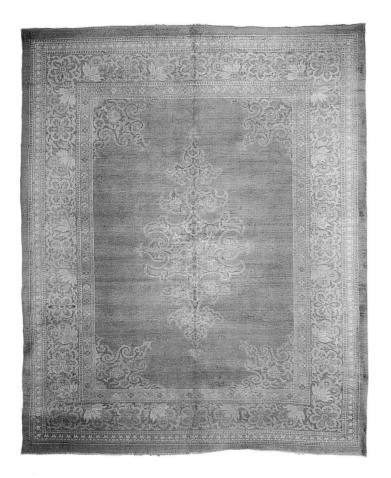

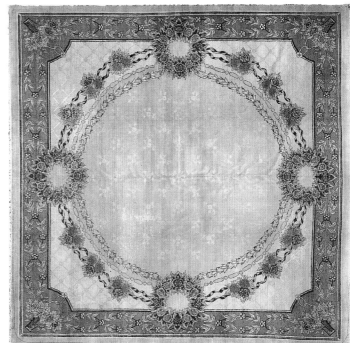

Medallion carpet
Northern India, second half of 19th century
Rome, Luciano Coen Collection

The above design is foreign to Mogul tradition and is clearly inspired by the Persian Kerman or Kashan central-medallion style. However, some elements decidedly more in keeping with Indian decorative tradition remain, in the sinuous shape of the medallion and spandrels and, above all, in the realistically rendered roundish flowers and fleshy buds that fill the border. Like the previous example, this carpet also has a more limited color palette, with three basic subdued tints, in accordance with the taste of the times.

Carpet with floral decoration
Northern India, second half of 19th century
Milan, Nilufar Collection

Nineteenth-century Indian carpets took their inspiration from ancient Mogul models, Persian styles and French Savonneries and Aubussons. The Western influence is evident in the architectural composition and decoration of this carpet; in fact, the main border is conceived as a ceiling molding, and the large round frieze is composed of four wreaths of typical Frenchified roses, bouquets of three roses, flourishes of ribbon, a fake beaded molding and a slender, monochrome floral cornice. Note also the precious pastel colors and the field's decoration, a refined tone-on-tone interplay of light beige and cream.

WESTERN TURKESTAN

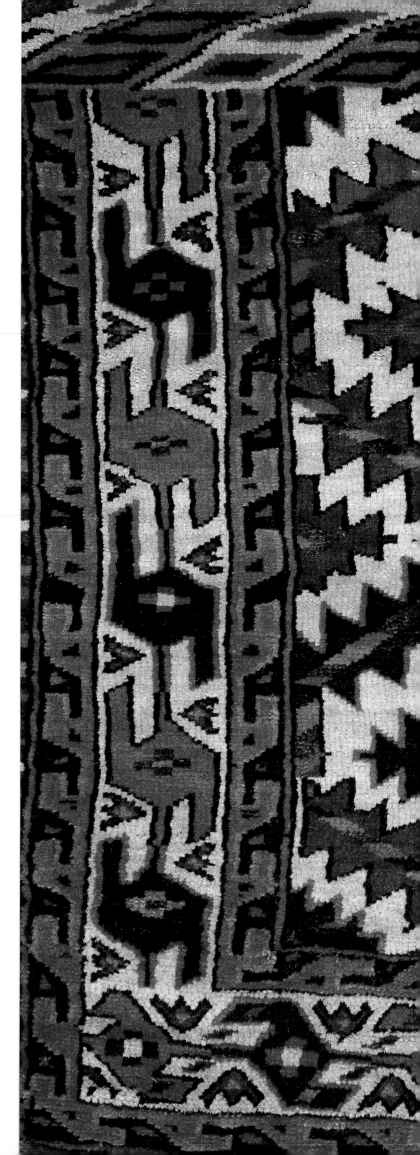

Carpets produced in Central Asia include those made in two distinct geographical areas: western and eastern Turkestan. For purposes of carpet production, western Turkestan is usually meant to refer to a complex region, not geographically uniform, that includes Turkmenistan, Kara-Kalpakistan, Uzbekistan, part of eastern Persia and part of northern Afghanistan.

It was quite probably in this vast region that the technique of carpet knotting was born and from which it expanded by way of periodic migrations of peoples. In the new regions where carpet making was introduced, it was subjected to a process of evolution that, from Anatolia to China, transformed it into a stately product made for the courts. In western Turkestan, however, it continued to maintain its original significance as an object tied to the people's daily life, religion and art. Hence the carpets from this region are unique in having exclusively kept intact their original, nomadic character.

Over the centuries, the nomadic and seminomadic Turkoman tribes have used the knotting technique to make their carpets, sacks and other objects of daily life, following an ancient tradition that has remained unaltered in terms of both technique and style. These carpets have been made on rudimentary horizontal looms by women and young girls, who primarily used the asymmetrical knot to perpetuate traditional designs and colors within decorative layouts that have been set and codified by the customs of each tribe and handed down orally from generation to generation.

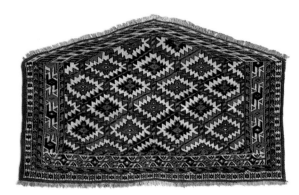

Asmalik Yomut with geometric decoration
Second half of 19th century
Rome, Luciano Coen Collection

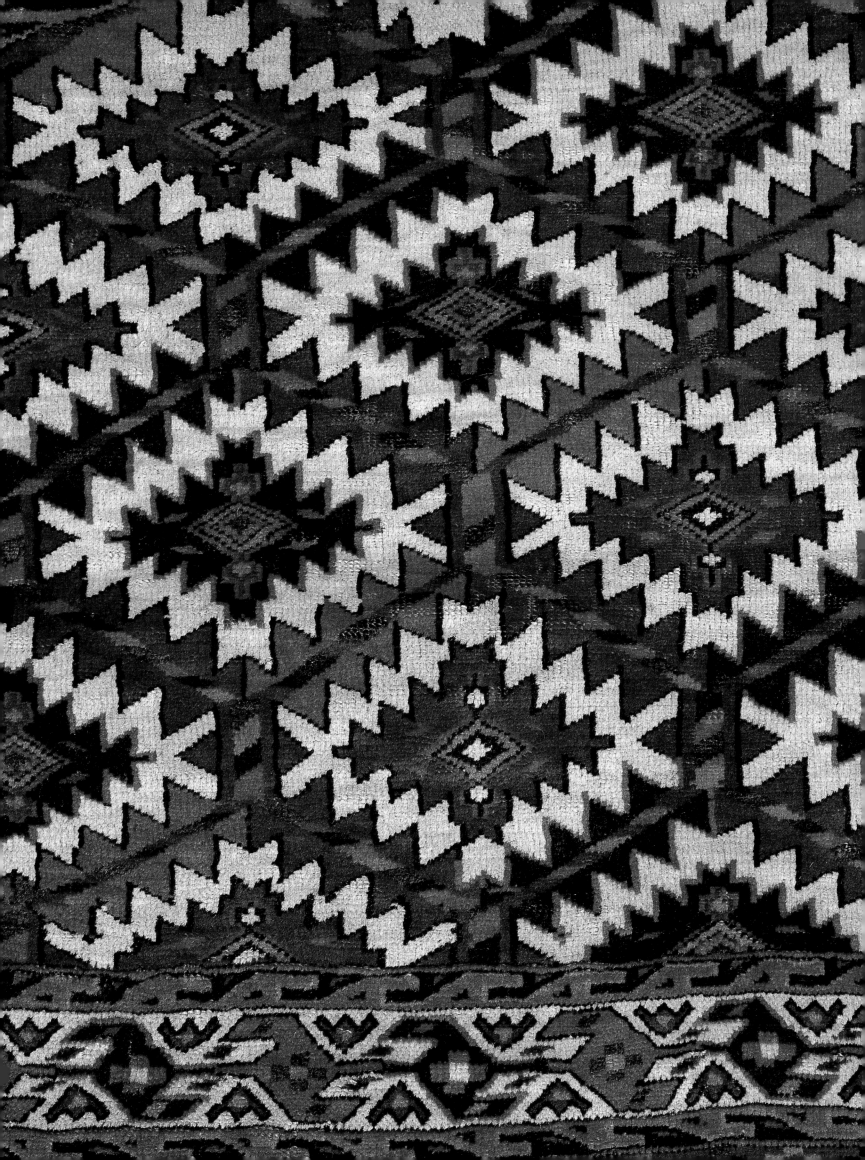

An unmistakable style

Carpets from western Turkestan are easy to recognize because of their unmistakable, vigorously geometric style based on designs and colors that have remained unaltered over the centuries and that are repeated as if they were part of a fixed code. The designs resemble Anatolian and Caucasian models, as can be seen by the small *gul* medallion, the decorative motif which distinguishes the entire production of western Turkestan and which varies in shape according to the Turkoman tribe that made the carpet. The *gul* can be octagonal, hexagonal or rhomboidal, outlined in various shapes, such as hooked, polylobate, stepped, and so on, and may contain within it other small geometric figures. The decoration of Turkoman carpets consists of a rhythmic repetition of *gul* in more or less dense parallel rows, sometimes linked to one another and often arranged with alternating series of secondary geometric figures, such as diamonds, star-shaped elements or crosslike figures.

The borders, which usually consist of a principal border and two minor ones, are decorated with geometric elements, such as variously shaped polygons, horizontal "S" motifs, frets and the typical *kotchanak*. Often, the short sides of the carpet have wide borders called *elam*, while the saddlebags and the *ensi* have one border along the long sides.

Each decorative motif was born from the stylization of an object from nature (flower, bird, etc.) and therefore originally had a symbolic meaning that unfortunately has since been lost. Similarly, we still do not know whether the *gul* were originally tribal emblems or whether they resulted

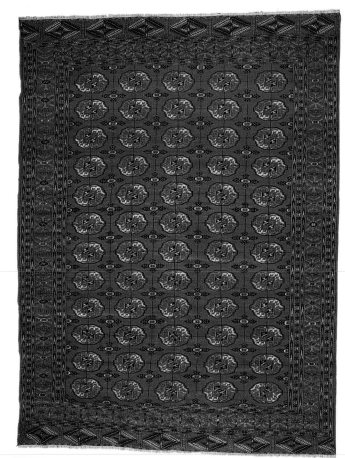

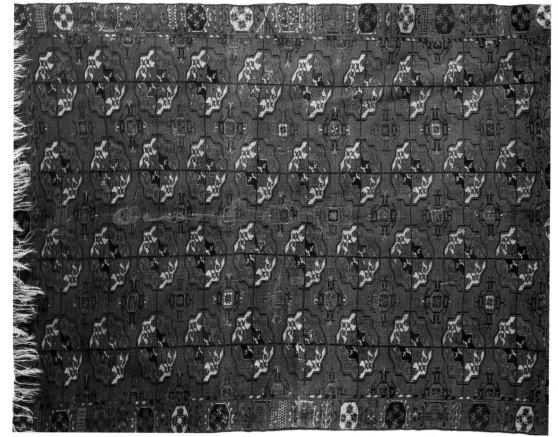

Above, Tekke carpet with geometric decoration. Second half of 19th century. Rome, Luciano Coen Collection. During the second half of the 19th century, the traditional designs become denser and more rigid, and colors lose their brilliance due to commercial necessity.

Left, detail of Tekke carpet with geometric decoration. 18th century. Hamburg, Hamburgisches Museum für Völkerkunde. This rare 18th-century example features the typical major and secondary *gul* of the most famous western Turkestan tribe, the Tekke. Carpets from this area are decorated full-field with *gul*, whose shapes vary according to the tribes they represent. Below, diagram of the major Tekke *gul*.

from a process of simplification of elaborate central medallions that would have been difficult to reproduce in series.

The colors used, in arrangements fixed by tradition, are few and dark but enlivened in the grounds of the field and in the borders by the generous use of red in all its hues. The other colors applied to the designs are restricted to white, brown, black, orange, yellow and, to a lesser extent, blue and green.

The general character of these carpets is undoubtedly simplicity, reflecting the nature of the nomadic and semi-nomadic peoples who made them. This does not mean, however, that they are monotonous: Their style is the fruit of an ancient tradition unchanged for centuries. The preservation of this archaic spirit, which evokes ancestral symbols, transforms any initial uniformity in pleasing evocative expressions of pride and strength.

Intended as functional objects of nomadic life, only a few rare specimens from the 18th century have survived. The rest of the existing carpets from western Turkestan are datable to the early part of the 1800s and later.

The 19th century

The carpets of western Turkestan made in the 19th century still follow tradition and are made with a high degree of technical expertise. However, the carpets from the latter half of the same century show an increasing rigidity and density in their designs and a diminished brilliance in their colors, no doubt the effect of new demands from outside markets and the introduction of chemical dyes in the 1880s. The decline in the quality was also affected by the general decline of tribal society, a process that was accelerated by the Russian conquest of the region at the turn of the century.

The carpets made in western Turkestan were once unjustly held to be of rough workmanship and monotonous, repetitive design and lacking in brilliance due to the dark colors used. They have since been rediscovered and newly appreciated, precisely because they constitute a living, authentic attachment to an ancient tradition, something that cannot be said of the sterile, modern imitations made in Pakistan or Afghanistan.

Below, detail of Salor panel with the *kejebe* motif. 18th century. London, Victoria and Albert Museum. These long, narrow panels (73 x 188 cm, or 29 x 74") possibly served as adorn-ment to bridal canopies and were decorated with the *kejebe* motif, consisting of small, starlike medallions and typical five-sided figures.

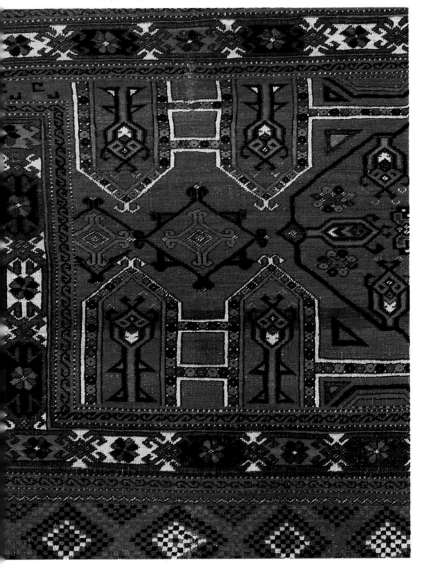

Knotted Objects of the Nomadic Life

Living at subsistence level from breeding sheep and weaving, the tribes of western Turkestan used the knotting technique to create large and small carpets to be used inside their movable dwellings—the *yurt*—as well as a variety of other items for everyday use. For this reason, the specimens from western Turkestan come in a great variety of shapes and sizes.

One common knotted object made for everyday use was the *chuval*, or *joval*, a large bag that served as a portable closet. Carefully crafted, with fringe decorations in the lower border, it was used by the bride to store her dowry and to hang inside the *yurt*. Other objects were the *torba*, a smaller bag, fringed in the lower part; the *chemche torba*, a long and narrow bag that held tableware; the *ensi*, an inside door that sometimes replaced the wooden door of the *yurt*; the *kapchuk*, pillows for decorating the *yurt*; the *kapunuk*, shaped like a "U" and decorated with fringes, which were hung around the *yurt's* opening during feast days; and the *asmalik*, shaped like a pentagon, with long tasseled fringes, used to decorate camels' backs for weddings.

To the nomads, the main carpet was an object of value that embodied the cultural and artistic tradition of their tribe. Even so, it was still an object to be used and was necessary to everyday life.

Asmalik Yomut with geometric decoration. Second half of 19th century. Venice, Rascid Rahaim Collection. The typical *ashik* design, a composition of diamond-shaped elements with serrated edges, may be derived from a leaf design.

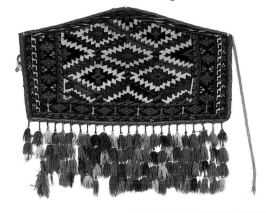

Among the oldest *gul* used in the eclectic Yomut production is the *dyrnak gul,* which has a very simple diamond shape with a hooked outline; it is usually found alone, distributed full-field, or sometimes alternating with other, smaller *dyrnak gul.* By the early 20th century, its use had diminished. Note the sensitive color palette of the Yomut production, which, unlike the rest of the carpets from western Turkestan, combines yellow with a typical purple-red ground and makes alternate use of three basic colors: white, red and blue.

In Yomut carpets, the main border always has a white or ivory ground; among the more frequently recurring decorative motifs is a stylized vine with curling leaves, here rendered in very geometric form.

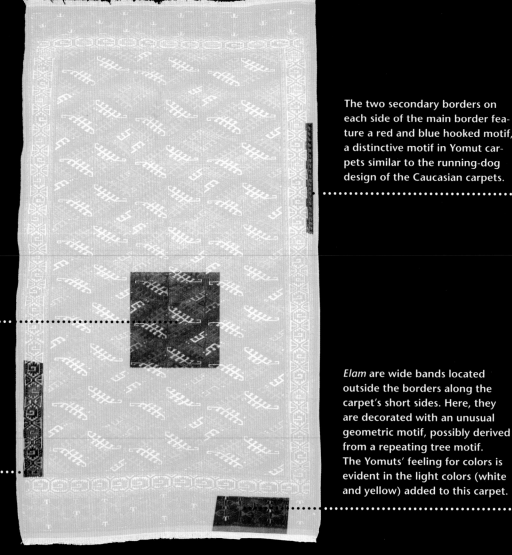

The two secondary borders on each side of the main border feature a red and blue hooked motif, a distinctive motif in Yomut carpets similar to the running-dog design of the Caucasian carpets.

Elam are wide bands located outside the borders along the carpet's short sides. Here, they are decorated with an unusual geometric motif, possibly derived from a repeating tree motif. The Yomuts' feeling for colors is evident in the light colors (white and yellow) added to this carpet.

Yomut carpet with geometric decoration
Second half of 19th century
Rome, Luciano Coen Collection

Carpets from western Turkestan go under the generic name of Bukhara, or Royal Bukhara, after the name of the city which, however, was only a collection and marketing center. Albeit with some difficulty due to the uneven nature of nomadic production, these carpets were grouped according to the type of *gul* used. Thus, the more significant types took the name of the tribe to which they referred. The Yomut type is among the more varied and interesting of this production.

Yomut tribal carpets

Carpets made by the Yomut tribe, one of the more important and famous tribes (along with the Tekkes and the Salors) of western Turkestan, stand out for the wide variety of their designs, which, however, always involve a modification of the *gul.*

Some of the typical Yomut designs are the *tauk nuska gul,* octagonal in shape and notable for the presence inside of four pairs of small, stylized animals; the *dyrnak gul,* diamond-shaped and with a typical hooked profile; the *kepse gul,* consisting of five to seven large, parallel notched segments arranged vertically in decreasing fashion from the center toward the sides, which, taken together, form a hexagon or rhombus. Yomut *gul* also differ from the production of other tribes in their color palette,

sometimes being distributed in alternating rows and colors to create diagonal color correspondences. The *ashik* is also a typical Yomut motif, consisting of a rhombus with serrated edges, possibly a leaf originally, arranged on a white ground and endowed with magic power.

The main borders often have repeating geometric motifs on a white ground, such as curling-leaf frets, or a "boat" motif, always composed of a stylized vine flanked on each side by floral elements resembling small boats. The minor borders typically contain *ashik* and hooked motifs, the latter resembling the Caucasian "running dog." In addition to rugs, the extremely rich production of western Turkestan also includes other items for use, such as *asmalik, chuval, ensi* and *torba.*

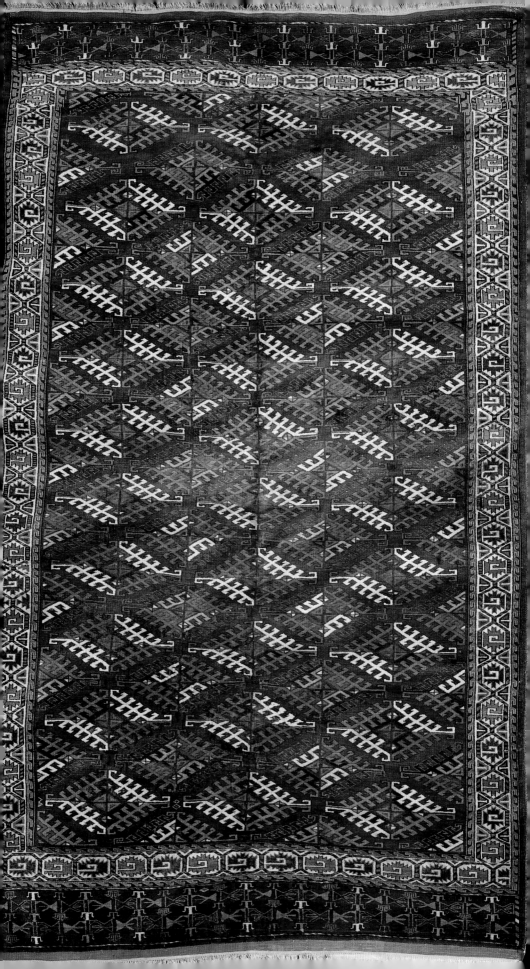

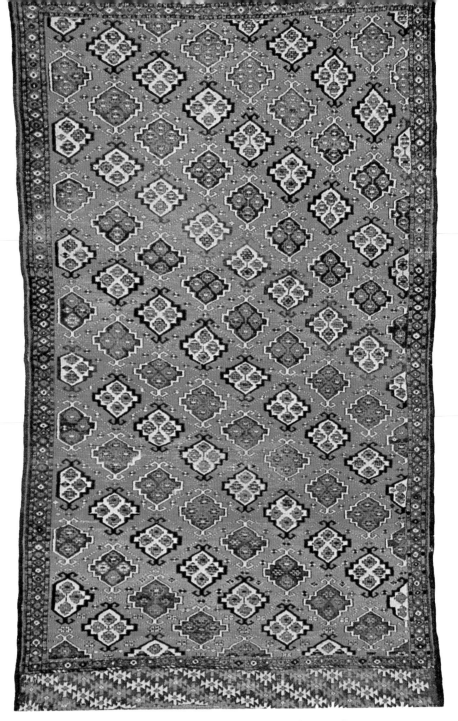

Chodor carpet with geometric decoration
19th century
Private collection

…decorated with the most typical Chodor tribe motif, the *ertmen gul*, recognizable by its stepped profile… …rated inside and finished at top and bottom with a thin double-hook design. This small *gul* is repeated… …sually, as in this case, without other filling elements; it can also be arranged inside a thin, diamond-net… …rated with an *ashik* motif in diagonal rows of alternating colors. In the past, Chodor carpets were includ… …se of these shared decorative elements.

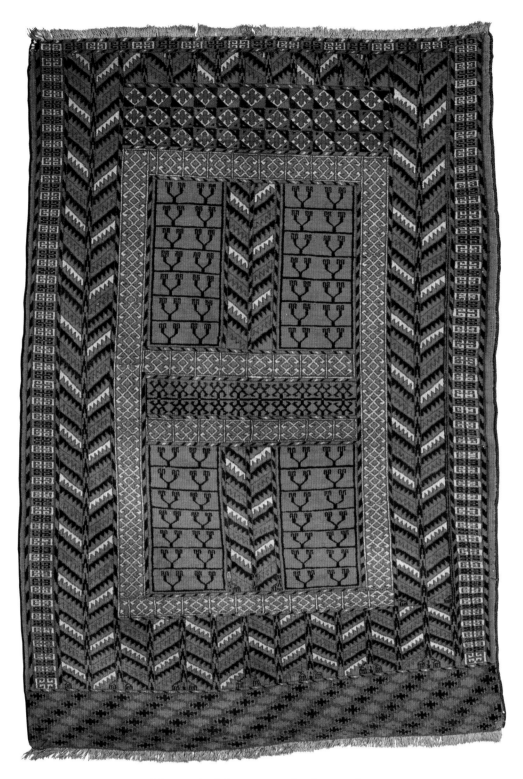

Tekke *ensi* with geometric decoration
Second half of 19th century
Rome, Luciano Coen Collection

Ensi carpets were used as *yurt* (nomadic tents) doors and are distinguished by a central cross, often with pointed ends, which creates four field panels containing archaic designs that vary, depending on the tribe. Typical of the *ensi* is a wide border decoration with a double hooked "T" motif. The lower part of the *ensi* has a wide *elam*, or outer band, partly knotted and partly woven kilim-style, decorated with geometric frames or stylized floral motifs; it served to protect the carpet from wear and tear. *Ensi* are also called *hatchlu*, "cross" in Armenian, and their meaning is connected to the shamanic belief in a cosmic axis and to an auspicious symbology.

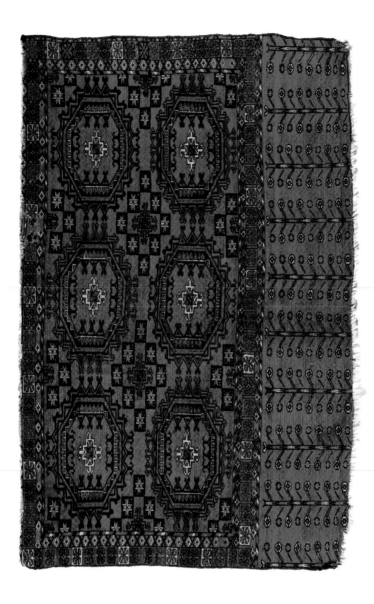

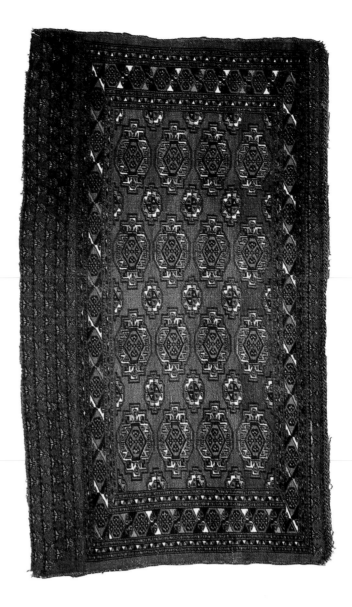

Salor *chuval* with geometric decoration
19th century
Hamburg, Hamburgisches Museum für Völkerkunde

The rare Salor carpets are recognizable by the roundish *gulli gul* with the typical trefoil motif and by the scarlet-red, which is typical of all their carpets. Salor *chuval* (bags) are distinguished by the tribe's *gul*, which is octagonal, with an outline of small, triangular, scalloped motifs, and is filled with the *aina-kotshak*, or *gotschak*, ("ram") motif, whose hooks resemble rams' horns. Repeated three, sometimes six, times, the Salor *gul* alternates with the *sagdak* motif, which consists of small black rectangles arranged in a rhombus shape, each, in turn, filled with an eight-pointed star. Note the geometric border and the wide *elam* decorated with stylized tree motifs.

Saryk *chuval* with geometric decoration
Late 19th century
Rome, Giacomo Cohen and Children Collection

Saryk production is distinguished by certain colors, such as a very dark blue in the designs and an unusual light orange on purple-red or brown-red ground. The typical Saryk *gul* is octagonal, many-faceted and filled inside with cruciform figures; toward the end of the 19th century, its shape became elongated, as in this example. In the *chuval*, the *gul* is usually repeated nine times, more rarely 16, and alternates with secondary figures. Both the main border and the minor ones have typical Saryk decorations of small colored triangles. The *elam* here, decorated with small, stylized floral elements, is interesting.

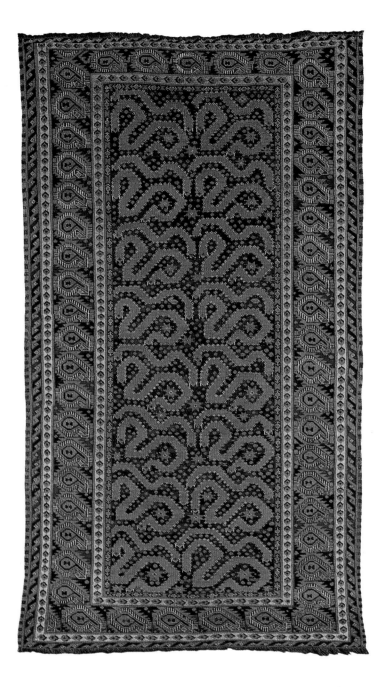

Ersari (or Beshir) carpet with geometric decoration
Second half of 19th century
Milan, Papazian Collection

Ersari (or Beshir) carpet with four-and-one medallion design
Late 19th to early 20th century
Private collection

Ersari tribe carpets are varied and were produced in large numbers; they may be classified into two groups. The first group belongs to the Turkoman tradition and is decorated with large, octagonal *gul* enclosing classic trefoil designs or with *termichin gul* enclosing typical intermeshing triangles. The second group, conventionally called "Beshir," after either a city or a subgroup of the Ersari tribe, uses decorative motifs foreign to the Turkoman tradition. The above carpet, for example, features a naturalistic, stylized field motif, called "cloud motif" because of its resemblance to a cloud band, although it could also represent a tulip.

Beshir carpets of the Ersari production are decorated with motifs that fall outside the Turkoman tradition, such as the Persian decorative motifs *herati*, *boteh* and *mina khani*, interpreted geometrically. The above carpet, for example, has a four-and-one medallion layout unknown to local tradition, with the field and the borders decorated with Persian *boteh* designs rendered geometrically. Only the wide outer bands and the border decorated with a typical stylized fretwork of curved leaves belong to the local tradition. Colors are lively and strong, with a heavy use of yellow and red, typical of Ersari production.

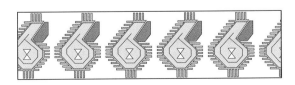

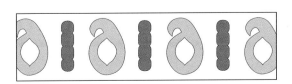

EASTERN TURKESTAN

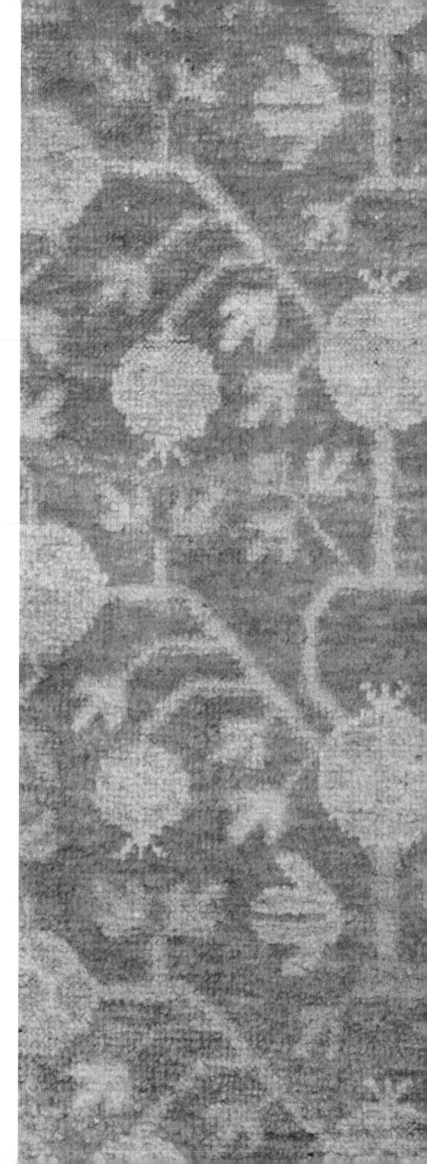

Eastern Turkestan is located between western Turkestan and Mongolia, in an area that generally corresponds to the present-day Chinese province of Sinkiang. It is largely desert, where only oases guarantee life. Archaeological expeditions to this area have found remnants of knotted carpets in the bed of the Tarim River datable to at least the third century A.D. Therefore, the knotting technique was an ancient tradition in eastern Turkestan as well, although concrete and indirect evidence is very scarce, since the intact examples that have survived are datable only to the end of the 18th century. Eastern Turkestan carpets were made in specialized workshops, mostly by men weavers, and are conventionally called Samarkands, from the name of the western Turkestan city that was a collection center for carpets to be sold and exported, primarily to the West.

Although Sinkiang was influenced by China, western Turkestan, Persia and India, as it constituted a passage point between East and West along the Silk Route and thus suffered numerous raids and invasions that influenced its local culture and art, it nonetheless remained faithful to its own traditions, descended from pre-Islamic, specifically shamanistic and especially Buddhist, cultures. Thus, these carpets are imbued with a simple, elementary spirit that is both strong and lively, secure in its solid tradition handed down through the centuries. Only in examples made since the end of the 19th century is this liveliness diminished by new colors in pastel tints.

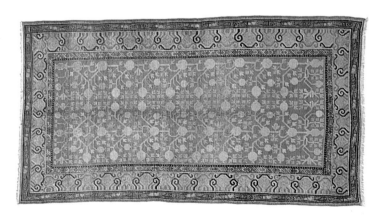

Carpet with pomegranate trees
Late 19th century
Vicenza, Hasan Pashamoglu Collection

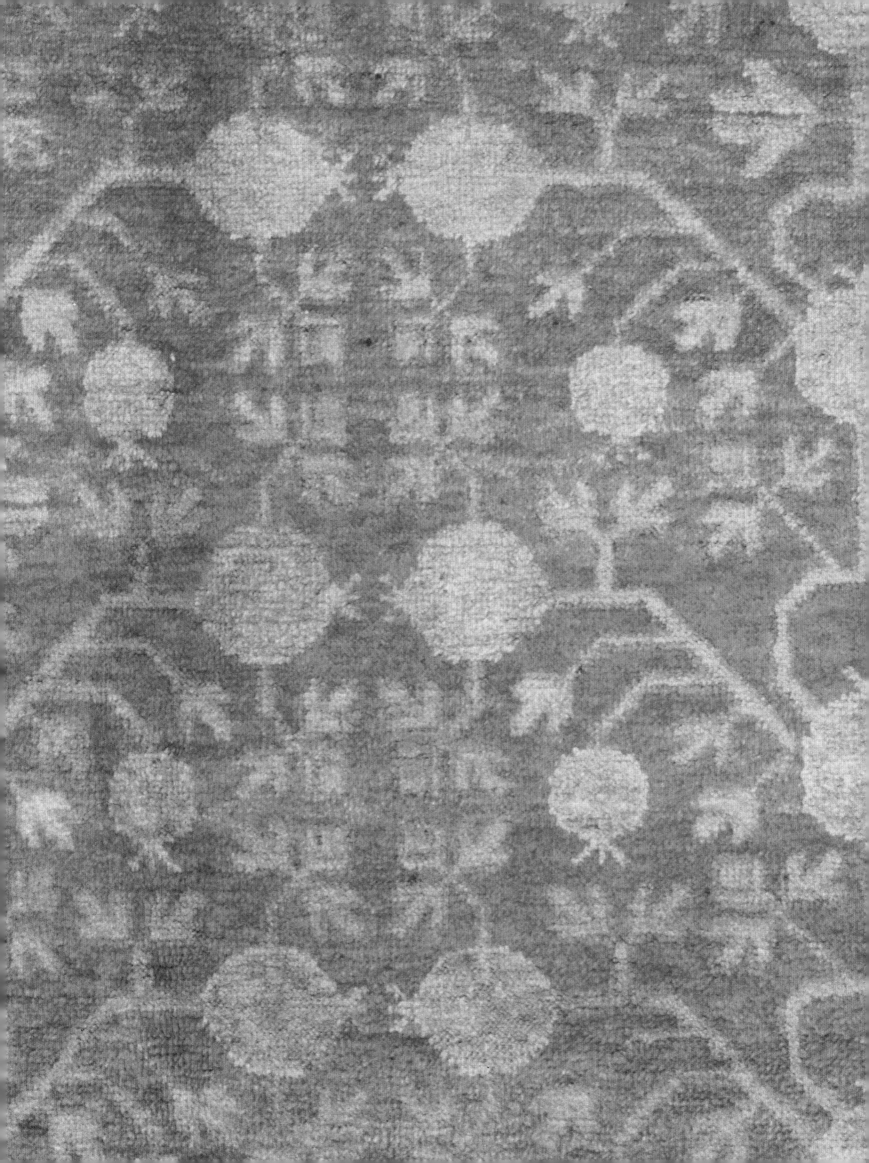

Major characteristics and style types

The basic stylistic elements that help to identity carpets from eastern Turkestan are the relatively small number of decorative motifs, the somewhat elementary geometric language and the distinctly lively color palette, which is limited and based primarily on all the tonalities of red, blue, yellow and brick color. The knotting system is asymmetrical, with an average medium-to-low density of knots. Cotton is usually used for the foundation, while both wool and silk are used for the pile, and metallic threads are sometimes used together with the silk. The pile is typically trimmed medium-low. The shapes are very elongated: As a rule, the length is nearly twice the width.

The earliest surviving specimens of eastern Turkestan carpets date from the end of the 18th century and are unusual in style. The most characteristic, although not

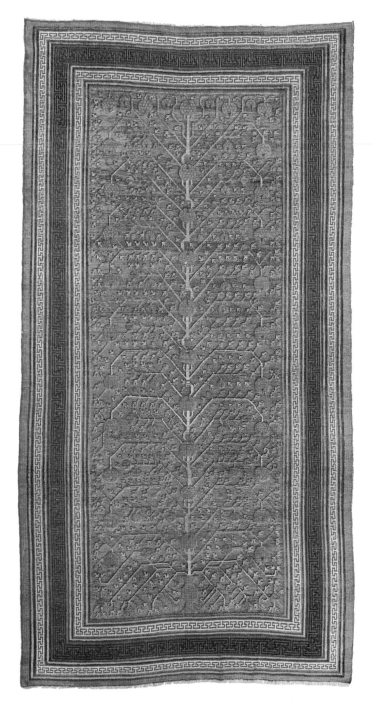

Major Areas and Types

Three major production areas existed in eastern Turkestan: Kashagar, Khotan and Yarkand. Given the uniformity of design common to these productions, however, one must carefully examine the structural characteristics of each specimen to determine its provenance.

the most common, is the "pomegranate tree" style, perhaps based on an ancient local design. This tree, which has abundant fruit and seeds, was believed to be a symbol of prosperity. The most common layout, however, is that of three superimposed medallions, for this arrangement is more closely in keeping with local taste and was probably derived from Buddhist symbolism, representing Buddha and his two acolytes.

Much less prevalent are layouts with central or with two or repeating medallions; the medallions, however, are always of roundish shape. Somewhat common is the *saph*, or multiple-niche, layout, likely resulting from the fusion of local pre-Islamic imagery with the true Islamic tradition, since no single-niche prayer rugs have ever been found in the area. The niches are in odd numbers and contain decorations of stylized trees of life, pomegranate trees, floral decorations and the typical geometric "wheat spike," or herringbone, motif.

Other style types reflect the influence or inspiration of other cultures: the Persian *herati*, transformed into the typical "five-bud" motif; cloud bands and perhaps curvilinear grids from China; bouquets of stylized flowers from India; and especially full-field *gul* from western Turkestan—the latter, however, transformed into roundish rosettes with hooked edges.

The border decorations are typical and varied and not necessarily related to the field design. The principal borders may contain two-colored trefoil motifs, wave motifs, octagonal rosettes, geometric vines or rows of unusual bouquets of three stylized flowers arranged in alternating directions. The more common minor borders are formed by geometric motifs, such as frets, swastikas and "T" motifs. Also typical of western Turkestan carpets is a brick-colored band running outside around the borders.

Left, carpet with pomegranate trees. First half of 19th century. Private collection. Although they were subjected to several outside decorative influences, carpets from eastern Turkestan always remained faithful to their traditional geometric language. This example features the most typical design of this production, a pomegranate tree rising from a vase.

Facing page, bottom, Kashgar carpet with *gul*. Late 18th century.

Private collection. Situated along many routes, Sinkiang suffered numerous invasions by different groups that influenced its art and culture. The influence from western Turkestan on this carpet's composition is clear, although the *gul* has been transformed into a rosette with a hooked outline, set inside a larger element, also with a hooked profile. Of interest is the wide main border decorated with the *bulou* Tibetan motif, which consists of small circles.

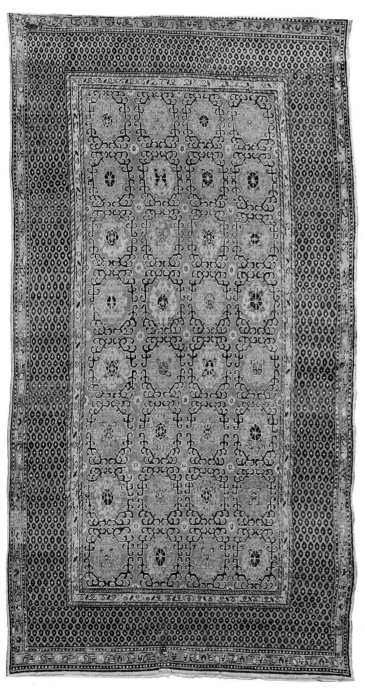

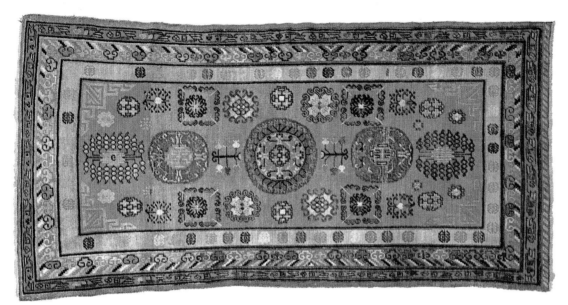

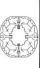

Khotan carpet with three medallions. 19th century. Milan, Pars Collection. The three-medallion layout is the most popular in eastern Turkestan. In this example, the medallions are roundish (see diagram above), and the principal border has a wave decoration.

The Shape of Sinkiang Carpets

Apart from the designs and the palette, the major distinguishing element of carpets from eastern Turkestan is their unusually long, narrow size (with the length being almost twice the width), for the most part measuring 100 x 200 cm (39 x 79"). This shape was determined by the specific, practical requirements of everyday life. From the earliest times, the traditional Sinkiang home featured a main living area, a rectangular room, called *supa* or *ivan*, which was equipped along most of its length with a wooden platform—the *kang*—suspended approximately a yard from the floor. This is where the family's daily life took place. To make it as comfortable as possible, it was covered with one or more carpets whose size and shape matched those of the platform.

However, around the turn of the 20th century, eastern Turkestan also produced more squarish carpets to fill the strong demand from Western markets. Thus, the shape of these carpets changed according to their use in European and American homes; the shape of these later carpets is usually 200–260 x 300–360 cm (79–102 x 118–142").

Production after the end of the 19th century

Around 1870, aniline dyes were introduced in eastern Turkestan, and these carpets were favorably received in the vast commercial markets in the West. These two factors brought about a considerable change in eastern Turkestan carpet styles, because the traditional designs became somewhat more rigid and confused and, with the introduction of pastel tints, the color palette was transformed from lively and contrasting colors to more muted and harmonious colors. False "antique" carpets appeared on the market, made in the 19th century but called "18th-century Samarkands." This production featured pastel colors that were artificially faded to simulate age and to fool inexperienced buyers. In fact, authentic 18th-century Sinkiang carpets have intense, contrasting palettes. Finally, in the 1920s, clear marketing factors dictated the introduction of naturalistic decorative elements taken from French carpets.

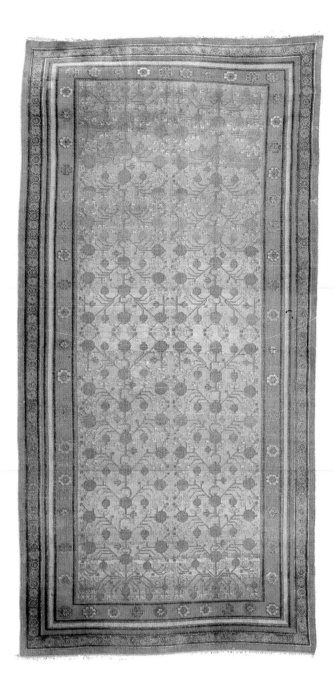

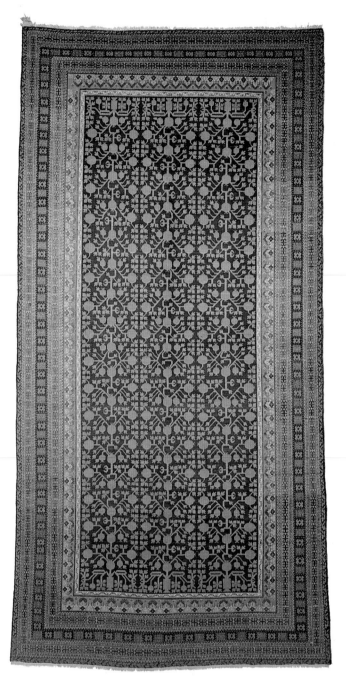

Yarkand carpet with pomegranate trees
19th century
Private collection

Carpets featuring a pomegranate-tree layout, the most typical of eastern Turkestan, have a light or dark blue ground on which are arranged one or two trees of an intense red growing from a small vase and projecting upward their geometric branches laden with leaves and flowers. Often, in the center of the field, the trees are repeated mirrorlike, as in this example, so that the layout becomes bi-directional. This carpet type, which probably originated locally and, in any case, predates Islamic culture, has a positive, auspicious meaning, since the pomegranate tree, rich in fruits and seeds, is a symbol of fertility and wealth.

Carpet with pomegranate trees
Early 20th century
Vicenza, Hasan Pashamoglu Collection

The general composition of this carpet and its colors are traditional: The trees rise and grow upward from the usual small vases placed above the borders, their branches heavy with three-lobed leaves and round fruits; in the center of the field, they are repeated mirrorlike, thus creating a bi-directional layout. The color composition is also traditional, with a blue ground and red decorations. Something, however, has changed, compared with the classic specimens. In fact, following the new aesthetic canons introduced at the end of the 19th century, the decoration is now denser, there are now three trees and the borders have multiplied.

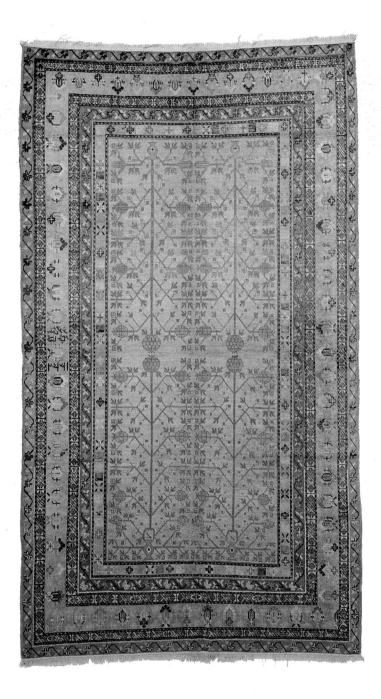

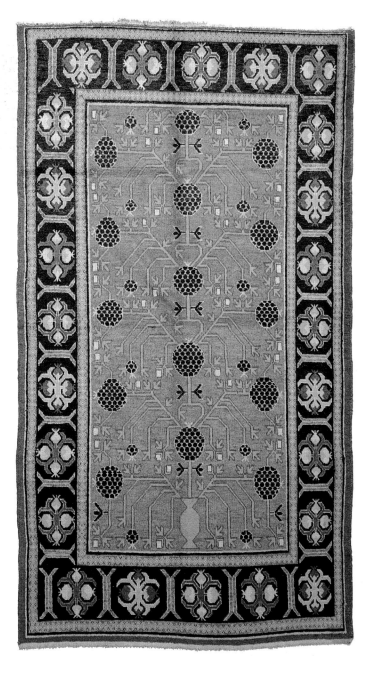

Carpet with pomegranate trees
Dated 1927–1928
Private collection

This carpet presents the traditional pomegranate-tree layout. However, some stylistic changes typical of this period have been introduced, making the composition more rigid: The trunks are now straight, the branches schematic and barer, the fruits larger but less numerous; also, the center of the field is now bare, with only four large, facing pomegranates. The field's colors are now pastel—light red on a delicate yellow ground. The borders also are of a lighter color. In the main border on the right is an inscription with the date in Islamic characters.

Carpet with pomegranate trees
Early 20th century
Bergamo, Giancarlo Cobelli Collection

This early-20th-century carpet reinterprets the traditional theme: There is now only one tree, without a facing double, thus giving orientation to the layout. The tree and the pomegranates are larger, the latter still roundish but now in a dark brown that contrasts with the light brick-red ground. The pastel tints—the tree's pale yellow, in particular—are unusual and do not follow tradition. Note the main border, which has a singular decoration of small, crosslike medallions, which, in turn, enclose pomegranates.

The secondary medallions have simply a decorative purpose like the other filling elements and contain a traditional, crosslike figure. From the density of the surrounding field, we can tell that this carpet is from a late period.

The three superimposed medallions have an octagonal, roundish shape. The central medallion stands out for either its larger size or its internal decoration, which is derived from the cloud collar; to some, it represents Buddha seated on a lotus flower.

The side medallions are identical to each other in shape and internal decoration; in this case, they are framed by a customary series of pomegranates, a token of good luck. These medallions are said to represent Buddha's two disciples, the *bodhisattva,* appropriately seated next to their master.

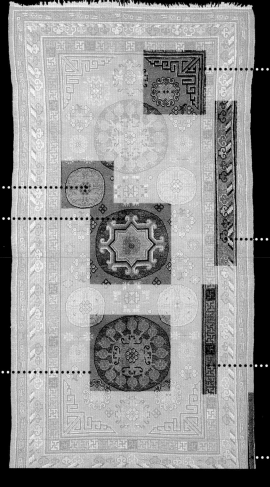

The cornerpieces are decorated with a typical geometric fretwork, a Chinese influence.

The principal border is decorated with a stylized version of the well-known multi-colored wave motif, representing the cosmos, specifically clouds, mountains and water.

This secondary border contains a typical swastika motif, also of Chinese origin, formed by four "T"s oriented in the four directions.

The outer band, in a brown color, appears frequently in eastern Turkestan carpets.

Carpet with three medallions
Early 20th century
Vicenza, Hasan Pashamoglu Collection

Although not the most original, medallion-layout carpets are the most common in eastern Turkestan production. The medallions have an unusual shape: They are roundish, octagonal figures with closed, distinctive outlines; not coincidentally, they are called *ay gul,* or "moon," because they are usually blue. They are filled inside with small, simple figures, such as rosettes, stars, cloud bands and, more rarely, stylized floral elements.

Medallion layouts
The most successful and widespread eastern Turkestan layout is that with three medallions, possibly derived from Buddhist symbolism. However, this analogy is by no means certain, since precise reference points have been lost with the passing of time.

In addition to identifying the central medallion with Buddha and the identical side medallions with the *bodhisattva* (his two acolytes), the colors of the more antique carpets also seem to harmonize with Buddhist symbolism and philosophy, with the traditional blue ground of the medallions representing thought and spiritual activity and the red of the field evoking the passions of earthly life. By contrast, one- and two-medallion layouts, always characterized by roundish figures, are less frequent.

In all these layouts, the rest of the field may be totally empty, that is, it appears as a solid color. Most of the time, however, it is decorated: The space near the corners may have geometric frets, or stylized flowers, of Chinese influence; and rosettes, stylized floral elements, stars, tiny medallions and other decorative elements may be strewn across the field to fill it. These decorations are sparser and more isolated in the older carpets and denser and closer to one another in the specimens datable to the mid-1800s onward.

One layout that appears less frequently than the other types is the repeated-medallion type, involving eight to ten medallions arranged in two rows inside a wide-meshed rectangular grid.

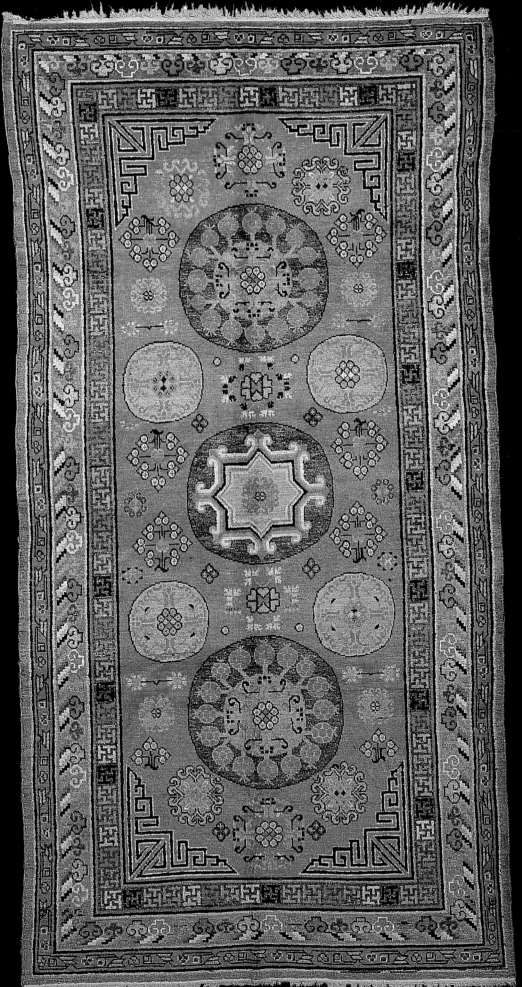

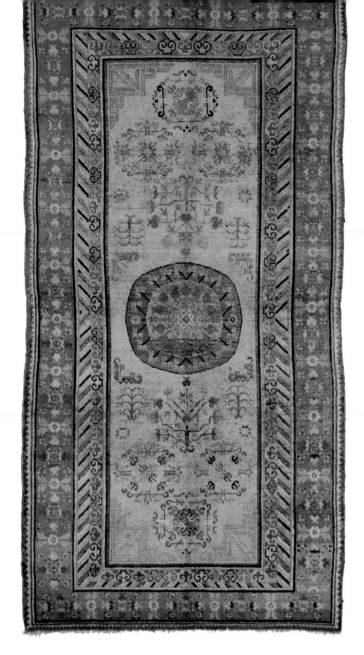

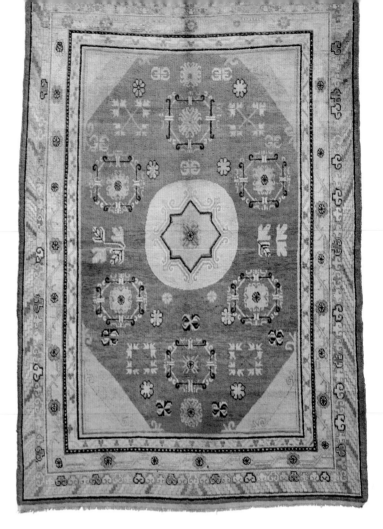

Medallion carpet
Late 19th century
Private collection

In this carpet, the traditional design is clearly marked by the roundish shape of the lovely central medallion, filled with an elaborate rosette from which red pomegranates rise to form a wreath; on a light brick-red ground, a second, outer wreath composed of stylized leaves surrounds the medallion. The field is filled with stylized pomegranate trees—a token of good luck—along with fretwork, geometric floral elements and small, hooked medallions. The main border has an unusual pomegranate motif alternating with flowers, while the inside border contains the traditional wave motif.

Medallion carpet
Early 20th century
Verona, Tiziano Meglioranzi Collection

This carpet is an example of the typical early-20th-century reinterpretation of traditional designs. In the cornerpieces, for example, the usual fretwork has been replaced by a space filled only with stylized plant motifs. An elongated central medallion on the field's red ground encloses a rosette and a star figure, all surrounded by secondary medallions, rosettes and stylized plant motifs. The main border is decorated with the wave pattern, the two minor ones with stylized flowering vines.

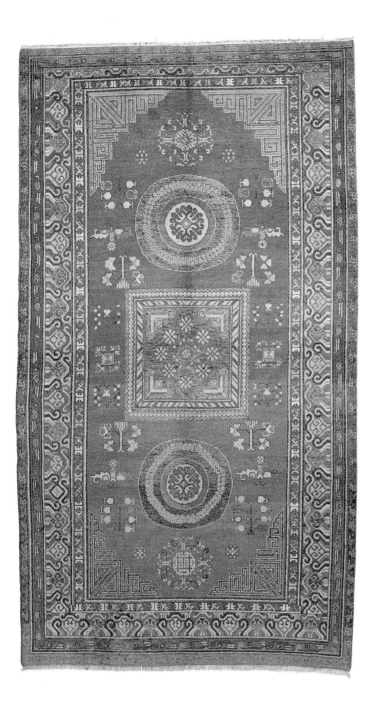

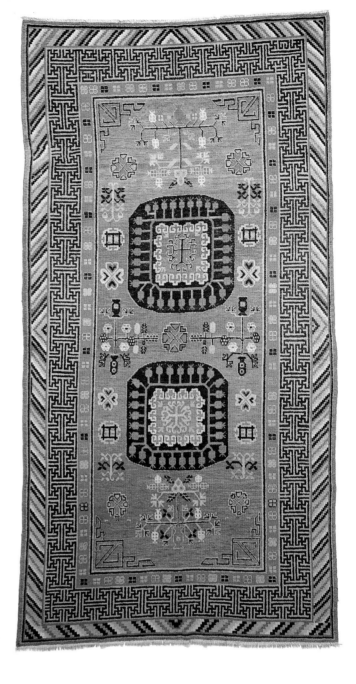

Carpet with three medallions
Early 20th century
Private collection

Carpet with two medallions
Early 20th century
Bergamo, Giancarlo Cobelli Collection

Here, the symbolic central medallion has even changed shape and is now square. The grayish light blue of the ground in all three medallions recalls the original blue, a color alluding to Buddhist spirituality, while the field is the traditional red, a color alluding to the worldly life. The medallions are decorated internally with concentric frames around central rosettes. The cornerpieces display fretwork of Chinese origin, and the field is filled with the customary geometric and floral motifs, among them the pomegranate. The principal border has an elaborate wave design, an allusion to the cosmos.

In this specimen, the use of traditional colors (blue for the medallions, red for the field's ground) contrasts with a marked stiffening in the design, typical of early-20th-century production. This is especially noticeable in the shape of the medallions, which are now sharply edged rather than roundish. Inside the medallion is a border of pomegranates, often used in these carpets because of their well-wishing symbolism. The field is decorated with the usual motifs, including complex flowering vases. Note the elaborate fretwork in the principal border and, in the outside border, multicolored diagonal stripes, a shrunken version of the wave motif.

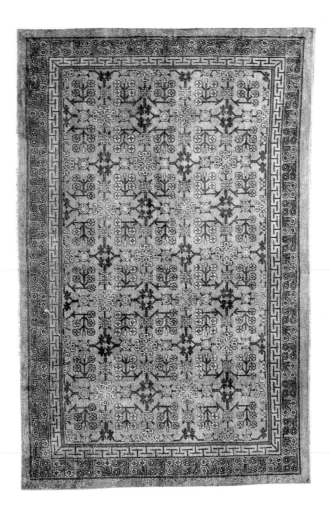

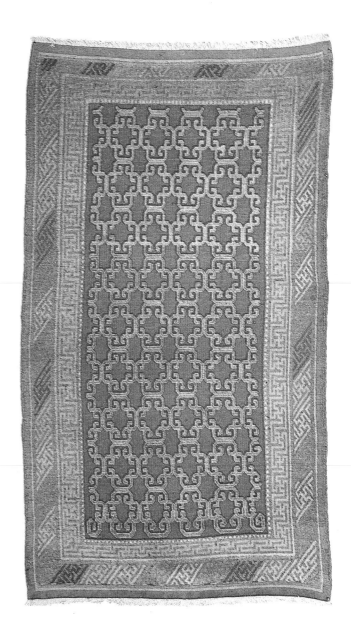

Khotan carpet with floral decorations
Late 19th century
Private collection

The *herati*, a typical Persian motif, was modified in eastern Turkestan to create the five-bud motif, typical of the Khotan region: The sickle-shaped leaves, the palmettes and the arabesques of the original *herati* are gone, replaced by a stylized design consisting of bouquets of five flowers, light blue and ivory in alternating colors, arranged around rhomboidal figures and small, roundish flowers (the only recognizable elements of the original Persian design). The decoration in the principal border is also typical of eastern Turkestan and is formed by stylized bouquets of three flowers oriented in two directions.

Khotan carpet with geometric decoration
Mid-19th century
Private collection

The bright red field of this carpet is decorated with a curvilinear grid extending full-field, formed by joining four elements resembling round parentheses. This motif is also found in Chinese decorations as one of the many stylized renderings of the cloud collar, so it is impossible to determine whether it was brought to eastern Turkestan from China or was developed independently. It was used especially in the oasis of Khotan. The decoration in the wide borders is also akin to Chinese taste; the inside border has the usual fretwork, while the outside border is decorated with a "T" design.

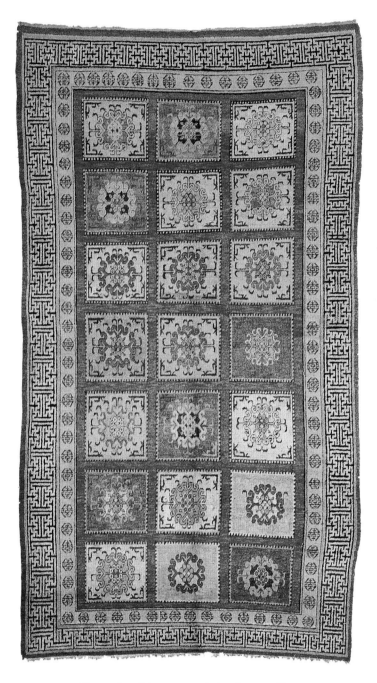

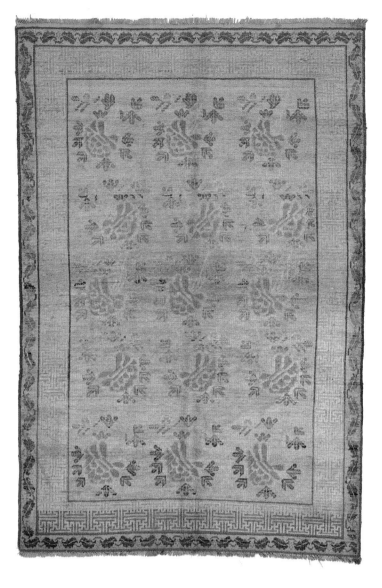

Carpet with geometric decoration
Early 20th century
Bergamo, Giancarlo Cobelli Collection

The motif inspiring this carpet is the western Turkestan *gul*; here, it becomes a squared central rosette surrounded by a very elaborate, hooked outline. The geometric grid is formed by the squares, within which the rosettes are arranged, creating color correspondences in alternating rows, as in Yomut carpets. In *gul*-decorated carpets, the ground is always red; in this example, the violet and pink reflect the inclination for pastel colors typical of the end of the 19th century. The principal border has an elaborate fretwork on a dark background.

Carpet with floral decoration
Early 20th century
Conegliano Veneto, Walter Marchi Collection

Pastel colors also dominate in this early-20th-century example decorated full-field with peonies. China's influence is clear in the choice of this particular flower—much used in Chinese art as a symbol of beauty—and its shape, the petals being arranged in a fan shape, surrounded by a wreath of leaves. It all corresponds to Chinese iconography, albeit translated into a more rigid, geometric version. Also unusual for eastern Turkestan is the outermost border decorated with naturalistic vine leaves, while the principal border is more traditional in its elaborate fretwork on a dark ground, similar to the carpet at left.

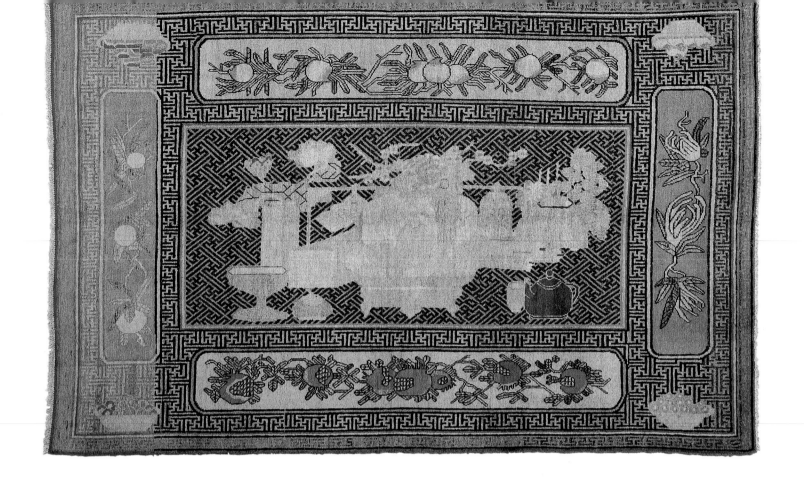

Carpet with naturalistic decoration
Early 20th century
Conegliano Veneto, Walter Marchi Collection

This type of iconography is totally foreign to local culture and shows the influence China had acquired in the art as well as the history of eastern Turkestan by the end of the 19th century. This type of panel composition and the naturalistic rendering of vases, tea vessels, goblets, flowers and other objects are elements of Chinese iconography, as are the landscapes and birds that we find reproduced in other carpets from the same and later periods. The local language is represented in the auspicious pomegranates arranged in the lower panel, which, however, are drawn quite naturalistically.

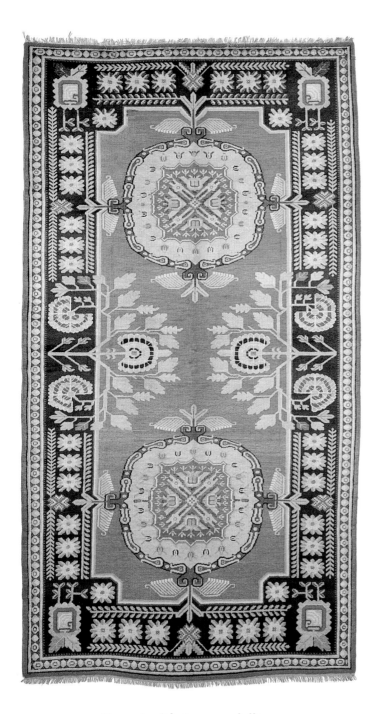

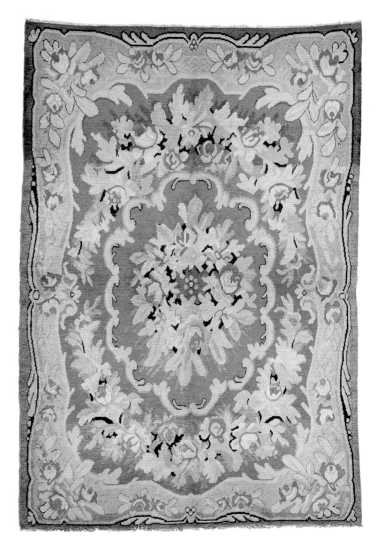

Carpet with two medallions
Eastern Turkestan, c. 1920
Conegliano Veneto, Walter Marchi Collection

Around 1920, carpet making in eastern Turkestan absorbed the influence of Western carpet decoration, which was sought and employed solely for commercial purposes. This is evident in this carpet, where the traditional two-medallion layout has been totally reworked along the lines of French carpets. Of the traditional medallions, only the roundish shape is left, not the decoration; floral motifs and wreaths of leaves have been introduced; the principal border now has an unusual black ground and is shaped like an architectural cornice; and the thin outer border is decorated with beads to achieve a three-dimensional effect.

Carpet with floral decoration
Eastern Turkestan, c. 1920
Verona, Tiziano Meglioranzi Collection

Compared with the previous example, the imitation of Savonnerie and Aubusson carpets in this specimen is even more in evidence, since the decoration as well as the layout are totally foreign to ancient eastern Turkestan tradition. In fact, the concentric composition reflects the Western architectural style, recalling, as it does, the decoration of ceilings, with a central bouquet of roses surrounded by a curvilinear frieze and two flowering branches, all enclosed within a shaped cornice bearing bunches of roses and small elements. The overall effect is naturalistic, with an effort at a three-dimensional effect.

CHINA

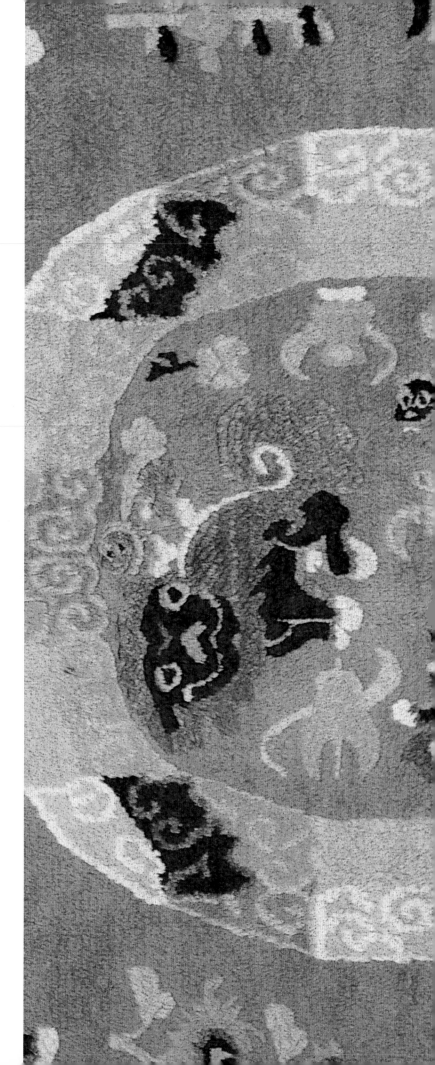

arpet making became accepted as one of the great courtly arts in China only from around the second half of the 17th century, that is, much later than in the other large production regions of the Orient. The late date can be partially explained by the fact that wool was available only in the northwestern regions of China, but it is primarily due to the specific characteristics of knotting, which cannot fully render the aesthetic canons of China that tend to favor fine detail work and calligraphic perfection. For these reasons, the carpet was belittled in China as the artistic expression of "barbarians" from Central Asia.

However, it was not a matter of introducing a new product from abroad, as had been the case in India, but of raising to a higher level a product already known and used for centuries, at least in some areas of China. In fact, the knotting technique had been brought to China during ancient times by the Central Asian tribes who invaded the northwestern provinces; thus, the tradition of carpet making had developed in those Chinese provinces. Even after the middle of the 17th century, when the official culture of the new Qing dynasty (1644–1912) began to take a positive interest in carpets, accepting them as valuable forms of artistic expression, production continued to be limited to the northwestern regions and to private workshops.

Although not developed in court ateliers, the art of the Chinese carpet nevertheless progressed and remained faithful to the general aesthetic canons of Chinese art and the preferences of the ruling class. Examples surviving today are datable especially from the 1800s. A few extremely rare specimens are datable to the 17th century.

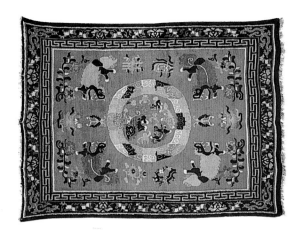

Medallion carpet
China, 19th century
Venice, Rascid Rahaim Collection

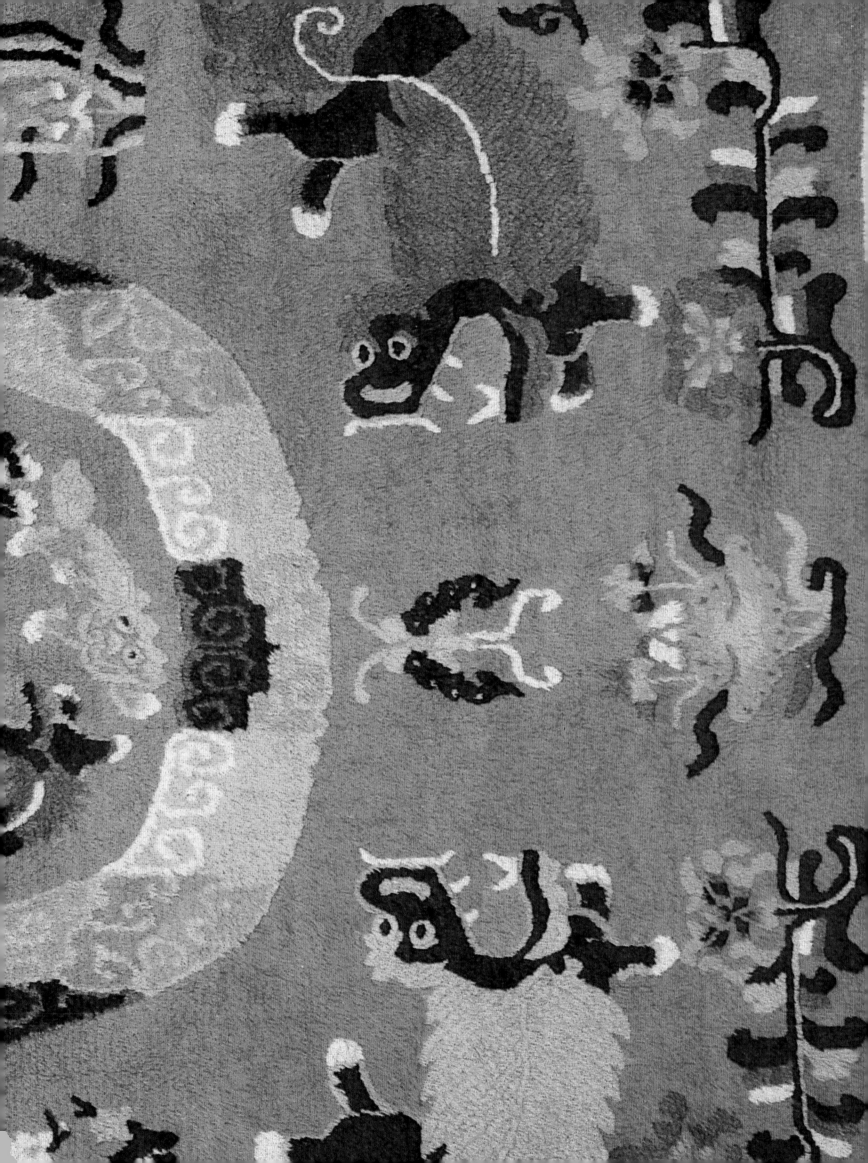

Technical characteristics and major styles

Chinese carpets are knotted using the asymmetrical knot, with a particularly low density—on the average, 500–600 knots per dm^2 (32–38 knots per square inch). Therefore, the cotton foundation is hidden by the wool pile, which is trimmed somewhat high. At the turn of the 20th century, the practice began of cutting the pile around the outlines of the figures with special small shears to make the designs stand out farther. Sometimes, this cutting even involved trimming the pile to different heights, leaving the areas with decorations higher than the ground areas. Antique carpets are usually squarish—measuring 200 x 270 cm (79 x 106") on average—while the more recent carpets are of varying size and shape and are sometimes quite large, measuring 300 x 400 cm (118 x 157") on average.

It is not easy to determine the provenance of a carpet based solely on design; differences in technique, however, have made it possible to identify several groups according to specific areas of production, for the most part located in northwestern China. These are the areas of Ningxia, Gansu, Baodou, Suiyüan and Peking.

Chinese style and Islamic style

The style of the Chinese carpet differs significantly from that of Islamic carpets. The space of the carpet, for instance, is understood as a simple support for traditional designs, mostly symbolic, without added ornamental decorations or any *horror vacui*. For this reason, the field is conceived as a fixed space in which the various traditional designs are suspended, isolated from one another, but always arranged by a compositional layout.

The Chinese decorative language is expressed in carpets using both the geometric and the floral style, combined with such refined skill that, instead of a hybrid or confused language, they produce balance and elegance, with some motifs that are strictly geometric and others that are soft and curvilinear. The color palette of Chinese carpets also contrasts vividly with that of Islamic carpets, since it is not based on variety, liveliness or contrast, red

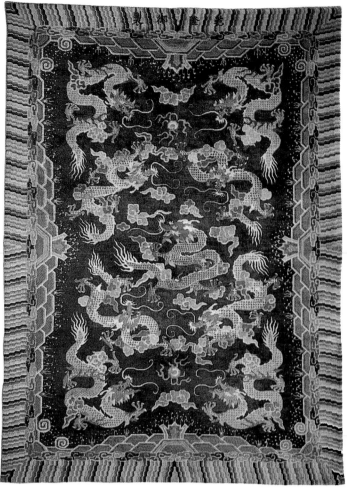

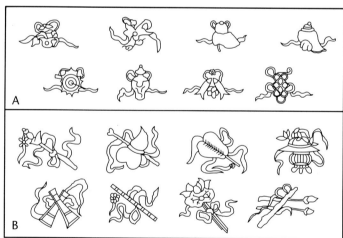

Left, detail of medallion carpet: 18th century. Washington, The Textile Museum. In this extremely rare 18th-century specimen, the central medallion, instead of being a large rosette or a polygon, is presented as an animal, a crane, arranged medallion-style. The crane belongs to Chinese symbolism and represents longevity, while the bats, which are scattered in the field in stylized yellow shapes together with small blue clouds, symbolize good luck.

Top, carpet with symbolic motifs. 18th century. Toronto, Royal Ontario Museum. This extremely rare 18th-century carpet is also decorated with symbolic decorations belonging to Chinese art and culture. The field is filled with dragons ready to conquer the flaming pearl, which symbolizes purity. The multicolored, striped border represents the sea, from which clouds and sacred mountains rise.

Above, A: diagrams of the eight Buddhist good-luck objects: canopy, lotus flower, umbrella, conch, wheel, vase, two fish, endless knot. B: diagrams of the eight Taoist precious objects: sword, gourd with crutch, fan, flower basket, castanets, flute, lotus flower, bamboo and staffs.

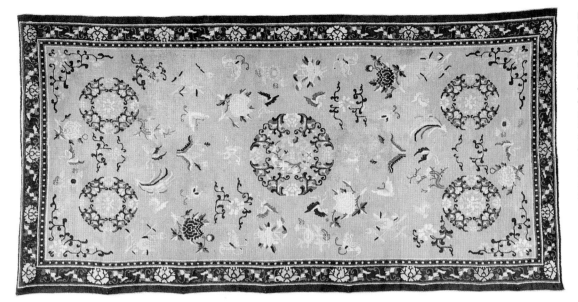

Four-and-one medallion carpet Ningxia region. 19th century. Private collection. The four-and-one medallion layout was among the most popular in Chinese carpet making, with the medallions rendered in special, open shapes, such as the flower wreaths in this example. The field presents various symbols, among them peonies, which symbolize beauty and harmony, and butterflies, which symbolize longevity and conjugal happiness. In Chinese art, even the colors are symbolic, with yellow standing for the earth and blue for the sky.

Monastery Carpets

Among carpets made specifically for Buddhist monasteries, especially in northern China, Tibet and Mongolia, one type is unique: the "pillar carpets," so-called because they served as pictures when tied or sewn around the pillar shafts of the temples to decorate them. They were generally made in sets of two, in shapes that, for the most part, measured 60–80 x 180–360 cm (24–31 x 71–142"). Once fastened to the pillar, they exhibited a continuous design consisting, appropriately, of a large dragon coiled around a column, with the sea and the sacred mountain beneath, and were completed by other well-wishing Buddhist symbols, such as the canopy, the lotus flower, the umbrella, the shell, the wheel, the vase, the fish and the endless knot, all scattered in the field. Since these car-

pets required a continuous design that would show clearly when tied around the pillar shaft, they had no borders.

Other carpets manufactured for the monasteries were long runners on which the monks sat during their prayers. These were composed of rows of squares, usually decorated with medallions and various geometric motifs. For seat covers, small separate square carpets were used, measuring on average 80–90 x 80–90 cm (31–34 x 31–34") on each side and decorated with one or more dragons. Sometimes, they were joined to chairback covers and were then called "throne cushions" because they were reserved for the lamas.

Seat cover depicting a dragon. Ningxia, first half of 19th century. Milan, Nilufar Collection.

is not dominant and dark outlines are not used.

Chinese taste is based on a few basic colors, such as yellow, blue, white, light red, black and brown, making use of all their possible shadings to secure harmonious and elegant combinations, such as pale yellow and gilded yellow or apricot-pink and salmon-pink. The predominant colors are yellow and blue, symbols of the earth and the sky, respectively. In carpets made before the second half of the 19th century, the ground of the field is almost exclusively yellow, while in later carpets, it is usually an intense blue.

The most common layouts are the central medallion and the four-and-one medallion layouts. The grid layout, in various shapes, is also widely used, especially in ancient carpets. Full-field layouts filled with lifelike floral motifs and layouts depicting various symbolic figures scattered in the field are also prevalent.

Unlike the Islamic carpet, the borders of the Chinese carpet are conceived not as integral elements that complete the field but simply as secondary frames to be filled with floral or geometric motifs. Among the most prevalent designs in principal borders are variously rendered frets, swastikas, "T" motifs and flowers rendered in a naturalistic manner. One of the typical decorations of the minor borders is the "pearl" motif. Also typical is the use of an outer band, which is brown in the most antique examples and blue in more recent ones.

Production since the 19th century

After its period of greatest splendor—from the 18th to the early 19th century—a slow process of decline set in, which grew more marked after the 1860–1870 decade, with a capitulation to Western taste. The small provincial workshops were replaced by the imperial works, such as those of Peking, and by factories managed by Western entrepreneurs. The traditional Chinese carpet disappeared around 1920, when landscapes and human figures were first introduced in their decoration. Even more important was the dominance of a hybrid genre that imitated the 17th-century floral carpets from France.

The central medallion of Chinese carpets has no set, clearly defined shape, nor is it completed by pendants; rather, it is a whole comprising several elements, such as mythical animals, flowers or geometric figures, usually arranged in a circle and often without any surrounding border. In this example, it is formed by symbolic Fo dogs, an allusion to protection from evil, surrounded by a wide floral frame.

Scattered over the pale yellow ground are several auspicious symbols, such as the endless knots (destiny, longevity), small swastikas (eternity), lotus plants (purity) and flowering vases (eternal harmony).

The solid-color outer border is typical of Chinese carpets: It is brown in the oldest examples and blue in the more recent carpets.

The principal border is decorated with a tall cartouche motif on a geometric background; the cartouches, in turn, are filled with plant elements and with the eight precious Taoist objects.

A secondary border decorated with geometric fretwork, a recurring motif in Chinese carpets.

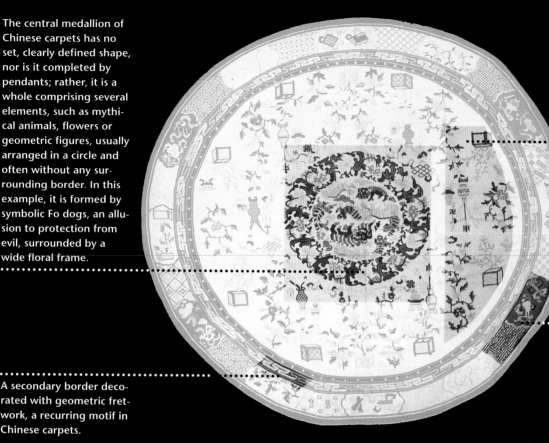

Medallion carpet
China (Suiyüan), second half of 19th century
Milan, Nilufar Collection

In Chinese philosophy, all forms of art, from porcelain to lacquer, are simply a vehicle for concepts, which are expressed by symbolic motifs that have been codified by tradition. In fact, the language of Chinese art is formed mainly by symbols shared by all artistic genres and techniques. Thus, even carpet designs refer to philosophical, religious and social concepts, only a few of them having a purely decorative character.

Ancient Chinese symbols

Round shapes occur frequently in Chinese carpets and give the decoration a particular sense of movement. In this medallion specimen, the general layout is bi-directional, with a symmetrical axis dividing the carpet into two horizontal halves, allowing for different scattered symbols to rotate around the central medallion.

The meaning of the ancient motifs that recur in Chinese carpets has remained unchanged over the centuries, but interpreting them correctly is not easy, in part because there are so many of them and various levels of reading them, depending on the context in which they were used. Some were drawn from the natural world, others from ancient local myths, and still others from the Buddhist and Taoist religions. A sizable group is composed of more or less complex abstract designs, while others were chosen because of their phonetic resemblance to abstract concepts.

The most common symbols are the dragon (union of the earthly and heavenly forces and the emperor), the phoenix (immortality and the empress), the Fo dog (protection from evil), the lotus flower (purity and summer), the peony (beauty, respect, wealth and the spring season), the stork (longevity), the butterfly (longevity, happiness and a happy marriage), the bat (luck, since its name, *fu*, phonetically resembles luck, *anfu*), the cloud (divine power), the mountain with water (stability over a stormy sea), the swastika (cosmic rotation and eternity—infinite luck) and the ideogram *shou* (fortune and longevity).

Also typical are the eight Buddhist objects that bring luck: the canopy (royalty), the lotus (prosperity and divinity), the umbrella (authority, good government), the shell (victory), the wheel (the road to salvation), the vase (harmony), the two fish (happiness and usefulness) and the endless knot (longevity and destiny). Also prevalent are eight Taoist precious objects: the sword (victory), the gourd and the crutch (healing), the fan (immortality), the basket of flowers (magic), the castanets (soothing music), the flute (miracles), the lotus (prosperity) and the bamboo and staffs (foresight and luck).

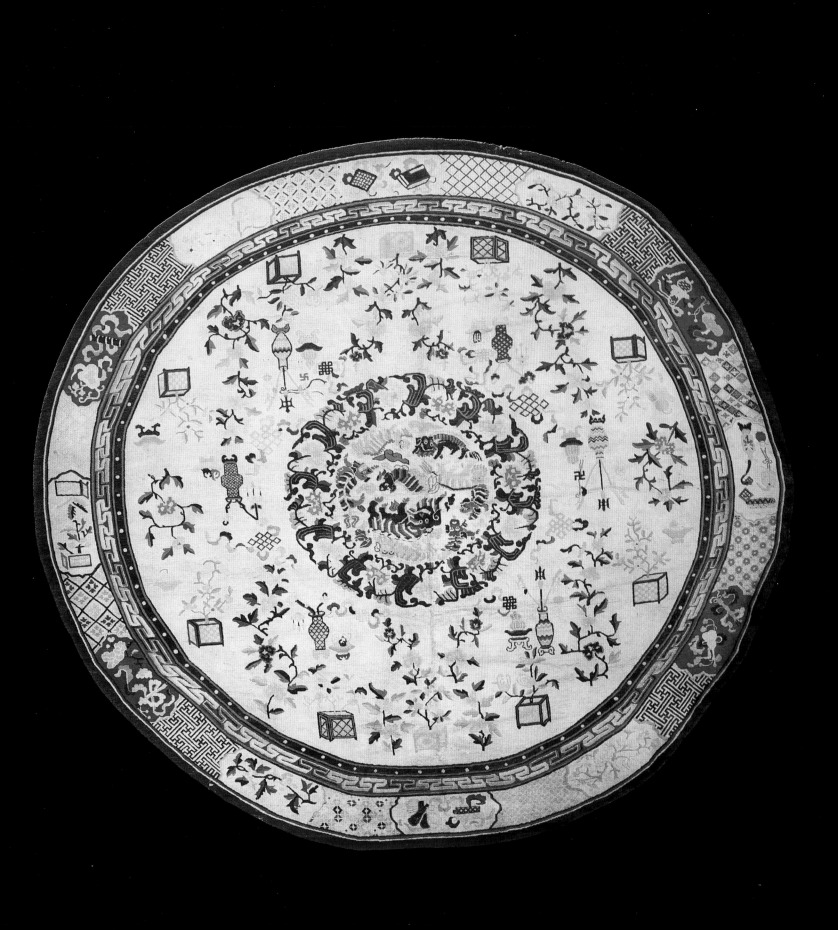

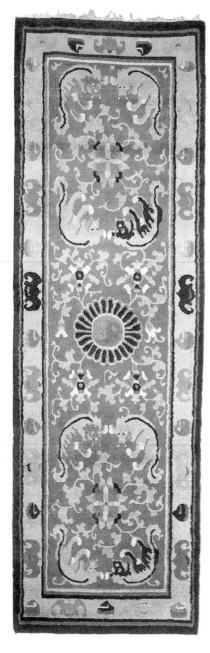

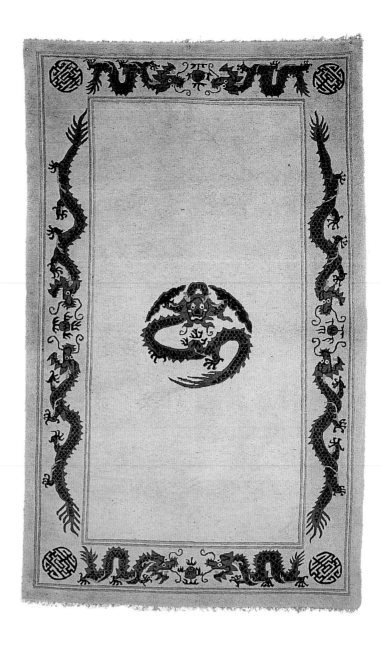

Medallion carpet
Ningxia region, first half of 19th century
Milan, Nilufar Collection

A runner made for use in a monastery, as evidenced by Buddhist symbols, such as the two groups of four Fo dogs guarding the lotus flower, which stands for the divinity; in the center, another flower, symbolizing Yin and Yang, dominates; four flowering lotus plants extend from the flower. The principal border has figures of bats alternating with Tibetan jewels (*norbu*, or teardrop pearls), alluding to fortune and happiness. The Fo dog, also called Buddha's dog—which actually resembles a lion—is a recurring figure in Chinese art. It watches over the divinity, purity, sacredness, dogmatic truths or home, depending on the environment for which the carpet is destined.

Medallion carpet
19th century
Venice, Rascid Rahaim Collection

The elegant essentiality of the above carpet is achieved through the typically isolated arrangement of Chinese decorative elements—as opposed to the Islamic *horror vacui*. The central medallion is composed of a single, open element, a dragon winding around itself to create a circle; in each border on the four sides is a pair of dragons facing each other and keeping watch over the flaming pearl, which symbolizes divine perfection; finally, each corner of the carpet depicts the *shou* ideogram, symbolizing longevity. The dragon is the most popular mythical animal in Chinese iconography and represents the positive forces of nature; originally depicted with five claws, it also symbolized the emperor.

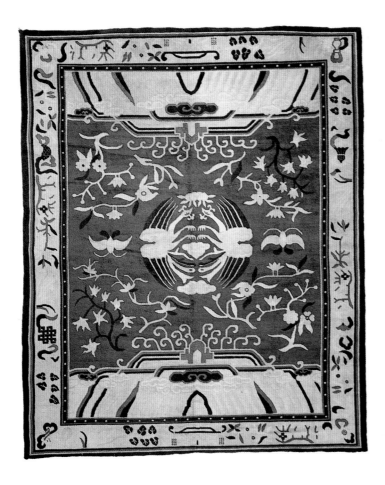

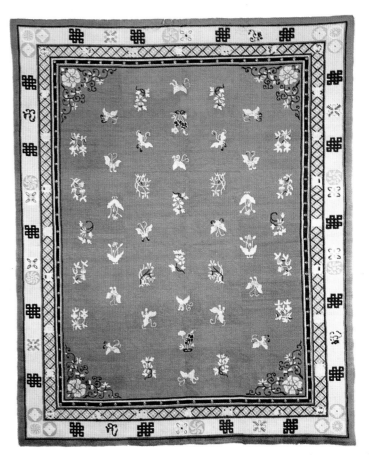

Medallion carpet
Baodou-Suiyüan, late 19th century
Milan, Nilufar Collection

In the center is a pair of animals—cranes (ancient symbol of longevity)—arranged to form a circle. In the center top and bottom is the sacred mountain, while the ground is filled with flowering plants and long-antennaed butterflies, the latter a symbol of conjugal happiness. The secondary inner border is decorated with a pearl motif, while in the principal border appear the eight Buddhist symbols of good luck, which are recurring themes in carpets destined for ritual uses in monasteries, as well as in carpets made for the laity who may not necessarily be Buddhist.

Carpet with symbols scattered full-field
Peking, late 19th century
Milan, Nilufar Collection

In Chinese carpets, the symbols are sometimes distributed full-field, in both directional and nondirectional layouts. These are auspicious symbols, such as, for example, the butterfly, which alludes to marital success, and the peony, a symbol of beauty and harmony. The peony also appears in the field's corners, complemented by thin plant tendrils. The inside minor border contains a three-dimensional late version of the pearl motif, while the other minor border in the center is decorated with geometric elements. The principal border contains auspicious symbols, including the endless knot, symbolizing long life.

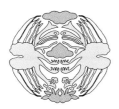

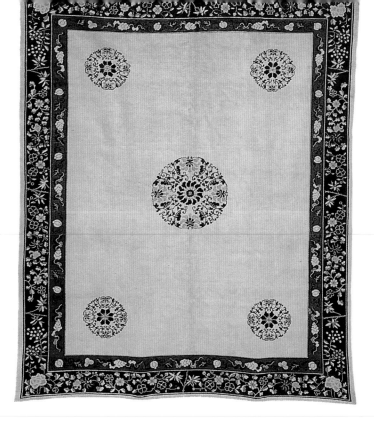

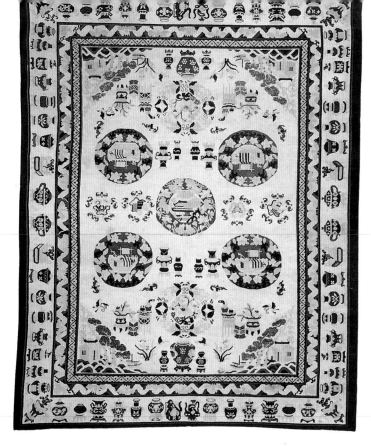

Carpet with four-and-one medallion design
Peking, late 19th century
Milan, Galleria Hermitage Collection

The four-and-one medallion layout appears quite frequently in Chinese carpets. Here, the field's decoration is reduced to its essence, just the five medallions; their elegant floral decoration, which includes light blue symbolic peonies, reflects the influence of Western taste, which the Peking workshops knew how to satisfy for obvious economic reasons. The naturalistic flowering vine set against a very dark background in the principal border also does not squarely belong to Chinese iconographic tradition, unlike the minor border, which is filled with symbolic designs.

Carpet with four-and-one medallion design
Peking, late 19th to early 20th century
Milan, Nilufar Collection

Although this example is of a more traditional character than the previous carpet, it still reflects a Western influence, as indicated by the landscapes inside the central medallion and in the spandrels and by the typical Chinese junks inside each of the four smaller medallions. The remaining decoration, however, is traditionally Chinese and consists of auspicious symbols, such as butterflies and bats, which augur good fortune and happiness, as well as variously shaped vases (with or without flowers), representing eternal harmony; it is no coincidence that they also decorate the principal border.

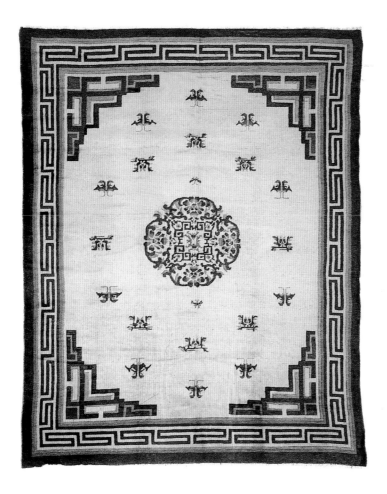

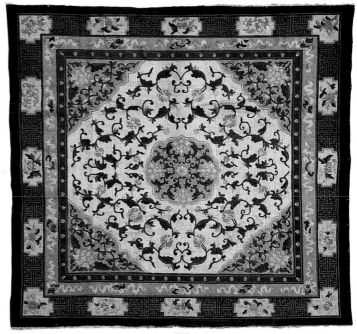

Medallion carpet
Northern China, late 19th century
Milan, Nilufar Collection

In the language of Chinese style, neither contradiction nor separation exists between naturalistic and geometric elements; rather, their apparent aesthetic and symbolic dualism points to the duality of spiritual and earthly life. This traditional carpet type clearly embodies this concept, with the medallion and the naturalistic elements of the field coexisting with the geometric cornerpieces and the principal border. The open medallion is decorated with peonies and plant tendrils, while the field contains small butterflies (symbols of happiness) and floral motifs. The cornerpiece fretwork is, in fact, an extremely stylized version of the dragon.

Medallion carpet
Late 19th century
Venice, Rascid Rahaim Collection

In Chinese carpets, the central medallion can be interpreted in various ways. Here, it is formed by a closed polylobate figure, which recalls the symbolic cloud collar, filled with plant tendrils and peonies, elements that are also present in the field, in the spandrels and in the cartouches of the principal border. Together with the lotus, the peony best represents Chinese art and symbolizes beauty, wealth and the season of spring. All the figures' borders are carved, thus giving the carpet a particular relief effect in early-20th-century fashion.

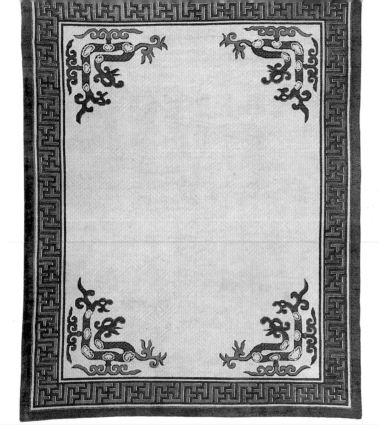

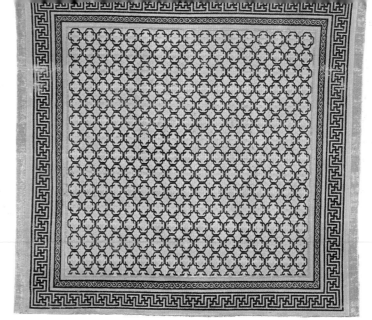

Dragon carpet
Late 19th to early 20th century
Milan, Nilufar Collection

Unlike the two preceding carpets, this example has no central el-ement, with the decoration being limited to the spandrels, each containing a stylized serpentine dragon. The rest of the field is decorated with an infinitely repeated grid of oblique orange swastikas that delicately contrast with the creamy ground color, typical of the Chinese palette. The oblique-swastika motif recurs in several Chinese artistic genres and represents unending for-tune. The principal border is decorated with an unusual, complex swastika fretwork, an infinite repetition of the good-fortune wish.

Carpet with geometric decoration
18th century
New York, The Metropolitan Museum of Art

The grid, rendered in various shapes, is a recurring theme in Chi-nese art; in carpets, it is often present in the curvilinear form (also typical of eastern Turkestan), resulting from the joining of four round-parenthesis elements, a derivation of the cloud collar. In this rare example, inside each grid square is a bat, symbol of good fortune, set apart by its darker orange, which contrasts with the lighter orange of the ground; the rhomboidal spaces between each grid square contain a peach-tree blossom, an allu-sion to longevity, also in a darker shade than that of the ground. Also of note are the minor border decorated with plant tendrils and the main border decorated with a swastika fretwork.

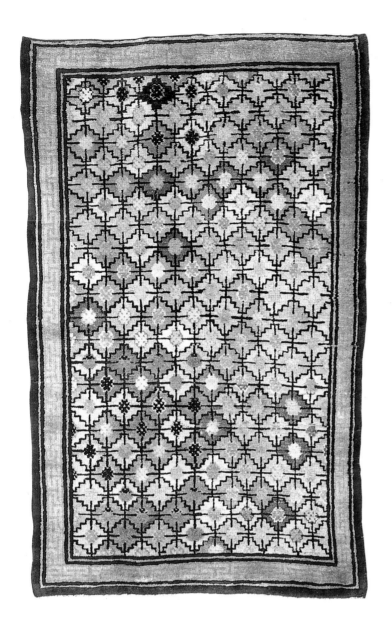

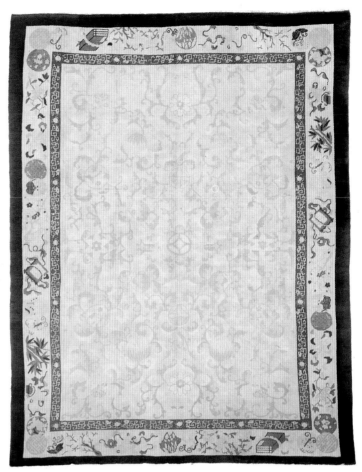

Carpet with geometric decoration
Northern China (Suiyüan), late 19th century
Milan, Nilufar Collection

Owing to its naïve, spontaneous character, this carpet could be attributed to nomadic production, as further confirmed by the imprecise quality of the overall design. The full-field layout consists of a geometric grid formed by polygons with stepped profiles, each filled with a small rhomboid. The colors, which include gray and cream, burnt brown and rose, seem to have been chosen haphazardly, without any precise layout, and give a pleasant sense of spontaneity to the whole. The principal border is decorated with a typical "T"-motif fretwork.

Carpet with floral decoration
Peking, late 19th century
Milan, Nilufar Collection

Placing a design without outlines on a ground of the same color, albeit of a lighter tonality, as in the full-field floral decoration of this carpet, is typical of the Chinese aesthetic canon. Here, the field's center contains a circular coinlike element alluding to wealth, while among the flowers depicted in the field are lotuses, symbol of purity and of summer, and the peony, which represents beauty and the spring season. The secondary border contains a fretwork derived from a stylized dragon, while the principal border exhibits the four honorable skills or virtues of the educated gentleman: books, a checkerboard, the lute and rolls and brushes.

EUROPE

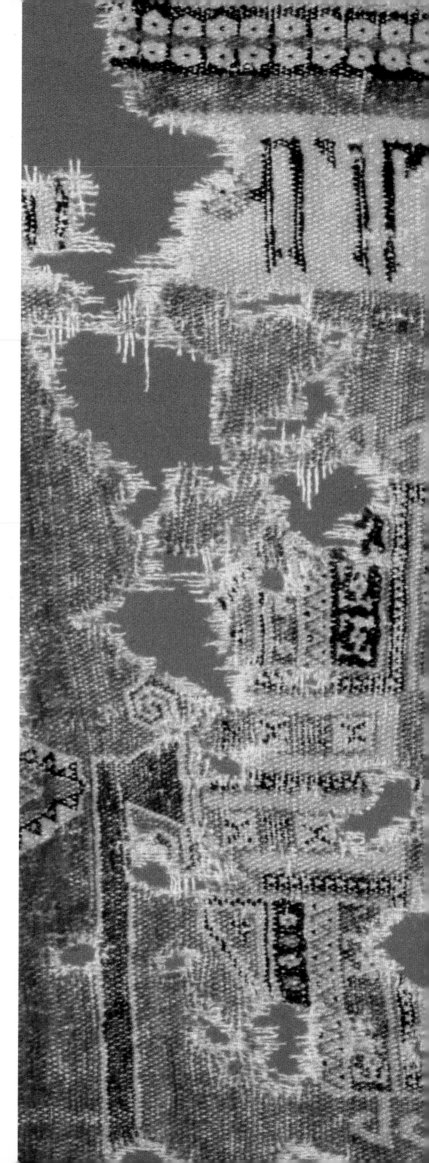

S ince the period of the Arab invasion of the Iberian Peninsula (8th to 14th centuries) and the Crusades (11th to 13th centuries), the knotted carpet has been one of the best-known and appreciated Oriental artifacts in Europe, where it was imported rather than produced locally. (It was produced in Spain, however, where the ancient Oriental models were at first imitated perfectly.)

Unlike the consideration the carpet enjoyed in the Orient, it was deemed exclusively a luxury object in Europe, a symbol of authority and power, totally devoid of ties to practical everyday life; paintings from the 1400s and 1500s frequently depict Anatolian carpets in religious scenes, placed at the feet of thrones or altars or spread out on windowsills and balustrades. In the secular paintings of the 16th century, though, they are used as coverings for table and furniture surfaces instead of floors, because in private homes, they were considered precious objects that should not be walked upon or worn out.

In any case, in Europe, the carpet was always considered strictly an object of furnishing, closely linked to the concept of interior decoration and therefore subject to changes in style in every period and in every country.

Thus, when the need arose in Spain, France and England, beginning in the 1600s, for a high-quality domestic production, workshops were created with the intention of reproducing the art and technique of Oriental carpets, and high-level products were manufactured. They were, however, totally different from the Oriental prototypes in design and style. And where the art of knotting developed in other localities, production remained at all times at the level of small artisans, without any artistic pretense, since the carpet was made for warmth and not decoration. It is fitting, nevertheless, to look briefly at the great Western carpets, very different from those we have studied so far.

Fragment of carpet with geometric decoration
Spain, 14th to 15th century
Berlin, Museum für Islamisches Kunst

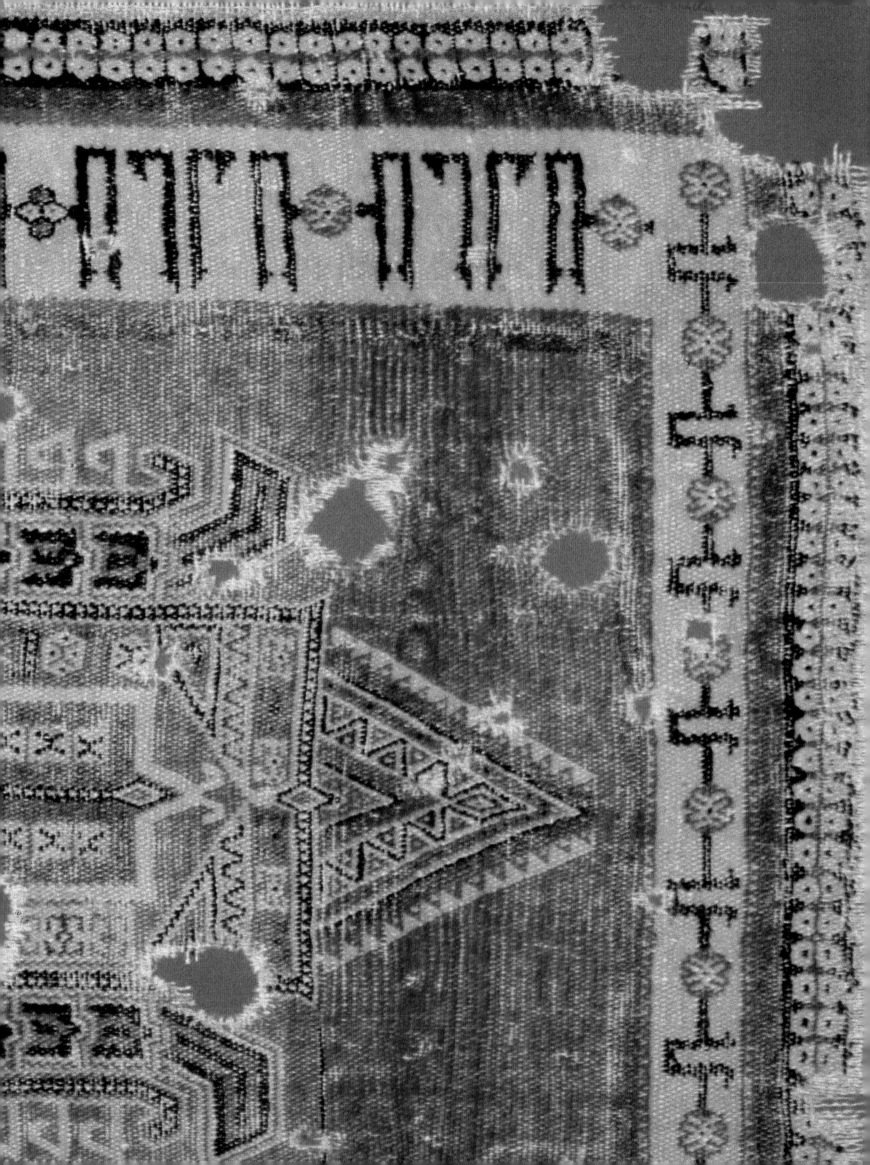

Spain

As a result of its long Arab domination, Spain is the only European nation that can boast an ancient carpet-making tradition, noted since the 12th century with the Chinchilla production. Spanish carpets are identifiable by the so-called Spanish knot, also called the "single-warp" knot. Decorated with geometric motifs of Islamic origin and now extremely rare, these first "Moorish" specimens were even exported to Egypt, where fragments have been discovered.

The earliest surviving Spanish carpets are datable to the 15th century. Carpets manufactured in the first half of that century, probably in Letur, introduced in the field coats of arms and trophies of the royal family and the local nobility, on a background decorated with small geometric elements. The borders were decorated with geometric motifs and figures, with flowers and animals, in a happy union of Islam and the West, typical of the Spanish art from the same period. From the middle of the 15th century, during the Gothic period and the era of triumphant Christianity, geometric Islamic motifs were replaced by Western floral motifs that took their inspiration from textiles of the same period and consisted of plant vines, buds and similar motifs.

In the 16th century, with the ushering in of the splendid period of the Spanish Renaissance (1500s–1600s), this process became more marked. Spanish carpets, especially those manufactured in Alcaraz, continued to find their inspiration in Islamic motifs, especially in the Holbein-type Anatolian carpets. However, these motifs were transformed in accordance with the European figurative style and interpreted with typical Spanish colors: red, yellow and light blue in various shades.

At the end of the 16th and in the 17th centuries, the creative vein was on the decline, and the Spaniards found it preferable to make copies of Oriental carpets, mostly Anatolian with a few Persian models, while at the same time including local motifs. In particular, in Cuenca, although the carpets manufactured were copies of the Anatolian or Lotto-type arabesque carpets, only typical Spanish colors were used, thus without strong contrasts.

By the 18th century, with Cuenca declining as the premier center of production and becoming a commercial rather than a manufacturing center, the Royal Works of Madrid took the lead and imposed the symmetrical knot, also imitating the rich, stately French style for carpets that were destined to decorate the large halls of the royal palaces. After a crisis lasting many years, the Cuenca plant and the Madrid works were finally closed. Later, the National Carpet Works were founded in Madrid.

France

To limit the importation of carpets from the Orient, Pierre Dupont—encouraged by King Henry IV (1589–1610)—opened a workshop in 1608 under the Louvre Gallery to make samples "in the fashion of the Levant and of Turkey," which would therefore resemble the Oriental prototypes in style and technique.

With the patronage of King Louis XIII (1610–1643) and because the factories were state-owned, a great royal carpet-making factory was set up in 1627 in Chaillot, near Paris, on the site of an old soap factory called Savonnerie, hence the name. Savonnerie was managed at first by Simon Lourdet, later joined by his master and partner, Pierre Dupont. The labor force consisted of young orphans, apprentices and artisans—all men—and the cartoons were supervised and approved by the best court painters, such as Charles Le Brun. In 1825, the factory was joined to the Manufacture Royale des Gobelins, creating the still-existing Manufactures Nationales des Gobelins, de Beauvais et de la Savonnerie.

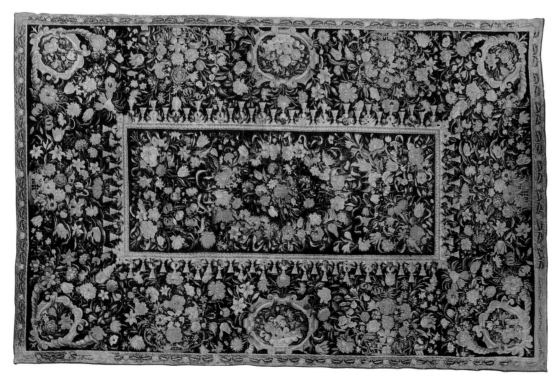

Left, Savonnerie carpet with floral decoration. France, 1640–1660. Paris, Louvre. European carpets were always influenced by the dominant style of each era and country. The design of this Savonnerie carpet is in Louis XIII style and is marked by a very dark ground and a rich, multi-colored floral decoration in the naturalistic style. Also, the field has shrunk, and there is almost no difference between it and the borders.

Facing page, bottom, carpet with naturalistic decoration. Great Britain, Exeter c. 1760. Delaware, Henry Francis du Pont Winthertur Museum. English production was always strongly influenced by French carpets, and this was especially true in the 19th century. In this 18th-century example, to the floral exuberance typical of the French baroque is added the English predilection—in that period—for birds, here represented by two magnificent peacocks placed in the center of the field and by two groups of light-colored ducks arranged amid the flowers in the center of the shorter borders.

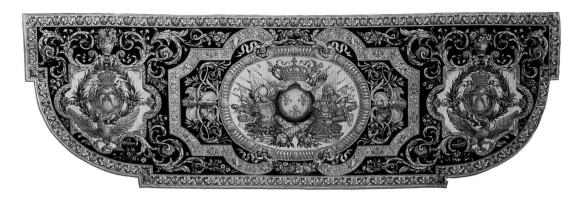

Savonnerie carpet of unusual shape, with naturalistic decoration; France, 1668. Paris, Louvre. The Savonnerie works primarily produced large carpets for the Royal House, such as this example measuring 930 x 310 cm (366 x 122") designed by Charles Le Brun, the leading court painter, for Louis XIV's (1653–1715) Grande Chambre in the Tuileries Palace. In the center of the opulent baroque decoration is France's coat of arms: a globe with golden *fleurs-de-lys*, surrounded by arms and trophies; Louis XIV's monogram is above the eagles on each side.

Made with the symmetrical knot, Savonnerie carpets are distinguished in their technique by foundations made of hemp or linen, by knots cut in rows by looping a series of them around a cutting bar, by their large size (suitable to the enormous halls of the court palaces) and by their naturalistic and architectural decorations with elaborate three-dimensional effects. These carpets were sumptuous and free of Oriental motifs, following, instead, the evolution of French taste and echoing the friezes and stuccowork of the various architectural decorations. They were created to complement the style of the furniture they would decorate, from baroque to art nouveau.

While the name Savonnerie indicates knotted carpets of extreme luxury, the name Aubusson is linked to tapestries, which are flat weaves and which are less costly. Less precious and produced in various shapes and sizes, Aubusson carpets took their name from the town where a tapestry-weaving tradition existed as far back as the 16th century and where carpets, or rather, "floor tapestries," started to be produced around 1760, following the decoration of the Savonnerie-style carpets but standing apart from these with their simpler and less refined designs.

The influence of both the Savonnerie and the Aubusson carpets on foreign production was so strong that between the end of the 18th century and the early 19th century, the French carpet became a model to be imitated even in the Orient (especially in Anatolia and in China), most of all for its curvilinear designs, naturalistic floral friezes (garlands, vines, scattered flowers) and generally pale and shaded colors. Like other European carpet productions, however, French carpet making went into a crisis around the second half of the 19th century.

Great Britain

Although the knotting technique was not totally unknown to the English, needlepoint and tapestry weaving were always the preferred techniques. It was only in the middle of the 18th century that the first knotted-carpet workshop producing Savonnerie-type carpets were set up in Fulham and Exeter: the first founded by the Frenchman Pierre Parisot and the second by the Swiss Claude Passavant. Starting in 1755, the carpets of the Thomas Whitty workshops at Axminster met with particular success. These carpets took the most diverse styles as their inspiration, from the Savonnerie to the Aubusson style, to China and the Orient, to neoclassicism and Egypt. Around 1757, Thomas Moore opened a workshop in Moorfields, where architect Robert Adam (1728–1792) also worked. His architectural designs gave special importance to floors. Therefore, the carpets he designed followed the rules of neoclassical architectural decoration of the period and contain sober motifs taken from antiquity.

During the 19th century, French carpets were a notable influence, and to this, the English combined motifs that recalled the Orient. However, around 1850, the decline of the handmade knotted carpet began, caused by competition from Western-style Oriental carpets and by the new local production made on mechanical looms. Attempts were made to reverse this trend, but manual knotting was soon abandoned throughout Europe in favor of the less expensive, albeit cold, industrial production with designs inspired by examples from European history.

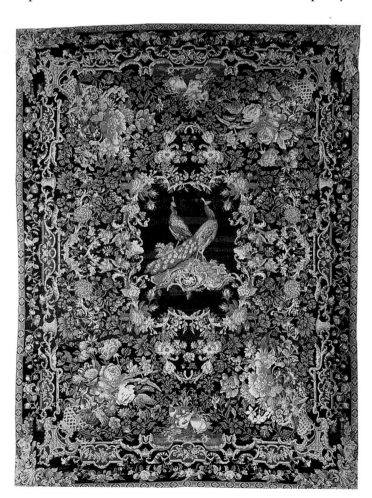

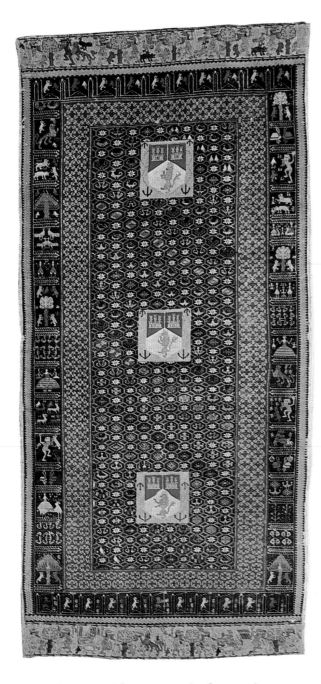

Carpet with geometric decoration
Spain (Letur?), 15th century
Philadelphia, Philadelphia Museum of Art

The merging of the Islamic and Western spirit, which typifies Spanish art, is also found in carpets. In this example, the Islamic geometric language, expressed in the octagonal elements of the field, in the wide inside border decorated with a grid and in the stylized naturalistic elements, merges in a curiously balanced fashion with the European figurative language. The latter language is expressed in the three coats of arms arranged along the vertical axis of the carpet, in the rampant lions and the small figures of women, birds and trees arranged along the blue ground of the border and especially in the narrative scenes of the lighter-colored bands along the shorter sides of the carpet.

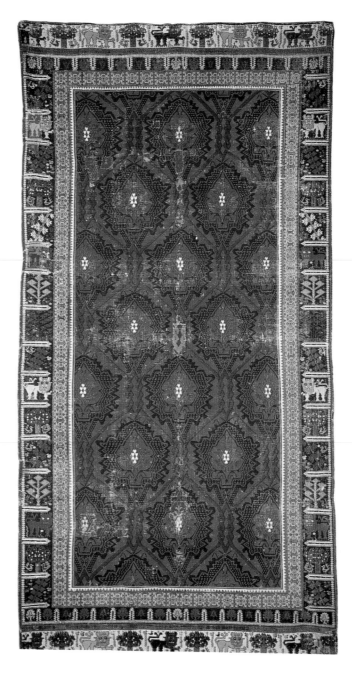

Carpet with floral decoration
Spain, 1450 to 1500
Washington, The Textile Museum

The Islamic geometric language and the European figurative sensitivity also merge in this carpet. The former is rendered in the motifs decorating the inside borders, in the stylized figurative elements and in the layout of the blue border into equal sections separated by a thin white ribbon, a derivation of the Kufic-script motif. The European figurative sensitivity is evident in the main border as well as in the light-colored bands along the shorter sides, with lions and trees set amid facing birds. The field decoration is unusual, consisting of a pomegranate-tree or lobate-leaf motif, adapted from designs on Spanish and Italian silks of the same era.

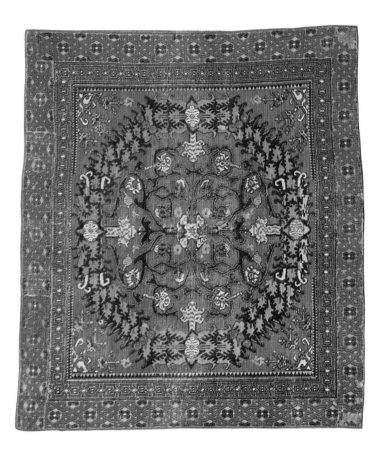

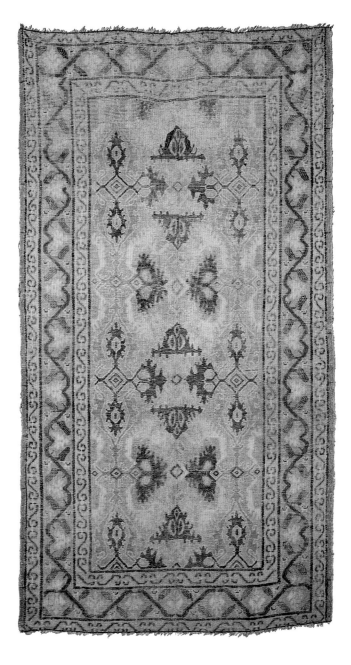

Medallion carpet
Spain, Alcaraz, 16th century
Washington, The Textile Museum

The adaptation of Islamic decorative motifs into designs suitable to Western taste and inspired by textiles of the same era is typical of Spanish 16th-century carpets. In this example, the large, Holbein-type, octagonal medallion typical of Anatolian production has become a rich wreath of leaves, flowers and fruits; inside the medallion, the arabesque is now a plant tendril, while in the spandrels, the fractions of secondary medallions have become stylized floral motifs. Even so, the geometric borders have remained closer to the Islamic spirit; the design of the main border recalls the interlacery of small-pattern Holbeins.

Carpet with Lotto-type arabesques
Spain, Cuenca, late 16th century
Turin, Maria Coen Collection

Copies of Oriental carpets, adapted to the local taste, were already being made in Spain by the end of the 16th and the beginning of the 17th centuries. The Cuenca works became known for the production of Lotto-type carpets such as the one above. The cruciform, arabesqued medallions are exact replicas of the original design, but the borders are not. The principal border has a zigzagging plant vine, which bespeaks a European taste, and the secondary borders are decorated with curvilinear fretwork. Even the colors do not follow the traditional Anatolian palette, as they are an interplay of yellow and blue, a popular Spanish combination.

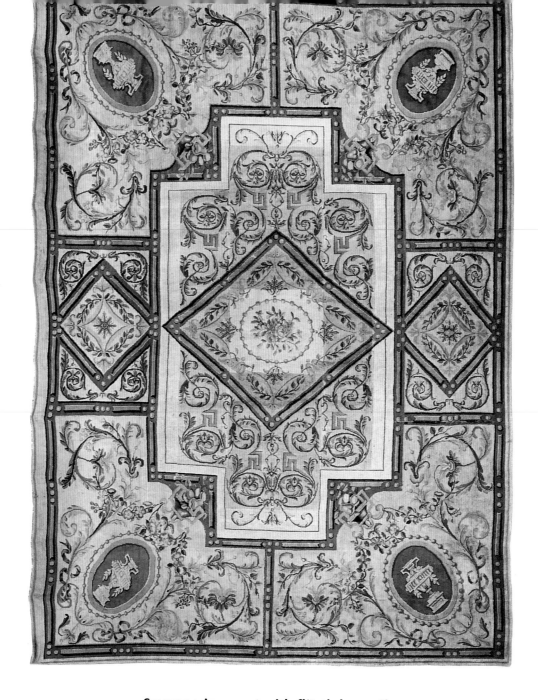

Savonnerie carpet with floral decoration
France, late 18th century
Milan, private collection

Although Savonnerie carpets were originally meant to imitate Oriental carpets, they have nothing in common with them, except for the symmetrical knot, which, however, was executed with a technique different from the original. The above 18th-century carpet (large—442 x 625 cm, or 174 x 246"—like all Savonnerie production) correctly interprets the taste of the era in which it was manufactured: The rich and heavy baroque decoration has given way to the light and grace of a light palette and neoclassical decorative motifs, both floral and architectural. Everything had to harmonize with the decoration on ceilings and walls, from the beaded frieze to the geometric compartments and the oval medallions on a blue ground adapted from ancient decorations.

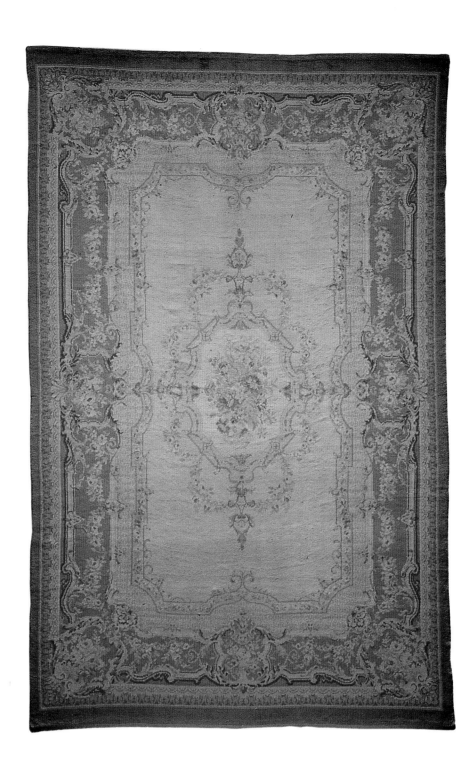

Savonnerie medallion carpet
France, early 19th century
Verona, Tiziano Meglioranzi Collection

This example is rendered in 18th-century rococo style, with sparse decorative motifs and light colors that were so successful, they were imitated in the Orient as well. The field's center is filled by an architectural mixed-line medallion, inside which is a bouquet of lifelike flowers. Rose-dominated lower wreaths surround the medallion and run alongside the borders, whose shape follows the stuccoed and gilded ceiling friezes. Also notable is the use of pastel tints, such as pale pink, light blue, cream and pale bordeaux.

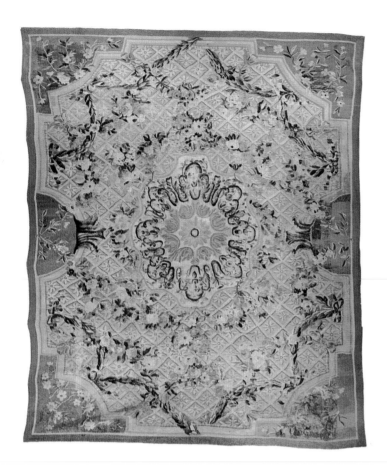

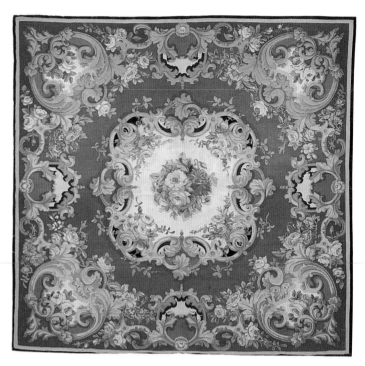

Aubusson medallion carpet
France, Louis XVI period (late 18th century)
Private collection

Unlike the Savonnerie production, Aubusson carpets were flat-woven, not knotted; having no pile, they were truly floor tapestries. Although less costly and prized than Savonnerie carpets, since they were produced to fill the demand of the private middle-class market, even Aubusson carpets followed the style of the period, albeit simplified. For example, during the reign of Louis XVI, when it was fashionable to meld neoclassical and rococo elements, the Aubusson production was marked by brown grounds and by wreaths, flowering vines and leaves connected by fluttering ribbons; these motifs were rendered in many variants. Note, in this carpet, the refined use of colors and the elegance of the central medallion, which contains a complex light blue frieze.

Aubusson medallion carpet
France, Napoleon III period (third quarter of 19th century)
Private collection

Under the rule of Napoleon III, at the time of the Second Empire (1852–1870), carpet decoration followed the then-fashionable neorococo style. Distinguishing features of this style were a return to curved lines with elaborate scrolls and friezes, as well as the predominance of rich, excessive floral decoration arranged in bouquets and wreaths. Colors of the palette became more vivid, with different colors used on preferably dark grounds. The above example has a typical decoration of false architectural friezes with scrolls and acanthus leaves, softened by a rich decoration of lifelike roses. The square shape of this carpet should not be a surprise, as Aubusson carpets were produced in different formats.

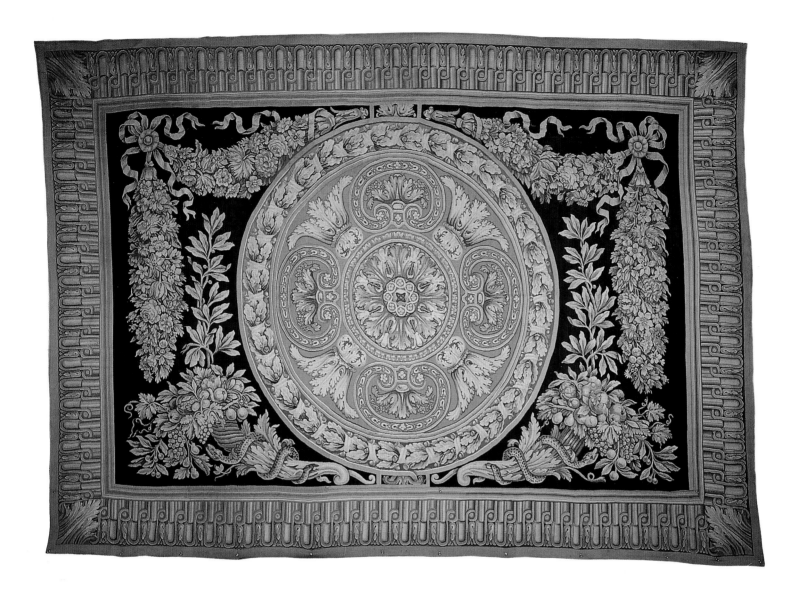

Aubusson medallion carpet
France, last quarter of 19th century
Venice, Rascid Rahaim Collection

In the eclectic period from the end of the Second Empire to the turn of the century, the decorative repertoire of previous centuries was revisited and often combined with new, original formulas. This carpet, for example, clearly recalls the grandiose opulence of the baroque in the ornate festoons of multicolored flowers, tempered by a skillful touch of classicism, such as the central shieldlike medallion with acanthus-leaf motifs, as well as the two cornucopias with winding snakes. The field's dark color brings out even more the whole design in all its richness.

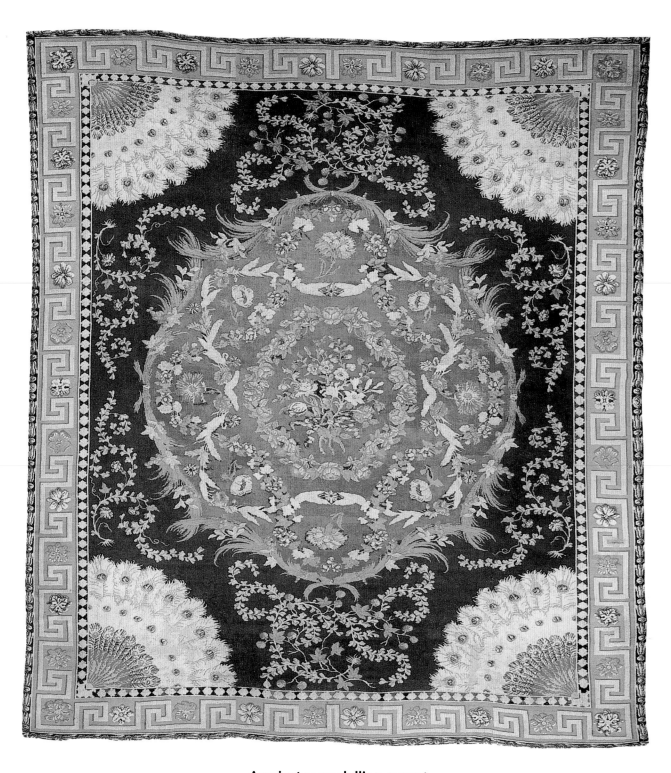

Axminster medallion carpet
Great Britain, 1765–1770
Private collection

At first, Axminster production was known for its imitation of Oriental prototypes; later, it followed the times and produced then-fashionable styles. This carpet dates from the English rococo period, which was marked by brown or white grounds and a decoration in which floral elements dominated, gracefully scattered in elegant wreaths or bouquets, as in the above central medallion. Also, the flowery ground and the principal border with a geometric fretwork present a skillful contrast with the spandrels, where the fractions of medallions have become precious feather fans.

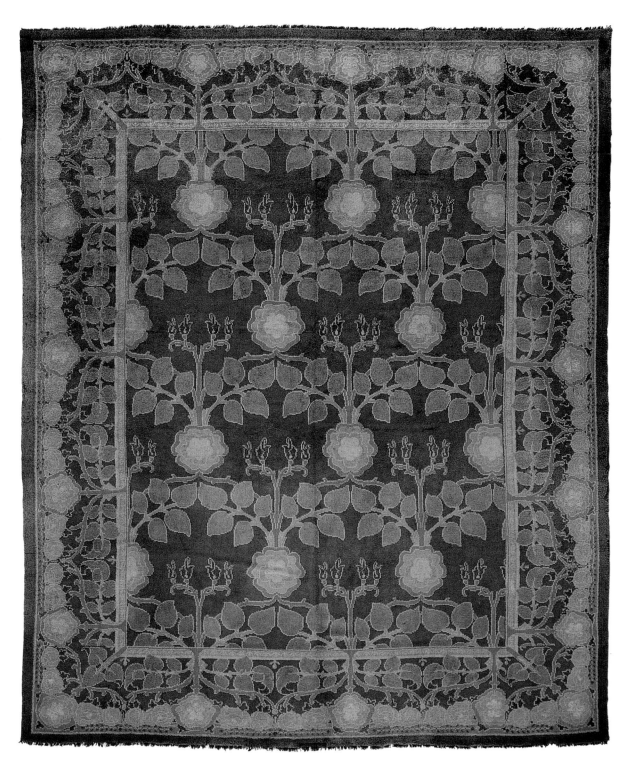

"The Rose" carpet with floral decoration
Great Britain, 1899
Private collection

The Arts and Crafts movement, founded by William Morris at the end of the 19th century, gave renewed impetus to the medieval artisan spirit versus machines, and its utopian program affected carpet making as well. The above carpet was designed by Charles F. A. Voysey (1857–1941), a founder of the movement and a leading Art Nouveau artist in Great Britain. In keeping with the fashion of the times, the flowers are stylized and curvilinear and are distributed symmetrically full-field; the elementary yet brilliant colors highlight the charming simplicity of the overall design.

MUSEUMS AND CARPETS

Berlin, Islamisches Museum: "Ming," or "Berlin," figural medallion carpet from Anatolia, first half of 15th century; Anatolian and dragon Caucasian carpets; Spanish carpet, 14th–15th century.

Berlin, Museum für Islamisches Kunst: Anatolian, Mameluke, Persian and dragon Caucasian carpets.

Boston, Museum of Fine Arts: Indian figural carpet, early 17th century.

Cleveland, The Cleveland Museum of Art: Carpets from Anatolia, Persia, the Caucasus and Spain.

Cuenca, Diocesan Museum: Spanish carpets.

Florence, Museo Bardini: Carpets from Anatolia (*chintamani,* coupled-column, double-niche carpets, etc.); Mameluke carpets; floral carpets from Persia and the Caucasus.

Florence, Ìuseo Nazionale del Bargello: Carpets from Anatolia (with birds, stars, etc.).

Hamburg, Hamburgisches Museum für Völkerkunde: Carpets from western Turkestan.

Istanbul, Türk ve Islam Eserleri Muzesi: Seljuk and Anatolian carpets; kilims.

Istanbul, Vakiflar Museum: Carpets and kilims from Anatolia.

Jaipur, Mahharaja Sawai Man Singh II Museum Trust: Carpets from India.

Lisbon, Fundação Calouste Gulbenkian: Carpets from Anatolia, Persia, the Caucasus, India, eastern Turkestan and western Turkestan.

London, Victoria and Albert Museum: "Ardabil" Persian medallion carpet, 1539–1540; carpets from Persia and western Turkestan.

Lugano, Thyssen-Bornemisza Foundation: Ushak medallion carpet from Anatolia, 16th century; carpets from Anatolia, Persia and India; Indian floral prayer rug, early 17th century.

Lübeck, Museum für Kunst und Kulturgeschichte: Carpets from western Turkestan.

Lyons, Musée Historique des Tissus: Persian, Indian and Savonnerie carpets.

Madrid, Royal Palace: Spanish carpets.

Milan, Museo Poldi Pezzoli: Persian medallion carpet with hunting scenes, 1522–1523 or 1542–1543; Persian carpets.

New York, The Metropolitan Museum of Art: Carpets from Anatolia, the Mameluke period, Persia and India.

Oxford, Ashmolean Museum: Indian floral carpet, early 18th century.

Paris, Louvre: Fragment of Indian carpet with animals, 15th–16th century; Savonnerie and Aubusson carpets.

Paris, Mobilier National: Savonnerie and Aubusson carpets.

Paris, Musée des Arts Décoratifs: Ottoman floral carpets, Persian, Savonnerie and Aubusson carpets.

Philadelphia, Philadelphia Museum of Art: Indian carpet with trees and shrubs, early 16th century; Persian and Spanish carpets.

Saint Petersburg, Hermitage: Pazyryk carpet, dated to the fifth century B.C.

San Gimignano (Siena), Museo Civico: Cruciform medallion carpet, Cairo, mid-16th century.

Stockholm, Historiska Museum: "Marby" Anatolian medallion carpet with figures, first half of 15th century.

Teheran, Carpet Museum: Carpets from Anatolia, Persia, the Caucasus, eastern Turkestan and China.

Toronto, Royal Ontario Museum: Chinese carpet with symbolic motifs, 18th century.

Venice, Museo del Tesoro della Basilica di San Marco: "Polish" carpets.

Versailles, Musée de Versailles: Savonnerie carpets.

Vienna, Österreichisches Museum für angewandte Kunst: Carpets from Anatolia, the Mameluke period, Persia; "Polish" carpets; "Portuguese" carpet, 17th century; Indian *millefleurs* prayer rug, late 17th century; Indian "peacock" carpet with animals, early 17th century.

Washington, National Gallery of Art: Carpets from Persia and India.

Washington, The Textile Museum: Carpets from Anatolia, dragon and floral carpets from Anatolia and the Caucasus; carpets from India, China and Spain.

GLOSSARY

Abrash. The presence of various shades of the same color in the carpet's ground. They are caused by different degrees of color absorption by the fibers or by the use of different skeins of the same shade, though from different dye baths. Although they may appear spontaneously, they may also be created by the weaver to provide movement to the ground color of the carpet.

Afshan (or **avshan**). A decorative field motif consisting of rosettes and palmettes and recognizable by the typical forked-leaf elements rotating around a small flower. It is found in the 19th-century carpet production of the Caucasus, especially in carpets from Kuba and Baku.

Arabesque. A decoration in the carpet's field, common to all Islamic arts. It consists of a continuous ribbon, which may be endlessly repeated, variously thin and intricate.

Ashik. A decorative motif, typical of Yomut carpets, originating from western Turkestan. It consists of a rhombus with a serrated profile, possibly derived from a leaf. Its wide use is probably due to its ascribed magical powers.

Asmalik. An ornamental covering typical of western Turkestan, with five sides and long tasseled fringes, used to dress a camel's flanks at weddings.

Asymmetrical knot. A knot is formed by inserting a length of thread between two warp threads, completely encircling one and passing around the back of the second so that the ends of the knot are separated by the unwrapped warp thread. Depending on which chain has been looped, the knot is said to be "open" to either the left or the right. It is also improperly called the Senneh, or Persian, knot.

Avshan: See **Afshan.**

Borders. The carpet's frames: Depending on their width and position with the respect to the field (see **Field**), borders are distinguished into main (or principal) border, minor (or secondary) border and inner and outer borders.

Boteh. A decorative field and border motif—of probable floral origin—in the shape of a teardrop, with the end bent to one side. It first appeared in 18th-century carpets. It is known in the West as the "Kashmir pattern," since it appeared there primarily in textiles imported from India.

Cartouche. A decorative border motif consisting of elongated polygons, with both straight and curved sides, filled with inscriptions or tiny decorations.

Chemche torba. A knotted sack typical of western Turkestan, which has a long, narrow shape and was used to store tableware.

Chi'lin: See **Jiling.**

Chintamani. A decorative field motif of symbolic origin, consisting of three small disks arranged in a triangle over two wavelike lines. Some ancient carpets produced in Ushak are known as *chintamani* carpets.

Chuval (or **joval**). A large, knotted bag typical of western Turkestan, decorated at the bottom with fringes. It was used to store the bride's dowry and was hung inside the *yurt.*

Cloud band. A decorative field and border motif of ancient Chinese origin, related to the cloud collar (see below). It consists of a ribbon arranged like an omega, called *chi,* variously narrow and sinuous.

Cloud collar. A symbolic decoration of Chinese origin, consisting of a circle with four or more elements shaped like three-pointed arrows or trefoils. It symbolizes the "heavenly gate," or communication with the divine, like the clouds surrounding the sun.

Çubukli. A decorative border motif consisting of long, narrow continuous frames alternating in two colors and decorated with tiny flowers or dotlike elements. Popular in Anatolia, it is named after the long and narrow pipe typical of the area, which it resembles.

Elam. Wide outermost bands, variously decorated, placed along the carpet's two short sides. They are typical of carpets produced by nomadic tribes, especially those of western Turkestan.

Ensi (or **hatchlu**). The *yurt's* inside door, made of knotted textile, typical of western Turkestan and used for special occasions instead of a wooden door. Decorated with a large, cross-shaped, central element, the *ensi* are also called *hatchlu,* or "cross," in Armenian.

False: See **Jufti.**

Field. The area of the carpet inside the borders, containing the central decoration.

Foundation. The carpet's foundation, consisting of the vertical warp which is interlaced by the horizontal weft. The knots are tied around the warp and are held in place by the weft.

Fringes. The upper and lower extremities of the warp; once cut from the loom, they are knotted or braided in various ways.

Gabbeh. Carpets with a very long, soft pile, possibly used

as pallets or blankets by Persian nomadic tribes, such as the Qashq'ai.

Ghiordes: See **Symmetrical knot.**

Gul. A decorative field motif, possibly of floral origin, consisting of a small, polygonal medallion rendered in various shapes, subdivided into four parts of different colors and filled inside with tiny geometric figures. It is the distinctive motif of western Turkestan tribes (different for each tribe).

Harshang: See **Kharshang.**

Hatchlu: See **Ensi.**

Herati. A decorative field motif, its basic version consisting of four flowers arranged at the points of a rhomboid, which in turn contains a small, roundish flower; the rhomboid is surrounded by four sickle-shaped leaves. The *herati* is also a border motif, with the palmettes and the typical lance-shaped leaves. It first appeared in 18th-century Persian carpets and later spread to Anatolia and the Caucasus.

In-and-out palmette. A decorative floral motif, consisting of one or two pairs of palmettes, with the points directed either toward the center of the carpet or toward its borders. First appearing in Persia in the 16th century, it enjoyed great success in later centuries as well, though in less elaborate versions.

Jiling (or **chi'lin**). A fantastic animal (half-dragon and half-deer) of Chinese origin used as a decorative element.

Joval: See **Chuval.**

Jufti. A variant of the symmetrical and asymmetrical knots, it is made by looping the thread around four warp threads instead of two. It is also called the "false knot," because it has been used to speed up manufacturing time. It was originally used in Khorasan to achieve special relief effects.

Kapchuk. Knotted pillows typical of western Turkestan, used to decorate the *yurt's* interior.

Kapunuk. Knotted textiles typical of western Turkestan, shaped in the form of a "U" and decorated with fringes; they were hung around the *yurt's* entrance on feast days.

Kharshang (or **harshang**). A decorative field motif arranged along three parallel rows and based on three elements: an unusual sunburst palmette; a diamond-shaped flower arranged diagonally, with four forked leaves; and a roundish flower resembling a toothed wheel. The name (which means "crab") refers to the zoomorphic palmette. A geometric version of this motif is typical of Caucasian carpets from the regions of Baku and Kuba.

Kilim. A flat-weave rug, like a tapestry, with no pile. The weft is passed only in the relevant colored areas, not along the whole width of the carpet; thus slits 2–5 cm (¾–1¾") long are formed at the junctions between colors.

Knotting. A technique for manufacturing knotted carpets, that is, carpets with a pile, in which knots are executed on the foundation (see **Foundation**) mounted on the loom. Each knot is looped around the warp threads and is secured by the weft; the two ends of the knot's thread form the carpet's pile, which hides the foundation.

Kotchanak. A decorative border motif, consisting of a rectangle or a square, with hooks resembling a ram's horns along two of its sides. A typical motif of western Turkestan carpets, it also appears in carpets from the Caucasus.

Kufic. A decorative border motif inspired by the Kufic script used by the Seljuk Turks. It was present in Anatolian carpets as early as the 13th century.

Loom. The structure or frame used to keep the vertical threads of the warp taut and straight, allowing the passing of the horizontal strands that form the weft, thus creating the carpet's foundation (see **Foundation**). It is the basic tool for manufacturing knotted carpets and comes in two kinds: the large, vertical, fixed loom used by settled peoples; and the smaller, horizontal loom that can be dismantled and therefore used mostly by nomadic tribes.

Medachyl (or **medakhell**). A decorative border motif derived from a simplified trefoil motif. It consists of two facing, intermeshing rows of arrowheads or triangles in two colors. It appears in Caucasian carpets.

Mihrab (or **niche**). An Islamic symbolic decoration present in prayer rugs; it also serves to orient the position of the faithful toward Mecca, like the architectural mihrab found inside each mosque. It first appeared in Anatolian carpets beginning in the 15th century and is one of the most famous and popular types of decoration.

Mina khani. A decorative field motif consisting of four roundish flowers akin to daisies, arranged in a diamond shape and linked by a tendril; inside the diamond is another, small flower. Repeated across the whole field, it forms a flower grid. It is typical of Persian carpets produced in Veramin.

Multiple-niche or **family prayer rug:** See **Saph.**

Niche: See **Mihrab.**

Palmette. An ancient decorative floral motif inspired by the fan-shaped leaves of the palm tree or by the lily, the palmette made its first appearance in carpets beginning in the 16th century. By the end of that century, it had become the protagonist of the Persian floral carpet type. Depending on the various epochs and areas of production, there are naturalistic interpretations of this motif, such as the 16th-century "Shah Abbas" palmette, as well as sunburst, budding, open, geometric palmettes, and more. The palmette appears in the field as well as in the borders; it may be a joint leading element, as in the *herati* motif, or the central element, as in the in-and-out palmette motif.

Pile. The carpet's "fleece," which distinguishes the knotted carpet from all other types of flat-weave textiles.

Prayer rug: See **Mihrab.**

Rosette. A decorative field and border motif used in filling and to complement the central design. Oval or round-shaped, it is symmetrical and enriched with petals.

Running dog. A decorative border motif in two colors, with varying patterns and interpretations, consisting of a geometric-wave or hooked fretwork. Popular in Caucasian productions.

Saph. Also known as "multiple niche" or "family prayer rug," it is composed of several mihrabs, placed one next to the other, of equal shape, sometimes of different colors and filled with various decorations. This type of prayer rug was typical of Anatolian production in the 15th century, *saph* meaning "row" or "in rows." Beginning in the 17th century, it also spread to other production areas, especially eastern Turkestan.

Senneh: See **Asymmetrical knot.**

Sinekli. A decorative motif consisting of tiny black elements ("flies") on a white ground, it is a symbol of fertility and appears in *kiz* wedding carpets from Anatolia's Ghiordes.

Soumak. A flat-weave carpet, with no pile, executed with the looped-weft technique in which the weft threads are looped around the warp, passing forward over three or four warp threads, then back under one or two threads, before proceeding forward again. This results in an oblique stitch, which, when executed in both directions, forms a "wheat spike" effect.

Spandrel. The area near each corner of the carpet's field. In the medallion layout, the spandrels (or cornerpieces) often contain fractions of secondary medallions.

Spanish knot. In the knotting technique, a knot formed by looping the thread around a single warp thread, using alternate threads. Widely used in Spain and practically unknown in the East, it is also called the "single-warp" knot.

S-spinning. A spinning technique in which the yarn's fibers are twisted in a counterclockwise direction.

Symmetrical knot. In the knotting technique, a knot formed by looping the thread around two warp threads so that the ends appear between the two warp threads. It is also improperly called the Ghiordes, or Turkish, knot.

Torba. A knotted bag typical of western Turkestan, smaller than the *chuval* (see **Chuval**) and decorated on the bottom with fringes.

Tree of life. Used throughout the Orient, a symbolic decoration with a positive meaning, in which the tree represents fertility, continuity and the cosmic axis that joins the realms of heaven (the divine), earth (the human) and the underground (the magical world).

Trefoil motif. A decorative border motif derived from the cloud collar (see **Cloud collar**), formed by two facing and intermeshing rows of trefoil-like elements which are variously rendered and come in two colors, usually red and blue or red and yellow. It was used in ancient Anatolian and Caucasian carpets and especially in carpets from eastern Turkestan.

Vaghireh. The models of traditional designs from each production to be executed on carpets: Placed to one side of the loom, they were used as patterns in the knotting phase. The *vaghireh* were either small paintings or true, miniature knotted carpets presenting the designs of sections of medallions and of borders to be then multiplied and rearranged on the carpet. The oldest *vaghireh* date from the 17th century and were used primarily in Persia, Anatolia and the Caucasus.

Waq-waq tree. An unusual symbolic figure of Indian origin, where the tree's branches or fruits are transformed into the heads of men and animal monsters screaming *"waq-waq"* ("howl" in Persian), thus representing the tree's vital energy and its divinatory powers. Appearing first in 16th-century Indian carpets, it later spread to Safavid Persia and was typical of the 19th-century carpets produced in Heriz.

Warp: See **Foundation.**

Weft: See **Foundation.**

Zil-i-sultan (or **zellol-sultan**). A decorative field motif consisting of a flowering vase flanked by two small birds. A 19th-century motif that first appeared in Persia during the reign of Prince Zellol, this motif spread especially to western Persia (to the Malayer region) and was rendered in more or less realistic versions.

Z-spinning. A fiber-spinning technique in which the twisting of the yarn's fibers is executed in a clockwise direction.

BIBLIOGRAPHY

Antique Carpets. Milan, 1991.

Arabeschi. Tappeti classici d'Oriente dal XVI al XIX secolo. Exhibition catalog. Venice: Palazzo Ducale, 1991.

Aslanapa, O. *One Thousand Years of Turkish Carpets.* Istanbul, 1988.

Banfo, C., and D. Basilico. *Tappeti orientali. Guida per conoscerli e collezionarli.* Milan, 1989.

Black, D. *World Rugs and Carpets.* London, 1985.

Boralevi, A. *L'Ushak Castellani-Stroganoff ed altri tappeti ottomani dal XVI al XVIII secolo.* Florence, 1987.

Campana, M. *Tappeti d'Occidente.* Milan, 1966.

Campana, M. *Tappeti d'Oriente.* Milan, 1966.

Curatola, G. *Tappeti.* Milan, 1981.

Curatola, G., ed. *Eredità dell'Islam. Arte islamica in Italia.* Exhibition catalog. Venice: Palazzo Ducale, October 30, 1993–April 30, 1994.

Eskenazi, J. *Il tappeto orientale.* Milan, 1983; Turin, 1987.

Festa Cioppa, Z. *Il tappeto persiano ieri e oggi.* Venice, 1989.

Formenton, F. *Il libro del tappeto.* Milan, 1970; Milan, 1987.

Formenton, F. *Il tappeto orientale.* Milan, 1986.

Gantzhorn, V. *Der christlich orientalische Teppich.* Cologne, 1990.

Great Carpets of the World. London, 1996.

Heinz, D. "Tappeti." In *Tessuti, tappeti, carte da parati,* part of "I quaderni dell'antiquariato" Series. Milan, 1981, pp. 44–57.

Javad Nassiri, M. *Il tappeto persiano.* Rome, 1990.

Milanesi, E. "Tappeti," in A. Tomei, ed. *Antiquariato. Guida al collezionismo.* Milan, 1993.

Milanesi, E. *The Bulfinch Guide to Carpets.* Boston, 1993.

Sabahi, T. *Tappeti d'Oriente.* Novara, 1986.

Sherrill, S. B. *Carpets and Rugs of Europe and America.* New York, 1995.

Stone, P. F. *The Oriental Rug Lexicon.* London, 1997.

Turkish Handwoven Carpets. 4 vols. Ankara, 1987; Ankara, 1992.

Viale Ferrero, M. *Impariamo a conoscere i tappeti.* Novara, 1969.

PHOTO CREDITS

Archivio Electa, Milan

Archivio Fotografico Scala, Florence, Antella

Bardazzi fotografia

Bildarchiv Preussischer Kulturbesitz K

Paolo Manusardi Fotografo

Union Centrales des arts décoratifs

Pp. 2–3. Detail of a medallion carpet fragment. Persia. 16th-17th century. Florence, Museo del Bargello.
Pp. 4–5. Detail of Ushak carpet with Lotto-type arabesques. Anatolia, 17th century. Florence, Museo del Bargello.
P. 6. Gansu medallion carpet. China, early 20th century. Private Collection.

P. 8. See p. 112.
Pp. 12–13. Detail of a Heriz medallion carpet. Persia, 19th century. Venice, Rascid Rahaim Collection.

Pp. 38–39. Detail of a carpet with animals. India, first half of 17th century. Washington, D.C., National Gallery of Art.

We thank the photographic archives of the museums for making available the photographs in their possession. Special thanks for making available the photographs of Samarkand carpets to Giancarlo Cobelli, Bergamo; Walter Marchi, Conegliano Veneto (Treviso); Tiziano Meglioranzi, Verona; Hasan Pashamoglu, Vicenza.

The publisher is at the disposal of the rightful owners for any unidentified photographic reference.